ART AND DEATH
IN A SENUFO VILLAGE

Traditional Arts of Africa

Editors

Paula Ben-Amos
Roy Sieber
Robert Farris Thompson

Art and Death in a Senufo Village

ANITA J. GLAZE

INDIANA UNIVERSITY PRESS
Bloomington

This book was brought to publication with the assistance of
a grant from the Andrew W. Mellon Foundation.

Manufactured in the United States of America
Library of Congress Cataloging in Publication Data
Glaze, Anita J 1940–
Art and death in a Senufo village.
(Traditional arts of Africa)
Bibliography: p.
1. Senufo (African people) 2. Art, Senufo
(African people) 3. Funeral rites and ceremonies,
Senufo (African people) I. Title. II. Series.
DT545.42.G55 745'.09666'8 79–2174
ISBN 0–253–17107–5 1 2 3 4 5 85 84 83 82 81

Contents

Plates

Color Plates

Preface

In view of the popularity of Senufo sculpture and its generous representation in Western collections over the past fifty years, it is surprising that our knowledge of its original setting and significance remains superficial and remarkably incomplete. A descriptive analysis of the cultural context of Senufo art should correct this imbalance in some measure.

This text is essentially a study of meaning, of the nature and purpose of art in the life rhythms of a typical Senufo village. For eighteen months I lived in a Senufo village with one purpose in view: to learn everything I could about the traditional framework of Senufo art. Almost from the beginning of my immersion in village life, I was led to focus increasingly on Senufo concepts of the spiritual universe and on the interrelationships of art and death in Senufo culture. The Senufo inhabit an environment where life has been precarious, where they have been subject to periods of drought, famine, and slave raids, and where the principal enemy continues to be mortal disease. Faced with constant hardship and death, the Senufo counter with a richly varied series of divination, initiation, and funeral rituals designed to protect and strengthen their community. In fact, the observer is struck by the importance of artistic activity as a life-preserving and life-enhancing force. The richness and vitality of Senufo art is best appreciated when seen in the time-and-motion framework of village institutions and ceremony. Senufo art is designed not merely as object in space but as object in controlled time-and-motion sequence. Indeed, to the Senufo, aesthetic experience involves the entire rhythm of exposure to artistic forms and events.

Conceived and brought forth by Sandogo and Poro, the women's and men's organizations, the two chief patrons of the arts, aesthetic

form and performance combine in a vital process whereby conflicts and tensions, in both a real and an ideological sense, are harmonized and resolved. The text will explore the role of art in this process at three levels of social interaction: farmer-artisan ethnic group inter-action, male-female role interaction, and generational interaction through structured age grades. In a larger sense, all participants are engaged in a fourth, and ultimately most important, level of inter-action: that of man and spirit. All major Senufo cultural institutions, and especially the women's divination society, are permeated with a concern for the restoration and maintenance of right relationships with the hierarchy of spiritual beings. The funeral, a multimedia event, is the dramatic and aesthetic setting *par excellence* at which all four levels of interaction are brought together. Through art, drama, and ritual, individual loss is set against the larger perspective of commun-ity, continuity, and communion.

In this reconstruction of a traditional village setting for the arts, the following chapters will consider these themes in detail: the ethnic group composition of the research area and its bearing on the arts; art traditions associated with women's roles and authority, especially in reference to the women's divination society (Sandogo); art tradi-tions associated with men's roles and authority, especially in reference to the men's initiation society (Poro); and, finally, the funeral as syn-thesis.

The art collectively termed "Senufo" is generated by a complex network of over thirty language and dialect groups, including at least six distinct artisan groups living intermingled with the farmer groups. I chose to focus on one small section of this ethnic network—a cluster of villages in the Dikodougou area—in order to separate, identify, and evaluate those strands that are interwoven structurally into its art tradi-tions. Since a corollary aim of my research was to explore the rela-tionship of ethnicity to stylistic and thematic variation in Senufo art, I paid particular attention to the specific groups involved and to usage patterns within this well-defined area. The pattern of group dynamics and art traditions that emerges from this village study can be consid-ered representative of much of the Senufo area and perhaps other Western Sudanic culture areas as well.

Based in the Dikodougou *sous-préfecture* of the Korhogo *préfecture* in the north-central Ivory Coast, I carried out field research from May 1969 to August 1970. Apart from some comparative data obtained in the neighboring Nafanra, Tyebara, and Kafiri dialect areas, my field data were collected primarily in a cluster of villages located within a thirty-kilometer radius of Dikodougou (see map). Known as the Kufulo region, this area is the home of seven distinct Senufo farmer

and artisan ethnic groups, discussed in some detail in the first chapter. Briefly these groups are as follows:

A. *Senufo farmer groups*
 1. Fodonon
 2. Kufulo
B. *Artisan groups assimilated into Senufo culture*
 1. Fono (blacksmithing, woodcarving, basketry)
 2. Kpëëne (brasscasting, pottery, weaving)
 3. Kule (woodcarving)
 4. Tyeli (farming and leatherworking)
 5. Tyeduno (blacksmithing, pottery, weaving)

A discussion of the art of any one village must take into account the nature of farmer and artisan group interaction in the Central Senufo area. It is characteristic of the Senufo artistic scene in general that the commissioning, production, and embellishment of a single art object may well involve several different artists and cross boundaries of as many as six different artisan and farmer ethnic groups.

The village selected as a microcosm of Senufo culture was Pundya, a predominantly Fodonon village of about 1,300 inhabitants. Close ties of kinship and ritual link the various ethnic groups of this village to a number of neighboring villages, the most important of which are the Fodonon villages of Kapilé (1,920), Puloro (900), Tapéré (510), and Tufundé (500) and the predominantly Kufulo villages of Nokataha (820) and Guiembe (1,920). Each of these villages is a composite settlement consisting of one or both of the region's farmer groups and generally two or more of the region's artisan groups. Some villages also harbor non-Senufo minorities.

It may be noted that this study does not deal with inroads of modernization on traditional village institutions. For example, I have not discussed how the village situation is affected by modern schools, labor migration, government development projects, and the growing number of converts to Islam and Christianity. In any case, the pace of social change has been far less rapid in the remoter districts, such as the Sirasso and Dikodougou *sous-préfectures*, than in the immediate environs of Korhogo. Indeed, the first public elementary school in Dikodougou opened late in 1969, and fewer than a dozen small boys from the core village were conscripted for the daily six-kilometer walk to school. Also in 1969, of a population of 1,300 in the core village, there were only about a dozen Christians and about four times that number of Muslims. The introduction of cash crops in the area was still new in 1969 and was being resisted strenuously by some villagers at the time. In short, one of the important factors in the

selection of the focal study area was the strength and persistence of its traditional institutions.

The equal attention devoted to the women's and men's spheres in the text is intended to reflect the Senufo cultural ideal, but it does not correspond to a balanced depth in field data. Probably 80 percent of research time was spent with male informants and in reference to men's activities, so the information obtained directly from women was disproportionately small. This was a result in part of the conservative and less publicly vocal role of women but more particularly of the insoluble problem of finding a local Senufo woman who could speak French. Faced with a male interpreter, the female leadership opted for postponing discussion of many sensitive topics until my level of Senari and Fodonro allowed more direct communication. Nevertheless, several valuable women contacts, along with male informant reinforcements on women-related topics, have made it possible to build up a preliminary picture of the women's Sandogo society and of divination. Over a period of thirteen months, I held a series of interviews with diviners and former diviners in the Fodonon, Kufuru, Kafiri, and Tyebara dialect areas.

As with the women's societies, most information concerning the men's initiation society and organization is considered secret knowledge by Poro society members. For this reason, as a rule I will not cite as sources the names of specific women or men in order to protect the identity of my informants in villages whose Sandogo and Poro memberships have given me invaluable assistance. The larger part of my data on Poro society affairs came from elders, including chiefs and formal "tutors" in Poro from the six villages where I had initiate status and the closest personal contacts with Poro society authorities and initiates.

I should like to note that I have returned twice to the same area of Senufo country since the initial 1969–70 period of research. The materials collected during an additional ten months in 1975 and 1978–79, while serving to confirm my original data, for the most part have been reserved for later studies.

Because preparation and fieldwork for this study covered a long period of time, I have incurred many obligations. First, I wish to acknowledge the generous support of the Foreign Area Fellowship Program, which made possible my field research. I also wish to thank Indiana University for financial assistance. I am also grateful for the assistance of Denise Paulme (Centre d'Etudes Africaines, Paris) and Louis Roussel (Institut National d'Etudes Démographiques, Paris). Postfieldwork interchanges with Albert Kientz, currently working in the Korhogo area, have also been invaluable.

I am particularly grateful for the gracious hospitality and assistance extended by the faculty and staff of the Université d'Abidjan. I also wish to express my thanks for the cooperation of the many ministries and administrators of the government of the République de la Côte d'Ivoire, without whose help my fieldwork would have been impossible. Special thanks are due to the former *préfet* of Korhogo, M. Koblan-Huberson, to M. le Député Gbon Coulibaly, and to the former *sous-préfets* of Dikodougou, M. Martin and M. Gaston Blé. I also gratefully acknowledge the assistance of the members of the Mission Baptiste of Korhogo, linguists Richard Mills and Betty Mills in particular, and the members of the Mission Catholique of Dikodougou, whose generous hospitality and practical assistance contributed so much to my time in the field.

I owe special thanks to Sally Ivaska, typist, editor, and steadfast friend, who has persevered through many drafts and revisions. I also wish to acknowledge my deep gratitude and appreciation for the patience, guidance, and insights of Dr. Roy Sieber, director of my 1976 doctoral dissertation, on which this book is based.

Finally, it would be impossible to express adequately the full extent of my indebtedness to the Senufo people, but I am especially grateful to the Fodonon family and the village, Pundya, that courageously chose to adopt me. Out of respect for the privacy of my sources, the many elders and friends who have contributed to my understanding of Senufo culture, I will single out by name only Ouagnime Soro, who was both interpreter and "brother." I owe much to those leaders and teachers of the Poro societies who accepted me in trust. I can only hope this book fulfills my promise to record faithfully their heritage for the sake of their great-grandchildren and that it has not compromised their trust.

ART AND DEATH
IN A SENUFO VILLAGE

CHAPTER 1

Senufo Farmer and Artisan Groups of the Kufulo Region

INTRODUCTION

THE SENUFO LANGUAGE FAMILY

The Senufo-speaking peoples, numbering over eight hundred fifty thousand, live in a large area that is divided today among parts of Ivory Coast, Mali, and Upper Volta (map). They fall into four broad cultural and language divisions: Northern, Eastern, Central, and Southern Senufo. To be sure, such a division does not account for inevitable problem areas that really form their own distinctive enclaves and cannot be assigned to one linguistic division rather than another without difficulty.

The subgroup composition of the Senufo peoples is exceedingly complex, but, as indicated by field data from the Kufulo region, this subgroup differentiation unquestionably has a bearing on the distribution of stylistic and typological variations in the arts. For this reason, before focusing on the area around Dikodougou, a region that bridges the Central and Southern language divisions, a brief résumé of the entire Senufo language family will provide a useful frame of reference. A synthesis of available information on the Senufo languages is presented in table 1 on the premise that language relationships provide the most reliable guide to historical relationships between two groups and that an understanding of them is a useful step prior to inquiry into other kinds of cultural relationships.

The Senufo language family is composed of more than thirty distinct dialects, which fall into the major divisions and subdivisions outlined in table 1.[1] The four major divisions may be considered discrete languages (Welmers 1957), each of which consists of a number of dialects with various degrees of mutual intelligibility. As evident in table 1, the dominant Senufo language grouping and that with by far the greatest population density is Central Senari, a cluster of nine

Table 1
The Senufo Language Group: Classification of Dialects

	Population Estimates
Northern Senufo	
Mambar, Sup'ire, and Nanerge	300,000
Banfora groups: Tenyer, Kler, Syer, Senar, and others	31,000
Central Senufo (Senari)	
Northwest Senari: Papara and Tingrela-Kandere	15,000
Central Senari Cluster (the Senambele people)	250,000

Dialect	*People*
Kafiri	(Kafibele)
Kasara	(Kasembele)
Kufuru	(Kufurubele, or "Kufulo")
Nafanra	(Nafanbele)
Patoro	(Patorobele)
Pogara	(Pongabele)
Tagbanri	(Tagbamana)
Tangara	(Tangabele)
Tyebara	(Tyebabele)

West-Central Senari: Messeni-Takpa, Tyebana, and Tenere	30,000
Southwest Senari: Nowulo, Zona, Dugube, and Gara	25,000
East Senari: Nyarafolo	17,000
Southern Senufo	
Dyimini	42,000
Gbonzoro	2,000
Fodönrö (Fodombele)	7,000*
Tafire	4,000
Tagbana	43,000
Eastern Senufo	
Palaka, Falafala, and Nafana	11,000

*Dikodougou district only; figures not available for Fodombele living in Tyebara and Nafanra areas.

It is important to note that this table concerns dialect classification and is not a comprehensive list of ethnic groups in the Senufo cultural sphere. (See Glaze 1976:6a–d for a more complete listing of dialects as well as brief historical and linguistic notes on problem dialect areas.) Senari dialects are spoken by both farmer and artisan groups in the Central Senufo area. The groups whose names incorporate the dialect name represent farmer ethnic groups (e.g., the Tyebara dialect is spoken by the Tyebabele people, one of the nine related farmer ethnicities who identify themselves by the generic name "Senambele"; *bele* is the plural suffix). The following artisan groups speak the Senari dialects of the farmer ethnic groups, whose villages they share and with whom they have close social, economic, and political relationships: Fono (Fononbele): blacksmithing, basketry; Kpëëne (Kpëënbele): brasscasting, pottery, weaving; Kule (Kulebele): woodcarving, calabash crafting; Tyeduno (Tyedunbele): blacksmithing, pottery, weaving; Tyeli (Tyelibele): farming, leatherworking.

closely related dialects (population, two hundred fifty thousand) that forms a major part of the Central Senufo language group. The Central Senari dialect cluster is concentrated in the former Korhogo *préfecture*, located in north-central Ivory Coast.[2]

Senufo Ethnic Groups of the Kufulo Region

The Kufulo region is an area that begins about twenty kilometers southwest of Korhogo and that historically seems to have extended as far south as the Bou River. Villages in this region range in size from fewer than fifty people to as many as nineteen hundred.[3]

The Senufo Farmer Groups: The Kufulo (Kufuru Dialect, Central Senufo Language Group) and the Fodonon (Fodonro Dialect, Southern Senufo Language Group)

The Kufulo belong to the Central Senufo language group and, more specifically, are one of the nine-member Central Senari dialect cluster. The Kufulo people frequently refer to themselves as the "Senambele," a generic term for all farmer ethnic groups of the Central Senari dialect cluster. Senambele peoples normally can neither understand nor speak Fodönrö, Tagbana, or other dialects of the Southern Senufo language group.

The Fodombele, or "Fodonon," as they have come to be called by the administration, constitute the majority population in the focal research area.[4] After a few months of field research, it became evident that Fodonon oral traditions and cultural institutions connect with those of the Southern Senufo groups. Recent evidence indicates that the Fodönrö dialect is reasonably close to Tagbana.[5] For these and other reasons that will be discussed below, the Fodonon should be assigned to the Southern Senufo language group. In contrast to the Kufulo, the Fodonon are bilingual, speaking a Central Senari dialect—Kufuru, Tyebara, or Nafanra, depending on the locale—in addition to Fodönrö, the language of the home. This is largely a result of political circumstances, involving first the powerful Tyebara chieftaincies and subsequently the colonial and then the national administrative headquarters, centered in and around Korhogo.

The Fodonon subgroup, its history and culture, is a topic that merits a more detailed exposition than is possible in this text. However, I would like to review briefly some of the reasons why the Fodonon are of particular importance in reconstructing Senufo cultural history.

First, because of a number of historical circumstances effecting change in many Senufo groups under Dyula, Bamana, Baule, and other non-Senufo influences, the Fodonon are one of the very few Senufo groups outside the Central Senari cluster with an active Poro,

or initiation, society and its accompanying art complex. Bochet has termed the Fodonon an "archaic" Senufo group (1959:63), implying that they represented an early development of Senufo culture as represented by the Central Senufo groups dominant in the Korhogo region. Bochet is apparently unaware of the historical and cultural ties between the Fodonon and the Gbonzoro, Tagbana, and other Southern Senufo groups; this is a finding of my own research that gives quite a different dimension to the cultural contrasts between the Fodonon and Central Senufo groups. The noticeable differences observers have remarked in the culture of Fodonon minorities living among the Tyebara and Nafanra of the Central Senari dialect cluster are in reality cultural differences that reflect linguistic boundaries and a separate historical development. The Fodonon are not in fact an "archaic" remnant in the linear development of Central Senufo culture but rather constitute a member of a second important Senufo cultural sphere, the Southern Senufo language family. The differences in institutions and art forms that sharply separate the Central Senufo and Fodonon groups should therefore be placed in this context.

Second, the relatively sheltered and conservative existence of the Fodonon group, as well as its key position as a transitional zone between the Central Senufo and Southern Senufo groups, makes this subgroup an ideal laboratory for ethnohistorical methodology and research. The other Southern Senufo groups have undergone considerably more cultural change than the Fodonon. The Dyimini-Dyamala area, in particular, has felt the presence of the centuries-old Dyula settlements linked to the Kong-Bondoukou route, the interaction with the Baule to the south, and, in more recent history, the destructive effects of the French-Samory conflicts in that area in the 1890s.

The Senufo Artisan Groups

Throughout the centuries, blacksmiths, brasscasters, woodcarvers, and other artisan groups have lived among the Senufo farmers and become an integral part of their culture. The economic interdependence of the farmers and blacksmiths is an especially important factor in Senufo culture; this theme is expressed in oral tradition and ritual. The principal artisan groups in the Kufulo region are shown in table 2. The artisan groups are thoroughly Senufo in terms of language and other cultural features shared with their farmer neighbors. However, each artisan group has a strong sense of historical identity, in some cases including memory of an original language of their own that had fallen into disuse subsequently. For all practical purposes, today artisan group members speak either Kufuru or other dialect

Table 2
Principal Artisan Groups in the Kufolo Region

	Occupation	
Ethnic group	Men	Women
The Fono	blacksmiths woodcarvers	basketmakers and mat weavers
The Kpeene	brasscasters weavers	potters
The Kule	woodcarvers	calabash crafters
The Tyeli	farmers, leatherworkers	
The Tyeduno	immigrant blacksmiths (*numu*) of Manding origin	potters

variants of Central Senari, the dominant language of the entire Senufo region. In theory the artisan groups are endogamous, although in fact marriages outside the group are part of Senufo social history.

There is reason to describe the Senufo as an occupationally caste-bound society, although I have avoided the term *caste* in this text for two reasons. First, anthropologists themselves are far from agreement on what constitutes caste and caste societies, with opinions ranging from rigid to loose definitions of the term. Second, the term *caste* often connotes to the average lay person and Westerner a corollary notion of "despised" and "pariah"; this misconception is firmly entrenched in early French sources, which invariably speak of "*castes meprisées*."[6] The "despised caste" stereotype does not accurately reflect the complex social attitudes and interrelationships of farmer and artisan groups in Senufo culture.

The Senufo view artisan groups as part of a divinely ordained social order. As one brasscaster tradition explains, the creator god created people and then gave them the specific work that each farmer and specialist artisan group should learn to do (Glaze 1976:281–2). The most recent research on social organization and the question of caste among the Senufo is Richter's important 1974–75 study of artisan groups and social change, which centered on the Kule woodcarver group in the Korhogo area (Richter 1977, 1978). According to Richter, the Senufo themselves perceive artisan groups as "hereditary endogamous groups that engage in god-given non-farming occupations, speak Senari, have Poro and traditionally follow the indigenous religion." In other words, artisans are "true" Senufo in every sense but one: the only fact that separates artisan groups from true Senufo, by their own definition, is that artisan group members are not farmers.

An examination of actual social and economic relationships, however, reveals a flexible and open-ended situation. Not only is there a regular pattern of shifts from artisanal activity to full-time farming, or vice versa, but the practice of exogamous marriages is also relatively common (Glaze 1976:62, Richter 1978:14–17). The close kinship relationships between Fono blacksmiths and Senambele in particular do not make it possible to think of artisan groups as inferior castes (Richter 1978:25). Finally, one of Richter's most provocative discoveries concerns the conscious exploitation, for economic reasons, of specialness on the part of certain artisan groups, notably the Kule. Richter notes that "the characteristics commonly associated with caste systems are often manipulated by the alleged lower status castes to their benefit, rather than by the majority farmers" (1978:1). The Kule sculptors may be "despised" in the sense that they are feared for their reputation for supernatural powers—a reputation deliberately sustained by the Kule themselves in order to "exploit the Senambele." However, even in this case, Richter maintains, they are not outcasts or of lower status than other artisan groups (1978:6–8, 24–5).

THE DYULA

Besides the farmer and artisan Senufo peoples who live in the Diko-dougou area, some villages have settlements of non-Senufo people. The Dyula, who belong to the Manding language family, have been of particular importance in terms of the area's political and economic history. Ancient Dyula settlements in the area have long been centers of trade and the weaving industry. Long-established families, farmers, traders, and weavers are termed "our Dyula" by the Senufo in contrast to "the stranger Dyula," as represented by the recent influx of commercial Dyula who remain outside the traditional sanctions exercised by the Senufo in relation to the Dyula.

THE SENUFO VILLAGE AND KATIOLO

The average Kufulo region village of eight hundred to twelve hundred inhabitants is a composite of independent but interrelated residential settlements (*katiolo*) whose members belong to the same ethnic group and whose leadership is identified with a particular matrilineal clan segment. Thus, a large village will include several different settlements of the dominant farmer population (Kufulo or Fodonon major-

ity, depending on the village), one or more settlements of the universally distributed Fono blacksmiths, and usually a settlement of at least one additional artisan group, such as the brasscaster-potters, the leatherworkers, or the woodcarvers. The focal village of Pundya was subdivided into ten residential settlements, or wards, as follows: five Fodonon farmer wards, one Kufulo farmer ward, three Fono blacksmith wards, and one farmer Tyeli ward. Neighboring villages included substantial settlements of artisan groups engaged in weaving (Kpeene and Tyeduno), pottery and brasscasting (Kpeene), and woodcarving (Kule).

The *katiolo* is a residential and cooperative work unit whose members share not only the same general living space but also the food harvested from communally worked land. A large *katiolo* may include several households (*gbo*). The literal word for "house," *gbo* in this context refers rather to the smallest unit of social organization in the village. Differing mainly in size, the *katiolo* and *gbo* have in common the definitive characteristic of a group of people living together and working collective fields. Moreover, both ward and household leadership may be said to be linked by descent to one dominant matrilineal clan segment, although neither unit is in the strictest sense a kinship structure. Two or more matrilineage segments may be represented in a sizeable *katiolo*, in which cases marriage contracts within the *katiolo* are common. A young woman who marries outside her mother's *katiolo* will become part of her husband's *katiolo* while at the same time retaining her identity as part of the mother's matrilineal descent group. Traditionally, her sons are more answerable to her mother's brothers, their maternal uncles, than to their own father. Within the codes of this matrilineal system, they may be called upon to return to work in their maternal uncles' fields or, in adulthood, to take over the leadership of their uncles' *katiolo*. Other sons may remain with their father's *katiolo*. Significantly, the generic word for "ancestors" is the same as the kinship term for maternal uncle (*syeenlëëö*).

Each *katiolo* has its own set of male and female leadership. The male elders, representing the interests and rights of their respective wards, constitute a type of village council. The village chief, who must be a male of matrilineal descent from the village's founding family, is the titular head of this council of elders. Traditionally, the village chief also holds the title *tarafolo*, "owner of the land" or earth priest, and is responsible for assigning land for cultivation and for the ritual purification of village lands contaminated by bloodshed or accidental death. Formerly, the village chief also held the title of head of that Poro society tracing its origin to the village founder.

Many governmental and social decisions are made by *katiolo* leaders in their roles within the structures of either the Sandogo society in the case of the women or the Poro societies in the case of the men. Although the number of Poro societies roughly corresponds to the number of major settlements in the village, there is no set relationship between the number of *katiolo* and the number of separate Poro societies. Sometimes as many as two or three *katiolo* may join together to furnish leadership and initiate classes of one single Poro organization. This consolidation may even bring together two separate ethnic groups, as was the case with the blacksmiths and the Kufulo farmer minority in the focal village.

An architectural expression of social organization, each *katiolo* is physically demarcated as a self-contained unit, its space defined by walls, granaries, men's and women's houses, courtyards, and various structures related to the ritual life of the *katiolo* (altars, log shelters, divination houses). Cylindrical granaries of sturdy abode flank the houses or serve as buttresses to reinforce the courtyard walls, which give privacy and create exterior living space for the families. Sometimes several generations old, veritable guardians of life and continuity, these granaries contain the yams and rice that will sustain the families until the next harvest (pl. 1). One large granary reserve is set aside to be used only during funeral celebrations honoring the dead of the *katiolo*.

THE FIELDS

Cultivating dry rice, yams, peanuts, and millet in the rolling savannah grasslands, the Senufo have been admired as skilled agriculturalists since the French entered their territory in the late nineteenth century. Senufo farmers of the Korhogo region call themselves "Senambele," "men of the fields." To be a disciplined and skilled cultivator is near the center of the Senufo's sense of identity.

For the Senufo male, one of the most important ways to gain prestige is to earn the title "champion cultivator" (*sambali*). Respected during their lifetime and paid special tribute at commemorative funerals, champion cultivators may even be said to achieve a degree of immortality since they are venerated as ancestral champions of their *katiolo*. The Senufo liken the champion to a "flag bearer" in that he upholds the honor of his *katiolo* before the entire village and throughout the surrounding district. Accordingly, champion-cultivator sculpture generally appears on display during the commemorative funeral of any important member of the *katiolo*, male or female. The art

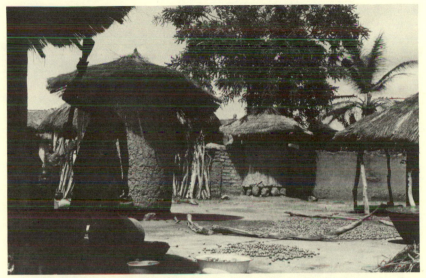

Plate 1 Courtyard scene in a *katiolo* section of a Kufulo village. Nuts used to make *karité* oil (shea butter) have been spread out to dry beside the front veranda of a woman's house (June 1975).

form that most visibly symbolizes the pride and honor of the *katiolo* unit is the sculptural trophy staff. Passed down through many age-grade generations, the staff is held in trust by the young man who has earned the title of champion during hoeing contests involving teams from other *katiolo*.

The hoeing contests are multimedia events of social, economic, and philosophical importance in Senufo culture. The contests transform grinding agricultural labor into ritual; this process is achieved primarily through the artistic media of sculpture, orchestra, song, and dance. From dawn to dusk during the cultivating season, teams of young men swing their iron hoes to the rhythms of drums and bala-fons while proud staff bearers follow the competing champions of each team (pl. 2). More than an expression of the importance of being an excellent farmer, the event and its art forms celebrate the values of strength, endurance, skill, obedience to authority, and leadership. Above all, the contest underscores the importance of working together as a group to meet each other's needs—in this case, the preparation for the planting of each elder's fields by large numbers of young men at the peak of their physical prowess.

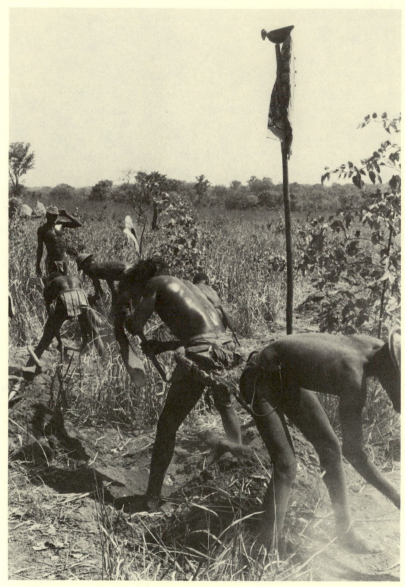

Plate 2 In the Kufulo-Tangara border area, contending champions from two competing teams vie for the title "*sambali*" for that day's hoeing contest. Girded with a *yapwöhö* belt, one champion is flanked by a tall staff bearing aloft the eagle variant of the champion-cultivator's staff (November 1969).

PORO: THE MEN'S SOCIETY

Through such institutions as age grades, the men's Poro societies knit social relationships that cut across kinship lines and household ties. Thus, Poro constitutes a stabilizing and unifying force at the community level. Participation in the Poro society and initiation system is universal for Senufo males, whereas women's age grades are involved only at key points during the initiation cycle. In a highly structured sequence of age grades climaxed by advancement ceremonies, the initiate is taught to "walk the path of Poro," which leads to responsibility, wisdom, authority, and power. From the children's primary grade of "discovery" through a long period of training and service that is highlighted by the initiate's ritual death and spiritual regeneration to the final graduation of the "finished man," Poro is preparation for responsible and enlightened leadership. The command of powerful and magical secrets possessed by each Poro organization head is directed toward protection of its members and their families, especially the initiates, who are not only the most vulnerable but also represent the group's future. Dramatic ceremonies, dances, masquerade performances, and visual displays mark the passages to higher grades and celebrate the final graduation. Traditionally, if a man did not graduate from Poro, he was virtually an outcast, excluded from village affairs.

Broadly speaking, each major *katiolo*, or settlement, within a large composite village has its own Poro society, set of initiates, and sacred grove. The membership of any one organization, however, is an admixture, depending on the nature of the relationship between a new initiate and his sponsor (father, maternal uncle, guardian, friend) as well as on individual motivations and circumstances. Membership in more than one Poro is not uncommon. A number of different Poro sanctuaries are secreted in dense groves of trees dotted about the perimeter of the village. The sacred grove and its buildings are used as a school, a political meetinghouse, a place of worship, and a kind of hidden "backstage" where the initiates prepare for ritual and theatrical performances. The sacred grove of each Poro group is viewed symbolically as a family compound, or *katiolo*, of the deity Ancient Mother. As a conceptual parallel to the secular *katiolo* unit within the village proper, this evokes an image of intimacy, of a settling place where the deity may reside, work, and eat among her people. The initiates and graduates of the Poro societies are considered to be her children and come under her protection, authority, and instruction. The last work is actually carried out by the male Poro leadership in close cooperation with the female leadership of the Sandogo society.

The Sandogo society is a powerful women's organization that unites the female leadership of the many extended household units and kinship groups of the village. Unlike the proliferation of men's societies in one village, reflecting in part the multiple bases of male political power, there is but one Sandogo society for the village, its head called "the *Sando*-Mother." Participation in Sandogo is not universal for women. Rather, each household unit and matrilineage segment is represented by at least one *Sando*, a term referring to both any member of Sandogo and those members who become divination specialists. Consecration of a female to Sandogo may happen at any time, from birth to middle age, and it is not uncommon for the process of initiation to begin at the age of eight years or earlier.

The members' responsibilities are both social and religious. In common with the men's societies, the Sandogo society exercises important social controls, in this case specifically directed toward protecting the sanctity of betrothal and marriage contracts. In accordance with the central religious purpose of Sandogo, each *Sando* is charged with the ritual maintenance of good relationships with beings of the supernatural world, although in practice not all Sandogo novices are able to master the demanding techniques of divination. The diviner acts as an interpreter and intermediary between the village people and their deity, the ancestors, spirits of twins, and, in particular, the bush spirits. A host of animate spirits that inhabit the fields, streams, and woods surrounding the village, bush spirits are believed to influence one's life for good or evil. Since the villagers must constantly disturb the bush spirits' domain by their farming, hunting, and artisan activities, the diviners' task of regulating appeasement and paying homage to the bush spirits is crucial to the welfare of both household and community. Not surprisingly, the bush spirits are considered to be the source of a diviner's power to explain the supernatural cause of a client's problem. It is especially in respect to their religious functions that the Sandogo society's responsibilities intersect with the Poro societies' interests. For example, in their capacity as diviners, the women of Sandogo are involved in the interpretation of dreams, apparitions, and other manifestations of the bush spirits, all of which are essential to the process of creating a new Poro society organization and power structure in the village.

SENUFO RELIGION

An awareness of some basic tenets of Senufo religious belief is

critical to an understanding of individual art forms and the prominence of the funeral setting for the arts. For example, the antiwitchcraft masks that help to create the visual drama of Senufo funeral ritual are sculptural expressions of an ideology of supernatural and personal power. In Senufo religious practice, worship, prayers, and sacrifices are directed toward three distinct spheres of spiritual beings. Deity, the ancestors, and the bush spirits are all viewed as spiritual resources in meeting everyday difficulties and supplying human needs or wants. But in addition to believing in this hierarchy of personified spirits, the Senufo believe in magical and impersonal sources of power that an individual can appropriate, by means of acquired knowledge and ritual, for his or her own or others' benefit. The welfare of a particular enclave within the community may be threatened by the activities of two kinds of spiritual forces: malignant spirits and witches. In this context, witches are human beings, motivated by envy, hatred, or greed for personal power and wealth, who use their knowledge of the supernatural for evil purposes rather than for the social good. I will elaborate on these concepts in subsequent chapters concerning the women's divination society, the men's Poro society, and the funeral.

A NOTE ON ETHNICITY AND STYLE

The complex ethnic makeup of Senufo villages, as exemplified by the primary research area, has significant implications for stylistic and typological studies of Senufo art. My data on art and artists of the Kufulo region and neighboring areas indicate that it is necessary to adjust previous concepts of Senufo substyles. In the literature, these substyles are generally described along strictly geographic lines and then in broad terms that do not take into account the substyle clusters *within* the Central Senufo area (e.g., "Central" or "Northern," as in Goldwater 1964). The Central Senufo language region is, after all, the province of the vast majority of known Senufo pieces. Ironically, the style factors that most closely coincide with dialect group boundaries and consequently a geographic ordering are precisely those elements of Senufo visual arts seldom preserved in museums. This includes the entire range of fiber masquerades as well as a multitude of local variations of costume, attributes, and other ephemeral details of masquerade categories that incorporate carved masks as but one component of the total visual construction.

Although certain fiber masquerade types exhibit marked stylistic changes from one dialect area to another, accompanied by name changes, it is possible, at the same time, that such masquerade com-

ponents as the carved face mask will bear the same sculptor's hand in several different dialect areas. The larger implications are obvious. Art historical analysis of the Senufo styles and style distribution must distinguish between forms and embellishments created by nonspecialists within the restricted sphere of a particular ethnic group, village, and secret society membership and the forms created by specialists, members of endogamous artisan groups whose characteristics of style extend over a much broader geographic range than that of the former. The interaction of these two contrasting patterns constitutes an important ingredient in the richness of Senufo visual art traditions.

Besides the inevitable personal expression of the artist, four broad factors affect style variation within the Kufulo region: ethnicity, family and workshop, stylized embellishments by the clientele, and forms created entirely by nonspecialists.

The first distinguishing factor is the ethnic identification of the sculptor—Kule or Fono in the case of wood sculpture, Kpeene in the case of cast brass. A serious difficulty with style classification based on geography alone is that this approach ignores the existence of two distinct groups of wood-sculpture specialists, the Kule and the Fono, working within the broad Central Senufo region. A more refined classification of substyles must deal with what Kufulo region blacksmith sculptors themselves refer to as the "Fono way of carving" as contrasted with the "Kule way of carving" (i.e., style, not merely technique, was meant here). For example, within a very restricted locale of just three or four neighboring villages in the Kufulo region, sharply differing styles of both figure and masquerade sculpture were observed side by side, ranging from delicately detailed work with a selective, stylized naturalism toward a more rigorous, angular, abstract definition of forms. Senufo awareness of stylistic differentiation as a function of ethnicity is suggested by the words of Songileena Sillue, a retired Fono sculptor and *katiolo* chief at Puloro. Songileena distinguished between "*gbomo e tëë më*," the ancient (Fono) way of carving, and "*Kulebele tëë më*," the Kule way of carving. According to this sculptor, the Kule were the first to carve figures with hands defined as a separate form from the lower arm, and "in the past, blacksmith sculptors did not carve feet." He summed up a major style differentiation by saying, "blacksmith [style] is without fingers, without feet."[7] This gives an entirely new significance to certain well known Senufo figural types, such as the so-called rhythm-pounder figures (pls. 3–6). This category of classic Senufo figurative style is nothing less than the essence of blacksmith style as opposed to Kule. Whether small scale for use in *Sando* divination or monumental in

scale for use in Poro society funerary displays and processions, the style is clearly identifiable.

A second important factor is the family and workshop background of the individual artist. In reference to both the brasscasters and wood-carvers, the most critical framework for a profitable discussion of stylistic grouping and influences is the network of family workshops and apprentices. To the relatively itinerant nature of the brasscasters and Kule woodcarvers in general must be added the factor of an apprenticeship system in which sons or nephews are commonly sent to be trained in the workshops of friends or relatives some distance away and in which newly trained apprentices may establish work-shops in yet another area. Furthermore, it is not unusual for sales or exchanges of figurative sculpture to take place between artists of different areas who are seeking new models. One interesting illustra-tion of this practice involved no fewer than three separate dialect areas: a Kufulo area brasscaster exchanged two of his own equestrian figures at the large market of Kanaroba in the Kafiri area for two older examples from an artisan working in the Patoro area (further southwest). This incident tells us that to an even greater extent than is true of Fono and Kule work, it is meaningless to speak of Kpeene "substyles" in a geographic sense.

The example of intricate family relationships represented by the carver communities at Sefon and Tapé, outlined in some detail below in a discussion of the Kule, demonstrates even more emphatically that future refinements of Senufo substyle classification must deal with the factor of carver family workshops. In the case of the Kule, one must take into account not only the workshops but also the practice of in-tentionally sending out members as apprentices to carvers outside the workshop. In brief, Kule sculptors are scattered among various dialect groups across a wide geographic area, and yet a number of sculptors, supplying widely separated villages, may have closely related personal styles. Mask substyle identification may therefore have little or no bearing on masquerade classification, which involves consideration of group ownership, usage, and audiovisual accoutrements.

The third factor affecting style variation is alteration of the sculp-ture *after* it is turned over to the client or clients who commissioned the specialist's work. Not only each ethnic group but each secret society and age-grade membership has its own traditional styles of embellishment. Quite apart from consideration of costume and motion styles, the original carvings are transformed by painted decorations on the surface and by a whole gallery of magical and ornamental addi-tives designed to heighten the visual, dramatic, and didactic impact

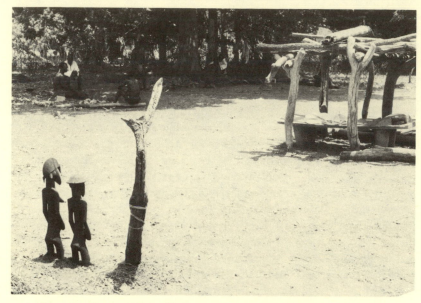

Plate 3 Poro society display sculpture (*Pombibele*, the Ancestral Couple, as initiates of Poro) by *kpaala* with *tyolobele* keeping watch at funeral for a Kufulo elder (March 1970).

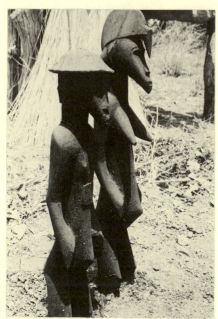

Plate 4 Detail of plate 3. Carving is in a local blacksmith style. Note champion-cultivator-style hat on male figure (female ca. 36″ high).

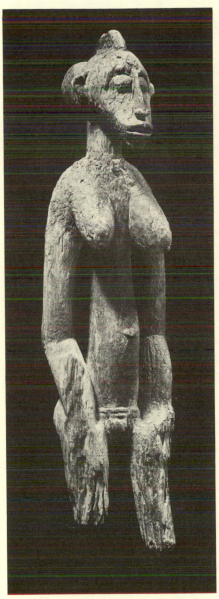

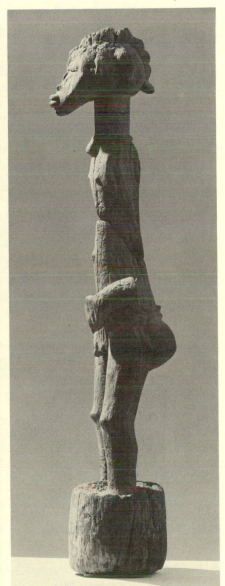

Plate 5 One of the most expressive images of the matriarch icon in Senufo art, this female figure forms half the rhythm-pounder pair collected in the Fodonon village of Lataha (height of fragment, 96 cm.; height of the torso alone measures over half the total height of the male figure, including its base; courtesy of the Museum Rietberg, Zurich).

Plate 6 Male figure, pair to the female in plate 5 (107 cm. high; courtesy of the Metropolitan Museum of Art, New York, The Michael C. Rockefeller Memorial Collection of Primitive Art).

of the masquerade performance or mounted assemblage. Severely blocked-out masses and planes explode in color and texture with such additives as impressionistic paint spots, spiky bundles of porcupine quills, glittering brass eyes, or great sprays of greenery from the sacred grove. A fairly consistent feature of Kufulo region styles in general is that both masquerade and figure sculpture are marked by a surprising degree of polychrome decoration, most of which is applied not by the sculptor himself but by his clients (see, for example, pls. 7–9 [color]). Significantly, the sculptural components made by specialists are incorporated into a final aesthetic assemblage created by nonspecialists, so the specialist's component may shift in purpose, meaning, and visual effect as it is used by one group or another.

The fourth factor concerns all those fiber masquerades, costume components, and other art forms created entirely by nonspecialists, that is, members of both farmer and artisan group Poro organizations who had earned reputations as artists (i.e., men of "creative intelligence," *sityiliime*). Kufulo region fiber masquerades such as *Tyelige* (pl. 10 [color]) and *Yalimidyo* (pl. 11 [color]) feature highly individualized facial designs that vary from one village to another and are a notable source of group pride. Thus, pieces by both specialists and nonspecialists ultimately evidence style variation as a function of group unity from the ethnic group identity to the level of a particular Poro society membership.

In summary, a meaningful investigation of Senufo style areas and relationships must begin by asking questions about ethnic group, family origins, apprenticeship, and workshop systems. The boundaries of Senufo stylistic subdivisions are *not* necessarily coincident with the boundaries of object usage or dialect groups.

FARMER AND ARTISAN GROUPS OF THE KUFULO REGION IN HISTORICAL PERSPECTIVE

KUFULO: THE FARMERS

The Kufulo, or *Kufurubele*, people are a dialect group (Kufuru) of Central Senari farmers living in the Dikodougou district and having locally developed variants of masking traditions and other Central Senari cultural institutions. The northern boundaries of the Kufuru dialect branch of Senambele farmers begin with the villages of Turu-

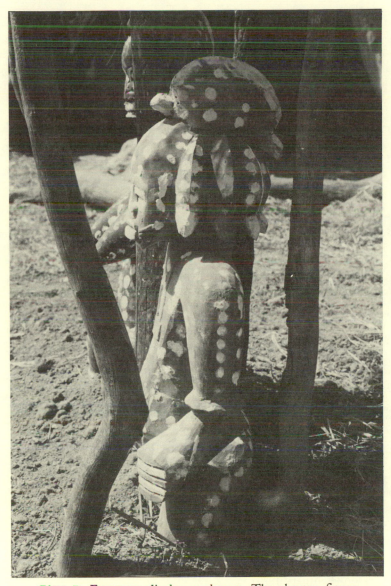

Plate 7 Funerary display sculpture. The shorter figure is male, with a hairstyle typical of the coiffure worn by male initiates in the Kafiri area during the first three years of *Tyologo*. In keeping with Kufulo region style, both figures are freshly painted with ritual spots of bright red ocher and white (June 1970).

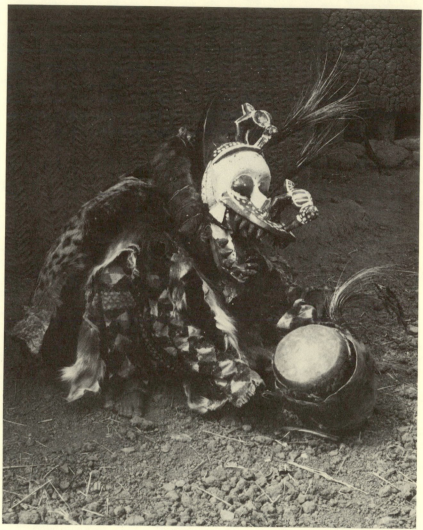

Plate 8 Kunugbaha masquerade (blacksmiths') drumming on its way from *sinzanga* to *kpaala* for final rites for a young Kufulo man. Sienna red and white polychrome style of the Kufulo region (February 1970).

pungo and Guiembe, south to southwest of Korhogo. The Solomou-
gou River creates a natural boundary between the Kufuru-speaking
Senambele and the Tyebara-speaking Senambele to the north. In-
deed, one Kufulo village chief explained that the word *Kufuru* is
derived from *kulo*, "a large country or territory," and *furu*, "to pierce
and cross through." Thus, the "Kufurubele" were those who had
drawn away from the rest of the Senambele by "piercing" the natural
boundary of the Solomougou River and inhabiting the large territory
beyond the south banks.[8]

Kufulo, as applied to the people, appears to be a name originally
applied by such outsiders as the Dyula, the Fodonon, and the French.
When referring to themselves, the Kufulo invariably employ the word
Senambele, a broad term embracing all farmer groups within the
Central Senari cluster. The Kufuru dialect itself is also spoken by all
those artisan groups, such as the Fono (blacksmiths) and the Kpeene
(brasscasters), who have lived in close association for several genera-
tions with this Kufuru-speaking branch of the Senari-speaking farmers.
For this reason, *Kufulo* has been retained here as a convenient means
of distinguishing the Kufuru-speaking farmer group from the Kufuru-
speaking artisan groups. The term also serves to distinguish them
from other Senambele groups, such as the Tyebara, Nafanra, and
Tangara, within the Central Senari dialect cluster.

Finally, *the Kufulo* is a general phrase commonly applied by other
Senufo to the entire Dikodougou region southwest of Korhogo. Many
distinct ethnic groups live in this region. They include a large section
of the Fodonon subgroup, which outnumbers the Kufulo group itself
in Dikodougou canton. In addition to the Fodonon, the Tyeli are
another dialect group in the region who are not part of the Central
Senari dialect cluster.

For the most part the Kufulo are a minority group in the Fodonon
villages, which, along with two Kufulo villages, constituted the core
villages of the research area. As one moves from the Dikodougou
canton to the northern half of Dikodougou *sous-préfecture*, the villages
become increasingly Kufulo in makeup, culminating in the ancient and
once politically powerful Kufulo village of Guiembe. An important
market city located near the northern border of the Kufulo region,
Guiembe became the seat of one of the paramount chieftaincies of the
pre-Samory era under a line of Kufulo chiefs of the Soro clan. Ac-
cording to chief Sona Soro, a venerable Kufulo elder and chief of
what is reputed to be the most powerful Poro society in the entire
Kufulo region, Guiembe was originally a Fodonon village. The Fodo-
non chieftaincy was later usurped by the Kufulo migrants from the

Tyebara and Nafanra areas. The Kufulo oral history of the ascendancy of Guiembe records no fewer than thirty-five smaller villages (twenty-three still extant) said to have been founded by Guiembe and whose Poro organizations were installed by the Poro at Guiembe. This ritually dependent relationship is acknowledged today by the daughter villages with a set of gestures. For example, whenever any of the villages is holding an advancement ceremony in the Poro cycle, its initiates, with masqueraders, pay a formal visit to the chief of Guiembe.[9]

FODONON: THE RAINMAKER-FARMERS

Four of the seven core villages in the focal study area were Fodonon, and the Senufo funeral described in the final chapter follows the form specified for a Fodonon male elder. Fodonon culture has several distinctive features that are not found among the Central Senari groups: first, their distinctive Poro cycle; second, their traditional "rainmaker" specialists (*Ndaafölö*); third, their ancient and widely renowned society of healing specialists (*Nökariga*), recognized by their brass insignia rings with the bush cow motif; and, finally, *Tyekpa*, a women's organization and concept now found only within the Fodonon group.[10] *Tyekpa*, a type of women's funerary society discussed briefly in the next chapter, has been a particularly important stimulus for the production of large-scale figure sculpture in the area.

The first reference to the Fodonon to appear in the literature was hidden under another name, the "Sonon," one of many instances of the adapting of Dyula names for Senufo groups by the French. Delafosse quite mistakenly calls them a special caste of "priests, sorcerers, and religious mimes," set apart from the Senufo "nobles" (1908:450). Maesen was later able to establish that the Sonon were in fact a Senufo group known as the "Fodombele," although he lacked the necessary contacts to add any further information on the group other than to refute Delafosse's notion that they were a caste of priests, set apart (Maesen 1940:177). From his description of the Senufo funeral, it is clear that Delafosse was confusing the Fodonon group with the masked and costumed members of the Poro societies whose rituals he viewed briefly (1909:2–3, 15).

Unquestionably the most important historical relationship brought to light in Fodonon oral histories was their connection with the Southern Senufo language grouping. As discussed above, the Fodonon farmers speak a dialect (*Fodönrö*) that is virtually incomprehensible to Central Senari speakers (e.g., Senambele farmers of the Korhogo region) but that has much in common with the Gbonzoro and Tagbana

dialects to the southeast. Despite the relatively recent political ties with the Korhogo area to the north, oral traditions collected in the Kufulo region and the Gbonzoro area, language, and material culture data all indicate that the Fodonon have their strongest historical ties with groups to the south: Southern Senufo groups such as Gbonzoro and Tagbana and non-Senufo groups such as southern Malinke and even the Guro (called the "*Löbele*" by the Fodonon).[11] The virtual non-existence of written historical records for this area makes it doubly important to examine evidence drawn from oral history, language, art and material culture, and specific cultural institutions, such as the Poro society.

Strongly linking the Fodonon to the Southern Senufo division is the Tagbana-Gbonzoro-Fodonon chain of relationships. Fodonon informants stated that the Gbonzoro dialect differs only slightly from their own and that otherwise their culture "is the same." As an illustration of this cultural similarity, five Gbonzoro villages were cited as having exactly the same Poro complex as the Fodonon of the Dikodougou area. Comparison of a major architectural tradition reinforces the Fodonon-Gbonzoro relationship: Gbonzoro villages boast the same massive log structures (Great *Kpaala*) found only among Fodonon groups to the north (pl. 12). There is no true parallel with the Fodonon-Gbonzoro "great shelter" among the blacksmiths and farmers of the Central Senufo groups of the Korhogo region. There exists only what might be viewed as a pared-down version, severely diminished in scale, structural quality, and aesthetic impact (pl. 3). These ritual men's council shelters, described briefly in Chapter 4, bear a striking resemblance to the men's council shelter (*toguna*) found among the Dogon, who belong to the same broad language family (Gur) as do the Senufo (Griaule 1938: pl. IX,A). The Fodonon and Gbonzoro *Kpaala*, however, is conceived on a more monumental scale than the Dogon counterpart. Oral histories further support the Fodonon connection with the Southern Senufo family: one Fodonon narrative relates how the Gbonzoro and Fodonon were originally one group that split during a war with the Dyula (Glaze 1976:17). Moreover, the Gbonzoro are linked by oral histories to the Tagbana subgroup, largest member of the Southern Senufo division. Northern Tagbana informants say that some Gbonzoro villages were founded by people who had migrated from the village of Niangbo in North Tagbana; this relationship is supported fully by linguistic evidence (Mills 1968:3–4). Thus, the Fodonon can be shown to be linked to the Southern Senufo group by oral traditions, material culture, and language.

The historical connection of the Fodonon people with territories as

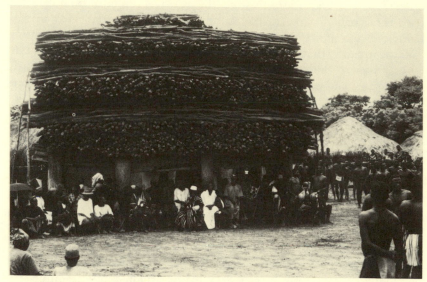

Plate 12 Great *Kpaala* of the Fodonon group with assembled
dignitaries at *Kafwö* ceremonies (August 1969).

far to the southwest of Korhogo as Mankono (150 kilometers) is
confirmed by oral histories collected from Fodonon of the Dikodou-
gou district. For example, one of the oldest Fodonon *katiolo* at Pundya
is Kanyene, whose founder named it after his village of origin in the
Mankono area. Indeed, Fodonon elders claim that all the villages
toward Mankono were originally settled by Fodonon, who have since
lost their identity by turning Muslim, and that many Fodonon
"ancient places" (*kataha*, "village sites no longer extant") lie to the
southwest.[12] The Islamized villages most frequently cited were Boron
(54 kilometers southwest of Dikodougou) and Sononso (about 71
kilometers southwest of Dikodougou, south of the Bou River). In the
Dyula language, Sononso means "village of the Sonon." The "Sonon"
(i.e., the Fodonon), whom Delafosse believed to be a "caste of priests"
in the Korhogo area, seem to be part of a broad band of Fodonon
settlements that formerly extended from the Mankono region to as
far north as Boundiali and Mbenge.

Today the greatest concentration of the Fodönrö dialect group is
in Dikodougou canton in the southern half of the Kufulo region.
Fodonon villages are scattered throughout the Nafanra and Tyebara
dialect areas as well, although the latter may be somewhat later in
date of origin. Oral histories collected from both Fodonon and Fono
groups agree that the first settlers in the Dikodougou area were the

Fodonon, whose villages were established for some time before the Fono blacksmiths arrived from the north.[13] Before that time, Fodonon needs (e.g., hand gongs, small iron hoes) were supplied by a quite different blacksmith group, the Sungboro, who still work in some villages to the south of the Fodonon villages of the Dikodougou canton.[14] The initial Fodonon-Sungboro connection is yet a further indication of Fodonon historical ties to the south. According to Fono blacksmith accounts, the Fono migrations were prompted by the state of war existing in the Tyebara country at the time (1870s?), moving them to seek the relative security of the Fodonon country to the south.[15]

In general, Senufo oral history does not seem to be characterized by large-scale movements of peoples involving long distances. The account of the founding of Pundya by its culture hero, the wise chief Metongoba, is an excellent example of the extremely small-scale migrations recorded in most Senufo oral histories (see Glaze 1976:269–77, for the complete text of the Metongoba narrative). Although the Fodonon of Pundya trace their origin to the Mankono region (map), in this particular narrative the actual distance involved in the Fodonon displacement is merely twelve kilometers to the southwest of their present location.

The traditionally insular nature of Senufo villages is attested to by Fodonon oral traditions and language patterns. Pundya elders spoke with pride of the times when young Pundya men were strong warriors. They noted that "in the old days" people did not travel much since those who strayed too far from their own villages might be seized by young men to sell into slavery in exchange for tobacco. Since the examples given by informants were Tapéré and Puloro, villages only seven and ten kilometers' distant, respectively, from Pundya, it is apparent that relations between even those villages with kinship and ritual interrelationships were not always amicable. This historical independence and isolationism is supported by minor dialect changes from one Fodonon village to another within a radius of twelve kilometers. Moreover, the secret Poro language (*Tiga*) of one Fodonon village was largely incomprehensible to the Poro members of a second Fodonon village a mere six kilometers away.

In addition to the micromigration pattern, the Metongoba narrative calls attention to a second important aspect of Senufo history at the village level—the ritual relationship entailed when the Poro society of one village helps install a Poro in a new village. The funeral is the primary context for the expression of this relationship. The account that the founders of Puloro turned to Pundya for help in establishing

their Poro society suggests either that Pundya's Poro organization was the most powerful in the area or that the founders had matrilineal kinship ties with Pundya. The latter agrees more with what appears to be the normal Senufo pattern of founding new Poro organizations, in which a group of new settlers would depend on the established Poro of their maternal relatives in the home, or "mother," village for ritual assistance in inaugurating a *sinzanga* in the new village; this situation is not unlike the medieval pattern of "mother-daughter" monasteries. The same pattern was true of the large Kufulo village Guiembe, a founder of some thirty-five Poro organizations, as mentioned in the previous section.

FONO: THE BLACKSMITHS

The Fono artisan group (Fononbele) appears to have lived in close association with the Central Senari farmer groups (the Senambele) for nearly as long as the latter's villages have been established in the Korhogo region. Each branch of the Fono group develops close cultural ties, including dialect (e.g., Tyebara, Kufuru, Nafanra), with the farmer groups among whom they live. What the Fono term their own "language" seems to be largely a matter of terminology relating to iron technology and blacksmith ritual.[16] A common refrain in blacksmith oral histories declares, "Our ancestors forged iron hoes to sell to the Senambele who would cultivate with them." Thus is expressed the centuries-old interdependence of the farmer and the blacksmith. The Senufo follow the classic Sudanic pattern of a symbiotic relationship of blacksmith and farmer based on the economic exchange of food crops and tools. The products of the forge include an extensive range of tools, weapons, musical instruments, wrought iron figure sculpture, lamps, and other objects for household and ritual use. In their oral histories, Fono blacksmiths identify themselves above all with manufacture of the *tiya*, a distinctive, short-handled hoe with a broad, scooped-out blade.

Following the general pattern in Senufo and other Sudanic cultures, the blacksmith groups are relatively more transient than the farmer groups. As one blacksmith elder commented, "Long ago, we blacksmiths weren't stable or settled in one place like the Senambele farmers but moved from place to place." As described by numerous oral histories of the founding of villages throughout the region, the arrival of a particular immigrant farmer group would soon be followed by a blacksmith group's joining the settlement; then, in the larger villages,

additional artisan and farmer groups in time would add their own quarters in the village.[17]

Indeed, as some blacksmith histories (Glaze 1976: 279–80) report, immigrating blacksmith families were sometimes actively solicited by farmer groups to join their village. In view of the reputed power of the chief blacksmith Poro masquerade (*Kunugbaha*) to combat malevolent spirits and witches, one may speculate that the farmers were seeking to achieve an equilibrium for their villages in not only the economic sphere but the spiritual one as well. An analysis of funerals for men and women of elder status has revealed that *Kunugbaha* held a unique position among the four helmet masquerade types represented in the Kufulo region—the Fono's *Kunugbaha*, the Fodonon's *Gbön*, the Kufulo's *Kponyungo*, and the Tyeli's *Korubla*. Only that of the blacksmiths was a constant feature of the funeral ritual irrespective of the sex or ethnic group membership. Man or woman, the *Kunugbaha* was always present in funerals for village elders. The historical depth and full significance of this special role played by blacksmiths in the ritual life of the community has yet to be ascertained.

As discussed above, historically the relationship of the Fono is with the Senambele farmers; their association with the Fodonon farmers is a later development. The Fono of the Dikodougou canton, in the southern half of the area known as "the Kufulo," trace their origins to Fono villages in the Tyebara and Nafara areas to the north as well as to Fono settlements in the Kafiri dialect area to the northwest. Blacksmith social ties cross dialect boundaries to a much greater extent than do those of farmer groups. Precisely because of the transient nature of the blacksmiths, Fono families settled in the Kufulo region tended to have more widespread kinship ties with villages in neighboring dialect areas than did the Fodonon and Kufulo families, whose kinship ties were largely in the surrounding villages of the same dialect group. Funeral exchange patterns are one of the best indicators of kinship network links since in Senufo culture the funeral provides a central context for the expression of social obligations and solidarity. For example, the Fono blacksmiths of Pundya and Kanaroba (a village in the Kafiri area about forty miles from Pundya by footpath) once held Great Funerals (*Kuumo*) together on a regular basis. When families hold funeral exchanges, the masquerades and figure sculptures of different areas participate jointly in the ceremonies. Occasions of this nature engender praise and criticism and build artists' reputations in the areas concerned. Although the Great Funeral has now fallen into disuse in the Pundya area, significant exchanges continue in such matters as sculpture commissions. For example, the Junior Grade of

Plate 13 Tiya, short-handled hoe, made
by Fonobele blacksmith, featuring the
curved and volumetric form in the con-
traction-expansion rhythm diagnostic of
Senufo carving style.

one blacksmith Poro of Pundya has twice commissioned a *Kodöli-yëhë*
face mask from a blacksmith sculptor, highly recommended by their
elders, who lived in Kanaroba.

Another factor linking the Pundya area blacksmiths to other Fono
groups outside the Fodonon and Kufulo areas is a technological one:
the matter of raw materials for the forge. Oral traditions from both
Kufulo and Kafiri area blacksmiths indicate that their smiths have been
in contact with blacksmith settlements to the north in order to obtain
ore supplies. Indeed, in 1968–70 the smiths were still purchasing part
of their iron stock from a number of blacksmith villages located ten

to thirty kilometers north of the Boundiali-Korhogo road, where iron ore continues to be mined and processed in smelting furnaces in the traditional manner.[18]

Although the products of the forge consisted largely of vital tools and equipment, a few local smiths (deceased) had been masters of forged-iron figurative sculpture. Such small-scale figures (averaging seven inches in height for male and female couples) are commissioned by the *Sando* diviners. The medium of paramount importance for Kufulo region blacksmith artists, however, is wood. According to elders in both the Kufulo and neighboring Kafiri dialect areas, in former times the sculpture in these areas was created by blacksmith-carvers and not by the intrusive Kule woodcarvers discussed in the next section. Some degree of woodcarving skills seems always to have been an integral part of the blacksmith's trade. A blacksmith apprentice must learn to master the basic tools and techniques of woodcarving before those of the forge. All smiths are able to carve ordinary utensils, such as hoe handles, stirring whisks, and spoons. The arched hoe handle that, combined with the wide, curving iron blade, forms the *tiya*, or hoe, is a tool that exhibits an impressive sculptural quality in its balanced design and purity of form (pl. 13).

In 1969 there were numerous Fono woodcarvers in the Kufulo region, and every blacksmith settlement in the focal cluster of villages boasted at least one excellent craftsman specializing in such forms as the large *numaha* trumpet (a sacred instrument of the Kufulo Poro), the traditional short-legged stool, with its long, scooped-out seat (like the hoe, a utilitarian object with highly sculptural qualities), or the decorative wooden cosmetic boxes carried by blacksmith Poro initiates (pl. 14).

In terms of major figurative and masquerade sculpture, however, there were but three or four Fono sculptors of note within the same general area. One of the most popular Fono sculptors was Warinyehe Soro, an ambitious artist of middle age whose "studio" was an adjunct of the large family forge in Puloro. Warinyehe felt a keen sense of competition with local Kule sculptors and proudly recalled an occasion when a group of Poro elders accepted his work, rejecting the competing mask of a Kule sculptor. Warinyehe's specialty was the helmet mask of the type used for the blacksmith Poro *Kunugbaha* masquerade (pl. 8), and his highly personalized, long-eared style was recognizable in the masquerades of a great many area Poro organizations. Within the countless and subtle variations of this one particular sculptural mode, Warinyehe was an accomplished sculptor. In 1969 the artist was beginning to branch out into other forms. His most ambitious venture in this regard was an attempt to create a clientele

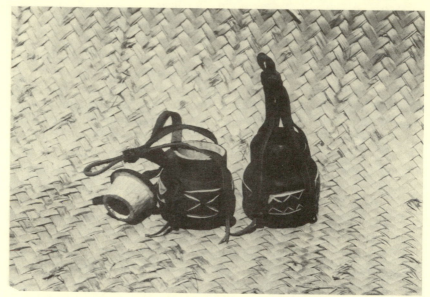

Plate 14 Carried by blacksmith Senior Grade initiates (*tyolo-bele*), container for oil used as body cosmetic and mask conditioning.

among the Kufulo farmer Poro groups by studying models (old masks purchased or traded in other villages) and carving samples of the long-horned antelope helmet mask types.

An introduction to the blacksmith group would not be complete without examining the traditional craft specialization of Fono women—mat making and basketry. In terms of the larger perspective of historical relationships among Western Sudanic artisan groups, it is important to note that unlike women of the *numu* blacksmith group in Bamana culture and those of the Kpeene and Tyeduno groups in Senufo culture, Fono women are not potters and never have been, according to their oral traditions.[19] This suggests that the Fono have quite different origins than the Kpeene and the Tyeduno, whose wives are potters, as are the blacksmith wives of the Manding-speaking peoples. The case for separate historical origins is reinforced by the marked difference in hoe type produced by Fono and Tyeduno blacksmiths. A likely hypothesis is that the Tyeduno are Senufo-ized *numu*, Manding blacksmiths of the Bamana area (see also Richter 1978:4).

Basketmaking of a certain delicate style is an ancient craft practiced by Fono blacksmith women.[20] Knowledge of the art is considered an "inheritance" passed down from mother to daughter. Although the craft is still flourishing and still largely the prerogative of

blacksmith women, one interesting aspect of the tradition has changed. Formerly the women worked in much the same aura of secrecy as the still-jealously-guarded privacy of the smiths' and sculptors' workshops. On the outskirts of every blacksmith quarter was a large subterranean pit, about the width and depth of the standard Senufo roundhouse, which was covered at night or in bad weather and was reached by a log ladder. This workshop served the dual purpose of providing both privacy and a "basement room" that permitted the fibers to stay cool and damp for better handling without the use of water. Any nonblacksmith who approached the area to watch would be forced to pay a fine—an excellent means of discouraging a competitive industry in other ethnicities.

KULE: THE WOODCARVERS

The Kule woodcarvers group (Kulebele) have worked for over a century in the immediate Korhogo area and territories west and northwest to the Mali border.[21] Important Kule settlements in these areas to the north of the Kufulo region include villages near Kouto in the Tyebala area, Sumo village in the Tagbanri area, Dyemtene village in the Tyebara area, and a city quarter of Korhogo. Until recently, Kule woodcarvers traditionally worked mainly to the north of the Kafiri, Kufuru, and Fodonon dialect areas.

The Senufo Kule are a southern extension of the Kule woodcarver group reported among the Manding peoples in Mali. In his 1955 dictionary of the Manding languages, Delafosse defines *kule* as "an individual belonging to the artisan caste that works wood" (p. 423). Sidibe's list of *nyamakala*, or "artisan castes," in Mali names the *koule* as the "lowest" of six artisan castes and describes them as working with "huge trees," from which they carved mortars, stools, and other objects (1959:13–14). Significantly, this *koule* "caste" was quite separate from the *numu*, or Manding blacksmiths, the artisan group generally named as the creators of Bamana sculpture (e.g., Goldwater 1960). By carefully following a chain of Kule family genealogies, Richter has been able to establish that the Kulebele of Ivory Coast originated in Mali toward the end of the nineteenth century (Richter 1977:130).[22] Both an Eastern Kule faction and a Western Kule one trace their roots to Mali. The Kule, in common with most Senufo, are matrilineal, speak a Senari dialect, and have had a Poro society for at least the last seventy years (Richter 1978:2, n. 3).

According to one oral tradition collected from local blacksmiths, the Fono and the Kule were originally "of the same family": "The younger brother's son worked in wood, and the older brother's son

knew how to forge iron. The elders called the one who knew wood-carving 'Kule' and the one who knew iron, 'Fono.' And they said, 'He who carves, if he needs iron tools, will talk to the one who works in iron; he who works with iron, if he needs a carving, will ask the other.' "[23] The account neatly ascribes an alleged seniority to the Fono and at the same time underscores the interrelationship between the two artisan technologies. Although one would hesitate to accept this mythic explanation as a literal description of the origin of the specific Senufo artisan group known as the "Kule," it does suggest the possibility of a remote historical relationship to the Fono group.

The Kafiri dialect area is like the Kufulo region in that the sculpture there was done previously by local blacksmith-carvers, and its Kule communities are relatively recent as compared with the northern Kule settlements. Following the typical pattern, Nafoun village oral traditions date the arrival of the Fono blacksmith settlement to a time "soon after" the settlement of the farmer immigrants; that attests to a considerable time depth to Fono carving in that area. Today, one of the largest and oldest of the Kule settlements in the Kafiri dialect area is at Nafoun. According to the chief of the blacksmith elders, the Kule had not yet come to Nafoun during the lifetime of his father's father. Yet in 1969 all mask and figurative sculpture in that village was carved by the Kule. Thus, Nafoun has witnessed a complete shift from Fono to Kule sculpture production within a span of three generations.

The presence of Kule sculptors in the Kufulo area is evidently even more recent than in the Kafiri area to the west. Only in the last decade or so have a number of carvers from the Kule artisan group moved into the Kufulo region, where Fono blacksmith-carvers still maintain control of the market despite the presence of competing Kule sculptors. The central reason for the Kule move south is the increasing shortage of suitable trees in the dense population zone surrounding Korhogo at a time when an increased wood supply is needed to meet the spiraling demands of the export market. There were no true settlements of Kule in the Kufulo region and hence no local Kule Poro societies. The sculptors were younger men whose elders holding authority over them were still members of Kule communities to the north. Their frequent return to the home village for initiation and funeral rituals was clear witness to their "stranger" status in the Kufulo region. Along with their wives, children, and perhaps a younger brother, these itinerant artists lived as long-term "guests" in the compounds of their Fodonon and Kufulo hosts.

The social attitudes toward the Kule were in marked contrast to the closely knit relationships of the Fono, Kufulo, and Fodonon groups. Fodonon informants intimated that the stranger Kule were suspect as

"thieves" by some local residents. Moreover, the Kule had the reputa-
tion of having certain magical and supernatural powers. These re-
puted powers included the redoubtable abilities of their Poro men and
maskers to change into ravaging hyenas in order to catch the villagers'
chickens and sheep. Similar prejudices were held against the Poro of
the Sungboro blacksmith group to the south. In this context, how-
ever, it should be reiterated that the Kule themselves apparently en-
courage such reputations for economic reasons. By threatening dire
supernatural penalties—sickness, sterility, and death—Kule leaders dis-
courage farmers from learning to carve and thereby impinging on the
Kule market (Richter 1978:11).

Other than one or two sculptors working in each of the Fodonon
villages of Puloro, Tapéré, and Pundya, area Kule activity centered in
three workshops of the Tyeli village of Sefon and the Kufulo villages
of Tapé and Karafine. The Sefon workshop, oldest and largest of the
Kule units in the region, offers an excellent illustration of the network
of Kule kinship and apprenticeship ties that characteristically cross
several dialect group boundaries.

Kule sculptors and their families in the Kufulo region trace their
origins to three villages to the north and northwest: Sumo, Nafoun,
and Korhogo. The carver of elder status at Sefon was Nawo, originally
from the Kule settlement at Nafoun, in the neighboring Kafiri dialect
area, where his nephew remained as the sculptor in residence. At the
Sefon workshop, Nawo's apprentice was Nimbaha, a younger man
from Sumo, a remote Kule village in the Tagbanri dialect area. Nim-
baha's uncle, the Kule elder Be Soro of Sumo, had sent him to work
under Nawo at Sefon for one year. At Sumo Nimbaha had first
learned carving from his older brother, Nalurugo, who later came
to the Kufulo area to establish a Kule workshop at Tapé village
(where a second carver's workshop was operated by Fono sculptors).
The brothers Nimbaha and Nalurugo, Nawo's wife, and a younger
sister married to a Kule sculptor at Korhogo were all three born of
the same mother at Sumo. Nalurugo's apprentice at the Tapé work-
shop was his cousin Zana, son of the Sumo elder Be Soro, who was
the younger brother of Nalurugo's deceased father.

Such details of kinship and apprenticeship represent only a very
small cross section of the interrelationships touching seven Kule sculp-
tors and yet involve five villages located in five separate dialect areas
(Kafiri, Tyebara, Tagbanri, Kufuru, and Fodonon). The mobility of
the Kule woodcarvers, combined with the kinship-linked apprentice-
ship system, accounts for much of the stylistic homogeneity found
in mask and figure sculpture within the Central Senufo language re-
gion. Similarly, the relatively fixed situation of the farmer dialect

groups with "their" blacksmiths (the symbiotically attached Fono groups) accounts for some of the stylistic and typological diversity found in sculpture and above all in complex masquerade constructions.

Of all sculptors, both Kule and Fono, working in that area, one artist in particular stood far above the rest in terms of both technical virtuosity and creative power. Zana Soro was born in Korhogo, where his maternal kin were under the authority of the important Kule chief Fobe Soro, head of the large Kule *katiolo* in Korhogo. Then a man in his middle thirties, Zana had worked in the Kufulo region for eight years. He had worked first at Zangaha village, where he found a valuable patron in the woman with the largest *Sando* divination practice in the area. From Zangaha he moved to his present location in the chief Fodonon *katiolo* at Pundya. There he headed a small workshop that included a younger brother, Be, and their two young sons. Zana Soro of Pundya was a prolific and versatile sculptor of high local repute who was able to function successfully in both the traditional and tourist art markets. His traditional works ranged from the small, delicately carved oracle figures (pl. 15) used by *Sando* diviners and the champion-cultivator staffs (pl. 16) to large-scale helmet masks commissioned by Poro organizations in at least three separate dialect areas (pl. 17).

KPEENE: THE BRASSCASTERS

Male members of the Kpeene artisan group residing in the Kufulo region can be divided into two categories: those few who still manage a livelihood by the ancient art of brasscasting and those, now the great majority, who have abandoned their traditional "heritage" for the considerably more lucrative profession of weaving. It is interesting enough that whatever the men's occupation, it is the Kpeene women's pottery specialization that forms the most important economic basis for the relationship with the farmer groups. This phenomenon was neatly expressed by one Kufulo village chief: "The Senambele were the first inhabitants of this village. When the Kpeenbele came, they said 'We are going to make pottery for your cooking; in exchange you cultivate the fields and we will eat together.' "[24] In this context, it should be noted that the concept of "eating together" reflects social attitudes toward this artisan caste that clearly weigh against any generalization of a "despised" or feared caste.

The larger Kpeene communities have been able to maintain the women's pottery specialization. Oral history records that pottery making has always been a traditional craft of Kpeene women from

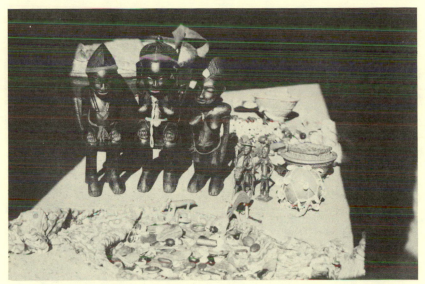

Plate 15 Sando divination equipment. Left to right: the leather-trimmed basketry container is traditional storage for the equipment; a male and female oracle pair, an extra female figure commissioned to "speak" for a particular client; a brass equestrian male with his wife for beauty and prestige; a cast chameleon; two twin baskets containing twinned cups with cowries; and a miniature insignia rattle, a powerful charm of the Sandogo society. Sculptor: Zana Soro of Pundya, ca. 1960 (June 1970).

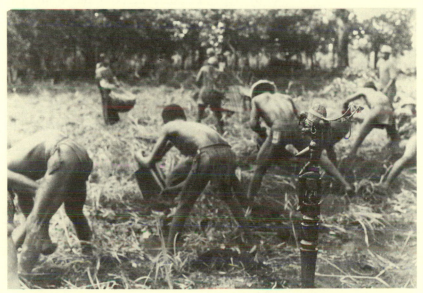

Plate 16 Champion-cultivator staff (*tefalipitya*). Sculptor: Zana Soro.

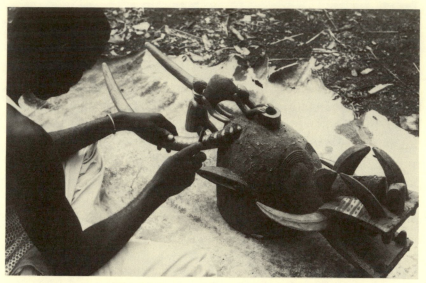

Plate 17 Sculptor Zana Soro applies river silt over the red
vegetable dye that will fix the black pattern on a *Kponyungo*
mask for the Kufulo Poro (1970).

the time they entered the Central Senufo territory from Kong to the
east. The majority of household pottery used by Fodonon Kufulo area
women is produced by the three area Kpeene settlements. (Pottery
made by Tyeduno and Nafanra women is also sold in local markets.)

Oral traditions related by Kpeene elders in both the Kafiri and
Kufulo areas are unanimous in tracing their lineages back to the city
of Kong, although none of the histories reach beyond this point
(map).[25] Dating from at least the end of the fourteenth century,
Kong was one of the relay stations between great sub-Saharan trading
crossroads, such as Timbuctu and Djenne, and the coastal regions,
in this case the Banda Hills area and the Akan gold fields of Ghana.[26]
The Kpeene may have enjoyed a fairly long period of settled pros-
perity at this key commercial city on a major trade artery. Traditions
are also in agreement that the Kpeene were forced to leave Kong
as a result of conflict with the Dyula, although the date of their
exodus and the exact nature of the conflict are not entirely clear. One
tradition relates that the Kpeene left Kong because of a war, possibly
the period of intense political crisis at Kong in the early eighteenth
century, when the powerful Ouattara Dyula State was established
(Glaze 1976: 35, 281–82). A second account describes a significantly
different kind of conflict, one in which a punitive act of aggression
by the Kpeene Poro against a Dyula "sorcerer" added yet another

dimension to the Dyula-Kpeene tensions that triggered the Kpeene migration: "In those days, the Kpeenbele practiced their Poro at Kpon. At that time, two villages of Dyula were there. If there was a funeral in the Kpeenbele village (or quarter of the town), they had Poro. Masks walked in the village. When the Kpeenbele Poro found a Dyula—the Dyula were already Muslim by that time—in the act of some "sorcery," they killed the Dyula. So the Dyula were upset by this and finally chased the Kpeenbele away. All of them left together."[27] According to this account, the brasscaster families moved west from Kong into Central Senufo country, settling first at Mbengue and then spreading out into a number of other villages throughout the Central Senari region (i.e., Katege, Sirasso, Syionba, Puloro) (Glaze 1976:281–82).

For several generations the Kpeene living in the Central Senufo area have spoken the Senari dialect of their immediate neighbors (such as Kafiri, Kufuru, and Tyebara). Although one Kpeene elder claimed that their "lost" dialect was definitely of the Senufo group, there is some reason to think that the Kpeene are a splinter group of the Lorho, another Gur language group who live mainly among the Kulango farmers in northeastern Ivory Coast and Ghana.[28] The Lorho range from the "Lorhoso" region in the southwesternmost corner of Upper Volta to as far south as Bondoukou in Ivory Coast and the Banda area of Ghana.[29]

Kufulo informants explained that *Löhö* was the Dyula name for the Kpeene. Maesen used the name *Lorho* for the brasscasters living in the Korhogo region (1948:109), and one may assume he was employing the Dyula term for the Kpeene (*Kpëënbele*). Briefly, a possible reconstruction of brasscasting history suggests a movement from northern Manding country via the medieval trade route to Kong, from where the brasscasters later split into two principal branches, one (the Kpeene) migrating west to Senufo country and the second (the Lorho) migrating to the southeast.

In contrast to the fairly sizeable Kpeene communities that constitute important *katiolos* in the Kufulo villages of Pindokaha, Katiorokpo, and Diegon, individual, practicing brasscasters live as itinerant artists attached to Fodonon hosts in separate villages. Like the Kule sculptors, individual Kpeene brasscasters, along with their immediate families and apprentices, sometimes live as "guests" for years in a host *katiolo*. In addition to the resident Kpeene artists, practicing brasscasters from surrounding dialect areas often follow the market circuits, coming to the Kufulo region to offer their work (divination charms and *Sando* figure sculpture in particular) at the principal markets of the area (e.g., Guiembe, Nöökataha, Dikodougou).

Along with the Tyeduno, the Kpeene are one of the artisan groups heavily Islamized in recent decades. One result of their conversion has been the collapse of the Poro organization. Until recently, the Kpeene have had their own Poro, with masquerades and a sacred grove outside the village, along the same general lines as the Poro organizations of other artisan and farmer groups of the community. At least four Kpeene communities interviewed in 1969–70 reported that their Poro had "fallen" within the last generation or so.

The brasscasting industry appears to have been more vulnerable than many of the artisan occupations to the rapidly changing modes of belief and behavior of recent years, and the profession has suffered accordingly.[30] Yet even when both aesthetic taste and religious conviction required much greater quantities of personal charms and ornaments than is now the case in Senufo culture, this highly specialized craft could rarely have supported large communities or kinship units. Thus, in long-range terms, the frequently wholesale shift to weaving that has taken place among Kpeene groups throughout the Central Senufo area can be seen as an energetic response to an opportunity for growth and economic advancement. In most of the Kpeene groups interviewed, the change has come about only within the last generation or so and has been a result of both economic pressures and Islamic proselytization. The former seems to be plainly contingent upon the latter since the lucrative textile industry has historically been largely in the hands of the Dyula from the time of its introduction, probably several centuries ago (at least by the early fifteenth century), by immigrant Dyula artisans from the north.[31]

In 1969–70 there were two Kpeene master craftsmen of note working in the Kufulo region: Nangbo Tuo of Tapéré village and Songi Soro of Dikodougou.[32] Nangbo worked for a strictly traditional clientele, filling commissions and following the local market circuit to sell the many types of ornaments required by *Sando* divination practices as well as such accessories as bells, whistles, and masquerade ornaments needed by the Poro society. Songi, on the other hand, directed some of his creative energies toward providing the Korhogo export art market with his specialty, cast-brass face masks, which exhibited considerable technical virtuosity and originality of style (pl. 18). A brief summary of the genealogy of Songi's workshop provides an excellent illustration of the far-reaching apprenticeship network that characterizes the Kpeene and Kule artisan groups in particular and makes the issue of substyles within the Central Senufo region so complicated.

According to Songi, it was the Kpeene who, "long ago in Kong," made the brass face masks used by the Kong Dyula in their *Lo* society (i.e., the Dyula equivalent of the Poro). Of course, the names of

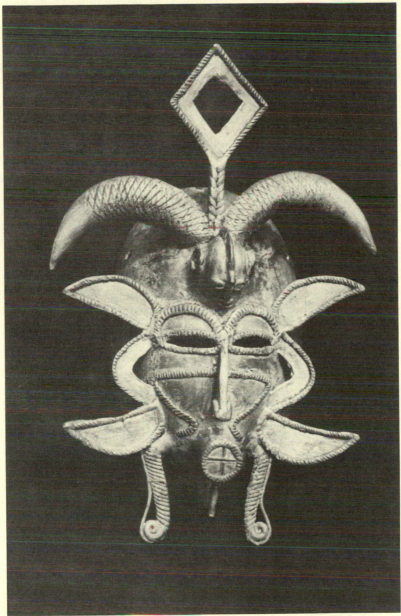

Plate 18 Face mask by the master brasscaster Songi of Diko-
dougou. Center crest ornament represents a chief's ornamental
fan; the head emerging from the forehead is a bush spirit (1970).

past masters do not reach back nearly so far in time. Songi's own lineage of recognized master-pupil descent begins two generations back with Ladyo Soro, a Kpeene who lived in a Tyebara village near Korhogo. A master renowned for his brass face masks, he and later his best pupil, Dopohoro, were the ones always approached by the Fono of the Kafiri and Kufuru areas who wanted to commission brass face masks. Dopohoro Soro was not a true Kpeene but rather a Fono blacksmith from a village in the Nafanra area. This transfer from an occupation linked with one artisan group to one normally linked with another group seems to be yet another indication of flux in Senufo ethnic-occupational relationships.

Dopohoro learned the complicated technique necessary to produce masks and known to only a small percentage of Kpeene brasscasters. For most of them, the large, hinged, cylindrical ankle bracelets and boat-shaped ankle bracelets constitute their most ambitious projects. In his later years, Dopohoro became the teacher of Songi, who worked for three years as a young man at the side of the master. During this apprenticeship period, Dopohoro provided Songi's food, and all work done by Songi was sold for the master's profit. When Songi became relatively skillful in the work, his teacher periodically gave him some metal, and Songi could sell the work done with this metal for his own profit.

After the old master died, Songi became the teacher of Dopohoro's nephew Nyenema, who today has his own workshop in Korhogo. In fact, nearly all the younger men supplying the Korhogo market have come to Songi for instruction. All of Songi's four sons have learned the trade in their father's workshop. The oldest, Mamadou, is married and has established his own workshop in a town in the Nyarafolo dialect area east of Korhogo. Bema, in his early twenties, is still un-married and assists his father in the Dikodougou workshop. The two younger boys are still at the preliminary stage of observation, minor tasks, and working the bellows at the kiln. In summary, Songi's history amply demonstrates that family and workshop are the only two frame-works for a profitable discussion of stylistic groupings and influences.

TYELI: FARMERS AND LEATHERWORKERS

A brief discussion of the Tyeli group will complete a general over-view of the ethnic makeup of Senufo peoples inhabiting the Kufulo region. The Tyeli, or leatherworkers, seem to be a distant member of the Senufo language family that has acquired its quasi-artisan status in comparatively recent times. The exact nature of the Tyeli group will

remain uncertain until more oral history and comparative linguistic data become available, but preliminary evidence indicates that the classification "leatherworker caste" is inadequate to describe their place in Senufo culture history (see Glaze 1976:44–51).[33] Basing the opinion on such facets of Tyeli culture as the Tyeliri dialect itself and a Poro complex similar to the Fodonon's, I propose that the Tyeli are a distant branch of the Senufo language family, separated linguistically from the Central Senari cluster at a remote time in the past, and that in more recent history the Tyeli found themselves under pressure by the movements of increasing numbers of Senari peoples into their settlement area and, out of economic necessity, were forced into learning the leatherworking trade from itinerant members of an artisan group from outside the Senufo culture sphere.

The Tyeliri dialect is as unintelligible to Central Senari speakers as is the distant Palaka language (see table 1), although there is general agreement that the Tyeli *are* Senufo. Mills (1968) has proposed that Tyeliri be classed as a separate language of Senufo along with Senari, Palaka, Sup'ire, and the Southern Senufo group. Like the Fodonon, the Tyeli are bilingual and speak Central Senari freely with their neighbors, who rarely speak Tyeliri. A comparison between the Tyeli and Fodonon groups reveals a striking number of cultural parallels, although the wider historical implications remain unclear in the absence of comparative language analysis. In reference to their Poro society art complex, the Tyeli shared with the Fodonon a number of masquerade and musical instrument forms, nearly identical in type and style, two of which will be described below in another context. Moreover, the Fodonon and Tyeli are the only Senufo groups, to my knowledge, with the institution of *Tyekpa*, a distinctive "women's Poro" not found among the Central Senufo groups. The still active *Tyekpa* of Fodonon women will be discussed briefly in the next chapter.

Several thousand Tyeli live in settlements scattered throughout the Central Senufo zone, sharing villages with the Tangabele, Tyebara, Kufulo, Nafanra, and other Central-Senari-speaking farmer groups (collectively, the Senambele). The Tyeli settlements in the Kufulo region, for the most part Islamized, include two Tyeli villages, a number of large Tyeli *katiolo* in five other villages, and numerous itinerant leather craftsmen. Similar lists could be given for the Nafanra, Kafiri, Tyebara, and other Central Senufo areas; this point needs to be underlined in view of Bochet's assertion that the group "has practically disappeared" (1959:63). The Tyeli of Sefon village were still resistant to Islam in 1970, and their Poro society enjoyed wide renown for the awesome performances of its fire-spitting mask (*Korubla*).

Tanners and leather craftsmen are generally members of larger Tyeli communities engaged in farming and, in a few cases, the weaving and tie-dye industries. Some Tyeli are itinerant craftsmen living in a host *katiolo* with a small family unit of two or three dwellings. Any number of Tyeli craftsmen in the Kufulo region supplied local villages with amulets, knife sheaths, and a wide range of utilitarian repairs and products, but certain of them were master craftsmen with high reputations and specialized skills. The leatherworkers' contributions are nearly equal to the brasscasters' in the Senufo arts of personal adornment and are especially important in respect to the costumes and ornaments worn by initiates in the men's and women's societies. Among the major commissions of this type are the highly decorative leather and cowrie shell waist ornaments worn by Kufulo Senior Poro initiates, the Fulani-type leather bag with elaborate appliqué designs carried by both blacksmith and Kufulo initiates (pl. 19 [color]), and the purely ornamental bandoliers of leather and shells (*työgö*) worn by Fodonon women *Tyekpa* graduates and blacksmith Poro initiates (pl. 19).

DYULA FARMER AND ARTISAN NEIGHBORS OF THE SENUFO

The Dyula are a non-Senufo group belonging to the Manding language family. A general history of the Senufo would be incomplete without incorporating the historical impact of ancient Dyula settlements, craftsmen, trade routes, and wars within Senufo territories. Similarly, an overview of Senufo ethnic groups in the Kufulo region would be just as incomplete without a brief mention of their Dyula neighbors.[34] Although conflict with the Dyula is a leitmotiv in many local Senufo historical narratives, the development of mutually beneficial relationships is an equally common theme and one that best describes the long-range situation. For example, in one Fodonon narrative ("The Metongoba Narrative," in Glaze 1976:269–77), the Dyula displaced the original Fodonon inhabitants of Kadyoha village, which later became an important center for weaving in the region. The Fodonon, for their part, remained the "owners of the land" at Kadyoha and as such retained the title and responsibility of earth priest (*tarafolo*). The ritual dependency of the Dyula of Kadyoha upon the Fodonon is demonstrated when the Fodonon earth priest provides the crucial service of "purifying the land" in case of violent or accidental deaths and other misfortunes affecting the Dyula village.

The long presence of the Dyula and the interaction with their Senufo neighbors has had a demonstrable effect on Senufo culture. A historical summary of the nature and extent of Dyula-Senufo inter-

changes in the research area is a task clearly beyond the scope of this study. However, the following documented example of Dyula input into the Senufo culture of the Kufulo region is instructive. *Kaariye* is a rich, multimedia art form that has come to be a prominent feature of Central Senufo region funerals and that constitutes one of the events in the Fodonon funeral described in Chapter 4. A particular genre of hunters' music for which a harp-lute incorporating figure sculpture is used (pl. 20), *kaariye* is one of the few art traditions in the Kufulo region that presents a clear case of cultural borrowing and local adaptation that can be reconstructed. Historically, *kaariye* probably has its roots in the closely related traditions of praise singers, or bards, also linked with hunters' associations found among other Manding cultures, such as the Bamana to the north in Mali. In his pioneer study of Seydou Camara, a master bard in Mali, Charles Bird describes a style of praise singing associated with hunters and heroes that is virtually identical to the *kaariye* parallel in the Senufo culture to the south. The form is characterized by three modes of performance: the praise-proverb mode, the narrative mode, and the song mode (Camara 1974:ix), all of which are used by Senufo *kaariye* performers.

The hunter is a culture hero and a central figure in Senufo oral history, tale, poetry, and song. The prominence of the mythic hunter theme and the many ramifications of "hunter" in Senufo thought have been discussed elsewhere (Glaze 1978). According to both Fodonon and Fono sources in the Kufulo region, the *kaariye* has gradually replaced a much older genre of Senufo hunters' music and entertainment, the *nöösuguri* ensemble (a vocalist wearing a warrior-hunter's cap and playing a small iron rasp, accompanied by a chorus of boys playing cowhide and seed rattles shaped rather like large, stiff bean bags). *Nöösuguri* is said to be a very ancient form of entertainment that dates back to an era before the introduction of guns, when Senufo hunters braved leopards, wildcats (e.g., genet, civet cat), and hyenas with their weapons of arrows and stabbing spears used at close range. Introduced by villagers from the neighboring Kafiri area to the northwest, *kaariye* entered the Kufulo region in the context of "the war" (unidentified, but before the Samory wars) and later became associated with Senufo paramount chiefs. Although its first context was with war parties and wartime processions accompanying chiefly delegations, the elders liked it and began using it for their own purposes. Oral traditions strongly reinforce the supposition of Manding origin: captives taken prisoner by the Dyula because of "strong hands" (the weak were killed) occasionally were able to return home from the north, bringing this new taste and skill with them. Finally, the most persuasive argument for Manding origin is the Senufo insistence that

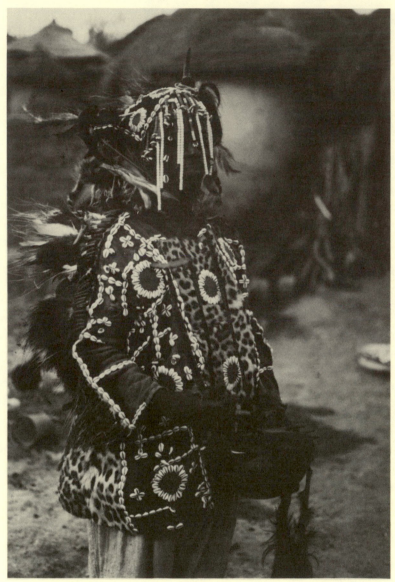

Plate 20 Hunter's bard in traditional performance dress, holding a harp-lute ornamented with a bush spirit figure (funeral for a Fodonon elder, March 1970).

for *kaariye* songs to be "right," the insertion of Dyula words and phrases is a firm stylistic requirement. Though of non-Senufo origin, *kaariye* has been appropriated and transformed into a thoroughly Senufo cultural expression and contributes a very special ingredient to the total aesthetic impact of Senufo funerals.

The lead vocalist is always elaborately costumed in a special tunic and headdress incorporating a wide range of materials, textures, and decorative designs loaded with accumulative insignia and images appropriated from the dangerous bush world, where the hunter-hero is exposed to the double perils of bush spirits and wild animals. The vocalist plays a harp-lute (*kŏri*) that incorporates a sculptural rendering of a stylized female head and bust, referring to the influence of bush spirits in the hunters' fortunes. The harpist is accompanied by a chorus playing iron rasps and occasionally a hunter playing a finely cast brass whistle (*satoro*) of the type traditionally used to announce a successful hunt.

Senufo performers have traditionally built upon the foundation of praise songs a wide variety of song texts with the result that *kaariye* music has become the context for both preserving and creating a wealth of oral literature. Although elaborately costumed in hunting regalia, the musicians themselves are not hunters. The Senufo use the general expression "hunters' music" to refer to the praise singer and harpist and his instrumental accompaniment, but in fact the textual content of the songs embraces a far broader range of topics than the "hunter" classification name suggests. The song texts draw heavily from the categories of both tales and "wisdom words" (*kaseele*), the latter a category of verbal art including proverbs and aphorisms. *Kaseele* is called "the language of the elders" because it takes years of learning and practice to develop the skills necessary to work proverbs and aphorisms into conversation. Although a major association of the *kaariye* praise-singers' ensemble is with hunters, the group is a common feature of funerals for older women and for "big men," such as chiefs. These categories of performance appearances underline the fact that the primary purpose of the genre is to honor individuals of high status, prestige, power, or wealth. A *kaariye* performance will be seen as one of the many art forms contributing to the funeral event described in the final chapter.

CHAPTER 2

Art and the Women's Sphere

INTRODUCTION

Senufo women, to a far greater degree than men, assume roles as ritual mediators between humankind and the supernatural world of spirits and deities, and several major categories of sculpture, ornament, and masquerade derive their intrinsic meaning from this role. For this reason, it is especially fitting to begin an analysis of the contexts of meaning for Senufo art by examining the women's sphere, that is, the nature, usage, and purpose of those visual arts directly related not only to women's activities and institutions per se but, at a deeper level, to the place of woman in Senufo thought and society.[1] Even in the men's society of Poro, women have a very special place in the ideology and ritual in much the same way that men have special roles in predominantly women's societies, such as Sandogo. The institutionalization in Senufo society of male and female roles, roles in which art plays an important part, is a second factor in my decision to separate the men's and women's spheres for the purpose of describing selected art traditions. However, the salient fact lies not in the compartmentalization of art within one group or the other but in art as an integrative factor in the rituals and interaction of groups and group segments.

The theme of woman in all its variations, including the important mother-and-child image, is widespread and constant in African art—this observation is hardly new.[2] The deficiency of numerous catalogs of African sculpture is that they tend to note the theme without coming to grips with the dynamics of its setting in a particular place and time. In this they risk doing disservice to the richly divergent aspirations and achievements of the Black African cultures concerned. The vital involvement of African women in some of the institutions

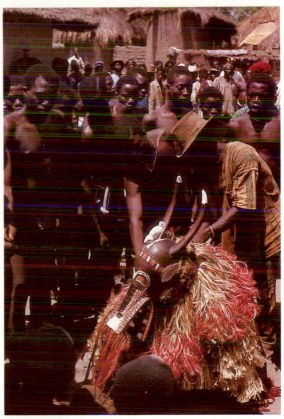

Plate 9 In the final ceremony for Fodonon male elder, a *Gbön* masker kneels before the funeral chief. Carved antelope-baboon head crowned by a chameleon is in the polychrome style of the Kufulo region (March 1970).

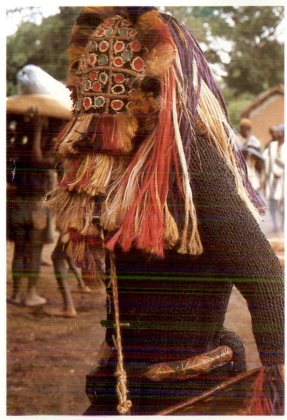

Plate 10 Tyelige masquerade, worn by Kufulo initiate in a newly formed *Tyologo* class at a funeral for a Kufulo elder. Masker displays the *sakelige* belt (May 1970).

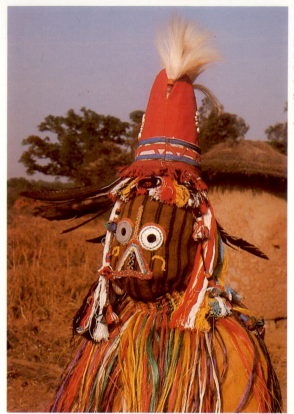

Plate 11 Detail of a *Yalimidyo* masquerade in Kufulo region style with an appliqué face, the design unique to each Poro society. Designer: Nanga Tuo, chief of his *Tyologo* class, with the assistance of an age mate (February 1970).

Plate 19 *Tyolo* initiate in ritual dress of the blacksmith *Tyolo*, worn at all Poro-related activities (even road work) during first three years of the *Tyologo* grade. Accumulation includes bow, belt, cowrie-cluster ornament, knife, leather bag, and quiver with basketry cap (cosmetic box and beads not visible in this view) (November 1969).

that have sustained great art traditions (e.g., divine kingships, initiation societies, divination cults) has often remained obscure behind such facile expressions as "fertility figure" or even "Queen Mother."[3] Quite apart from consideration of the impressive contributions of African women in such creative fields as personal ornament, textiles, and pottery, it is time for a closer scrutiny of women's roles in all those spheres of aesthetic expression that are integral to the structures of social, political, and spiritual authority in the community.

Within the framework of Senufo culture as represented in a typical Kufulo region village, this chapter will indicate briefly the range and depth of women's involvement with those aesthetic forms and events that communicate, control, and create power in both the temporal and supernatural senses of the word. This involvement will be considered for the most part in reference to two separate institutions, Poro (or Pondo, its Fodonon equivalent), the men's society, and Sandogo, the women's divination society. To avoid possible misunderstanding of what exactly is meant by women's "power" in the Senufo context, it must be noted at the outset that in Senufo thought *all* powers and positions rest ultimately on supernatural authority. There is no question here of women usurping male authority. It would be a travesty of the Senufo world view to diminish in any way the authority of the male in the sociopolitical order. Rather, my concern is to restore to discussions of Senufo culture that balance of male and female components that will be seen to constitute a basic principle of Senufo ideology.

From the literature one would conclude that Senufo art is essentially a man's world. Except for passing references to the Sandogo divination society, the discussion of Senufo art has centered on the Poro society.[4] With a few important exceptions, it is true that the more dramatic contexts for the arts, such as masquerade performances, are at one level men's business, yet even in the area of spectacle and aesthetic display some women's activities must be included. For example, in certain funeral ceremonies performed by the Fodonon women's *Tyekpa* societies, the virtuoso drummers are women; during an all-night consultation to the beat of drum and rattle, a female diviner (*Sando*) is possessed by spirits made visually manifest in the sculptures that become her dancing partners one by one.[5] The real point, however, is that disproportionate attention to outward spectacle may lead to a serious misunderstanding of the active, if less outwardly visible, roles of either women or men in *both* Poro and Sandogo, the two institutions that are the chief patrons of the arts.

A telescopic vision that, understandably, focuses on the visual excitement of masquerades in a Senufo funeral ritual is apt to miss the

elder women standing unobtrusively at the periphery of the ritual
arena, yet it is the very presence of the Sandogo leaders that both
validates and adds power to the ritual itself. Poro and Sandogo work
hand in hand, so to speak, in meeting problems and ensuring the
continuity of the group; however, in the Senufo system, women
ultimately have greater responsibility than men for seeking the good-
will and blessings of the supernatural world—Deity, the ancestors,
and the bush spirits. My evidence suggests that as the activities of these
two institutions move toward a more critical relationship with the
supernatural and spiritual world, the objects and events become more
secret and the role of women (real or mythological) more important.

So meager has been our understanding of what the women do in
the Senufo scheme of things that it has not really been made clear in
much of the literature that the Senufo are matrilineal and that the
spiritual figurehead of the men's society is a woman. A dearth of in-
formation regarding kinship structures has been a serious barrier to the
better understanding of the woman's role in Senufo culture in general,
of which the art is but one expression.[6] A high degree of matrilineality
in the Kufulo region was evident in the number and kind of rights,
status, obligations, and property that were said to pass through the
mother's line. Even to those families and groups that have shifted to a
patrilineal system under increasing Islamic and Western influences, the
matrilineage seems to retain an ideological significance not readily
dismissed. Of course, it does not necessarily follow that in a matrilineal
succession all types of power lie in the hands of women since authority
is commonly delegated to the mother's brother and other males on the
maternal side of the family. The fact remains that a consideration of
the critical importance of the matrilineage adds an essential dimension
to our understanding of categories of Senufo masquerades and sculp-
ture.

A deep respect for women, particularly the elder leadership, is
expressed in traditional Senufo culture, in not only its art but a great
number of formal gestures and honors paid to women within various
structured "living art" situations. As an illustration of one such formal
gesture, a young initiate of the blacksmith Poro Junior Grade at the
time of *Kwörö* initiation (pl. 21) is seen paying homage to a woman
elder of his lineage. Attired in the masquerade that celebrates his
advancement in Poro, the initiate places his hands on the woman's
shoulders in a gesture that simultaneously honors her status and draws
sustenance and protection from her as one who can secure ancestral
blessings. That is, the masquerader, by this action, is making a non-
verbal statement concerning the role of women elders as mediators
with the ancestors.

Plate 21 Kwöbele-kodöli masquerade: a blacksmith *Kwö-rö* graduate participating in "old" funeral (*kuufuloro*) for a Kufulo man and woman (June 1970).

A clear-cut instance of ritual that places male-female role inter-
action in the context of aesthetic forms is *Lango*, essentially a young
men's dance paying homage to women elders. *Lango* is an ancient
Fodonon dance tradition with songs. It is performed only at the
funeral celebrations of important Fodonon women elders. A strong,
vibrant dance, *Lango* is characterized by vigorous foot stamps that
ring the stacks of iron bell anklets, by the crack of metal-ringed whips,
and by the hot rhythms of a barrel drum and hand gongs.[7] As the
dance column moves swiftly through the village paths and courtyards,
a few young women who sing well (literally "strong" but referring
to quality, not volume, of voice) intersect and support the male
dancers. Thus, *Lango* honors elder women and is danced by young
men, who are themselves encouraged and strengthened by the support
of young women. This basic pattern typifies the flow of male-female
interaction in the considerably more complex setting of Poro. These
relationships are made concrete and visible through the ritual forms
used in both the initiation and the funeral, the paramount rites of
passage important in Senufo culture.

WOMEN, THE MEN'S PORO, AND DEITY

My Kufulo region data indicate that a kind of balance of power
between the male and female sectors of the community is achieved
within the formats of both the Sandogo, essentially a female society,
and the Poro, essentially a male one. Significantly, the mere presence
of both a women's society and a men's society is by no means the
critical aspect of "balance." This would be far too static an image to
portray what in reality is an ingeniously graded series of structured
opportunities for dynamic interaction between the male and female
sectors of the community.

Close examination reveals that Poro is indeed a vital channel for
interaction at a surprising number of age-group levels and that the role
of female age grades is critical to the functions and continuity of
Poro. So critical is the woman's part in Poro that her presence is
absolutely necessary for the founding of a new Poro organization
and its sacred forest sanctuary (*sinzanga*). The initial ritual act that
"creates" and dedicates the *sinzanga* is performed by a man and a
woman acting together. The male *sinzangafölö*, or chief of a particular
sacred forest membership, succeeds to the title through the maternal
line: he is a nephew rather than a son. The elder woman's title is
nërëjäö, head of the lineage segment concerned; she is normally the

oldest sister of the uncle of the new *sinzangafölö*. Moreover, it is the woman, the *nërëjäö*, who, at an ideological level, is considered the true chief, or head, of Poro—a staggering fact in light of our previous conception of the so-called men's society. However, since the woman cannot "kill," that is, risk contamination with sacrificial blood, or play the Poro drums (having lost this right in the mythological past, as will be seen in Chapter 3), these important jobs become the responsibilities of her brothers and nephews.[8]

In its role as the principal center of male religious and social instruction and as the basic framework for the male political leadership, Poro is most certainly a men's society. Uninitiated women, along with junior boys and children, the vulnerable ones, are excluded from participation in many Poro activities out of concern for their own protection from powerful supernatural forces. Moreover, secrecy itself is an important psychological factor in the institutionalization of male and female members of Senufo society; this principle extends as well to establishing identity with a particular ethnic or age group. Although such terms as *men's*, *secret*, *initiation*, and *sacred forest* all convey an important fact of Poro, none is really sufficient in itself. For example, *sacred forest* draws attention to the *sinzanga* as the sanctuary of each Poro society and the locus of many of its activities. To call Poro a "village society" has the advantage of not excluding the integrated activities of the girls and women (discussed briefly in Chapter 3) and at the same time points to the larger sociopolitical and religious contexts. A village will have a number of Poro organizations, all linked ultimately to matrilineal kin groups whose ancestors had settled there. The *zingböhö*, literally "the big *sinzanga*," is the title given the principal *sinzanga*, that of the founding lineage in the village.

Largely through its educational and governmental functions, Poro is above all an organization designed to maintain the right relationships with Deity and the ancestors. The most important ancestor of all is the woman who was head of the founding matrilineage of each *sinzanga*. The greater ideological weight of "ancestress" over "ancestor" is neatly expressed in the larger size of the female in the majority of male and female sculptural couples, the primary category of figure sculpture used by Poro and Sandogo (pls. 4–7, 22, 23).[9] A dramatic example of art as philosophy, the dominating stature of the female figure is a succinct declaration, in plastic terms, of core Senufo social and religious concepts: the procreative, nourishing, sustaining role of both mothers and Deity; the priority of the uterine line in tracing relationships and determining succession rights to title and property; and the special role of women as intermediaries with the supernatural world.

Plate 22 Female and male pair in blacksmith style, the hairstyle typical of the Kafiri dialect area. Intermediate in scale, this pair is of a type placed inside the *sinzanga* precincts to adorn the altar honoring the bush spirits. The female figure, which is missing part of its base, has been designed to stand taller than her male partner (female, 17½″ high; male, 16¾″ high; private collection).

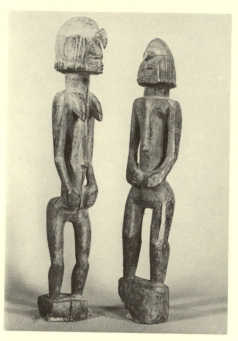

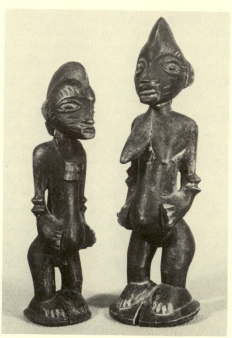

Plate 23 Female and male divination pair (female, 8″ high; male 7″ high; private collection). (Photograph by David L. Kuntz.)

I can think of no single expression in Senufo language that better communicates the ideological core of "woman power" or more intimately touches the very heart of Senufo religious thought than the phrase "at our Mother's work." A literal translation from a local modification of Senari used as a secret language by Poro initiates, this phrase forms the nucleus of a combination of formal greeting and password used wherever members are engaged in the affairs of Poro, especially within the sacred precincts of the *sinzanga*.[10] The phrase refers to the initiated Senufo's status as a child of a divinity conceived of as distinctly on the distaff side and under whose control human activity finds wisdom, creativity, and order. Thought of in human terms as "Ancient Mother," *Katyelëëö* (the female aspect of Deity) is considered to have her "*katiolo*," her home and seat of authority, in the *sinzanga*.[11] This sanctuary, at an abstract level, is the nexus of divine and temporal authority in the Senufo village.

The sacred requirement that a woman be the true head of Poro follows with logic and consistency from the basic premises of Senufo thought concerning the nature of Deity and family, that is, of cosmological and social order. The involvement of women in Poro also seems to be an institutionalized expression of the deeply rooted concept of twinship in Senufo cosmogony.

Central to Senufo religious belief is the concept of a bipartite (dualistic) deity called "*Kolotyolo*" in its aspect of divine creator and "*Katyelëëö*" in its aspect as a protective, nurturing being.[12] As suggested above, Ancient Mother works at the level of village life primarily through the institution of the sacred grove and its attendant Poro members. The secret names of certain of the Poro's most sacred equipment (such as the most important drum types) refer back directly or indirectly to Ancient Mother. Although justice and punishment are a concern of both facets of the deity, it falls primarily to Ancient Mother to deal with crimes that threaten the well-being of the community as a whole. Suspected murderers or thieves, for example, would traditionally come before the sacred drum of Ancient Mother for trial.[13] The members of Poro are entrusted under the authority and validation of Ancient Mother to maintain community order by means of protective devices against witchcraft and by an initiatory system of education designed to help shape the intellect, moral character, and skills of each succeeding generation and age set.

The other aspect of this deity, the creator god *Kolotyolo*, is seen as a wholly good but relatively remote being responsible for the original Creation and for "bringing us forth." There is some evidence to suggest that *Kolotyolo* was originally considered female in nature (*Tyoloo wii*, for example, means "woman" or "wife"), although pres-

ent usage suggests a more neuter or even paternal image. According to elder informants, *Kolotyolo* is invisible and difficult to approach without the help of *Yirigefölö* (literally, the "owner" or chief of "creating, making, bringing forth") or *Nyëhënë* ("sky" or "light"), two corollary spirit guises of the creator god. Like *Kolotyolo*, their essential nature is spirit, but these manifestations of the creator god are associated with specific material forms. As one elder explained, "*Yirigefölö* is a thing one sees to help pray to *Kolotyolo*." Thus, *Yirigefölö* and *Nyëhënë* are both spirits and specialized icons in honor of *Kolotyolo*.[14] The material icons sometimes incorporate aesthetic objects intended as visual aids for worship, supplication, and sacrifices.

One's creator spirit or guardian spirit, *Yirigefölö*, is usually expressed sculpturally as a shrine in the shape of a miniature adobe house, significantly positioned by the beautiful, large water jar that a woman is given at marriage and that is the central feature in the outer chamber of her house. The shrine is usually built upon the advice of a *Sando* diviner as part of her prescription in meeting a particular domestic crisis. The miniature house, cubic in shape, frequently contains some of the small cast-brass charms (pls. 24–27) that are purchased as a result of consultation with the diviner and are inherited through the maternal line. In contrast, the *Nyëhënë* altar, a truncated cone of adobe with a python motif in relief, is placed outside, in the courtyard; it is often crowned with a pottery bowl containing the brass and wood sculpture associated with *Sando* divination (pls. 28, 29). *Fo* the python, messenger of spirits, is first in the hierarchy of symbols of power used by the diviner (pl. 24).[15] Brass and iron figures and ornaments that relate to lesser spirits than *Kolotyolo* frequently complete the total gestalt of *Nyëhënë*.[16] Of particular importance among them are the unpredictable and potentially dangerous bush spirits, to be discussed briefly in this chapter.

SANDOGO: THE WOMEN'S DIVINATION SOCIETY

With the more immediate, material manifestations of Deity, we have come full circle to the crucial involvement of women, in this case the diviners. Neither a male nor a female leader would make an important decision or perform a ritual act without consulting one or more *Sando*, whose assistance in intermediating with the supernatural world is considered indispensable. Unlike the Poro society groups, with their emphasis on prestigious visual display for large audiences

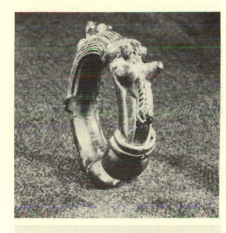

Plate 24 Brass python bracelet of the heavier, more elaborate type made for men of wealth and status.

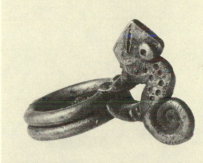

Plate 25 Brass *yawiige* ring with chameleon (2″ high), by far the most common of the ring motifs, mounted on a double band in reference to twins.

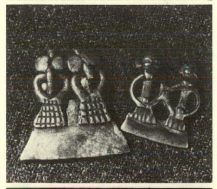

Plate 26 Twin amulets of cast brass (1³⁄₁₆″ and ⅞″ high). Twin brass amulets are normally sewn onto a leather backing with braided leather necklace and worn as a pendant by women associated with twins.

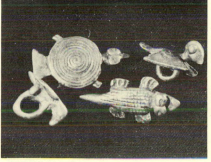

Plate 27 Small *yawiige* charms representing (left to right) bird (⅝″ long), tortoise (1⅛″ long), crocodile (1½″ long), and generic bird (⅞″ long). The smallest category of *yawiige* charms, these are attached by string to an infant's ankle or wrist.

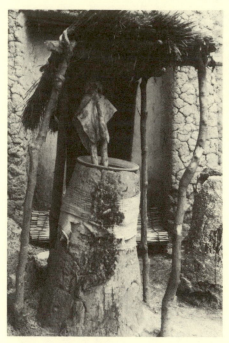

Plate 28 Village chief's altar to *nyëhënë* for the welfare of the *katiolo* and village: python in mudmolding and *madebele* figures in a pottery bowl inserted in an earthen cone (Kufulo chief's compound, December 1969).

Plate 29 Detail of pot holding *Sando*-divination-related objects, including python bracelets and *madebele* figures in brass and wood.

in the context of funeral and initiation rituals, the sphere of Sandogo is more an inner, closed arena where the individual grapples with day-to-day personal problems (as the Senufo say, "from affair to affair") and with his or her relationship with the unknown. In the small consultation chamber of the diviner, an atmosphere of supernatural power is created by a glittering, intentionally bewildering display of visual forms but, on a miniature scale, suitable to the intimate, private relationship of diviner and client. The contrast of a public versus a private visual world is reflected in the dimensions of figure sculpture used by Poro and *Tyekpa* (two or three feet average) and that which forms part of the *Sando*'s equipment (averaging six to eight inches; cf. pls. 3, 4, 7 with pls. 15, 30, 31).

Sandogo, the association of diviners, or *Sandobele* (plural form of *Sando*), is a powerful women's organization, a village institution found throughout the Senufo culture area. Sandogo society members are charged with two broad areas of responsibility: first, safeguarding the purity of the matrilineage and, second, ritual maintenance of good relationships with the hierarchy of spiritual beings through a particular technique of divination (*tyëlë*). According to Senufo oral tradition, its existence predates the introduction of the men's Poro society in village life; this mythic event required the intercession of the woman diviner to appease the bush spirits from whom Poro was stolen (this account of Poro origin will be taken up again in Chapter 3). As described in Chapter 1, Sandogo society membership comprises representatives of every matrilineage segment and "house" (*gbo*) in the village. It should be remembered that *gbo* is used in this context not in the ordinary sense of "house" but to refer to a social grouping, an extended household unit including members of more than one matrilineage. Senufo generally describe the possessions and functions associated with the *Sando* office of a particular household as "an ancient inheritance within the maternal family."

As is the case with the Poro men's society, translating Sandogo as "women's" or "divination" society is merely a useful oversimplification. Not all *Sandobele* are practicing diviners, nor, for that matter, are they always women. Indeed, in the Nafanra dialect area, male *Sando* diviners seem to be nearly as numerous as women practitioners. In the Kufulo region, a male may inherit the obligation to become a *Sando* through the maternal line because there are no girls of that house (*gbo*) to take up the responsibility.[17] The fundamentals of the divination system (*tyëlë*) are taught to all novices entering the Sandogo society, although only a small percentage of trainees are able to master the difficult system and become practicing diviners with a large clientele.

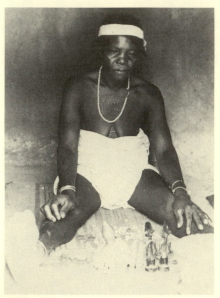

Plate 30 Sando diviner in small consultation house (*sandokpaha*) with oracle sculpture and set of signs (February 1970).

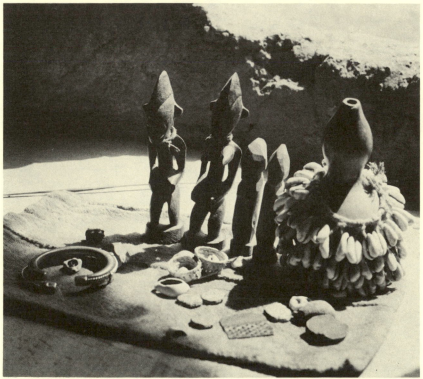

Plate 31 Detail of a basic display kit. Left to right: python bracelets, cowrie-within-a-cowrie sign, two pairs of *madebele* couples, twin baskets, and Sandogo society insignia rattle. The crude pair was used when the *Sando* was a beginner; the more detailed pair is in local blacksmith style (ca. 5½″ high).

In Senufo thinking, there are two different categories of *Sando* diviner, each defined essentially by the reason a person becomes a *Sando*. The first and by far the most important category concerns the inherited office of *Sando* to a particular house (*gbo*) and its representation in the village Sandogo society. The second category is one in which the reason for a person to become a *Sando* is attributed to a dramatic confrontation with a particular bush spirit, thus initially bypassing the Sandogo organizational structure. A *Sando* diviner can belong to either category or both; in the latter case the Senufo speak of "uniting two different kinds into one."

The first category is essentially a women's affair, although male *katiolo* heads do play an important role in matters concerning money and blood sacrifice, activities deemed appropriate men's business. For example, it was explained that after selecting a new member, the Sandogo will inform the village chief of their choice, and the chief "will agree but has no voice in the actual selection." The chief will then sacrifice a chicken to the ancestors on behalf of the new *Sando*.[18]

The principal route to Sandogo membership is through kin group succession, reinforced by ancestral directives as interpreted by diviners. To become a *Sando* is both a right and an obligation considered "an inheritance from the ancestors" within the nexus of "house" and matrilineage boundaries. If a *Sando* dies, another member of the same house and lineage grouping, preferably from the younger generation, takes her place as mediator and "protector" of the house. In theory, the successor is never chosen arbitrarily but is always designated by the "dead ones," the ancestors. Sometimes a child is dedicated to Sandogo even before leaving her mother's womb as a consequence of the mother's consultations with a diviner. In other cases, the ancestors are said to designate a deceased *Sando*'s successor by causing that person to fall ill. When her family consults with diviners of other houses to discover the cause of the illness, the diviners explain that the recently deceased *Sando* intends to kill the sick woman and perhaps others in the family as well unless she agrees to become initiated into Sandogo. The designated person may resist becoming a *Sando* because of the many kinds of foods and work activities she is expected to renounce, including basic staples in the diet, farming, and making pottery, but failure to comply is rare since any misfortunes or deaths in the family would be blamed on her having incurred the wrath of the ancestral *Sandobele* of that house and lineage. In short, the newly designated *Sando* is expected to take up the responsibility of "protecting" the family in her role as intercessor with the spirit world.

The second path to Sandogo membership is through the direct intervention of the python-messenger or the bush spirits, whose male-

volent attention to a particular individual can be propitiated and redirected toward good only by his or her becoming a *Sando*. The bush spirits of a person's field are said to be the most frequent cause of people's having to cease cultivation and turn to divination for a livelihood. Thus, the Senufo explain that for some *Sando* diviners it is an inheritance but for others it is the spirits that work in their fields who "catch" them.[19] A second common circumstance is that an individual comes under the domination of a bush spirit that had taken the form of an animal until the latter was unwittingly killed. This type of transformational spirit (called "*nikanhaö*") is said to establish a possessive relationship with the person and to provide her with special powers of divination. It should be noted that especially in reference to the second category of *Sando* diviners, the outside observer cannot ignore the factor of the individual's abilities and inclinations. This factor is not allowed for within their cultural premises, so it is expressed euphemistically as "the bush spirits gave it to me."[20] Ultimately, however, *Sando* appointment reverts to matrilineal succession.[21] If a person becomes a *Sando* via the route of python or bush spirits and is the first in her (or his) family to do so, then at her death a *new* line of descent begins, and the category is considered changed to *kubelewoho*, "inherited from the ancestors." When the *Sando* is a man, the position goes in turn to all possible females in the line of succession before reverting to a male.[22]

SANDOGO AND SOCIAL CONTROL

A major area of responsibility for Sandogo society members is safeguarding the purity of the matrilineage. Their activities include, for example, administering penalties in cases of adultery or unsanctioned premarital sexual behavior (i.e., anyone other than a formally designated boyfriend). To take a case that occurred during fieldwork, a young Fodonon was caught sleeping with another man's wife. The woman was corrected by her family with a beating, but the young man had to pay a heavy fine to the Sandogo guardianship of the woman's matrilineage segment. Informants explained that if the woman committed this wrong again, "the Sandogo could kill her or someone in her family."[23] More precisely, it is the power of the kin group's ancestors working through the instrument of Sandogo.

Another case I observed concerned an unmarried woman who was caught sleeping with a young man from another village. Since the two families concerned were able to make arrangements for marriage, the elders of the girl's kin group were lenient in the matter of fines, which can be especially heavy in the Fodonon group. The fine cited

for adultery is severe: payment of one sheep to the Sandogo, one dog
to the healers' association (*Nökariga*), and one chicken each to the
water spirits, the ancestors, *Nökariga*, and Sandogo. This is a con-
siderable outlay for young men, who traditionally have little or no
right to crops and animals outside their families' benevolence.[24]

The effectiveness of this traditional means of social control is ap-
parent in the description of what would happen if a man refused to
"repair" or purify the Sandogo of a woman's family (*nërëgë*, i.e., the
Sandogo-guarded matrilineage segment and its ancestral antecedents):
"The ancestors, along with Sandogo, will cause the death of someone
in the girl's lineage if the young man refuses to help the *nërëgë*.
People will keep insisting he should repair her people's *nërëgë*. He
will be shamed because the girl will say, 'You want to kill someone
in our family.' Then, if someone *does* die in her family, the funeral
singers will name him publicly as the killer. The family will cry aloud;
all the girls would refuse to marry him, and he would have to leave the
village [the worst possible combination of misfortunes]."[25] It is not
surprising that only rarely would a young man dare flout the power
of the Sandogo society by refusing to make the prescribed payments
or other obligations to the Sandogo leadership of the matrilineage
segment concerned.

THE DIVINATION SYSTEM AND THE BUSH SPIRITS

Tyëlë, the system of divination used by *Sando* diviners, is a ritual
form of diagnosis and a technique for determining the supernatural
cause of any misfortune and for actively soliciting supernatural aid in
order to obtain a desired result, such as good hunting, successful preg-
nancy, or a good harvest. The same root word, *tyëlë*, is used to refer
to both the act of divining and the act of consulting a diviner. *Tyëlë*
divination involves both a mechanical system and a supplication to
conscious, knowing beings. The latter aspect of the system is evident
in the number of ritual abstinences, prayers, and sacrifices that must
be observed if the system is to work and the diviner to maintain her
power. This power is thought to come mainly from the bush spirits
and ancestors. In addition, the *tyëlë* system requires a large measure of
psychological insight on the part of the diviner. In principle, the
diviner-client relationship includes an aspect of privacy in much the
same way that a psychiatrist preserves confidentiality about the de-
tails of his or her patients' problems. A principal difference in the
case of the *Sando* diviner, however, is the aura of mystery created by
the element of belief in the supernatural. The successful creation of
this supernatural framework is an integral part of her profession. In

tyëlë, as in other systems of divination, the specialist is charged with obtaining information from nonhuman sources about affairs that would ordinarily be hidden from human knowledge.

The bush spirits are thought to be the chief source of the *Sando*'s power and the chief cause of her clients' problems. *Madebele* are animate spirits who inhabit the bush, fields, and streams surrounding the villages. They demand gifts, worship, and visual commemoration in order to remain happy. If one unwittingly disturbs them or breaks a promise made to them, they can become angry enough to kill. Cultivating in a field where there are "ancient settlements" of *madebele* can be an especially dangerous risk for farmers, who usually consult *Sando* diviners as a preventive measure. The diviners advise the farmers to sacrifice a chicken and "talk with the *madebele*" in their fields.[26]

To understand Senufo thinking about the bush spirits it is necessary first to recognize a critical distinction between the thoroughly evil nature of *dëëbele* (evil spirits and witches) and the ambiguous nature of the *madebele*, the bush spirits. Unlike *Kolotyolo* and *Yirigefölö*, who have an essentially benevolent nature and are "always good," the bush spirits are more likely than not to cause one misfortune.[27] The bush spirits, however, have the potential for benevolent action if properly approached by humans, and this is where both the analytic technique of *Sando* divination and the role of the aesthetic as antidote enter the picture. The Senufo believe that there is a positive element in the supernatural powers of the bush spirits that can be appropriated for good, helping to bring long life and good fortune. The *Sando* diviner's task as medium is to learn by means of the *tyëlë* technique what the *madebele* require of the individual, who is either petitioning the *madebele* for a particular favor or, more commonly, seeking to learn the reason for a misfortune that has already occurred. For some villagers this necessitates a constant round of consultations with diviners or else the risk of accusation from relatives and neighbors that their families' misfortunes are the direct result of their failure either to consult enough diviners or to follow the *madebele*'s instructions (as interpreted by the *Sando*). Of course, death or misfortune may be caused by other supernatural agencies, such as witches or wrathful ancestors, and here too it is the *Sando*'s task to discover the reason. Dreams, family problems, and desire for wealth were other reasons given for consulting a diviner. As one elder asserted, "No matter what you want, you can go to the *Sando*—you don't need to be sick."[28] In short, the *Sando* often has a position of tremendous influence in the everyday life of the Senufo. If abused, the *Sando*'s powers can become an exploitative, rather than stabilizing, force in the community.

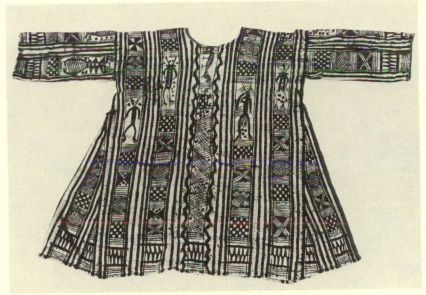

Plate 32 *Fila* shirt painted by Siityenyimë Tuo of Karafiné, 1975.

The bush spirits are thought to have some humanlike responses, to have their own villages and their own Poro societies, and, moreover, to enjoy such aesthetic forms as music, dance, sculpture, and ornament. Consequently, one aspect of the technique of pleasing the bush spirits concerns the aesthetic quality of the *Sando*'s consulting-chamber decorations, personal ornament, and equipment, especially the carved oracle figures that "speak" for the *madebele*. The same principle holds true in respect to the many cast-brass ornaments, painted textile clothing (*fila*) (pl. 32), and even masquerade costumes worn by clients as protection and appeasement for past offenses against the *madebele*. All such ornaments, shirts, wraparound cloths, and the like fall under a general category of *yawiige*, which is anything worn as a protective magical device and prescribed for a client by a *Sando*.[29] The oracle figures, the masquerades, and other selected *Sando*-related objects will be described below in this chapter.

A comprehensive description of the secret "language" of the *tyëlë* technique and the entire socioreligious process of divination is not critical to the central purposes of this study. However, some explanation of the *tyëlë* system will help to place the related aesthetic expressions into a larger context of meaning. This is particularly important in order to understand one highly significant feature of divination-related art, namely, that *Sando* art objects are conceptually and functionally linked

with nonart objects within a visual and symbolic gestalt, a larger category that includes *more* than art. That is, here is a particular Senufo order of classification that includes works of art as one of several kinds of objects. Many of these divination objects, when taken singly, are clearly not art according to either Senufo or Western definitions (such as a red seed, an antelope horn, a button, a white cowrie shell, or even a tiny basket).

To begin to understand the *Sando* experience, one might begin by visualizing the formal body positions assumed during consultation. Within a small house built expressly for this purpose (*sandokpahagi*), the diviner sits on the floor with her legs spread out in front, providing an area for the divination objects to be thrown in front of a set of carved oracle figures that, facing the diviner, preside over the session (pls. 30, 31). Also present by sacred requirement are the two principal insignia of Sandogo membership, first, an image of *Fo*, the python-messenger, and, second, a calabash rattle with a string and white cowrie shell network (pl. 31). The client is seated in such a way that he or she faces the diviner, his or her right leg placed alongside her left and his or her right hand grasped by her right. She thereby achieves intimate psychological and physical contact with her client during the consultation. Throughout the session, spirits' responses and interpretations by the diviner-medium are emphasized by her slapping the client's hand against her knee (pl. 33).

The name for this type of divination (*tyëlë*, high tone) may possibly relate to the verb "to sift" (*tyëlë*, midtone), thus reflecting an important aspect of procedure in *tyëlë* divination. The diviner picks up in both hands, or sometimes together with one hand of the consultant, some of the pieces in the assortment of objects placed at her feet. This random "catch" is then thrown down before the set of figures lined up and facing the diviner. The *Sando*, under the influence of the *madebele* spirits that guide her client's and her right hands to this or that object, "sifts" through the objects thrown. The identity of the pieces and the way in which they fall are the code that allows the diviner to read messages from the spirit world to her client. That is, the technique of *Sando* divination is centered upon a set of signs in plastic, rather than graphic, form that only a trained diviner knowns how to interpret. These signs include the following classes of objects: (1) a number of forged-iron miniatures of certain objects important in village life, such as blacksmith tools, the cultivator's hoe, a spade such as that used in digging graves, and a knife; (2) miniature representations (in basketry, brass, iron, and wood) of divination equipment and other sacred objects, including abstract male and female pairs in forged iron, miniature *Sando* rattles, and twin cult baskets

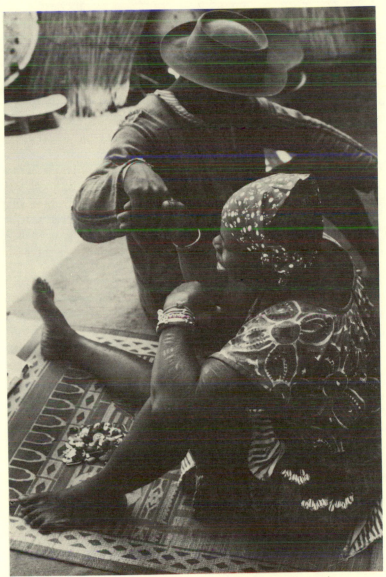

Plate 33 Sando diviner with client (June 1975).

(pl. 31); (3) abstract symbols made of fiber, metal, or wood, including a short iron bar with one end bent back that can be a sign of death; and (4) certain natural objects that have been assigned fixed symbolic meanings, such as large, glossy, red and purple seeds and marked shells. The object collection is traditionally stored in a large, lidded basket of the four-cornered type made by blacksmith women and decorated by leatherworkers (pl. 15). According to one *Sando* diviner, the "ancient words" (i.e., referring to the ritual and literary idioms as opposed to the vernacular) for the basket and its lid are "the mother" and "the child," respectively.

The objects that make up the set are always mixed in at random with a quantity of nonsignifying objects intended to camouflage the core set from the client and prevent his or her comprehension of the technique. Some of these objects are added for their purely aesthetic value. Beyond the basic set, the total number of objects is irrelevant to the technique itself. Any small object of pleasing form, color, or texture that catches the eye and imagination of the diviner may be added to the basic equipment. Diviners may tell a client that the *madebele* say to buy them a "shiny" brass thing before they will speak of the client's problems. Prestige is enhanced by the aesthetic merits of the visual setting; in some ways, artistic elaboration of equipment and "office decor" is a direct index of the diviner's skills and popularity. Thus, novices, as well as diviners with a relatively modest clientele and, one suspects, relatively limited creative imaginations and abilities, tend to have a fairly simple and basic kit, such as that seen in plate 31. In contrast, successful and clever diviners (who may serve twenty to twenty-five clients a day) may possess hundreds of bits and pieces in their repertoire (pl. 15). Diviners may add their individual contributions to the core set by assigning a fixed meaning to a certain number of new acquisitions. When the diviner makes a throw of the pieces, any one sign takes on its relationship to another sign (or other signs) among the pieces thrown. For example, if a miniature hoe falls upside down and near the marked cowrie shell that symbolizes the client's *Yirigefölö* (creator and guardian spirit), the diviner will interpret this to mean that the *Yirigefölö* is telling this person not to work in his fields (a very harsh taboo that might be reversed by subsequent throws). Similarly, the sign's falling near the python bracelet (pls. 24, 31) is interpreted as a command from *Fo*. Natural objects, such as cowrie shells, are sometimes modified to create a sign with a fixed symbolic value; for example, a small cowrie inserted within the valve cavity of a large cowrie (pl. 31, placed inside python bracelets) refers to pregnancy; this basic meaning is given varied interpretations, depending on whether the pregnancy sign

falls near certain other pieces.[30] These are but two simple examples of a fairly complex code with many permutations that must be memorized by the *Sando* trainee. Together with the many taboo restrictions on the *Sando*'s private life (i.e., diet, work activity, dress) and the necessary skills in interpreting human relationships, it is readily understandable that only a small proportion of Sandogo members become practicing diviners.

<div align="center">DISPLAY AND ORACLE FIGURES: THE MADEBELE</div>

The most pervasive theme in Senufo sculpture, ornament, and decorative arts is the bush spirits. *Madebili*, or *madeö*, meaning "little spirit" or "bush spirit" (plural, *madebele*), is itself a core term in Senufo visual arts vocabulary. Language usage of *madebele* observed in the Kufulo region suggested that the term, in addition to meaning bush spirits, has come to be a generic one for the figurative image in graphics or sculpture. That is, "*madebele*" figures are not necessarily representative of bush spirits. This distinction is important for iconographic analysis because many sculptures given the generic name "*madebele*" in fact have as their primary meaning a reference to the ancestors, the primordial couple, commemorative representations of recently deceased elders, the ideal social unit of man and wife, the twins, the idealized Poro or Sandogo initiate, the idealized champion cultivator, and so on.

As part of the core objects essential to a diviner's equipment, the figurative sculpture set up on display is equal in importance to the set of signs that are thrown for each "reading." In aesthetic terms, the figures are intended to provide the highlight and central focus of the *Sando*'s display accumulation, and their beauty of form and detail is a reflection of her prestige and powers. Only a successful diviner can afford the better sculptors. Nearly all small-scale woodcarvings, generally falling within a range of six to eight inches in height, belong to this category of *Sando* divination sculpture (pl. 34). It includes some of the finest examples of Senufo sculpture and the most delicate expressions of the woodcarvers' skills.

According to *Sando* diviners, the carved images act as a visual reference and substitute for the real but invisible *madebele*, or bush spirits. Through the mechanics of the thrown objects, the *madebele* are said to "speak," to communicate their messages from the spirit world to the diviner. "Speaking" is indeed one of the two principal purposes of the figure sculpture in the *Sando*'s own thinking; the other is visual enhancement. Because they "speak," the *madebele* sculpture can properly be called oracles. Their primary importance is their role

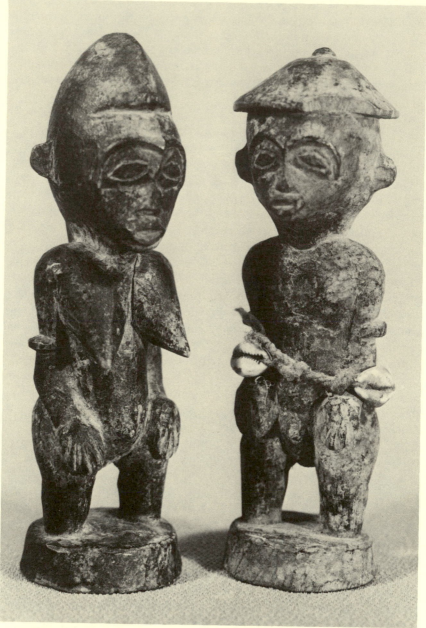

Plate 34 Female and male pair of type used as oracle figures in *Sando* divination (female, 6⅛″ high; male in warrior hat, 6″ high; private collection). (Photograph by David L. Kuntz.)

as the mouthpieces or messengers of beings in the supernatural world. Verbalization of details of the *madebele*'s invisible world constitutes a feature of the diviner's interpretation and is an important element in the traditional fictional tales (*mëhërinye*).

It should be noted that in Senufo culture there is a relationship between dreams and creativity. Sculptors and other artists would often speak of their "dreams" as the source of the idea for a particular image or design. The same phenomenon was found among the sculptors' clients, such as diviners, who sometimes commissioned work with certain specifications based on their dreams and visions.[31] One male *Sando* put the acquisition of new objects for the divination display and setting into two categories: first, personal dreams and, second, "if a new *Sando* doesn't happen to dream of a new thing," the advice through consultation with an older, more experienced diviner. Male diviners, as a rule, were their own artists in the realm of graphic arts; for example, the graphic designs painted by one male *Sando* on his consultation-chamber wall (a drawing of a *Tyo* masker) were said to have been shown to him in a dream by the bush spirits. Women's *Sando* dreams were translated into sculpture with special instructions to the carver. One diviner renowned for her powers had a vision of a one-horned beast when she went to the stream and commissioned such a beast to be carved by her favorite sculptor as an addition to her divination display.

Significantly, the *Sando*'s equipment, at a minimal level, *must* include a carved figurative male and female pair, however crudely or finely executed (pls. 23, 24). Beyond this requirement, the individual diviner of means may purchase in the market or commission from specialists a host of human and animal figurative sculpture in forged iron, cast brass, and wood. Diviners occasionally may add individual figures to act as a special oracle for a particular client, who, in that case, commissions the carving, leaves it in the care of the diviner, and offers generous sacrifices at each consultation. The standing female figure in plate 15 is an illustration of this special arrangement. This diviner's truly lavish display included even a "wife" for the more traditional equestrian *madeö* in cast brass. Typically, the female is the larger of the *madebele* pair, both seated in this case. As noted above, this sculptural convention seems to express by means of proportion the greater ideological importance of the female (see also pls. 4, 7, 22, 23). Kufulo region woodcarvers, as a whole, seem automatically to make the female larger than the male, whether working on commission or simply adding to their stockpile of marketable sculpture.

In addition to the requisite male and female couple, divination display sculpture commonly includes an equestrian figure of wood, cast

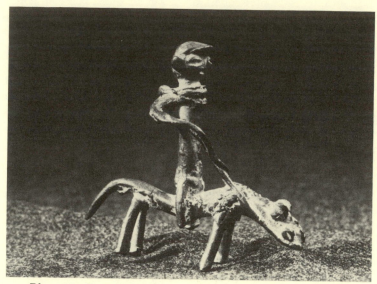

Plate 35 Brass equestrian *madeö* (4¾″ high) made for sale to *Sando* diviners.

brass, or forged iron. Equestrian "bush spirit" sculpture portrays a male mounted on a horse, frequently with a war hat and spear (pls. 35, 36). The hats, either conical or fedora shaped, represent a type of magic-imbued warrior's or hunter's hat or both, often covered with wildcat skin and leather amulets. The popular equestrian theme connotes the aggressive power and augmented mobility of the diviner's bush spirit contacts. In Senufo visual language, the equestrian motif communicates power, wealth, and status. Historically an import from the north, the horse—and the donkey as well—has no role in Senufo oral literature except as the sign of a great chief or rich man's wealth and power. Also, to the average Senufo, the horse is still associated with the aggressive incursions of the "Dyula wars" into their area during the often turbulent years of the nineteenth and twentieth centuries. Thus, to place a figure, especially an armed figure, on a horse is to express the important status and above all the aggressive and motive power of the *madeö*, or bush spirit. The *madeö* is portrayed in the image of a strong leader (*fanhafölö*, literally "power owner") and therefore a better-equipped and more prestigious messenger and oracle for its diviner-owner. As one *Sando* explained, "A rich man can buy a horse; similarly, because the *madebele* are strong, they would need a horse. Also, the *madebele* want a horse to travel about at night. Not all *Sandobele* can afford to buy a horse in wood or brass

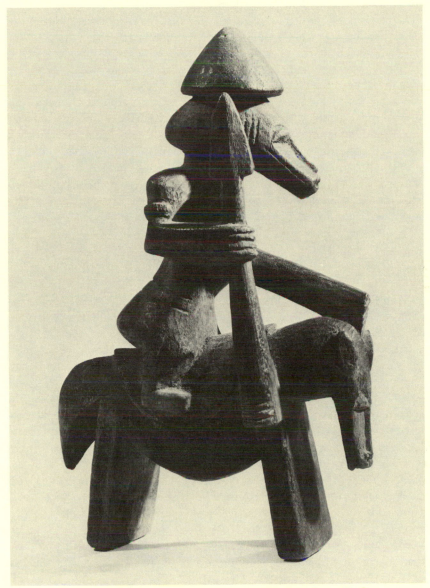

Plate 36 Equestrian figure of the type used as display sculpture by a *Sando* diviner (9¼″ high; courtesy of the Museum of African Art, Eliot Elisofon Archives, Washington, DC).

to put with the *madebele*, so the diviner will draw a design instead."[32]
The mention of nighttime is a reminder that *madebele* are dangerously
uncertain beings who, in common with witches, move about in the
hours of darkness.

The equestrian theme, understandably, has been a favorite one with
Senufo sculptors in wood and brass. In the remarkable range of varia-
tions on the theme, the artists have sometimes stressed the pride of
status and wealth with a style of finished surfaces and naturalistic
detail and sometimes have emphasized power with an expressionistic
style of abstract, aggressive, thrusting shapes (pl. 36). Significantly,
the equestrian figure, an expensive and optional element in a diviner's
kit, was described by the diviner as *tana*, the only word for "beautiful"
that carries the additional connotation of luxury art used for presti-
gious aesthetic display.

TWINS (NGÁAMBELE)

Among the various spirits that communicate through the mediation
powers of a *Sando* diviner are twins, *ngáambele*. Spirits of twins
could be considered a highly specialized subdivision of the ancestors
(*kuubele*, "the dead ones"), although living twins are given special
treatment, also. A reader generally familiar with West African cul-
tures will recognize that belief in the supernatural properties of twins
is a widespread phenomenon. Twins play an important role in the
Creation narratives of several Sudanic cultures, the Dogon apparently
having the most elaborate development of the theme, and the Senufo
are clearly part of the same broadly based tradition. The Senufo ex-
plain the tremendous significance of twins as follows: "When *Kolo-
tyolo* created the first man and woman, they became man and wife.
When the woman conceived for the first time, she gave birth to a
boy and a girl, who were twins. So it was that twins were the first
children born to man."[33] Senufo believe that twins possess a super-
natural power that can be a potential force for good or bad. Thus,
attitudes toward twins are ambivalent: twin spirits are considered dan-
gerous and yet, if properly approached, can bring about good and
desirable results.

Given the role of twins in the Senufo creation myth and the Senufo
concept of "power" as having a supernatural base, it seems reasonable
to conclude that twins are thought to possess more inherent power
because of having closer ties with the supernatural world than ordinary
people. To be good and right, however, this twinness must have the
ideal sexual balance indicated in the creation myth: *male and female*.

The birth of two girls or two boys or the death of one twin is feared
as a potential source of great misfortune, evil, and death.

The criterion of balance as an ideal quality is expressed even in the
concern for absolutely equal treatment of the twins. Jealousy on the
part of one twin (living or dead) caused by unequal treatment is a
constant danger to the health and life of the family bound by twin
ritual. For instance, food offerings placed in the twin shrine must not
be unequal in size or come from different qualities of plants or animals.
For this reason, the Senufo have developed an elaborate set of rules
of behavior toward twins and ritual precautions to be followed by the
appropriate relatives. They include the wearing of cast-brass rings,
bracelets, and amulets bearing twin motifs (pl. 26). A common sight
in a Senufo marketplace is a woman seated behind her wares with a
small lidded basket (about four inches in diameter) placed incon-
spicuously at the side. Inside each basket is a set of two or four tiny
baskets (about one inch in diameter), joined as twins, each just large
enough to hold a single cowrie shell (pls. 15, 31). Twin spirits are
thought to be especially effective in helping mothers of twins or
women relatives in the close maternal family (such as a sister) to
have a successful market day. Conversely, failure to take the twin
baskets to market "will make the twins angry." Most diviners include
as part of their basic equipment the small twinned baskets or cast-
brass replicas to "speak for the twin spirits" to the appropriate clients.[34]
Sando diviners will blame any misfortune that befalls the family on
the failure to meet one or more of these ritual requirements, and con-
sequently the birth of twins is not a welcome event.

To the student of aesthetic forms and behavior in human society,
the interesting point about the twin tradition is that it provides yet
another example of how Senufo culture brings beauty into difficult
circumstances as a positive and ameliorating force. The aesthetic
quality of a brass twin bracelet, for example, goes far toward pleasing
the twins concerned and warding off further malevolent acts.

There is some evidence that the relationship of the twinship and
Ancient Mother concepts is visually articulated in the carved linear
design that ornaments the female navel (see on female figures, pl.
37).[35] By the age of puberty, every young girl has permanently cut
on her abdomen a scarification pattern that is at once a synthesis of
the creation myth and a promise of her future role as wife and mother
in the matrilineage. Called *kunoodyäädya* ("navel of mother," "woman
of twins," or "female twin"), this highly abstract design is one of
the two most important scarification motifs in Senufo personal art.
Long familiar to students and collectors of Senufo sculpture, the
basic design is a configuration of four sets of three (or four) lines

grouped into fan-shaped units that radiate from the navel in a com-
position of two intersecting pairs, or "twins" (pl. 37). One pair has
an exact parallel in the three lines that fan out from the corner of
each side of the mouth; this is an elemental motif carved on every
child, male and female ("face scars," *yegi kabaara*, a generic descrip-
tion). In the nonverbal language of body decoration, the pair orna-
menting the mouth establishes ethnicity, proclaiming "I am a Senufo
person" and, one may speculate, "child of the original twins." The
choice of placement is significant in itself: one major educational aim
of the Poro society is to teach control of self, and Poro "sayings" indi-
cate that control of the mouth is necessary to self-control, a quality
found in the ideal Senufo man and woman. This quality of inner con-
trol and reserve is expressed above all in the large-scale figures that
commemorate the first couple (pls. 5–7). When the same design units
that identify one as a Senufo form part of the navel design, they are
called *njäadya piipele täari*, which translates roughly as "female twin,
three little marks." The crossing of the two pairs with the navel as
the center point creates the completed navel design. Philosophy re-
duced to a few abstract lines, this design is a celebration of the Senufo
woman as matrix of life, guardian of matrilineal and village continuity.
Implicit in the design is the balanced interaction of two twinned parts,
reminiscent of the first man and woman (or the twins, their children).
The projecting, peglike navel, remnant of the umbilical cord linked to
one's mother, is a constant reminder of the ancestral mothers reaching
back to the Ancient Mother. Among Senufo young people, a short,
convex navel (i.e., slightly herniated) is a much appreciated aesthetic
criterion of both male and female physical beauty, as is reflected again
clearly in Senufo sculptural idealizations of the human form. As the
navel is the nucleus of the body design, so the *nërëjaö* (head of the
matrilineage) is the center axis of family organization, and so *Katye-
lëëö*, Ancient Mother, is the ideological axis of the sacred forest so-
ciety and village order.

YAWIIGE ORNAMENTS

Apart from a few purely decorative ornaments of beads and cowrie
shells and a charming group of bangles and bells (*bwö-bwö*) for
children of prestige-minded parents, the vast majority of traditional
ornaments worn by the Senufo is in fact a vital component of the
Sando divination complex. Although an appreciation of aesthetic
beauty and the need to express personal pride are both important
factors in the development of this category of Senufo art, the intrinsic

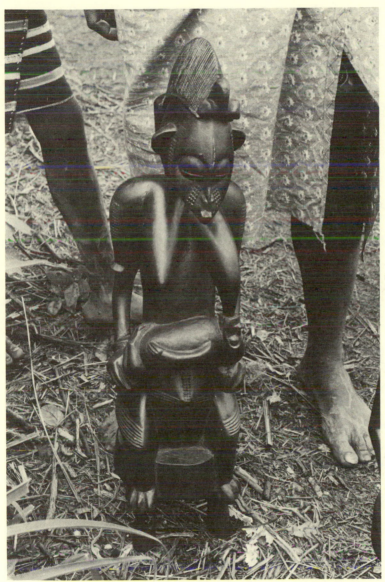

Plate 37 *Tyekpa* figure of nursing mother with navel motif. Carving is in the style of Korhogo area Kule sculptors (funeral of a "mother" of *Tyekpa*, July 1970).

meaning of *Sando*-related ornament is essentially a religious one. As is true of other periods and styles, the religious art of *Sando* divination can be good, bad, or indifferent in aesthetic quality. The evidence suggests that both the Senufo diviner and client consider that the degree of expert craftsmanship and artistic merit appreciably enhances the power of the ornament to fulfill its religious function. Created by the lost wax method, a remarkable number of these castings exhibit not only skilled craftsmanship but also a fine sensitivity on the part of the artist to such elements of design as balance, proportion, and texture, sometimes on an extremely small scale (pls. 24–27).

All of the *Sando*-related ornaments fall under the Senufo classification of *yawiige*, literally, "thing worn as protective medicine or charm." The verb provides the key to the meaning of the word, in this case *wii*—"to wear a magic thing, a protective charm"; *ya* is a prefix meaning "thing." *Yawiige* is at one level a Senufo category of material objects worn as protective and propitiatory devices and prescribed for a particular person's situation by a *Sando* diviner. The word *yawiige* may also be used to refer to the *condition* requiring the material charm, as "something you have." Information from *Sando* clientele indicates that, in general, the condition is some imbalance in the relationship between a person and a particular spirit that is causing problems for the person. On consulting a *Sando* diviner, the person will be told that he or she has a *yawiige*. The material charm is a descriptive reference to the specific nature and identity of that person's *yawiige*.

Along with the male-and-female-couple theme discussed under "*madebele*" sculpture, two other principal figurative themes in Sandogo iconography are *Fo* the python and *Gberi* the chameleon, two of the first beings created in primordial times, according to Senufo creation myths.[36] The most common motif of *yawiige* rings worn by men is the chameleon. This animal is associated with supernatural powers of transformation, sorcery, and primal knowledge. One oral tradition describes the chameleon as the equestrian mount used by the bush spirits to convey messages to Deity. In wood, cast brass, or, more recently, lower-grade scrap metals (see standing chameleon figure in front of equestrian figure in plate 15), the chameleon is a frequent component of *Sando* display sculpture. It is also a favorite graphic motif on the wall paintings sometimes found decorating the diviner's consulting room.

The python motif is ubiquitous in Senufo imagery and the python icon considered the "first" in *Sando* equipment. All *Sando* diviner informants stressed the priority of meaning given to *Fo* and designated *Fo* as the first emblem to be purchased by a new diviner. Cast-brass

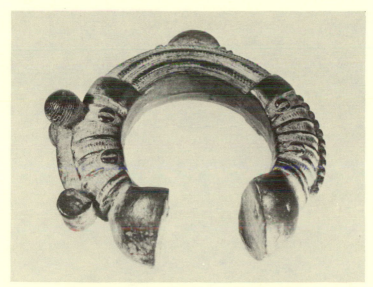

Plate 38 Large, cast-brass bracelet of *Fo* the python, of the elaborate type generally used as a divination prop rather than actually worn as a bracelet. The eyes are handled in the same manner as small brass bells; this is an appropriate stylization for a bracelet used as a signal device to attract the attention of the bush spirits (4¼″ wide; private collection). (Photograph by David L. Kuntz.)

bracelets in the form of a python are the principal insignia of diviners as well as a redemptive charm (*yawiige*) worn as expiation for broken taboos by large numbers of clients (pls. 24, 31). Large and highly sculptural examples of *Fo* bracelets (pls. 24, 38) are rarely worn as bracelets but function rather as "props"—display ornament for diviners' shrines. Such bracelets are also used as signal devices to attract the attention of Deity and the lesser spirits. A diviner, for example, will place the python bracelet at the side of the earthen altar (*Nyĕhënë*) to the creator god (Glaze 1978). The design convention of the python bracelet includes a configuration of three highly stylized motifs representing the eyes, the lungs (or male sex organ), and the heart (Glaze 1978). Each of the parts is considered a life sign and life-support organ by the Senufo (to them it is the liver, not the heart, that is the seat of emotions and affection). One is tempted to see in the origins of this highly stylized design motif a visual summary expressing the widely held philosophy that keeping in touch with the

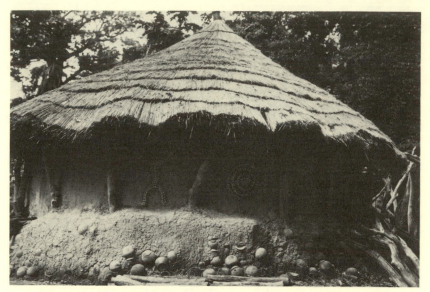

Plate 39 Storage house in a Kufulo *sinzanga* with bas-relief sculpture. Mud-molded designs include the bush spirit motif, *madeö*, the python, *Fo*, and the crocodile, *wotyon* (July 1969).

spirit world through *Sando* divination is the only safe route to health, vitality, and life itself. The python is thus a metaphor for *Sando* divination, the life-sustaining communication channel with spirits.

Sando round houses (*sandokpaagi*), as well as various Poro-related architecture, are frequently adorned with exterior or interior painted bas-relief moldings of *Fo*, often designed as a complete encircling of the space (pl. 39). *Fo*, chief messenger of the spirits, is noted for his powers of transformation into human form. Children who die in infancy are said to have been *Fo* in disguise (i.e., never really human). One of the tales (*mëhërinye*) concerning Sandogo describes how *Fo* transformed himself into a handsome young man who nearly succeeded in tricking a young woman into a disastrous marriage (Glaze 1976: 283–7). The wisdom of an elder woman prevented this, thereby protecting the purity of the girl's matrilineage. The tale thus refers to an association of *Fo* with sexual symbolism, male-female relationships, and the protective role of Sandogo.

Extremely small brass charms are worn by children, who, as adults, will keep them in their *yirigefölö* altar. Animals appear as cast-brass miniatures, each having a small loop for attaching it with a string to a child's ankle or waist or as high relief on the arc of the standard cast-brass bracelets (pls. 27, 29). Among the animals depicted are the tortoise, chicken, water lizard, small crocodile, mudfish, goat, and

rabbit. Another charm, depicting the *serenge*, an unidentified, many-legged insect, is worn only by *Sando* diviners. The list is in fact open ended for the reason that the Senufo believe that a spirit can take on the form of any animal. If sickness comes, the *Sando* may reveal that her client, sometime in the past, killed a certain animal that was in reality a *nikanhaö*, a *madeö* changed into another form.[87] Stockpiling their work for sale in the market, the brasscasters make up dozens of different forms, some of which are iconographic conventions recognized by everyone (such as the tortoise seen in plate 27) and some of which are generalized forms (such as a quadruped) that will be taken to represent different animals by different clients.

YAWIIGE-RELATED MASQUERADES

In general, Senufo masquerades come entirely within the province of the Poro society and are direct expressions of ethnic identity, age grades, and functions of each organization in its performances at initiations and funerals. In the Kufulo region there existed three masquerade types that were exceptions to this general rule: *Fila*, *Kotopitya*, and women's *Nafiri*.[38] Although all three were worn by males and one, *Kotopitya*, always appeared in the context of the Pondo society's *Koto* masquerade performance, the primary connection in all three cases is with the sphere of women, *Sando* diviners, and the bush spirits.

Fila is a textile masquerade worn by a child in the context of funerals (pl. 40; see Appendix, IV-A, for details).

Kotopitya is a masquerade worn by Fodonon initiates as an accompaniment to *Koto* masquerade performances at funerals (pl. 41; Appendix, V-B). In terms of Senufo masquerade classification and typology, it is especially important to note that the carved wooden face mask component, according to Fodonon informants, is in itself indistinguishable from face masks used in the blacksmiths' *Kodoli-yëhë* masquerade (pl. 42). Indeed, the one example of the *Kotopitya* face mask documented was identical in type and iconography to that illustrated in plate 69, including the center crest motif of the female head. In other words, the identifying factors were costume and context; this principle of classification will be dealt with in greater detail in Chapter 3.

Fodonon informants insisted that the women's *Nafiri* masquerade is exactly the same as the men's *Nafiri* of the Pondo society (e.g., carries a whip, features a knit suit, appears at funerals), except for two points of contrast: (1) style: the women's *Nafiri* is reported to have

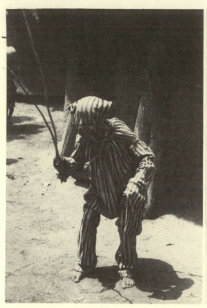

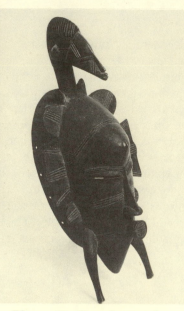

Plate 40 *Fila* masquerade worn by boy for his mother as a *Sando* charm for the *madebele* at a funeral for a blacksmith woman elder (25 February 1970).

Plate 41 Carved wooden face mask component of a *Kotopitya* masquerade ensemble. Previously owned by a Fodonon woman. Sculptor: Wobehe Soro (deceased), a Kule of Sumo (private collection, 1970).

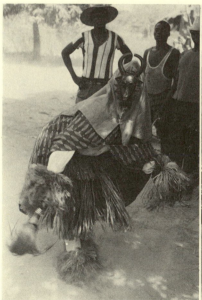

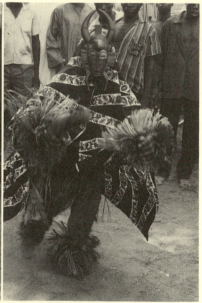

Plate 42 *Kodöli-yëhë* masquerade of the Junior Grade blacksmith Poro performing at a second burial celebration (February 1970).

Plate 43 *Kodöli-yëhë* masquerade of blacksmith Junior Grade. Center crest represents *blama wuro* from the Kapok tree, same motif as in Fodonon *Poyoro* face mask in plate 44 (color) (February 1970).

a bizarre effect because of its having many bright colors and its more stylized motion pattern, "a special unnatural way of walking" as compared to the men's *Nafiri*, which moves along with manly, rapid strides; and (2) context: the women's *Nafiri* is owned not by the Poro but by a particular woman and her family. Commissioned by a woman in response to a diviner's prescription, it is directly linked to the Sandogo institution and bush spirits. In addition to its appearance at funerals, it goes annually to the field to sacrifice to the bush spirits (not included in the Appendix).

According to my Fodonon informants, the bush spirits that "seized" a woman in the fields and made her dream are then said to be "represented in the village by the *Nafiri* masquerade," which will walk about the woman's house during funerals. Once a year, the woman's family will go with the *Nafiri* masquerade to the field where she was seized in order to worship and make sacrifices to the bush spirits there. The masquerade itself is made by the woman's son or other male relatives, who, as Pondo society initiates, learned the art of knitting the *Nafiri* suit. The many-colored women's *Nafiri* masquerade was considered very beautiful by Fodonon informants. A West African parallel that immediately comes to mind is the Yoruba *Gelede* cult, whose masquerades are said to honor and please the witches by aesthetic means, including the arts of sculpture, dress, and dance (Thompson 1975:200).

If, in the course of time, the original owner's family allows the *Nafiri* to fall into disrepair and drops the tradition and then troubles begin to plague the family, *Sando* diviners will tell the female descendant that a new *Nafiri* must be made in order to placate the bush spirits. The circumstances that initiate the women's *Nafiri* masking tradition within a particular family can always be reduced to the following series of events: malevolent action by bush spirits, resulting in troubles or dreams, which in turn lead to the victim's consulting with a number of *Sando* diviners. To be certain, the women will consult perhaps as many as four or five *Sando* in different villages.

NYAMËËNË: THE WOMEN'S MOURNING SONGS

There are several additional channels outside Sandogo and Poro wherein Senufo women exercise a tremendous influence in the area of social control. Since the funeral, as a context for the arts, is of particular interest to this analysis, it will be useful to examine briefly a peculiarly female institution centered on a type of funeral song

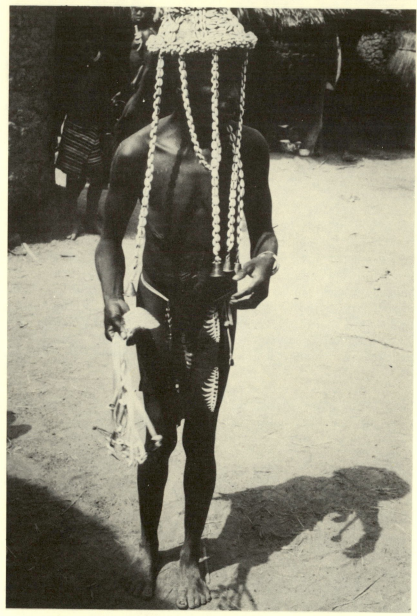

Plate 45 A blacksmith woman singing *nyamëënë* com-
memorative song at funeral for her mother, an important
woman elder and a member of the Poro society (*tyotya*)
and Sandogo. The dance ornament carried by the daugh-
ter refers to her mother's skill in the traditional black-
smith woman's craft, matmaking (February 1970).

known as "*nyamëënë*," literally, "the cord of weeping," a true account that threads together the significant events and relationships in the story of a person's life and death.[39] Apart from the central role of Sandogo, *nyamëënë* songs reinforce the special role of women as interpreters of the supernatural world and commentators on group relationships (pl. 45). If there have been any problems or tensions between the dead person's family and another, they will be publicly aired in the course of the song. If someone in the village has failed to pay outstanding debts to the immediate family concerned, he or she will be named. If the death is suspected to be caused by witchcraft or by having angered the ancestors of the matrilineage and its Sandogo, suspected individuals will be accused publicly as murderers. If a friend has donated generously to pay for the funeral costs even though not strictly obligated to do so, he or she will be praised. Family and interfamily bonds are publicly recognized and acclaimed through this funeral-song medium. For example, a woman's husband is not a true relative of her family in Senufo reckoning and has no obligation if, say, her mother dies. If he contributes generously to his mother-in-law's funeral, the *nyamëënë* singer will praise the husband in song.

The style of *nyamëënë* singing is in itself like a cord: some major themes strung together with intervals of greetings, audience response, and coloratura ornamentation. Thus, the allusion here is twofold: the cord refers to both the chain of events in a person's life and what may be called a stylistic element. *Nyamëënë* singers, who appear in pairs or as solo performers, carry on frequent exchanges in song with the members of each courtyard visited on their circuit through the village (pl. 45). In most instances the central theme is essentially a positive and intercessory one, with the *nyamëënë* vocalists praying to the person who has just died if the latter is an elder of some importance with potential influence in the ancestral world. A case in point was the song for the wife of the village rainmaker, whose death had occurred one year before his wife's. Excerpts from the two women's song and a sample of audience response (also sung) are given below as an illustration of *nyamëënë* themes and song phrases:

First vocalist:	There must be right conditions for a good funeral.
Second vocalist:	Let the rain fall, God, like a torrent from the sky.
Woman in audience:	That will make the burial difficult [*i.e., because of the deceased wife's status as wife of a rainmaker, let the rain fall as a good sign, but don't forget the consequences*].

Duet repeat: Let the rain fall from God's side in the heavens
 Even though it will make burial difficult;
 Even though it will make the burial unpleasant
 for us.
First vocalist: Friendship between families is a very beautiful
 thing.
 Friendship with the Sekongo [*kin group*] is
 something very good.
Woman in audience: Greetings at your work—we agree.
Second vocalist: Pehe [*deceased's youngest son*] is fulfilling his
 obligations, we hear [*mention of son also meant
 as a reminder that the couple has accomplished
 something before leaving—the woman has left
 children*].
Duet: Even though Yefingyenge's husband [*the rain-
 maker*] is in the country of the ancestors, he
 has understood the petition.
 Let the rain fall and may the rainmaker and his
 wife be our interpreters with God in the
 heavens.[40]

Although the institution of *nyamëënë* belongs more to the domain
of the verbal and musical arts, the decorative hat traditionally worn
by the vocalist is an excellent example of the multiple-artist pattern
characteristic of aesthetic productions in Senufo and many other West
African cultures. The *danga* hat is an expensive investment that be-
comes a carefully preserved possession of any lineage group. The art
of *nyamëënë* singing itself is considered an "inheritance," learned from
one's mother and passed on as a legacy from the "ancestors." The
woman who commissions a *danga* hat must herself provide the cowrie
shells and other key ornaments that are given to the craftsman who
will assemble the final product. In this area in 1969 the fad was small,
round mirrors that caught the light and flashed with the motion of
the dance.

The hat maker is not necessarily of an artisan group but is more
likely to be a farmer. In turn he must obtain, at the local market from
a blacksmith woman, the basket (*danga*) that will form the base of the
assemblage. This particular type of basket, with a four-cornered base,
is an ancient craft heritage for the women of the Fono blacksmith
group. Similarly, the specialist in assemblage must go to either a local
brasscaster or an itinerant one at a local market to commission or buy
the brass bell ornaments that terminate the four long cowrie shell
strands. Finally, the hat as an object is not the completed work of art

but rather one important component of a creative form that must occur in time as well as space. Total aesthetic fulfillment comes only when the vocalist wearing the hat sways to the rhythm of her song and when the long cowrie strands that are a fluid extension of the four corners swing in response to the movement of her hips. In plate 45 a *nyaměěně* singer from the blacksmith group holds in addition a miniature mat (another ancient craft of this group) that also terminates in long strands with cowries at the tip; it is a highly effective dance ornament in terms of reinforcing body movements with the visual accents of fluid lines in space (pl. 45).

TYEKPA: THE FODONON WOMEN'S "PORO" SOCIETY

A second important women's organization is *Tyekpa* (literally "women's Poro" in Fodonon ritual language), a secret society found today only among the Fodonon people. However, local Fodonon women informed me that just two generations ago area women of the now-Islamized Tyeli groups also had *Tyekpa* societies. Until the recent decline of the Tyeli women's Poro, Fodonon and Tyeli women of the Kufulo Region "used each others' songs when they did funerals together," and current *Tyekpa* songs still include words of Tyeli origin. In short, *Tyekpa* is but one of several culture features shared by both the Fodonon and Tyeli ethnic groups that historically set them apart from Central Senari culture. A brief mention of the Fodonon women's *Tyekpa* society will serve as a final example of art and the women's sphere in Senufo culture.

Tyekpa in no way parallels the Sandogo divination society, a universal Senufo socioreligious institution that complements and is integrated with the functions of the men's Poro society in a pattern characteristic of all Senufo groups, including the Fodonon. Rather, *Tyekpa*, in effect, appears to be a declaration of independence on the part of Fodonon women. Essentially a funerary society for honoring the dead, *Tyekpa* is a counterpart to the men's Pondo society in Fodonon culture, providing women with comparable opportunities for visible social and ceremonial expression.

In common with oral traditions explaining the origin of Pondo, the first *Tyekpa* society belonged to the bush spirits. According to the narrative, an elder woman discovered the bush spirits drumming and dancing by a stream; she exclaimed at the beauty of the dance and was then told she could take for herself the bush spirits' *Tyekpa*. In the

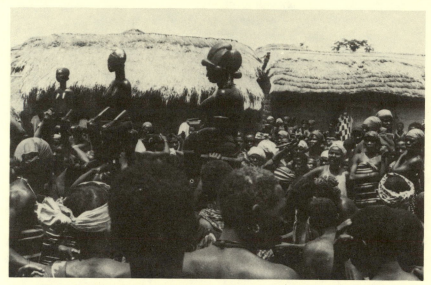

Plate 46 Members of three *Tyekpa* societies join for the commemorative funeral of a *Tyekpa* member (July 1969).

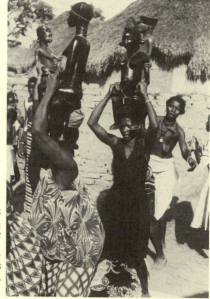

Plate 47 Senior initiates of the *Tyekpa* society take turns dancing over the body with *pombibele* sculpture (each of which has a secret personal name) during funeral rites for an elder member (January 1970).

woman's village, *Sando* diviners confirmed that the bush spirits required the women to continue the *Tyekpa* complex of drums, dances, songs, and sculpture in order to prosper (Glaze 1976:283).

Tyekpa presents deliberate and striking parallels with the men's Pondo society. As is the case for Pondo masquerades, funeral dance and ritual provide the motion context for *Tyekpa* society sculpture. However, in place of masks, the *Tyekpa* members dance with figure sculpture balanced on their heads (pl. 46). Unlike the small-scale sculpture employed in the private, screened chambers of *Sando* diviners, *Tyekpa* figure sculpture is large, reflecting its purpose as spectacular public display art. In this it parallels the dramatic masquerades of the Pondo society. Just as it is taboo for women to touch or view certain masks and drums of the men's society, so the men are warned that they face certain death by coming near or, in certain circumstances, even viewing the sacred sculpture of *Tyekpa*. Finally, direct parallels between *Tyekpa* and Pondo include the use of specific gestures and movement patterns in *Tyekpa* funeral ritual that exactly mirror the patterns of the men's masquerade performances. Even the "parturition" stance that the Pondo helmet masquerade (*Gbön*) assumes over the body of an elder member, symbolically marking the beginning of new life as "spirit," is used in *Tyekpa* ritual (pl. 47). And, as with Pondo society practices, the most secret and powerful *Tyekpa* objects are less visible, their significance camouflaged to all but initiates, than the more aesthetically exciting appearance of the large figure sculpture.

The intimate relationship of sculpture and dance in African art is generally associated exclusively with the category of masks, yet this is by no means always the case. *Tyekpa* funeral ritual is a marvelous example of how figure sculpture is given a mysterious vitality in a multimedia theater of music, dance, and song. Raised above the heads of the members, the figures progress in a dignified manner, their movements large and measured; at intervals and in response to musical change, their restrained energy is released in counterpoint motions of rapid, rhythmic twists. The dance is centered around long, elegantly carved, three-legged drums played by women musicians whose artistry rivals the men's (pl. 48 [color]). The drums are often lavishly decorated with images related to the bush spirits and carved in bas-relief on the sides of the drums (pl. 49).

As a final commentary, I would like to note that *Tyekpa* traditions reinforce the triangular women–bush spirits–figure sculpture relationship, as seen also in reference to Sandogo. In other words, *Tyekpa* sculpture demonstrates what is proposed here to be a fundamental typological division in Senufo art: figure sculpture belongs primarily

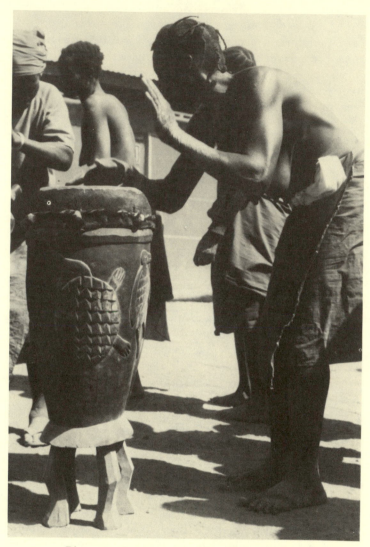

Plate 49 Tortoise in bas-relief on *Tyekpa*
society drum, executed in a lively style
that participates in the women's dance
movements (April 1979).

to the women's sphere and masquerades primarily to the men's. The
division could therefore be said to support visually the sharply dif-
ferentiated roles of male and female in Senufo society. The exceptions
to this division are comprehensible for the most part in terms of their
symbolizing points of interaction between the two spheres.

CHAPTER 3

Art and the Men's Sphere

INTRODUCTION

If a primary function of the women's divination society in the community is to prevent death and sustain life through ritual communication with the spirits, then a complementary purpose of the men's initiation societies is to regulate and enrich the quality of that life. In the traditional Senufo community, the men's Poro societies constitute collectively a male power structure exercising extensive social, political, and economic controls. As an initiation society, Poro is concerned with the moral and intellectual formation of the young, male and female, but with an emphasis on preparing village males for responsible and able leadership. As a funerary society, Poro is concerned with both honoring the dead, the men and women elders who have contributed to the life of the community, and ensuring through ritual a continuity between the living and the ancestral dead. The role of the arts in each of these two broad spheres of Poro activities will be explored in this and the following chapter. In the contexts of both the initiation and funeral rites of passage, the dual themes of spiritual regeneration and community are given aesthetic expression.

In its complexity of structure and function, in its density as a traditional reservoir of Senufo thought, and in its richness of associated forms, Poro has an importance in Senufo culture comparable to the relatively well documented institutions of *Ifa* among the Yoruba and the *Bwami* society among the Lega. For the purposes of this study, the discussion of Poro will be restricted largely to the two themes described above—initiation and funeral contexts for the arts. The chapter concludes with a discussion of selected Poro society masquerades. This section explores how masquerade style and type function as visual codes corresponding to patterns of ethnic continuity

and age-grade change and, when engaged in community events of
initiation or funeral, are visual signs of ethnic and age-group inter-
action.

Generally speaking, Poro may be termed both a "secret society" and
a "men's society" with certain qualifications.[1] First, the Senufo Poro
is literally a secret society, for it is protected by a host of secrets,
which multiply as the initiate rises in a graded hierarchy of ascending
knowledge and authority. However, the secret society is universal in
the sense that all members of the community are expected to partici-
pate in its initiation cycle and membership obligations. Because of this
universality, it must be distinguished clearly from voluntary associa-
tions, such as the *Nökariga* healers' society among the Senufo or the
Masonic Lodge among Americans. Second, as noted above, it is no
more strictly accurate to term the Poro a "men's society" than it is to
term the Sandogo a "women's society": the internal structures of both
organizations involve the dynamic interaction of male and female
sectors of the community. It would be closer to Senufo thinking to
translate Poro as a "village society," a designation that has the advan-
tage of not excluding women. Girls and women participate to some
degree in most of the important levels of the initiation cycle. Yet,
Poro *is* the men's sphere in that men have the far more active role in
its affairs.

Briefly, the involvement of the female counterparts of the male age
sets is particularly important during the advancement and graduation
ceremonies of *Kwörö*, *Segbo*, and *Görö* (see the résumés of the Poro
cycle at the end of this chapter). That is, the pattern of the inclusion
of female sets is in part an emphasis on those points of advancement
that mark the completion of critical segments of the initiation cycle.
Among Kufulo and Fono groups, for example, *Kwörö* is the culmina-
tion of the most important phase of the Junior Grade training cycle,
and *Segbo* marks the completion of the most demanding phase of the
Senior Grade cycle. Similarly, *Görö*, a series of joyous public dance
festivals during the dry season following *Kafwö*, celebrates the final
graduation from Poro. Once the young women who have danced as
beautiful maidens at *Görö* marry, they are excluded from all Poro
activities during their childbearing years, protected from blood sacri-
fice and exposure to powerful masquerades. When they reach meno-
pause, women elders become eligible for initiation into the secret
affairs of Poro and the category of secrets revealed to the men during
Tyologo, the Senior Grade of Poro. Thus, the *Tyotya*, older women
initiates at the *Tyologo* level of knowledge, are actively reengaged in
Poro activities.

THE ORIGIN OF PORO: A MYTHIC EXPLANATION OF MALE-FEMALE ROLES

The Poro society and especially Poro masks and drums figure largely in the process of male-female role orientation in Senufo culture. The basic myth explaining the origin of Poro combines the hunter culture hero theme with the bush spirits and *Sando* divination theme. According to this dramatic account, the hunter is able to steal the drums and masquerades of Poro from the bush spirits and brings these objects of aesthetic power into the village to institute the first Poro society. Senufo male elders in Poro have said that "Poro is a woman," referring to the central paradox of the Poro society, its origin and its power. As explained by one elder wise in Poro lore, the crux of the paradox is this: first, if it were not for the woman who brought the hunter into the world, there would have been no discovery of Poro in the bush, and if the hunter had not been able to consult with a *Sando* diviner (who was always a woman in those days) after he brought the bush spirits' Poro into the village, the bush spirits would have killed him! Thus, even though it is the men who now have control in the Poro society, there would be no boys born to fill the initiate classes and no diviners to intercede on their behalf with the bush spirits if it were not for the women.[2]

The discrepancy between the ideological and the sociopolitical importance of women in Poro affairs is given mythic justification in a second version of the origin of Poro. The following account of the origin of the Fodonon men's Poro society (Pondo) relates how the women were the first to enjoy the things of Poro and how they eventually lost this privilege to the men. *Poro*, as used in this narrative, refers to not only the secret society as a whole but especially its sacred paraphernalia, such as drums, masquerades, and figure sculpture; this usage is common practice in Senufo conversational idiom.

The Origin of Poro

In the beginning, Poro was with the women. If you hear "*Malëëö*" or "*Katyelëëö*" ["Ancient Mother"], this is to remind us that the first Poro belonged to the women and was not with the men. The men prepared food and pounded yam. When the men finished preparing the meals of pounded yam, the women would come out of the sacred forest of Poro to take the food. But the men were forbidden to see the secret things of Poro. If the women came out dressed in Poro, the men had to hide, leaving the dishes of food outside the house. The men were *too* tired and thin! They had to hide while the wom-

en ate. Then *Kolotyölöö* [the creator god] said, "No, I cannot leave Poro with the women—they are too wicked and sinful." So he seized the Poro and gave it to the men.[3]

Ironically, the position is now reversed, and it is the women who must leave food for the male initiates and hide from the masqueraders. A major theme that emerges clearly in the narrative is tension between male and female roles, and this conflict requires supernatural intervention. As expressed in the creation theme of the primordial couple and the twins, issue of the first procreation, the philosophic ideal is a balance of male and female roles in Senufo society. The ideal balance is a precarious one, however, and the text relating the origin of the Fodonon Pondo reveals that the real situation can become distorted through human weaknesses and abuses of power. So it came about that in ancient times Senufo women lost certain privileges and aesthetic pleasures of Poro because of their "wickedness."[4]

There are two quite separate aspects of this myth. First, the indictment of "wickedness" leveled against the women could be said to reflect the essentially male bias of the narrative and perhaps functions as a rationale for the dominant male role in Poro; this major sex-role differentiation validates male social and political controls. Second, the teaching that power may be used for good or evil is a constant theme in Senufo oral literature. Those who break the laws of Ancient Mother and the ancestors and those who appropriate supernatural power for antisocial purposes—the witches—are an ever-present threat to the equilibrium of self, family, and village.

The largely male leadership in Poro is responsible for ensuring the stability and continuity of village social and political order, just as the largely female leadership of Sandogo is responsible for ensuring kin group order and continuity. Leadership of both institutions working in dynamic harmony is responsible for the continuous interaction with the supernatural universe that is essential to Senufo village security and prosperity. Whereas the *Sando* diviners are concerned with the relations of human and spirit at the level of everyday living and individual confrontation (especially with the bush spirits), the Poro society is concerned more particularly with the relation of the lineage segments and village as a whole with the cumulative body of past leaders of the group, with the ancestors, and, through the intercession of the dead leaders, with Deity. As mentioned above, the Poro *sinzanga*, or sacred forest sanctuary, is conceived as the home, or *katiolo*, of *Katyelëëö*, the protective and nourishing Ancient Mother deity. The *sinzanga* is primarily the focus of the sanctioned authority of village male leadership, who, for the welfare of the community, must

make frequent blood sacrifices to the past children of Ancient
Mother—that is, the ancestors—to intercede on behalf of her living
children and those yet to be born. Structured as an unbroken con-
tinuum, Deity's laws and systems of knowledge, held in trust by the
elders, keep sharply defined the demarcations between order and
chaos, civilization and the untamed, village and bush.

THE PATH OF PORO:
EDUCATION AND STRUCTURED AUTHORITY

Grounded upon essentially religious premises, the Poro initiation
cycle, above all, is a process of socialization and education. It is an
intricate system of tutelage and controls designed to tame and civilize,
to inculcate values and standards of behavior in each generation that
will ensure that the boundaries between village and bush do not break
down, and to pass on the knowledge and skills that are an "inheritance"
from the ancestors.

One of the most important precepts taught in Poro is giving respect
and obedience to one's elders. One Poro elder in Pundya stressed this
purpose of the initiation system: "The only path that has priority over
the path of the Senambele [i.e., being a Senufo farmer] is that of
Poro. Our children—whether they are attentive to their elders or
whether they are not—it lies in Poro [i.e., it will be because of Poro].
If a young Senufo does not will to step on the path of Poro, he will
listen to none of the elders. We are sure of that."[5]

The process of growth from what the Senufo term "a child of
Poro" to a "finished man of Poro" who can take his (or her) place
as an adult member of the community is structured according to an
initiation cycle of successive age grades, each lasting approximately
six and one-half years (see résumés 1–3 at the end of this chapter).
Advancement is celebrated periodically with a series of graduation
ceremonies. Age sets are formed at successive intervals, and members
of the same age set will retain close bonds for the rest of their lives.
Each set progresses through a series of fixed grades, distinct stages of
training and status in the Poro system. Each generation has a fixed
pattern of upward mobility in village society in terms of these grades
of Poro. The leaders of the age sets chosen in the course of the initia-
tion cycle are generally the ones who, as elders, along with their
female counterparts, will provide the political and intellectual leader-
ship of the village. The Poro system ensures cohesion among residen-
tial and lineage units of the village, with the Poro society leadership

forming a council of elders that cuts horizontally across *katiolo* and *nërëgë* social organization. Finally, the age-grade system of Poro traditionally ensured that village males, from childhood to as late as the midthirties, remained firmly under the control of the elders; that was a contributing factor to political and economic stability in the community.

The system is such that each age set, except for the youngest class, always has the dual role of learner and teacher. Systematically, as each class moves through the grades, its members become the instructors and disciplinarians of the lower grade ("younger brothers"), scheduled to take their places. In addition to his "older brother" in the next higher grade, each initiate has a "tutor" in a still higher grade or among Poro graduates. "*N'taö*" is the honorific title in Poro language for a high-ranking elder acting as tutor. The tutor serves as the initiate's counselor, teacher, and protector. He explains the intricacies of Poro secret idiom to his pupil and helps prepare him for the grueling examination sessions held in the *sinzanga* at regular intervals.

Apart from his educational role, the tutor acts as intercessor on his pupil's behalf if there is trouble between the initiate and the next older age set. The tutor's role as mediator and advisor provides a check upon the faults or excesses of the "older brother" class. An excellent example of this safety valve in operation was observed during a *ponzoho* ceremony in a Fodonon *sinzanga*. One of many obligatory fees, *ponzoho*, meaning "Pondo food preparation," is a costly payment that each initiate must organize and present to the Pondo society. The food is distributed among elder members of that *sinzanga*, and free portions are given to leaders of other Poro organizations in the village. On one occasion, three Lower Grade Fodonon initiates were presenting their share of the food fees required of this class. For hours the supervising "older brother" class (Middle Grade) had rejected the presentation as inadequate in quality but eventually was persuaded to accept the food when the three initiates concerned made formal appeal to their tutors in the Upper Grade.

An abbreviated discussion of two stages of the Fodonon Pondo initiation cycle will serve to illustrate two of many contexts in which an older age grade has teaching responsibilities toward a younger one. The first example is drawn from activities of the Fodonon Middle Grade and the second from the *Tiga* preparatory school. The Fodonon Middle Grade involves young men of approximately twenty to twenty-eight years of age, by which time Kufulo age mates would be in *Tyologo*, or Senior Grade.

In general, the Fodonon consider the Middle Grade to be a "rest

period" in comparison with the demands made upon the Lower and Upper grades. It is during funerals that the brunt of their teaching duties comes. The Middle Graders have the serious responsibility of teaching the *pombibele*, or "freshmen," by example and guidance, the various skills needed for a proper commemorative funeral. Rigid restrictions on when the sacred musical instruments can be played mean, in effect, that the Lower Grade initiates (*pombibele*) must learn techniques and repertoire on the spot and under great pressure at the side of their "older brothers" during an actual funeral ritual. While more secular groups, such as balafon musicians, can get together to practice or compose new songs whether or not there is a funeral, it is forbidden (*kapeele*, "a sin") for Poro drums to be struck at any time other than a funeral occasion. If an initiate is "stupid" and "mixes up" the drum passages, the Middle Graders are expected to discipline him with a whip until he gets it right. (The Fodonon will occasionally say "hitting order" when referring to the hierarchy of Pondo grades!)

"*Tiga*" is the name of an intensive-language-learning school that is prerequisite to entrance into the Fodonon *sinzanga* precincts. The heavy responsibility of *Tiga* school falls to the Middle Grade initiates, who become instructors for the new class entering the Lower Grade of Pondo. No Middle Grader dare be absent when the new class is learning *Tiga* because the elders come by to check up on the progress of instruction. An unusual feature of *Tiga* is that both boys and girls study together in the *Tiga* school, except for special sessions for males only when Pondo words and songs are taught.[6] Traditionally educated Fodonon men and women thus have in common a basic *Tiga* vocabulary and repertoire of songs, but the women have a more restricted vocabulary than the men in secret matters of Pondo. The school lasts three months and takes place during the rainy season sometime after a new age-grade class of *pombibele* is formed. In addition to the Fodonon youngsters, a *Tiga* class will occasionally include some older Kufulo or Fono from the village who want to participate in the Fodonon Pondo in addition to their own Poro. The entrance fees represent the first of many that each individual Pondo initiate will have to produce.

Tiga is also the "language of the ancestors" (*kuubele*). The funeral is the definitive purpose and context of *Tiga*.[7] *Tiga* songs must be sung at the side of an elder's wrapped body (male or female) and when the masks come out. This secret language is largely idiosyncratic to each local *sinzanga* and village, and a Fodonon does not speak his own *Tiga* to elders in another village as a matter of course. Even neighboring villages, only a few kilometers apart, will not understand each other's *Tiga* entirely.[8] Song is the principal technique of teaching this secret

language, and *Tiga* is appreciated greatly for what we would call its rhythmic, poetic, musical qualities. It is considerably more elaborate than normal speech, interlaced and embroidered with many short consonant-vowel syllables.

THE PORO AND PONDO INITIATION CYCLES

Outline summaries of the Fodonon Pondo system and the Kufulo-Fono Poro system and a detailed outline of the complex Senior Grade (*Tyologo*) of the latter are given in résumés 1–3. Although a comprehensive analysis of the multiple activities of each successive grade in both initiation cycles is not the subject here, it is important to emphasize those concepts and values that reemerge and find their greatest expression in the commemorative and propitiatory funerals for elders. It is not accidental that the prime responsibility of the Senior initiate classes, under elders' supervision, is the organization and performance of rituals stipulated for funerals of community members. The themes and forms that are introduced in the children's grades are reiterated and developed further during the Intermediate and Final grades.

Despite many points of comparison, there are major structural differences between the Fodonon version of the Poro cycle (*Pondo*) and the Kufulo-Fono Poro cycle. For precisely this reason, it has been necessary in this text to employ a separate terminology for the age grades of the two systems. Though both systems have a children's Poro, the Fodonon system is more demanding in that the initiate must then complete three grades of six-and-one-half-years' duration each, whereas a young man in the Central Senari Poro cycle need complete only a two-grade sequence of the same six-and-one-half-years' duration. In short, the Fodonon initiate is under the systematic control of his elders for a significantly longer period of time. A reasonably close parallel can be drawn between the Fodonon Lower Grade (*Plaö*) and the Kufulo-Fono Junior Grade (*Plawo*). The Kufulo-Fono Senior Grade, or *Tyologo*, is rather like a condensation of the Fodonon Middle and Upper grades. All three Fodonon grades have access to the Pondo sacred forest and are directly involved in activities based within the sacred grove. In contrast, in the Kufulo-Fono system, access to the *sinzanga* precincts is one of the distinguishing features of advancement from the Junior Grade (*Plawo*) to the Senior Grade (*Tyologo*).

In some respects, the Fodonon system has a certain simplicity of outline that contrasts markedly with several more elaborate features of

the Poro initiation cycle found in the Central Senari groups (including the Kufulo, Tyebara, Nafanra, and interdependent blacksmith groups). Some of these structural differences have a direct bearing on the arts. The most notable difference is that the Fodonon have no real parallel to the periodic, dramatic appearances of masquerade types and dances that celebrate the completion of the most demanding phase of the Kufulo and Fono Junior Grade. Among the Fodonon, the passage from the first two grades takes place relatively quietly, with the general attention focused on the climactic final graduation (*Kafwö*). In the Kufulo-Fono system the important passage ceremony for the Juniors, *Kwörö*, is a dramatic sequence of events staged about two years before the group finally moves into the place vacated by the graduating Senior Grade at the time of *Kafwö*. In both groups, the *Kafwö* ceremony has been a tremendous stimulus to the development of supplementary events and art forms, which have a high degree of variation in regional expressions. In general, the Fodonon Pondo's visual style is more economical and austere than that of their Kufulo and Fono counterparts. In this sense the boundary between the two language groups is reflected in the marked contrast seen in such areas of expression as initiates' personal adornment and *sinzanga* architectural plans and decoration. In both these areas the Fodonon style is the very essence of simplicity as compared to that of their neighbors.

THE INTERRELATIONSHIP OF THE AGRICULTURAL AND RITUAL CALENDARS

A summary of the intersection of the annual agricultural calendar and the ritual calendar of the six-and-one-half-year Poro cycle (table 3) illustrates how the events of the initiation system, which have given rise to major art forms, work into the general life rhythms of a Senufo village. Since the Senufo follow a seasonal calendar, a precise alignment of Senufo and the Christian calendar months cannot be made. An approximate correlation is given with a brief indication of some agricultural and seasonal activities associated with each Senufo month. This calendar begins with September, reflecting the Senufo sense of the beginning of the year, which coincides with the launching of a fresh class of initiates into the final grade of Poro.

A comparison of the annual calendar with the Poro ritual calendar reveals that none of the major ceremonies celebrating advancement in the Poro initiation system take place during the height of the dry season. The Intermediate graduation ceremony (*Kwörö*) occurs at

Table 3
The Senufo Year

Month	Seasonal Activities	Poro and Poro-Related Activities
1. September-October (*Yewöhö*) "End of rainy season" New Year	Storms at end of rainy season are prelude to a period of heavy agricultural activity.	By October, field contests (*kahama**) begin in yam fields (see pls. 10–12).
2. November (*Yafiipile*) "Dry season begins"	Dry rice harvest. Village houses and granaries constructed or repaired.	Field contests continue.
3. December (*Yegboho*) "The 'cold' time begins"	Rice harvest continues. Construction and repairs continue.	Poro initiates work in fields of elders (*tyotiya*).
4. December-January (*Yefukpoho*) "Time of 'old' funerals"	Peak season for artisans' work on special projects for market and clients.	The time of "old" funerals begins now that families have rice and time.
5. January-February (*Kukpokolohogo*†) "Smoke of burning"	Clearing fields in preparation for hoeing in later months (typical Sudanic slash-and-burn pattern).	Peak season for "old" funerals.
6. March (*Tafupele*)	Dry season nears its end.	No special Poro activities.
7. April-May (*Tafukpo*) "Earth is very hot"	Field work started again. Preparation and clearing of rice fields. Planting of early yams.	*Kwörö*, Intermediate graduation, in late May (Kufulo and Fono Poro, fifth year of cycle).
8. May (*Beheyewoho*)	Cultivation in fields continues. Beginning of planting of yams near end of month.	*Kwörö* continues. Poro work in fields (*kwotiya*).
9. June (*Weeliyugo* or *Weeliyube*) "A little cooler"	Traditionally women plant peanuts. Beginning of planting rice seed.	No special activities other than the normal weekly meetings.
10. July (*Karimano*) "Heavy rains"	Time of hunger; past year's food supply gone; new crops not yet ripe.	*Poliiri* (Poro feast), *Segbo* (advancement ceremony feast, fourth year of Kufolo and Fono cycle).

Table 3 (continued)
The Senufo Year

Month	Seasonal Activities	Poro and Poro-Related Activities
11. July-August (*Karimato*) "Rains"	Time of hunger. New yams may be available near the end of the period.	No special Poro activities.
12. August-September (*Fotugutãa*) "Time of new yams"	Weeding rice fields. Time of eating new yams. A few start cultivation, forming mounds for later planting of seed yams.	*Kafwö* (Final graduation, sixth year of cycle). On last day (*Yewöhö* eve) new *tyolobele* enter sacred forest (*sinzanga*).

*Although the Senufo did not consider the *kahama* a part of Poro, I have classed it as a Poro-related activity since they view it as a pre-Poro testing ground for boys and youth up to Senior Grade rank.

†Fodonon version, said to refer to the imagery of a broken calabash being chased across a yard by the wind. I did not learn whether any of the other month names have similarly poetic meanings.

the beginning of the rainy season, when there is much work to be done in the fields. All the main ceremonial events of *Tyologo* take place during the rainy season, including final graduation (*Kafwö*), which takes place just before the heaviest labors of cultivation begin. Clearly, the initiation pattern contradicts the generalization that in West Africa major ceremonies tend to be held during the dry season, when field work is at a minimum and conditions for travel are ideal. The significance of the precise timing of the Poro ritual may be seen at two levels, practical and symbolic. The seasonal dates of certain of the Poro events suggest some practical explanations for the timing. The ceremonial Poro feasts (*Poliiri*), for example, are held during July, a month of heavy rains and low food supply. Another month or two must pass before the new yams are ready to eat. One of the principal financial obligations of the Senior initiates (*tyolobele*) is to provide a specified quantity of food to be distributed among Poro elders and their families during the *Poliiri* feasts. In this case, the timing of a Poro ritual ensures food distribution during the traditional time of "famine" and contributes to the social security system that is built into Poro. At the same time, it is an occasion for relaxation between critical stages of the agricultural calendar, when work in the village is also at an ebb because of the rains.

The same concern for an adequate food supply for festivals can be seen in the scheduling of the *Kafwö* graduation at a time when the long-awaited, new yams have become available. However, in respect to the relationship of Poro cycle to crop cycle, there may well be a deeper significance that is more symbolic than practical. Unlike certain other groups in West Africa (for example, the Yoruba, Idoma, and Ibo of Nigeria), the Senufo do not have a harvest festival or new yam festival as such. However, approximately once every seven years, a class of "finished men" graduates from Poro, and, at the start of the new moon, a new class begins a fresh six-and-one-half-year cycle. In the choice of month it is possible to see an unvoiced analogy to the harvest of the mature, new yam.

During the month of August, the yam growth is completed, ready for harvest, and the final graduation marking the end of the arduous Senior initiation also takes place in villages at that point in the six-and-one-half-year cycle. Some time in May, depending on when the dry season ends and the rainy one begins, the *Kwörö* Intermediate graduation is scheduled for the period of change from the end of the dry season to the beginning of the rainy one, a time in the agricultural cycle marked chiefly as a period of preparation for planting the next crop. For the young men and women participating in *Kwörö*, the period is also one of clearing and preparing for the next phase of their educational growth in Poro (*Tyologo*). And as with the beginning of the rainy season, *Kwörö* is a time of symbolic new life for the initiates, whose former selves are "killed" in the *Kwörö* rite and whose new selves are celebrated in dance.

Before examining the *Kwörö* phase of the Junior Grade in greater detail, it will be instructive to look first at what happens in the Primary Grade. In the masquerade associations of the children's Poro can be seen the beginnings of patterns that will develop more fully in the later grades.

THE CHILDREN'S PORO:
ESTABLISHMENT OF A PATTERN

In Senufo speech, *Poro* may refer to any matter concerning the Poro society and the structured initiation cycle but more especially to those grades having access to the sacred forest precincts. The preliminary phases are not considered true Poro in this sense, although the pre-Poro associations are designed to prepare the young for the critical initiation period to come and are clearly viewed by the Senufo

themselves as part of the total initiation structure. The very youngest group is termed by the elders, with both amusement and affection, "the children's Poro." Among the Kufulo and Fono groups, both the children's masquerade association and its masquerade bear the name *Kamuru*, a word that appears to be derived from *muru*, a verb meaning "to open, discover." Certainly it is true that as the child first begins to come under the influence of Poro, he is embarking on a structured series of "discoveries" in the Poro educational system that will eventually form of him a "finished man," a term describing the Poro graduate.

While they may smile at the children's often comic efforts to imitate the older grades, Senufo adults take seriously the underlying purposes of the primary level and masquerade association. Broadly speaking, it is in the children's Poro that the socialization and education of the child outside the family compound begin. As expressed by one blacksmith informant, "If children don't go through *Kamuru* or *Kodöli* [Intermediate masquerade for blacksmiths], the elders can't have confidence in them."[9] This terse statement reveals a fundamental motive behind the idea of children's Poro. Preparation for the true Poro means above all learning obedience to one's elders and cooperation with one's age mates; these values are strongly reinforced throughout training in the higher grades. This includes the acceptance of responsibility and the establishment of leadership within the group. A young person who fails or refuses to comply with the system of age-grade power hierarchy is one who cannot be trusted. This analysis, based on my field data, is confirmed by Baba Coulibaly's description of the central themes of the "moral talks" delivered to the young boys of the *Kamuru* association: "obeying the chief, working, helping each other."[10] These themes express the ideals of behavior introduced at this age level.

Elders describe the Primary Grade masquerade as "the first Poro," stressing that each boy must have the necessary experience with this costume and dance if he is ever to be considered eligible for initiation into the *Tyologo*, or Senior Grade, and thus gain access to the sacred precincts of the *sinzanga*.[11] An analysis of the clearly observable formal relationships between children's masquerades and adult Poro masquerades reveals, first, the concept of anticipation, which prepares and motivates younger sets to develop skills needed in later grades. As described below in this chapter, the Fodonon children's mask *Kanbiri* is really an incipient *Koto* mask, a major masquerade of the Pondo society. Fodonon elders confirmed that the children make the most of the *Kanbiri* costume without adult assistance on the basis of observation of Upper Grade masquerades. The children's measure of success

is regarded as an important index of their potential abilities in later life. Second, in the children's masquerades is the beginning of an association of specific stylistic and typological features with ethnic identity. Just as the Junior and Senior Grade masks can be classified according to ethnic group, so also the Primary Grade masquerades are usually distinguished as "Fodonon," "Nafanra," "Fono," or similar identifications of dialect or artisan group.

At an early age a child is expected to begin learning the importance of age and sex roles. One of the social purposes of the children's Poro is to maintain and sharpen the demarcation of age-grade roles. One venerable chief regretted the loss of traditional respect toward the elders: "In the past, a child of four or five years was already responsible for guarding the peanut and yam fields. Now they stay in the village with the elders and there is *less difference* [i.e., between the roles and privileges of age groups]. The young man was given a hoe and then, at the age of marriage, a wife. Now children refuse to do the old things."[12] The reader will note here the sequence of thought that leads from hoe to wife, referring to a relationship between achievement in Poro-related field work and the rewards of being granted a wife by one's elders. This relationship is an important aspect of champion-cultivator display sculpture and music, a prominent feature of the commemorative funeral.

As would be expected, at this age level (about six to ten years), Primary Grade activity consists of free play as well as the training sessions directed by the "older brothers" in the Junior Grade and by the elders. The play activities often imitate the adolescent and adult worlds. For example, directly related to the Poro system but still essentially in the free-play category, the children will go to play in the fields or in tucked-away corners of the village where "they will pretend they have their own Poro."[13] There, in their imaginary *sinzanga*, they will build their own Poro house, assemble grass skirts, and make drums of calabash. To complete the basic paraphernalia of Poro, they will steal rags in the village, taking their spoils to the fields, where they will work to sew the costumes. Then the group will make its appearance in the village, hoping to solicit a few cowries. If the children succeed in winning enough cowries, they will buy the millet or corn cakes that can still be purchased for only a few cowries in local markets. With them they can celebrate their own play *Poliiri*, the Poro feast of the Senior initiate cycle.

Although the purposes of the children's Poro do not extend much beyond the essentially social and educational motives outlined above, there appears to be some religious content as well. This seems to be the case in at least two other Western Sudanic cultures, the Dogon and

the Bamana. In his *Jeux dogons* (1938), Griaule reported three rituals
performed solely by children's groups that were thought to be instru-
mental in bringing about results beneficial to the community as a
whole, such as making sacrifices for rain during a drought.[14] In the
Senufo context, the carefully supervised participation of children's
groups in funerals indicates that their presence is felt to be an essential
component of the funeral-ritual complex. It is viewed as a beginning
step in their education in ancestor worship, especially in reference to
duties toward the dead and a healthy respect for their powers to harm
or benefit the living. This also holds true at the family level: an exam-
ple in point is the special, carved whistle played by a male child at
funerals where the death is considered to have been the result of
kapeele, a wrong committed by some member of the family against
the spirits (pl. 50).

THE JUNIOR GRADE PORO AND THE KWÖRÖ RITE OF PASSAGE

The Junior Grade of the Kufulo-Fono Poro system is a critical
period of preparing and testing. One important proving ground for
the initiates during this time is work in the fields under elder super-
vision, both as an initiate-class assignment and as part of the seasonal
hoeing contests involving other classes. Although the hoeing-contest
institution is not considered *of* Poro, achievement in the annual, four-
month period of contests is prerequisite to advancement toward
Tyologo, the Senior and most important grade of the Poro initiation
cycle.

The training school for the Junior Grade, or *Plawo* class, is com-
parable to the *Tiga* school as described for the Fodonon system. The
Junior Grade initiates begin learning the language of Poro by means of
lengthy songs taught by their "older brothers," the Senior initiates
(*tyolobele*). They also learn to play iron gongs at this time. The ini-
tiates are called *sindyohobele*, a term indicating that they do not yet
have access to the sacred grove (*sinzanga*). The training house, located
between the village compound and the *sinzanga* (pl. 51) is called
"Mother's House" (*Nongbaö*) in reference to the Mother Deity's
tutelage. It is encircled by the *Fo* (python) motif in bas-relief. The
protective encircling of the Poro society novices by *Fo*, primary in-
signia of Sandogo, may be a significant visual reminder of the inter-
relationships of Poro with Sandogo and the women's sphere. The
space above the python sign is decorated with the bas-relief sculptural

Plate 50 During an "old" funeral for a relative, a young
Senufo plays a special whistle to appease the spirits who
may have been the cause of death (Kufulo area, 1970).

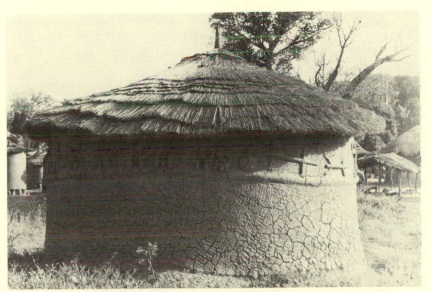

Plate 51 Boys' training house (*nongbaö*) where Junior Grade initiates learn songs prior to entry into the *Tyologo* grade and the sacred grove. Bas-relief sculpture is made by the initiates (December 1969).

designs, one made by each initiate. The designs selected by the boys include animals associated with pain, danger, water, and supernatural powers (e.g., the caiman, the snapping water tortoise, and other water reptiles), male and female figures with exaggerated sex organs, and masquerades, such as *Yalimidyo* and *Tyelige*. The three masquerades are all types the boys have seen during funerals. As children, they may have been chased and frightened by the masquerades, but even now the full meaning of these ritual characters will not be revealed until the initiates move into the Senior Grade.

The focus of this section is the character and significance of *Kwörö*, the climax of the Junior Grade phase of the Fono-Kufulo Poro system and threshold of the next and highest grade (*Tyologo*). *Kwörö*, one of the most important phases of the entire initiation cycle, takes place during the fifth year of the Junior Grade. The initiates undergo a two-month period of seclusion, intensive instruction, and ordeals, climaxed by an advancement ceremory for the young men and women. The *Kwörö* graduation ceremonies provide the context for an important series of masquerades, described in detail in the Appendix. The highlight of *Kwörö* initiation is a rite that symbolically enacts a social and spiritual "death" and rebirth of the initiates, both male and female.

The advancement ceremonies celebrate the transformation of the raw "child" into a more civilized being—sentient, skilled, purified—better equipped mentally, physically, and spiritually to face the Final Grade of Poro and ultimately adulthood.

Kwörö can be seen logically as both the end of the preparatory "child" stages and the first step leading to the final *Tyologo* grade, when the initiates first enter the *sinzanga*. Until an initiate of the Junior Grade (*Plawo*) goes through *Kwörö*, he must "hide like a woman" and not see the masks and other secret things of Poro. *Kwörö* is a transitional period, when the initiates wait quite literally at the edge of the sacred forest world of Poro men. Their mock *sinzanga* (*lödala*) is located in the general forest area but on the fringe of the real *sinzanga*. The *kakpara*, temporary thatch enclosures serving as rest and activity centers for the *Kwörö* initiates of each participating Poro society, are likewise situated around the fringes of the true *sinzanga*. The *kwöbele*, or *Kwörö* initiates, may not yet wear or touch the sacred implements carried by the Senior Grade initiates (*tyolobele*) but instead carry simplified replicas on a miniature scale. When there is a funeral during this period, the *kwöbele* stand beside the Senior initiates, whose real drums speak to the dead. The *kwöbele's* small "drums," which are little more than small logs of wood given leather caps and a string shoulder sling, are silent as they imitate the motions of their elder brothers (pl. 52).

Among the Central Senufo groups of the Kufulo region, the normal pattern is for all the farmer (Kufulo) and blacksmith (Fono) Poro organizations of a village to hold *Kwörö* as an inter-*sinzanga* endeavor. The joint participation of farmer and blacksmith sectors of the community has an integrative function, reinforcing in ritual the economic interdependence of the two ethnic groups. At the same time, differences in the art forms of the two sets of initiates are proud expressions of ethnicity. Separate categories of masquerade, dance, and dress communicate social and cultural differences. There may be several different *kakpara* enclosures (one village observed had four) but only one *lödala*, usually set up near the founder-ancestors' *sinzanga*.

When the time comes for a village to do *Kwörö*, the elders send announcements to all villages that have reciprocal funeral relationships, including all "daughter" *sinzangas* it has helped to found. These villages will come with their Senior initiate groups, whose *Tyelige* and *Yalimidyo* maskers help with the serious ceremonies and contribute to the general pageantry and amusements of the occasion. A large and historically important village, such as Guiembe, has had over twenty-five *Tyelige* maskers participating in its final *Kwörö* ceremonies. In addition to participation in ritual, a secondary activity of the *Tyelige*

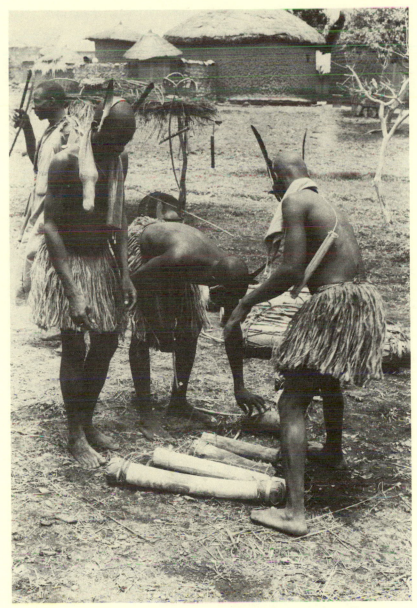

Plate 52 Initiates (*kwöbele*) in ritual dress during *Kwörö* graduation ceremonies, with mock drums, quivers, and sacks in imitation of the *tyolobele* initiates (May 1970).

maskers is to stop travelers passing by the village and demand a toll of cowries or money.

The *Kwörö* initiation and graduation celebration is a highlight of the life of young Senufo men and women and one that engenders considerable excitement in the community. The entire village is infected with the festive atmosphere—the tension, anticipation, the spirit of close comradeship, the bustle of preparations for the masquerades, and the long nights of dancing practice, all building with increasing momentum toward the final, closing, secret ceremony and the public celebrations. Special male-female relationships, ritually defined and rigidly nonsexual by Poro law, are formed that will continue throughout the rest of the initiation cycle and create life-long friendships.

This is not to ignore the more serious dimensions of *Kwörö*; indeed, the social and aesthetic pleasures of the graduation celebrations are actually the rewards of having successfully passed through a period of severe physical and mental testing. The final celebrations come after more than two months of seclusion, communal living, special education, and ordeals. Some of the demands made on the *kwöbele* have to do with learning new skills and techniques, but the majority are various ordeals and discomforts designed to test the initiate's capacities for endurance. In addition to physical suffering, what could be termed psychological pressures are brought to bear on the young initiates, capitalizing on their fear of the unknown. In former times, occasionally a young person would not survive the hardships of *Kwörö*, such as prolonged exposure to cold and damp after an exhausting jog in the bush, in which case his or her disappearance would be attributed to the mysterious power of Poro. A positive result of such trials is that the young men and women who share the experience retain a lasting sense of group solidarity and interdependence.

INSIDE THE LÖDALA: REHEARSALS AND MASK-MAKING

The *lödala* is a mock or proto-*sinzanga*, created in the forested area just outside the village and near the actual sacred forest precincts. Here the *Kwörö* initiates stay during the day and begin to learn correct rules of behavior in sanctified precincts. *Kwörö* materials, such as the "hitting" masks (*Kmötöhö*), the ritual grass skirts neatly hung out between poles, and the special *Kwörö* initiation drums, are constructed and stored there when not in use. Here, during daylight hours, the initiates practice their dance steps and drum songs (pl. 53) and prepare the complicated graduation masquerades with the help of "older brothers." During the two months of ordeals, training, and

Plate 53 Kwörö initiates practicing dance steps in the mock sacred forest (*lödala*) (May 1970).

preparation, initiates wearing the lesser *Kmötöhö* masks (pl. 54; Appendix, IV-A) sporadically leave the *lödala* to run through the village chasing the younger sets and threatening them with short fiber whips. A two-cornered sack mask of plaited mat fibers attached to a rudimentary grass cape, a *Kmötöhö* mask is made by each male initiate and is in theory the only mask that may be worn by the female initiates. The erratic sorties of the *Kmötöhö* maskers serve as an announcement of the impending ceremony with the higher-ranking masquerades.

The Kufulo farmer and Fono blacksmith groups each have a distinctive masquerade to celebrate the completion of the *Kwörö* initiation period. The awesome bulk and ponderous march of the *Gbongara* honors the farmer initiates, whereas the slim *Kwöbele-kodöli* dances a praise poem to the blacksmiths with bright, agile movements. Weeks in preparation, the *Gbongara* fiber masquerade (pl. 55; Appendix, III-A) is a complex raffia construction intended to impress with its massive size and breadth and with the detailed craftsmanship of raffia treated to achieve several different textural effects. The blacksmith initiates' Junior *Kwöbele-kodöli* (pl. 21; Appendix, II-C) is a knit fiber masquerade with a red crest ornamented with cowrie shells and featuring a prestigious leather hip belt lavishly decorated with braids, shells, brass bells, and ornaments. Blacksmiths consider this fiber masquerade of greater importance than the lower-ranking carved face masquerade (*Kodöli-yëhë*) worn during the years prior to *Kwörö*. The *Kmötöhö*

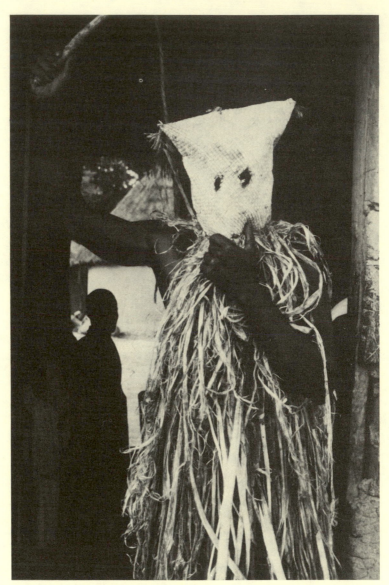

Plate 54 The appearance of the *Kmötöhö* masks in the village announces the coming *Kwörö* ceremonies weeks before the event (May 1970).

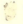

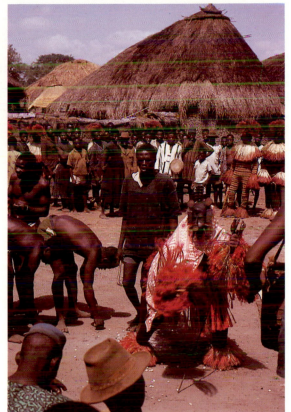

Plate 44 *Poyoro* masquerade, designed to be beautiful and sensuous, the "wife" of the group's antiwitchcraft mask. The masker, holding a four-belled iron staff, dances up to greet the *kuugofölö* and other elders. *Nafiri* maskers in background maintain the performance space (Fodonon village, March 1970).

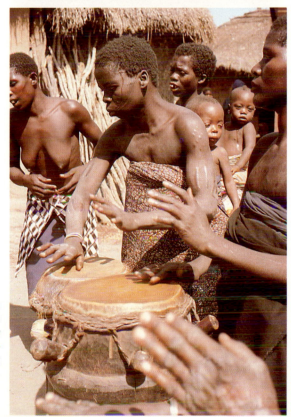

Plate 48 Two Fodonon women virtuoso drummers provide the polymetric rhythms of a *Tyekpa* society dance, accompanied by vocalists and two musicians playing calabash–string net rattles (April 1979).

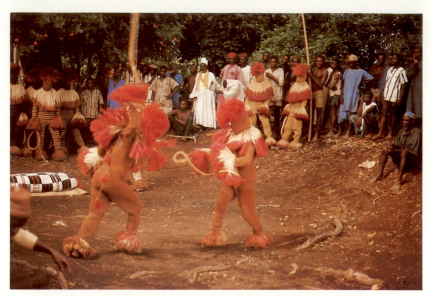

Plate 62 Pairs of *Nafiri* maskers from several Pondo societies perform the whipping ritual in the *sinzanga* as the last ceremonial act before burial. The red cap attached to the burial-cloth casing marks the death of a Fodonon elder (May 1970).

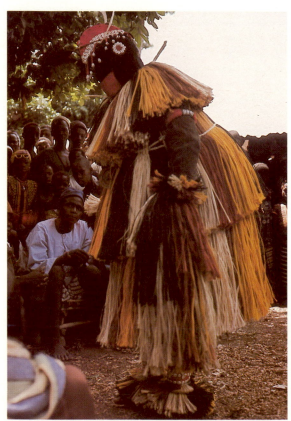

Plate 71 Tyeli group version of the *Koto* masquerade performing at a *Kuumo* in the Kafiri dialect area (May 1970).

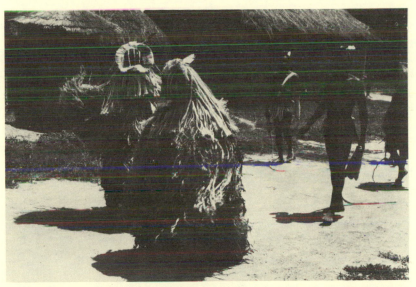

Plate 55 *Gbongara* masquerades and *kwöbele* of the Kufulo group at an "old" funeral (*kuufuloro*) for a male elder (June 1970).

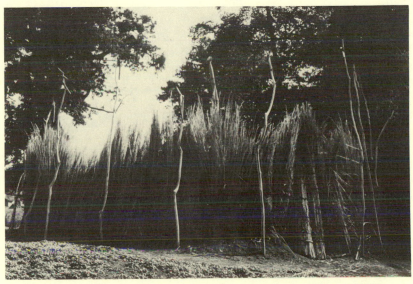

Plate 56 *Kakpara* enclosure featuring the mounted hoe handles that symbolize the initiates' contribution during the hoeing contests of the previous five years (May 1970).

masks can come out without offerings of food, but the high-ranking *Gbongara* and *Kwöbele-kodöli* masquerades require large payments of food to Poro society elders.

When all is ready and the time for the final ceremonies arrives, the Kufulo and Fono leaders summon the supervisors who traditionally help the initiates to assemble and tie on the masquerade parts. In one Kufulo village it is traditional for members of the Fodonon ethnic group to perform this office, perhaps a ritual acknowledgment of the original Fodonon chieftaincy prior to the Kufulo rise to power. The work is done by the Fodonon initiates and recent graduates, and the Fodonon elders are present to watch, advise, and enjoy the food and drink.

BESIDE THE KAKPARA: CELEBRATION OF COMPLETED LABORS

An enclosure constructed of long bundles of grass thatch, the *kakpara* (pl. 56) is located outside the village and near the passageway to the sacred grove. Tall poles rise above the enclosure, with carved wooden hoe handles attached to the tops. The prominent display of hoe handles alludes to "hoeing of the *Kwöbele*," the group cultivation labors required of *Kwörö* initiates. These handles were part of the large iron hoes used to work the fields of Poro elders as partial fee for advancement in the Poro society. The *kakpara* is the scene of night-time activities of the *Kwöbele*, both the men and their female counterparts. They may continue work on the masquerades here if necessary, but the main activity enjoyed is dancing. Here, too, they may sleep.

KWÖRÖ DRESS STYLES

In addition to the ritual seclusion of *lödala* and *kakpara*, special modes of dress set apart the *Kwörö* initiates from the community at large and serve to emphasize this special time in their lives. A short, full skirt of undyed grass or palm fiber is worn by the male initiates (pls. 52, 53). The girls, bodies gleaming with oil, wear simple loin-cloths of blue and white weave similar to those worn by Senior male initiates. One of several instances of apparent transvestism to be ob-served in Poro ritual apparel and masquerades, the skirt motif may well have mythological or symbolic significance. The Senufo mythic theme relating how men took Poro away from the women, discussed in Chapter 2, has a striking parallel in Dogon myth. In relating the origin of death in Dogon society, the narrative describes how the men

took away from the women the grass skirt, prototype of masking-society costumes (Griaule 1938:53–54).

The male dress is the more elaborate, a reflection of the more visible and public role of the Poro society in contrast to Sandogo. Male initiates wear a traverse headband ornament with a chin strap featuring two white and black feathers attached at each side above the ear (pl. 52). Feathers as symbols of masculine pride and strength occur elsewhere in the Senufo visual code, most notably in the context of champion-cultivator contests, in which the champion is likened to a powerful and courageous eagle. In the context of *Kwörö*, there is an additional overtone, a humorous analogy between the vulture and the initiates' voracious search for cowrie shells. A second style of feathered headband, featuring a raffia topknot centered on the headband and one feather (pl. 55), is worn by the *kwöbele* acting as support teams to the *Gbongara* and *Kodöli* masquerades and cowrie collection agents during formal appearances. The feathers come from birds of prey, including buzzards, vultures, and hawk-eagles. The "vulture" theme, in the context of age-grade advancement, also appears in the Fodonon group in reference to the cowrie-scavenging antics of Fodonon Middle Graders during the final graduation festival (*Kafwö*). In both cases the "vultures" are destined to move soon into the place of the graduating seniors.

Of particular importance to the men is a decorative fiber belt (*sakelige*) that signifies new status in wearing Poro masquerades. Worn by the *kwöbele* support teams for *Gbongara* and *Kodöli*, the belt is also a *Tyelige* masquerade component. Since *Tyelige* is a "learner" *Yalimidyo* masquerade for new *tyolobele* initiates, the belt is a visual code for the advancement from Junior to Senior Grade (pl. 10 [color]; Appendix, IV-B).

<center>"DEATH" OF THE INITIATE</center>

Unlike the quasi-public appearances of the major graduation masquerades, the most important art form of *Kwörö* ritual is a mixed-media assemblage hidden deep within the sacred forest. A carved, wooden, zoomorphic animal head, a prefiguration of the *Nosolo* and *Kponyungo* masquerades associated with the Senior Grade and Poro leadership, is placed on a body of molded clay and given a multicolored raffia cape (pl. 57). The stationary display sculpture *Nyungolöhö* ("head-water") guards what might be termed the "baptism" site, where the highlight of the *Kwörö* secret ritual takes place. This is a ritual that "kills" the old initiate and gives rise to the new one.

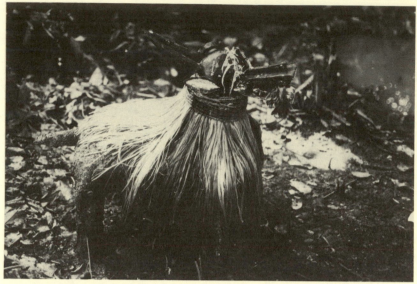

Plate 57 Kwörö display sculpture of mudmolding, raffia, and wood, incorporating carved antelope head used in *Nosolo* masquerade. The tutelary beast stands by site where the definitive *Kwörö* rite of passage takes place (May 1970).

The secret phrase for this ritual in Senari underlines explicitly the concept of the "death" of the child and thus the "rebirth" of the initiate. In the course of this ceremony, the initiates must swear a vow of secrecy never to reveal to outsiders what takes place. After this transformation, the initiates assume an additional title.

When this key ritual is completed, the colorful *Yalimidyo* fiber masqueraders—spokesmen for the elders and the ancestors—assist in the final exuberant ceremony inside the true *sinzinga*, where the *Kwörö* graduates are received as reborn children of Poro.

MASQUERADE PATTERNS OF
CONTINUITY, CHANGE, AND INTERACTION

My central purpose, in this section, is to explore the role of masquerade style and type in the process of age-grade and ethnic group differentiation and interaction. To understand how Poro masquerades create visual codes corresponding to patterns of ethnic continuity and age-grade change, it is best to return to the first level—the children's masquerades.

KANBIRI AND KAMURU: THE CHILDREN'S MASQUERADES

Among the Fodonon, the commemorative funeral for men and women elders would be considered incomplete without the entertaining performances of the small boys' *Kanbiri* masquerade association. A clear example of calculated stylistic and typological relationships between children's and higher-grade masquerades, *Kanbiri* may be described as an incipient version of *Koto*, an important initiation and funerary masquerade of the Pondo society. A comparison of *Kanbiri* (pl. 58; Appendix, I-A) and *Koto* (pl. 59; Appendix, I-D) reveals striking similarities in materials and design. The similarity between the two mask types in some cases was even closer than is apparent in this example of *Kanbiri*, which is missing such details as cowrie ornaments on the crest and a reflector disk. Both types exhibit an almost sculptural use of grasses and raffia fibers, shaped to form central, domelike masses that are rhythmically echoed in similarly shaped ornaments that camouflage the hands and feet. In the adult *Koto*, the two shoulder and waist masses of the *Kanbiri* are merged into one dome-like shape. Already in the first Poro of the Fodonon male, then, can be identified a major distinguishing feature of Fodonon masking styles. In an overall comparison with the Kufulo and blacksmith traditions, the Fodonon show a marked predilection for a highly sculptural handling of raffia, creating a bell-shaped mass with complex textures and surface qualities. A comparison of virtually every Fodonon masquerade with similar types in the Fono or Kufulo groups reveals this feature of Fodonon style. For example, compare the Fodonon *Kurutaha* (pl. 60) with the Kufulo and Fono *Yalimidyo* (pl. 61), the Fodonon *Nafiri* (pl. 62 [color]) with the Fono *Kwöbele-kodöli* (pl. 21), and the Fodonon *Gbön* (pl. 88) with the Kufulo *Kponyungo* (pl. 63) and the Fono *Kunugbaha* (pls. 8, 64), neither of which features raffia at all. The same distinction is visible in the distinct architectural styles of the *sinzanga* storage houses.

To be sure, the beginner's mask is simpler and lacks the *Koto*'s finished quality and refinement of detail. Apart from differences of material, the raw tufts of grass are not brought under the same kind of control and have a tendency to shoot out in all directions. More than ten or fifteen years will pass before this age class will be taught by older initiates the secret techniques of preparing fiber until it attains a silken, luminous shine, making the dyes that give rich, warm tones, braiding and building up layer upon layer of raffia wraps.

As discussed above in reference to the children's Poro, one reason for such close parallelism of materials and design in Lower and Upper

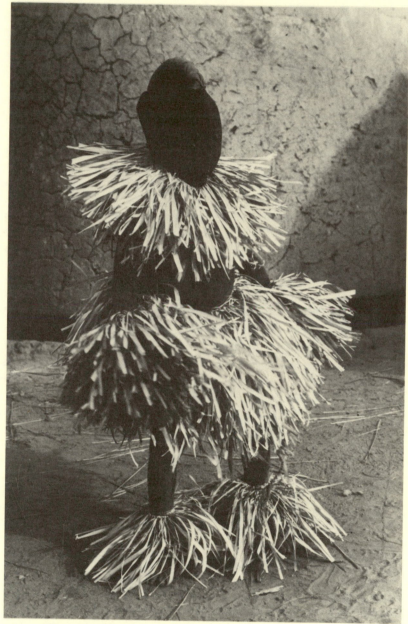

Plate 58 Kanbiri masquerade worn by child in the six-to nine-year age group of the Fodonon children's Poro (February 1970).

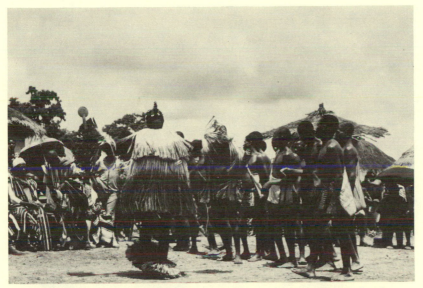

Plate 59 Koto masquerade supported by the new Upper Grade initiates of Pondo on the third day of the Fodonon *Kafwö* graduation ceremonies. *Koto* dances to honor the graduates (left), festive in their bright *Kafwö* robes (August 1969).

Grade masquerades is that type and style play an important role in the process of ethnic identification; this pattern characterizes all phases of Poro. A second reason is that the art of creating and performing the *Koto* is the most difficult to master of all Fodonon Pondo society masquerades. It is not surprising, then, to find that the youngest boys are encouraged to begin developing the essential skills that will help prepare them for difficult features of the *Koto* and *Gbön* masquerades. The similarities of design and materials used in *Koto* and *Kanbiri* mask construction enable the small protoinitiate to learn how to cope with difficult-to-manage features of costume, such as the cumbersome raffia anklets, while executing controlled dance movements. The small eyeholes of the knit mask necessitate learning a code of directional signals involving the guide and chorus. The tripartite unit of masker, guide, and chorus constitutes a pattern of masquerade performances that continues throughout the later grades.

Kamuru, the children's masquerade association of the Fono and Kufulo cycle, is also the name of the two first masquerade types worn by boys. Both are fiber masquerades, the first neat and decorative (pl. 65; Appendix, II-A), the second intentionally ragged looking (pl. 66). Among blacksmiths, the presence of two *Kamuru* masquerade styles seems to represent a distinction between two phases of the Primary

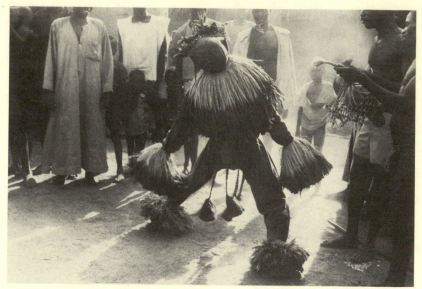

Plate 60 Kurutaha masquerade at funeral for a Fodonon male
(March 1970).

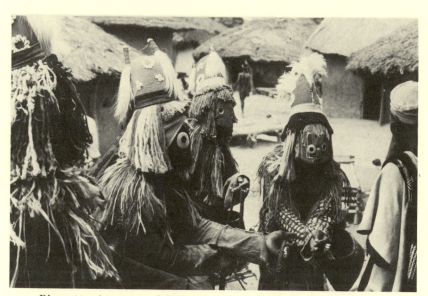

Plate 61 A group of *Yalimidyo* maskers from four *sinzangas*,
on a tour of village compounds prior to burial of a Kufulo
elder, soliciting money from a recent graduate of Poro (identi-
fiable by his robe). Note the cowrie-ring ornaments, which
refer to this activity (February 1970).

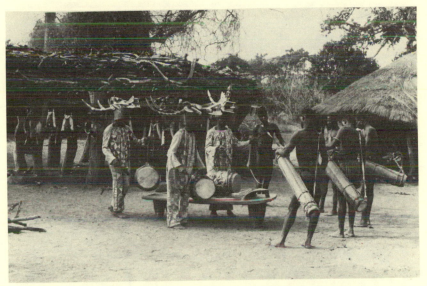

Plate 63 Kponyungo masquerade by a Kufulo *Kpaala*: drummers from five Kufulo Poro societies and three *Kponyungo* maskers surround the carved funeral bed at a *kuufuloro* for a blacksmith woman (February 1970).

Grade. *Kamuru* describes fiber masks worn by a boy of whatever age who has not yet reached the intermediate stage. Completion of *Kamuru* is a mandatory prerequisite of participation in *Kwörö*, the climax phase of the Junior Grade. Blacksmith elders explained that whether a raffia costume is put on a toddler or worn by a youth, "the name *Kamuru* is the same." Thus, despite the height, older age, and skill of a *Kamuru* dancer whom I observed at Nerkene (the masked dancer to the right in the background, pl. 66), he was a late starter, had not yet arrived at the next grade, and so was still *Kamuru*.

The *Kamuru* masquerade was first described and illustrated in an unpublished Institut Fondamental d'Afrique Noir (IFAN) document written by Baba Coulibaly on Senufo secret societies of the Korhogo area.[15] Unfortunately, this otherwise valuable document suffers from the same troublesome lack of precision about subgroup identification that hampers most publications on Senufo art, and one is left to wonder which of the many ethnic-linked Poro organizations in and around Korhogo was being described (e.g., Fono, Tyebara, Tyeli, Nafanra) and if indeed several groups were not lumped together indiscriminately. All but one of the *Kamuru* masquerades I observed in the Kufulo Region were Fono (blacksmith), but the *Kamuru* masking tradition

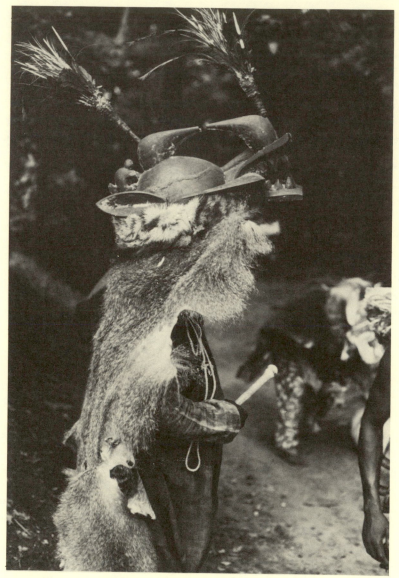

Plate 64 A blacksmith *Kunugbaha* masquerade reputed
in the Kufulo region to be an exceptionally lethal weapon
against sorcerers, as suggested plastically by the aggressive
battery of warthog tusks (July 1969).

seems to be found throughout the Central Senufo region and probably involves farmer as well as blacksmith groups.

The first *Kamuru* style (pl. 65; Appendix, II-A), observed among blacksmith groups in both the Kufuru and Tyebara dialect areas, was essentially the same as that illustrated by Coulibaly; it he also calls *Kamuru*.[16] The essential components of this masquerade are as follows: a one-piece, knit suit with horizontal band designs; a knit hood; a longitudinal, red, cloth crest with a tail and cowrie decorations; a short, neatly trimmed waist skirt of multicolored raffia; a belt of iron bells (which are pulled tight over the buttocks and shaken in a sideways movement); and raffia trim on ankles and wrists. Local variations are rather minor, such as the colored design of the knitted, horizontal bands. One children's masquerade association presented a small-scale imitation of the "pregnant belly" motif characteristic of two Senior textile masquerades in the area (compare pl. 65 with *Yalimidyo* and *Kurutaha*, pl. 60).

The second *Kamuru* style has the same basic knit hood with longitudinal cloth crest as the first style. However, in this second style a loose arrangement of raffia wraps at the collar, waist, wrists, and ankles is combined with a plain cloth shirt or pants or both (pl. 67). Apart from the absence of matching knit suit and the iron-bell belt, the most notable contrast of this style with the first *Kamuru* style is the singular lack of any attempt to display acceptable craftsmanship with the raffia forms, which are deliberately thin and scraggly in appearance (pl. 66, right background). Even the hood and pants may be torn and ragged. In brief, the second *Kamuru* style seems to be an example of the anti-aesthetic element that characterizes several Senufo masking traditions. In this case, I believe, it is associated with a stage of advancement intermediate between the youngest set (wearing the neat *Kamuru*-style one) and the Junior Grade set, eligible to wear the intentionally beautiful *Kodöli-yëhë* masquerade (also seen in pl. 66).

Although stylistic relationships exist between *Kamuru* and higher-grade masquerades in the Kufulo-Fono Poro system, the affinities are perhaps less clear cut than in the Fodonon case. The first *Kamuru* style compares closely with the blacksmith Junior Grade mask, *Kwöbele-kodöli*, worn during the *Kwörö* graduation ceremonies (pl. 21; Appendix, II-C): both are characterized by a dark-on-light, knitted suit and short-trimmed, multicolored raffia. This stylistic trait of variegated polychrome raffia ornamentation is also seen in the costume of the Fono Junior face masquerade, *Kodöli-yëhë* (pls. 42, 66). Short-cut skirts and capes of a single layer (unlike the multilayered wraps of the Fodonon) are also characteristic of Senior masquerades. This particular handling of raffia is a style element that can distinguish both

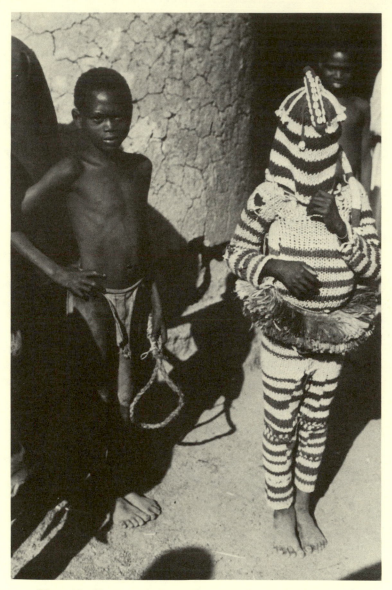

Plate 65 Kamuru masquerade, worn by youngest set of
a blacksmith children's Poro group. They are participating
in climax of ceremonies just before burial of an important
Fodonon woman. The belt of iron bells worn over the
hips is not visible beneath the raffia in this view (January
1970).

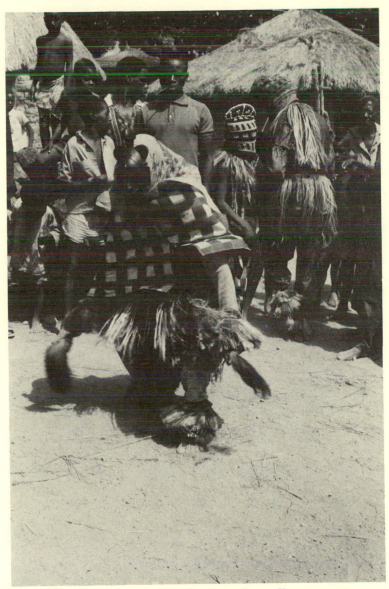

Plate 66 Blacksmith *Kodöli-yëhë* and two *Kamuru* mask-
ers (right, background) at funeral for a Kufulo male
(March 1970).

Plate 67 Kamuru masquerade dancing with
walking drum and rasp orchestra of the
Junior Grade blacksmith Poro (February
1970).

farmer and blacksmith masquerades of the Central Senari cluster from
those of the Fodonon.

The carry-over of masquerade visual and behavioral styles from one
grade to a higher one occurs throughout the Central Senufo region. In
addition to striking similarities between a child's masquerade costume
and that of a particular Senior mask of the same ethnic group, chil-
dren's performances reveal patterns that will persist into the higher-
grade masquerades. The performance pattern of masked dancer, guide,
and supporting chorus is established in the children's first masquerade
experiences. Other patterns include the soliciting of money or cowries
for the group, the ritualized feasts, and an occasional foray into social

commentary. In the last context, one *Kamuru* performance witnessed in the Tyebara area included an interlude of comic pantomine with a moralistic bite worked into the dance routine. While the chorus sang and clapped and the guide stood by with the miniature whip, the masked dancer rolled and flopped about on the ground, representing a drunkard. The performance was rewarded with cowries.

The *Kamuru* masqueraders perform as part of the climactic buildup of events just before burial, as participants in the all-night watch after burial, and during second burial festivals. The normal performance pattern is that of a masked dancer with guide, accompanied by the chorus of his age set, who provide the rhythm by clapping and singing. The *Kamuru* learner is also required to dance to the rhythms of both the iron rasp and flute ensemble and the drum and flute ensemble played by the older blacksmith initiates. In this context, the common pattern is that the youngest masker appears first, followed by the face masquerade (*Kodöli-yëhë*) of the Junior Grade, which is judged to be far more important and beautiful. The Senior initiates, wearing Poro masks that cannot be seen by either of the two younger age sets, appear much later, in the concluding sequence of the funeral ritual.

THREE FIBER MASQUERADES: THE SYMBOLIC TRANSPOSITION OF PARTS

A comparison of children's and higher-grade masking styles has demonstrated the general principle that stylistic continuity reflects ethnic unity and that, within the same ethnic boundaries, stylistic and typological changes signal changes of age status and purpose. A third dimension of masquerade design as visual communication is the principle of symbolic transposition of masquerade components. A fascinating set of transposed costume components emerges upon comparison of two Junior Grade fiber masquerades from the *Kwörö* phase, one Senior Grade fiber masquerade from the first phase of *Tyologo*, and a unit of *Kwörö* body ornament (table 4). The three fiber masquerades are as follows: Kufulo farmer group's *Gbongara* (pl. 55; Appendix, III-A), the Fono blacksmith group's *Kwöbele-kodöli* (pl. 21; Appendix, II-C), and *Tyelige* (pl. 10 [color]; Appendix, IV-B).

First to be noted is the pattern of object crossover from intermediate age grade (*Kwörö*) to Senior age grade (*Tyologo*), visually reinforcing the themes of advancement and continuity in the initiation cycle. Thus, the decorative leather and fiber belt (*Sakelige*) worn as ceremonial dress by the Junior Grade initiates during *Kwörö* is transposed in more elaborate design as a prominent feature of the

Table 4
Transposed Components of Three Masquerade Styles

Unit	Wearer of Costume Kufulo (Farmer)	Wearer of Costume Fono (Blacksmith)	Age Grade
1. Composite fiber helmet with raffia facial frame	1. *Gbongara* 2. *Tyelige*	*Tyelige*	*Kwörö* *Tyologo*
2. Knit suit	1. 2. *Tyelige*	*Kwöbele-kodöli* *Tyelige*	*Kwörö* *Tyologo*
3. Ornamental belt	1. *Kwörö* initiates 2. *Tyelige*	*Kwörö* initiates *Tyelige*	*Kwörö* *Tyologo*

Tyelige, the most important fiber masquerade worn by new Senior Grade initiates. The same pattern of object crossover from lower to higher grade has already been seen in the case of the *Nyungolöhö* display sculpture of *Kwörö*. In that instance, the only component of the mixed-media construction made of permanent materials, the carved wood "mask" or animal head, is used as the head component of the "tent" masquerade construction (*Nosolo*), which celebrates the Seniors' third year in *Tyologo*. Moreover, the design of the head itself imitates the important Poro helmet masquerade *Kponyungo*.

Second, a very interesting thing happens in terms of the general design and construction of the major costume units for these three masquerades. The mask, or head portion, of the farmer Junior Poro masquerade (*Gbongara*) and the suit, or body portion, of the blacksmith Junior Poro masquerade (*Kwöbele-kodöli*) are combined to form the *Tyelige* learner masquerade of the Senior Poro of both the farmer and blacksmith groups.

If this is intentional, we have a remarkable concept of costume

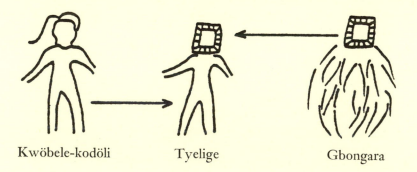

Kwöbele-kodöli Tyelige Gbongara

design, one that embodies, ritually and visibly, the dependent relationship of the farmer and blacksmith groups (figure 1). That it should be the farmer Junior masquerade that contributes the head unit is appropriate to the local concepts of correct village leadership. A blacksmith would never be chief of a village over a farmer, even if the village was initially founded by a blacksmith group.

THREE FACE MASQUERADE CATEGORIES

An excellent example of the need to reexamine our classification of Senufo masks can be seen in the problem of the carved wooden face mask, an important and prevalent object type in the body of Senufo sculpture (pls. 41–43, 44 [color], 69).[17] A category of *Kpelié* or any other specific name for "face mask" does not work cross-culturally and is an incorrect application of a Senufo classification term. In short, the Senufo do not classify masks or masquerades according to form alone. *Kpelié* is a French version of the Senufo *Kpeli-yëhë*, the Kafiri dialect area term parallel to the Kufuru term *Kodöli-yëhë*. In the Central Senufo language, *yëhë* means "face." The geometric projections at each side of the face mask are called "decoration" except for the center one, which is called the "ear." The leglike pendants below the face are a stylized rendering of a woman's traditional hairstyle. The abstract forms of the mask are not meant to be a naturalistic portrait; rather, the finely drawn contours and textures of the face mask, as well as the artistry of the dancer, are intended to be beautiful as a young woman is beautiful. Sometimes called "girlfriend" or "wife" of a male-associated masquerade or spirit, as in the case of the Fodonon group's *Poyoro* masquerade (pl. 44 [color]), the face masquerade is always intended to "be beautiful" in praise of a man or youth on the occasion of his commemorative funeral. Among the blacksmiths, each Junior Grade class of the Poro society selects from among their group the most skillful dancer to perform the exciting *Kodöli-yëhë* masquerade dance. Other members of the class provide the musical accompaniment to the dancer. The orchestra is composed of three forged-iron rasps and a bamboo flute. Although hip and shoulder movements refer to the feminine qualities of a "beautiful young woman," the youthful strength of the male dancer is demonstrated by the intricate foot movements, which are executed with both precision and individualized flair. The dancer's feet must match the rapid beats and quickly changing rhythms of the music (pls. 42, 43).

As suggested above, the *Kodöli-yëhë* masquerade type is only one of several options for the face mask object type.[18] Not all Senufo

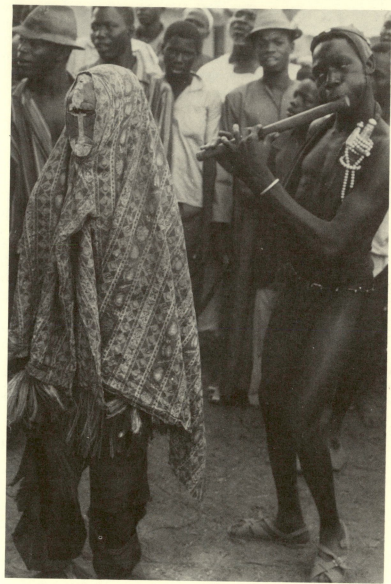

Plate 68 Beginner "ugly" *Kodöli-yëhë* mask performing at funeral for a young blacksmith male of *Plawo* grade (blacksmith Junior Grade of Kapile) (February 1970).

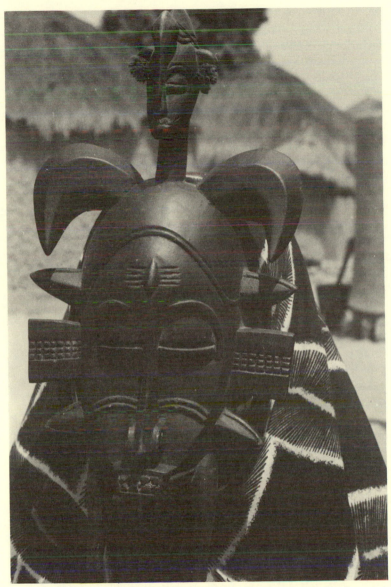

Plate 69 Kodöli-yëbë masquerade of blacksmith Junior
Grade. Center crest of female head and general form
identical to those of a Fodonon *Kotopitya* mask (see plate
41) (February 1970).

ethnic groups have the face masquerade featuring the carved-wood or cast-brass face mask. Never used traditionally by the Senambele farmer groups, the face masquerade is part of the cultural heritage of four specific Senufo peoples: the Fodonon farmers, the Fono black-smiths, the Kpeene brasscasters, and the Kule woodcarvers. The carved face mask is a vital component of no fewer than three distinct masquerade types in the Kufulo region alone: (1) *Kodöli-yëhë* (pls. 43, 69; Appendix, II-B), (2) *Poyoro* (pl. 44 [color]; Appendix, I-F), and (3) *Kotopitya* (pl. 41; Appendix, V-B).

The formal features, which are constant and constitute a typological unity of masquerade *component*, not *type*, are as follows: (1) an oval human face close to natural proportions, often slightly smaller than life size; (2) two or more geometric projections symmetrically flank-ing each side of the face, the central set considered to represent ears; (3) emerging from each lower side of the mask, two tapering, oblong ornaments closely related in form and style to the carving convention used to represent pendant hair bobs in figurative sculpture[19]; and (4) a central crest, surmounting the forehead, both representational and emblematic, sometimes symmetrically flanked by horns (bull horns up, ram horns down).

Disregarding wide stylistic variations for the moment, the principal variable that distinguishes this object type is the range of forms crown-ing the face and creating the vertical thrust of the mask crest. The exact significance of this iconographic element appears to be amaz-ingly fluid, its general content and purpose changing from one owner-ship group to another. Goldwater's assertion (p. 15), based on Maesen's data (1940:383–87), that the heraldic emblems provide a *fixed* clue to ethnic group was not found to hold true where I did my research. Compare, for example, the center crests of one Fono *Kodöli-yëhë* (pl. 43) and one Fodonon *Poyoro* (pl. 44 [color]). The two masks bear the same type crest; the only difference is the individual sculptor's stylistic treatment of the motif. That is, in no way is this variable an *essential* factor in a Senufo classification of the different face mas-querade types, much less an art historical clue to the provenance of the carving.

Thus, to the Senufo, the face mask so defined does not constitute a typological unity ipso facto for the sufficient reason that Senufo classification involves more than just this one masquerade component. Such criteria as instrumental accompaniment, song text, materials and composition of the total costume, and other coordinate attributes associated with a particular mask type provide the necessary data for the two most basic subdivisions in any Senufo masquerade classifica-tion—identification of ethnic group (dialect and occupation) and age grade. In table 5 are indicated the points at which the masquerade

Table 5
The Face Mask Component of Three Masquerade Types

	Fodonon	Fono	Kufulo
Poro			
Age Grade			
Junior	*	Kodöli-yëhë	*
Senior	Poyoro	*	*
Sandogo Related	Kotopitya	*	*

*This component is absent in this ethnic or age-grade group or both.

component and formal category "wood face mask" intersect with considerations of ethnic and age-grade groups in Senufo classification. All three masquerade types may be present within the same village in the Kufulo region.

As noted in Chapter 2, the *Kotopitya* mask is worn by Pondo society initiates although the owner and trustees of the mask are women. In view of the fact that Fodonon groups also live interspersed with the Tyebara and Nafanra farmer and blacksmith groups, the data from those areas concerning face masks need reexamination in this context.

Since the word *kodöli* forms part of the names for two masquerade types discussed above, *Kwöbele-kodöli* and *Kodöli-yëhë*, a note on this important word is in order. *Kodöli* is clearly a general word that can encompass several different masquerade types, but whether *kodöli* is actually a *class* of masquerade type is less certain. In some respects, *kodöli* appears to be a near equivalent of *masquerade* or *costume* in Senari. All masquerade types termed *kodöli* were in the fiber masquerade or "soft sculpture" category—that is, constructions of raffia, grasses, and knit and woven textiles. The exception to this general rule is the blacksmith *Kodöli-yëhë*, which is always qualified as "face" (*yëhë*) *Kodöli* in reference to the carved face mask component. Linguistic research into the etymology of the word *kodöli* may clarify the issue. In this regard, it is interesting to note two vocabulary items in the "Dictionary: Tyebara-English; English-Tyebara" (1967:72):

> kòdölögö—grass skirts used by sacred forest members.
> kodöligö—a person who wears a special outfit such as pants, shirt and hat all of the same materials. This costume is only for wearing to funerals, so if one sees this on someone, one always knows there is a funeral in progress somewhere.

The material construction, however, cannot be the only consideration

in the Senufo classification since not all fiber masquerade types can be called "*kodöli.*"

Only one other criterion seems to fit all known instances of masquerades referred to as "*Kodöli.*" Some are public, pre-Poro, or Intermediate dance masks, some are public Senior Poro masks that dance, and some are public Poro masks that do not dance. The one feature all of them seem to have in common is that they can be seen by women, children, and uninitiated males in one or more contexts. In conclusion, then, it seems a reasonable hypothesis to assume that *Kodöli* refers to a loose category of masquerade types composed of raffia or textile materials and that are public during at least one type of event. A category so defined is not without problems since a few masquerade types that would fit logically (such as *Yalimidyo* and *Tyo*) were never heard to be called "*kodöli.*"

TWO KOTO FIBER MASQUERADES

Of the Pondo society masquerade repertoire, the Fodonon fiber masquerade *Koto* (pl. 59; Appendix, I-D) is second in importance only to *Gbön.* With its supporting masquerades, *Kurutaha* (pl. 60; Appendix, I-C) and *Tyo* (pl. 70; Appendix, I-B), *Koto* is both initiation and funeral masquerade. *Koto* has the pivotal role in the final graduation ceremony (*Kafwö*), honoring each graduate in turn with a dance and confirming his new name as a "finished man" of Pondo. In the Fodonon pattern of commemorative funerals for elders, ancestral rites (to be discussed in detail in Chapter 4) are followed by burial; after a brief respite, a postlude performance in honor of the deceased elder is given by the *Koto* masquerade team. In both the initiation and funeral contexts, the primary purpose of *Koto* is to lend beauty and splendor to the event with its visual forms and prowess in acrobatics and dance. The entertainment theme is considerably expanded by the comic, mimed theater provided by the secondary maskers, *Tyo* and *Kurutaha.*[20]

My concern here is not to provide a detailed description of *Koto* team performances but to make two general points that depend on the *Koto* example. First, the Fodonon *Koto* gives an excellent example of how masquerade style and type can provide important clues to the historical and cultural relationship between two or more ethnic groups—in this case, the Fodonon and the Tyeli. As mentioned above, both the Fodonon and Tyeli dialects are outside the Central Senari dialect cluster, although there is not yet any data available on their linguistic relationship to each other. The close stylistic and typological

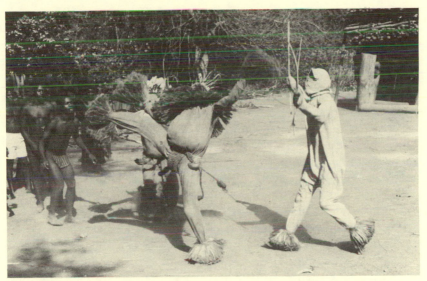

Plate 70 Kurutaha and ***Tyo*** maskers performing a series of comic pantomimes as part of the public entertainment following the burial of a Fodonon male elder (January 1970).

similarities of a fiber masquerade type (*Koto*) found in both the Fodonon and Tyeli groups, along with certain other features of their Poro complex, provide the only real clue to their historical relationship in the absence of comparative linguistic data or Tyeli oral history documentation. Second, I intend to demonstrate with this and related examples that in Senufo masking traditions, style differences are often intended to convey rank and hierarchy and may involve the use of deliberately antiaesthetic forms.

Although my research was concentrated largely on the Fodonon and Fono groups, the very nature of ethnic group interaction in the focal area meant that some observation of Tyeli forms was inevitable. It became increasingly apparent that the Tyeli Poro society's art complex features some masquerade and musical instrument forms nearly identical in type and style to those of the Fodonon complex. The following striking parallels were noted in the Kufulo, Kafiri, and Tyebara areas in 1969–70. First, the sacred instrumental ensembles used by both groups are very much alike and contrast markedly with those of the blacksmith and Central Senari farmer groups. Both ensembles, for example, use three high-pitched pottery bowl drums of diminishing size. Second, the Tyeli and Fodonon groups were the only ones with a masking tradition featuring the action attribute of climbing the roof of the dead member's house as part of the funeral ritual. How-

ever, the Fodonon *Gbön* has antelope horns whereas the Tyeli *Korubla* is hornless: this is an important typological distinction.[21] Finally, both groups have the *Koto* masking tradition, a fiber masquerade type of considerable importance to their initiation cycles. Only minor stylistic variations (such as color scheme and raffia-layering methods) differentiate each *Koto* type (see pl. 59; Appendix, I-D).

In broad outlines, the Tyeli's version (pl. 71 [color]) is nearly identical in format to the Fodonon's *Koto*. Features in common include the black, knit head mask with the red center crest coiffure ornamented with cowries and white feathers; the rounded body of layered raffia wraps; the ornamental detail of the round brass disks; and the vocalist-musician accompaniment using the calabash–string net rattle. As discussed in Chapter 1, the Tyeli ethnic group has come to be associated with the vocational specialization of leatherworking. Details particularly appropriate to the leatherworkers' identity include such extras as the bright red double arm band (arm band charms are a standard market item provided by their craft), the stitched "buttons" ornamenting the crest, and the red and white cowrie ankle bands added just above the raffia "feet." A comparison of the Fodonon *Koto* and the Tyeli variant underlines the essential conservatism and consistency of the Fodonon style. For example, the Tyeli add an extra tier, or skirt length, that falls just below the calves, thereby losing the domed contours of the *Koto*, which are a diagnostic feature of Fodonon style. And despite the similar construction of the two masquerade forms, the bright, polychrome panels of the Tyeli *Koto* masquerade preclude its being identified as a Fodonon *Koto* with its characteristically Fodonon color scheme of red and cream raffia. The polychrome panels do not provide a parallel diagnostic of "Tyeli," however, since, in addition to the Tyeli, the Kufulo, the Tyebara, the Fono, and the "Työhöbele," or Dyula, all have been found to arrange raffia into variegated panels of color.

The particular Tyeli masquerade illustrated in plate 71 (color) was photographed at a Great Funeral (*Kuumo*) in the Kafiri area. The performance context affords an additional clue to mask identification since the supportive, or secondary, masks associated with each *Koto* type are considerably different. The Tyeli *Koto*'s arrival is preceded by a comic fiber mask intentionally ill formed and unbalanced in appearance. The Tyeli liken the two masks to "a beautiful woman who gives birth to an ugly child." In common with numerous secondary mask types, the "ugly child" has a practical function, "policing" the crowds and ensuring a controlled performance arena for its superior mask. Typically, this role is signaled visually by the attribute of a

small whip. In a performance, the "child" comes out first and the "beautiful mother" last. The "ugly child" mask gambols out into the dance arena in a series of uncoordinated skips, its topknot of raffia flopping disjointedly and its stringy cape hanging limply. Then, with dignified and measured strides, the "beautiful" mask arrives and greets the elder leadership on bended knees before launching into its whirling dance.[22] Thus, the visual appeal of the *Koto* mask is intensified by a dramatic contrast with the deliberately unaesthetic. The lower rank of the supporting mask is also underlined by this device.

This skillful heightening of aesthetic effect through the device of contrast occurs elsewhere in Senufo masking traditions. In the Kufulo region, the refined beauty of the Fono (blacksmith) Junior Grade face mask is much appreciated by its audience at funeral celebrations. Blacksmith Junior groups were observed to employ a contrastive device similar to that described above, and in this case the purpose clearly involved the establishment of a different age-set status as well as aesthetic reasons. During one blacksmith funeral for an initiate of *Kwörö* status, a younger boy, a beginner at learning the art of *Kodöli-yëhë*, was brought to the dance circle costumed in the most pathetic travesty of a carved *Kodöli-yëhë* that one could imagine (pl. 68). The costume was wrinkled and riddled with holes, but the central contrast lay in the face mask, which went wrong on about every point demanded by the acceptable standard of what a *Kodöli-yëhë* should be: it lacked the slit eyes, side projections, center crest, sharply defined features, and smooth, glossy surface (all being essential criteria as specified by Fono elders). The ideal *Kodöli-yëhë* was illustrated by the Junior Grade masker who followed the first performer's appearance (pl. 69). By means of sequence and contrast, its beauty was heightened by the antiaesthetic qualities of the learner's mask. In effect, style differentiation, in this case intensified by the device of the antiaesthetic, is an expression of age-set status and differentiation.

YALIMIDYO FIBER MASQUERADES: THREE VERSIONS

Fiber masquerades constitute a virtually unknown dimension of Senufo art. The *Yalimidyo* fiber masquerade is a striking example of Senufo soft sculpture, created by a rich mixed-media assemblage incorporating stuffed fibers, textiles, metal and cloth appliqué, braiding, and some other techniques and materials. The constantly recreated versions of the masquerade for each Senior Grade initiate class in both farmer and blacksmith Poro societies become the focus of a keen sense

of local and regional competition for aesthetic effect and thus an important expression of male pride and age-grade and ethnic group identity. I have freely translated *Yalimidyo* as "Linguist" mask in order to reflect the primary task of the *Yalimidyo* masker, who must be a master of the verbal arts. He must be learned in and adept at the use of the Poro secret language, with all its subtlety of double entendre; he also must be praise singer, dancer, and mime, with a gift for spontaneous comedy and satire. Multidimensional in purpose, *Yalimidyo* is a spiritualized personage, both sacred and profane; he is at once ancestor, elder, and clown. As an emissary from the sacred forest, he speaks for Ancient Mother, the mother deity. A classic example of the mask as an instrument of leadership control, *Yalimidyo* acts as a mouthpiece of social consensus on sanctioned and unsanctioned behavior and in serious cases is empowered to serve a policing function, using violent means if necessary. In the Poro repertoire of the Kufulo and Fono, the *Yalimidyo* mask (pls. 11 [color], 61; Appendix, IV-C) is second in importance to the zoomorphic helmet masquerades only. Once one gets beyond a Western assumption that only carved masks qualify as art, a manifestly inadequate concept for appreciating Senufo art and aesthetics, then the *Yalimidyo* mask type can be seen as the most interesting of the Senufo masquerades in some ways. The *Yalimidyo* stylistic range is considerably more versatile than that of other types, and its activities are richly multifunctional (for details see Appendix, IV-C).

The *Yalimidyo* masquerade type, and its equivalent in other dialect groups, is a clear example of stylistic (not typological) variation as an expression of ethnicity, of style as an index to ethnic group identity. As well as can be judged on the basis of documentation in the Tyebara, Nafanra, Kafiri, and Kufuru dialect areas, this mask type is a constant in the Poro masquerade repertoire of all groups in the Central Senari dialect cluster (the names vary, but not the basic type). At the same time, the style varies significantly from one dialect area to another. Compare, for example, the sharp stylistic variations that distinguish the Kufulo type (pls. 11 [color], 61) from the Tyebara type (pl. 72) and from the Kafiri type (pl. 73). Indeed, since the masquerade components are designed and executed by the members of each local *sinzanga*, this particular mask, and all fiber mask types in general, are suited better to a study of substyle or dialect area relationships than are the carved wooden mask types. The latter are created by specialists who are part of an artisan network that tends to ignore subgroup boundaries.

THREE HELMET MASQUERADES

As we know from the Tassili frescoes, the horned cap or helmet is an ancient West African masquerade form. Throughout the western Sudan, antelope masking traditions are frequently associated with initiation, with the introduction of agriculture (e.g., the Bamana *Tyi Wara* mask), and with male power (i.e., ensuring the exclusion of women from certain roles). To the Senufo, the antelope is the "bush horse," associated with speed, endurance, beauty, pride, status, and prosperity. Above all, the horned imagery of the antelope, along with that of the wild bush cow, is a major symbol of power and magic. Small antelope horns are used as containers for herbal and magical substances; fine antelope skins are used as the membranes of drum heads of the sacred Poro drums. The beautiful but dangerous horns of large antelopes, such as the roan antelope, provide one of the sculpturally expressive motifs of helmet masks used in certain categories of Poro societies' masquerades.

At its best, Senufo zoomorphic helmet masquerade assemblage is a condensed visual statement acknowledging the reality of evil and at the same time providing a means to deal with it. The masquerades incorporate natural substances and iconographic elements that are both signs and magical appropriations of the aggressive, combative powers of dangerous creatures of the bush world. By the processes of form reduction, the combination of natural forms in unnatural ways, and the addition of accumulative materials to the assembled masquerade unit, Senufo artists and performers have evolved images of tremendously expressive power (pl. 64). Horns; tusks; doubled arrays of teeth; hyena and wildcat skins; lush, green leaves from the dense foliage of the sacred forest; porcupine quills, which may be compared to lethal arrows lanced at the enemy; potions of herbal knowledge, blood, and sacrifice—they are but a few of the images that speak of knowledge, power, danger, and death. Along with the image of the chameleon, with its reference to transformational powers and primordial knowledge (Glaze 1978), the most dominant motif is the warthog tusk. A daggerlike image of concentrated aggression, the tusk is a visual metaphor of the pain and disorder that enter human society through supernatural or human malevolence. The wild boar, when angered, is a destructive and mindless force, its erratic and violent nature the very opposite of what the initiation societies teach as ideal human behavior. The blacksmith *Kunugbaha* masquerade, illustrated in plate 64, presents an explosion of pointing tusks; in a rhythmic repetition of the mouth tusks, two thrusting pairs of tusks face each other like a battery

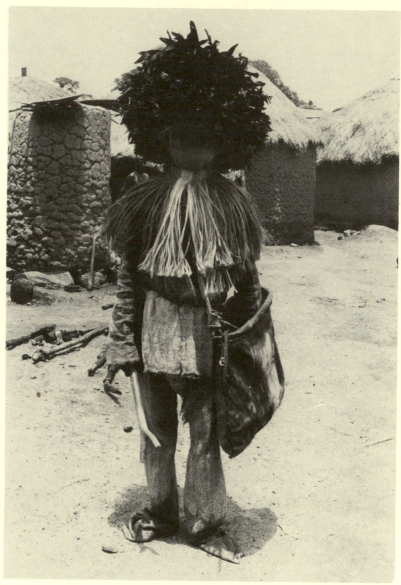

Plate 72 Tyebara variant (*yaridyogo* is the public name)
of the Kufulo *Yalimidyo*, assisting at a neighboring Ku-
fulo celebration of *Kwörö*. Its dramatic black feather
headdress sets it apart from the Kufulo style (May 1970).

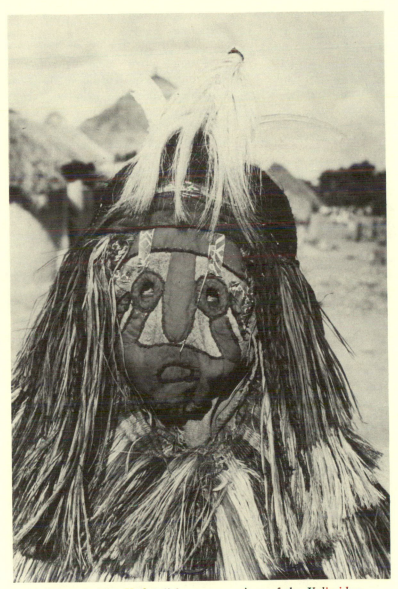

Plate 73 The Kafiri dialect area variant of the *Yalimidyo* type features a naturalistic coiffure of tressed braids, a reference to the elaborate hairstyles of *Tyologo* initiates, who were forbidden to cut their hair for three years (Sirasso area, 1970).

of antiaircraft guns. Thus do the mask forms reiterate the theme of the necessity of control in this imperfect world. The masquerade imagery defines its purpose—an antievil weapon that elders of the village have devised for legitimate social and political control.

A brief note on the helmet masquerades of Kufulo region farmer and artisan groups will serve as a final example of Poro society masquerades as an expression of group relationships. As stated in Chapter 1, the crucial symbiotic economic relationship of farmer and blacksmith groups in the Senufo area seems to be paralleled by the ritual interrelationships of these two groups at the village level. In a highly synthesized version, one could say that, traditionally, the farmers and blacksmiths have a mutual economic need—the exchange of agricultural produce for tools—and that although political control is in the hands of the farmers, they are dependent to some extent on the blacksmiths in certain matters dealing with the supernatural as it concerns the welfare of the individual and the community. To begin with, the farmer groups are dependent on the blacksmith-carvers to supply the very instruments of worship, the sculpture of *Sando* divination and the Poro society. Second, the blacksmith himself has come to acquire the role of mediator and ritual specialist in many Sudanic groups, and there is some evidence that this may be the case in Senufo culture. At the same time it seems clear that, in the Senufo context, blacksmiths and other minority groups may acquire or consolidate political authority and personal power through the possession of supernatural knowledge associated with a particular masking society (i.e., Poro-related) or personal shrine. In this sense, the ritual and economic reciprocity do not describe the whole picture. Although much remains obscure about the historical development and the complex infrastructure of this relationship, it is certain that a classification of Senufo visual arts and an analysis of their meaning must take into account the farmer-artisan interaction. The Kufulo data provide a few fresh facts relevant to this general question and suggest the hypothesis that this interaction has had a significant role in the origin, diffusion, and use patterns of Senufo figurative and masquerade types and styles.

The selected data from my analysis of Kufulo region funerals, outlined in table 6, illustrate the involvement pattern of helmet masquerades used by the three major ethnic groups with active Poro organizations in the focal area of study. The three zoomorphic helmet masquerade types, highest-ranking and most powerful masquerades of the Poro societies, are the Fodonon's *Gbön* (pl. 9; Appendix, I-G), the Kufulo's *Kponyungo* (pl. 63; Appendix, III-C), and the Fono's *Kunugbaha* (pl. 8; Appendix, II-D). Forty years earlier than the period

Table 6
Farmer and Artisan Ritual Interaction:
Performance Pattern of Poro Society Helmet Masquerades
in Kufulo Region Funerals

| Identity of Dead One | | | Zoomorphic Helmet Masquerades | | |
| | | | Farmer | | Artisan |
Ethnic Group	Sex	Status (E-Elder, G-Graduate of Poro)	Kponyungo (Kufulo)	Gbön (Fodonon)	Kunugbaha (Fono)
Fodonon	F	E/wife of rainmaker			x
Kufulo	F	E/wife of village chief	x		x
Fodonon	M	G/son of village chief		x	†
Kufulo	F	E/wife of village chief			x
Fono	M	E	?*		x
Fono	F	E/*tyotiya*	?*		x
Kufulo	F	E			x
Kufulo	M	E/dual Poro membership	x	x	x
Fodonon	M	E		x	†
Kufulo	M	G/dual Poro membership	x	x	x
Fodonon	M	G/relative of *sinzangafölö*	x	x	x
Kufulo	M	E	x		x
Kufulo	M	E/*nokarigafölö*	x		?
Fodonon	M	E/*sinzangafölö*	x	x	x
Fodonon	F	E/head of Tyekpa			x
Kufulo	M	E/chief	x		x
Fono	M	Pre-G			
	F	E			x
Fono	F	E/head of *katiolo*	x		x
Kufulo	M/F	M—an ancient dead one F—of chief's *nërëgë*	x		x

*Data incomplete for these two funerals; question mark indicates probability of farmer participation; this deduction is based on later funerals at same village.

†In the two villages concerned, the Tyeli *Korubla* mask assisted at a Fodonon farmer funeral, seemingly replacing the Fono mask.

Of a total of thirty-six documented funerals, observed in part or in their entire sequence, this group of nineteen samples was selected as most representative of funerals in which helmet masquerades appear. It should be noted that even one generation ago, many of these funerals would have included participation of Poro societies of Kpeene and Tyeli groups, heavily Islamized.

represented by table 6 (1969–70), the number of participating Poro masquerades would have included representatives of the Kpeene, Tyeli, and Tyeduno Poro societies of settlements now converted to Islam. As indicated in table 6, the only other participating ethnic group with an equivalent helmet masquerade was the Tyeli, a group of quasi-artisan status. Only two Tyeli groups in the Kufulo region still maintained an active Poro society. The local Kule, all temporary "guests" (however long term), returned to their villages of origin (e.g., Korhogo, Sumo) for Poro ritual activities. But even allowing for the collapse of local Kpeene and Tyeli Poro societies, the three ethnicities—Fodonon, Kufulo, and Fono—have always been the three principals at area funerals.

With this in mind, a striking feature of area funerals emerges from a comparison of the data presented in table 6—the ubiquitous presence of the blacksmith masquerade. In significant contrast to the other Poro helmet masquerades in a multigroup village, the blacksmith masquerades are present at *all* funerals of village elders, whether male or female or whether a member of the blacksmith group. None of the other helmet masquerades consistently cuts across group boundaries in this fashion.

The *Gbön* masquerade is restricted to men only, graduate members or advanced initiates of the Fodonon Pondo society. The *Gbön* participates in funerals of elders of other ethnic groups only if those people have completed one or more parts of Pondo and thus hold a dual membership in Poro. Moreover, the *Gbön* masquerade and companion ("wife") *Poyoro* masquerade are rigorously excluded from the funeral ritual for women leaders in the Fodonon group, although the blacksmith *Kunugbaha* never fails to constitute part of the women's ritual. The evidence indicates that the blacksmith *Kunugbaha* masquerade performs an essential and possibly unique role at funeral ceremonies of village leaders and associated members of the men and women's organizations.[23]

CONCLUSION

In this chapter I have examined those aspects of the Poro society important to a general understanding of its social, ideological, and ritual context. A central focus has been social and religious education within the traditional framework of the initiation system and its associated art forms. I have also emphasized the role of masquerades as a visual index to sex role, ethnicity, age status, and the pattern of gene-

rational and ethnic group interaction in community-wide events. Finally, in the context of Poro as well as Sandogo, we have seen the *engagement* of art in this process at what the Senufo would view as the most important level of relationship—that of man and woman, farmer and artisan, initiate and graduate, to the supernatural universe that sustains them.

Conceptually, the *Kwörö* initiation rite of passage can be compared to the funeral: the initiate's experience and the death of an elder have in common the theme of social and spiritual death and rebirth. The funeral, which should be viewed as the final rite of passage in the Poro system, concerns physical death, in which the dead one is transformed into a new state, that of ancestral spirit made beneficial to the living by appropriate funeral ritual. In both, death is an occasion for the village leadership to reaffirm and solidify the values and institutions of the living. The deeply symbolic relationship between initiation and funeral ritual is stated explicitly in the secret language encoded in both Sandogo and Poro dance movements. During that part of the funeral ceremony when aesthetic and ritual elements reach the dramatic peak of a gradual three-day crescendo of activities, the body is straddled and slowly passed over three times in what Fodonon elders call "the initiation of the cadaver" (pl. 88). A ritual act of dual meaning, the gesture recalls the three age grades of arduous service in Poro and simultaneously dances out the "birth" of a new ancestral spirit.

RÉSUMÉ 1:
THE BASIC INITIATION CYCLE OF KUFULO AND FONO PORO SYSTEMS

Farmer and blacksmith groups throughout the Central Senari region follow the basic cycle below, with minor variations.

PRIMARY GRADE (INDEFINITE TIME PERIOD):
"CHILDREN'S PORO" (PIIBELE PORO)

Age: Children begin anywhere from six years of age to early teens
Masquerade: *Kamuru*

JUNIOR GRADE (SIX-AND-ONE-HALF-YEAR CYCLE): PLAWO

Age: Fifteen to seventeen years of age on entering first phase
Years 1–3: *Plawo*, "the Little Ones"

Farmers: An important proving ground of initiates is in the fields; hoeing contests (*kahama*) are work transformed into ritual.

Sculpture: Champion-cultivator staff (seated female) or *Kpono* (eagle variant) or both: *tefalipitya*

Blacksmiths: An important proving ground is traditionally the forge, though most Fono initiates now also practice *kahama* and have *tefalipitya*.

Masquerade: *Kodöli-yëhë*

Year 4: Ritual participation in the Senior initiates' fourth-year advancement ceremony (*Segbo*)

Year 5: *Kwörö*, two-month seclusion climaxed by advancement ceremony.

Fiber masquerades worn by Junior initiates (*kwöbele*):
 Kmotoho (both Kufulo and Fono)
 Gbongara (Kufulo)
 Kwöbele-kodöli (Fono)

Masquerades worn by assisting Senior initiates:
 Yalimidyo (both Kufulo and Fono)

Displays, including mud sculpture featuring *Kponyungo*-type carving

Year 6: A rest period for new graduates

Year 7: Entrance into *sinzanga* as new *tyolobele* (Seniors)

SENIOR GRADE (SIX-AND-ONE-HALF-YEAR CYCLE): TYOLOGO

Age: Twenty-two to twenty-six years of age on entrance

Years 1–3: This period is the most demanding in fees, obligatory work parties, strictly defined ritual dress codes, and instructional sessions. Each year is terminated by a feast.

Masquerades include: *Tyelige*
 Yalimidyo
 Kunugbaha (Fono)
 Kponyungo (Kufulo)

Year 4: *Segbo*, advancement ceremony

Year 5: Supervision of the *Kwörö* initiation and ceremony

Year 6: A rest period

Year 7: *Kafwö*, final graduation

RÉSUMÉ 2:
PONDO, THE FODONON VERSION
OF THE PORO CYCLE

This résumé is an abbreviated outline for comparison with the Poro cycle of the Kufulo and Fono. The three Fodonon age grades are again divided into three subdivisions, each of which has a special name. Since there are major structural differences between the Fodonon cycle and the Kufulo-Fono cycle, I am using a separate terminology for the age grades of the two systems. What, for convenience, has been termed the Fodonon "Middle Grade" does not correspond with the Junior Grade of the Kufulo-Fono system. However, a reasonably close parallel can be drawn between the Fodonon Lower Grade (*Plaö*) and the Kufulo-Fono Junior Grade (*Plawo*). The Kufulo-Fono Senior Grade (*Tyologo*) is rather like a condensation of the Fodonon Middle and Upper grades.

PRIMARY GRADE, OR "CHILDREN'S PORO"

Age: Children begin anywhere from five to eight years of age
Masquerade: *Kanbiri*

LOWER GRADE: PILAAO, "THE LITTLE ONES," OR
POMBIA, "CHILD OF PORO"

Age: fifteen or sixteen years of age on entrance
Phase 1: *Tiga* preparatory school (last three months of rainy season)
Phase 2 (six-and-one-half-year period):
 Entry into sacred grove activities.
 Masquerade: Entrance rites include first direct exposure to *Gbön* masquerade.
 Field work contests (*kahama*) with *tefalipitya* cultivator staff
 Masquerades: From the time of entry into the *sinzanga* as a new *pombia*, the Fodonon initiate has the right to wear all the masquerades of the Pondo repertoire, depending on his aptitude and family connections. For example, boys begin practicing the acrobatic leaps of *Koto* secretly in the bush many years before they actually may be privileged to perform at a funeral. De-

tailed descriptions of the forms and performance contexts of
these masquerades are given in the Appendix.

Tyo
Kurutaha
Koto
Nafiri
Poyoro
Gbön (In fact, only select older initiates would carry the
Gbön masquerade.)

<div align="center">

MIDDLE GRADE (SIX-AND-ONE-HALF-YEAR CYCLE):

PILALËËSALANG'O ("THOSE WHO RELY ON" OR "SUPPORT" THE "PILALËËO")

</div>

Age: Twenty-two to twenty-three years of age on entrance
During this period they serve as instructors at *Tiga* school, teach-
ing the new *pombibele* techniques of funeral ritual and "resting"
from severe duties and fees.

<div align="center">

UPPER GRADE (SIX-AND-ONE-HALF-YEAR CYCLE):

PILALËËÖ (THE "ELDER" OR "MATURE CHILD")

</div>

Age: Twenty-eight to thirty years of age on entrance
Heavy fees and responsibilities renewed, including learning ad-
vanced areas of Poro knowledge.
Final year: *Kafwö* graduation ceremonies (comparable to Kufulo-
Fono *Kafwö*)
Graduation masquerades: *Koto* team—*Koto*, *Kurutaha*, *Tyo* (pls.
59, 60, 70). This important masquerade team appears at both
Kafwö graduation and at funerals. The *Koto* masker plays a key
role at graduation, validating the new secret name of the Pondo
graduate. The *Tyo* and *Kurutaha* maskers' activities are mainly
fund soliciting and joking with elders in the audience, their more
dramatic comedy routines reserved for entertainment at the com-
memorative funerals honoring past graduates.

RÉSUMÉ 3: TYOLOGO, SENIOR GRADE OF THE KUFULO-FONO PORO CYCLE

"True" Poro begins with entry into the *sinzanga* sanctuary, which
inaugurates the arduous final initiation period. *Tyologo* is both the
most critical period of training in Poro and a time of obligatory

service to the community of elders. Above all other responsibilities, it is the duty of *tyolobele* to serve their organization at funerals; this entails an extensive range of tasks, including upkeep of the *sinzanga*, difficult travels, long watches, and masquerade performances. A second major responsibility is *tyotiya*, the *tyolobele* cooperative work force in the fields of the member elders.

Year 1: on the eve of *Yewöhö*, the first month of the Senufo ritual year, the initiates enter the *sinzanga*, where, after a night of ordeals, they will live for a period of time, sleeping within an enclosure designated for their use.

Years 1–3: The first three-year period is the most demanding in fees, obligatory work parties, strictly defined ritual dress codes, and instructional sessions. In former times, the *tyolobele* could not cut their hair during this period; hence the elaborate coiffures still retained in male figurative sculpture.

Masquerades: First, the learner mask, *Tyelige* (pl. 10 [color]), then *Yalimidyo* (pl. 11 [color]); select initiates wear the Poro helmet masquerades, *Kunugbaha* (pl. 8) or *Kponyungo* (pl. 63), of their respective Fono or Kufulo *sinzangas*.

Year 3: *Karimano* (July), Third *Poliire* (Poro feast): *Nosolo* masquerade. Large feast provided by initiates each year. The *Nosolo* advancement celebration is also a time of singing ancient songs with the sacred *numaha*, a carved trumpet. Roofing, bas-relief sculpture, and paintings on *sinzanga* storage houses are renewed at this time (once every six and one-half years) (pl. 39). Many weeks in preparation, the spectacular and "very powerful" *Nosolo* masquerade promenades through the village, with its body like a "house of cloths" and its small *Kponyungo* (the head component same as that in plate 57). Afterwards, all but the carved animal head is burned.

Year 4: *Segbo* (or *Syoongoro*), advancement ceremony and feast, a public ceremony honoring the *tyolobele*. An impressive procession of *Segbo* graduates, followed by younger Junior Grade initiates, leaves the *sinzanga* toward an enclosure constructed near the edge of the village, above which rise two long drums mounted horizontally on high posts. *Segbo* graduates have cut their hair and now wear colorful cloths wrapped around their waists. Flanked by older musicians astride the long drums first mastered as *Kwöbele*, each graduate sings to the villagers of his joy at coming this far.

Year 5: A year spent in the supervision of the *Kwörö* initiation and the advancement ceremony for the Junior Grade.

Year 6: During this rest year the men are released from heavy

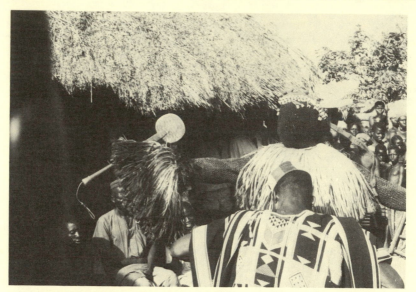

Plate 74 A recent Pondo graduate in *Kafwö* graduation robe with rich overweave patterns greets a *Koto* masker, who holds the insignia *gbenege* ("stirring spoon"), a symbol of its femaleness (March 1970).

fee and labor obligation to the elders and are freed to work full time in their own family and personal fields.

Year 7: *Kafwö*, final graduation. For the initiates, *Kafwö* is the culmination of a long, rigorous period of training, hardship, and service. For them and their families, *Kafwö* is a time of great joy and pride. Fono graduates, for example, travel in pairs from compound to compound throughout the village, singing of their happiness, giving details of their past hardships (e.g., walking long distances to funerals, carrying heavy masquerades and drums) and of the personal sacrifices of friends and family who helped them financially. For months the graduates' families are busy gathering tremendous quantities of cowries, goats, honey mead, beer, and, above all, the graduates' chairs and expensive "coming out" robes of colorful woven textiles (pl. 74).

CHAPTER 4

The Funeral as Synthesis

 The Senufo funeral is a multimedia event designed to protect the living and to ensure the continuing integration of social groups and the village community as a whole with the spiritual world of Deity, the ancestors, and the bush spirits. Secondary gains, such as the reinforcement of social values, group integration within the village, the stimulation of the creative arts, and the pleasures of pure aesthetic enjoyment, are contingent upon this first and central purpose of the funeral.

Virtually all activities associated with the funeral are designed to meet the requirement imposed by certain ideological premises. The entire series of events that form the funeral are undertaken for one encompassing purpose: to mark the completion of the spiritual, intellectual, and social formation of the individual member within the group and to create the necessary conditions under which the dead one will now leave the world of the living. The funeral is the final rite of passage, one that transforms the dead into a state of being that is beneficial to the living community, thereby ensuring a sense of continuity between the living and the dead. Only in the "village of the dead" can the dead one function effectively and safely as an ancestor, a mediator between the human and the supernatural. Left angry or dissatisfied with relatives and the home village, the dead one remains a dangerous threat to all succeeding generations. Even those events which have a strong element of pedagogy, entertainment, prestige building, sheer aesthetic pleasure—all can be seen as ultimately part of an effort on the part of family and age mates to protect their future and their children's future as well as to commemorate a particular individual. The close link between the ritual funeral thus conceived

and the imperatives of ancestor worship becomes all the more evident when one observes that the deaths of infants, the uninitiated, and victims of violence or accident are handled in an entirely different way from those of "completed people," that is, initiated members of society, who alone qualify for ancestral status.

The word *funeral* does not readily translate cross-culturally from Senufo to English. A proper commemorative funeral is defined by ritual requirements. It may either begin with events preceding and surrounding burial or take place some months or even years after the actual burial, at a time when the family is able to complete the complex preparations. Thus, a preliminary distinction must be drawn between the event of formal or informal *burial* and the more selective ritual funeral incorporating the ancestor rites. Whether any one case of death involves mere burial or a ritual funeral depends upon the nature of the death and the age and status of the dead person. Depending on circumstances, the actual burial may be handled quietly and expeditiously according to basic formulae. An infant death, for example, receives no public mourning ceremony; social custom allows no tears since such an infant is generally considered to have been a dangerous python spirit in human guise.

In a word, the death of anyone but an initiated adult of considerable age is considered "abnormal" and viewed with suspicion of supernatural or magical intervention. Death may come in the form of sickness, but the disease itself is not thought to be the true cause. The ultimate cause of such a death is generally attributed to one of the following agencies or actions:

1) witchcraft or sorcery; that is, human malevolent intent in collusion with and empowered by evil spirits (*dëëbele*).

2) evil or malignant spirits acting independently. For example, the victim may have accidentally disturbed or offended some spirit in the fields or bush.

3) deceased human beings (*kuubele*, "the dead ones"), of whom there are two categories: the "wandering dead" (dead elders who have not been given a proper ritual funeral and who therefore are in a dangerous state of suspension between the worlds of the living and the dead[1]) and the ancestors (important dead of the family or village who are "angry" with the failures and sins of the living; spirits of *Sando* diviners are especially lethal when crossed).

4) bush spirits (*madebele*). Much of the suffering and adversity that touch Senufo lives is attributed to persecution by these unpredictable spirits, but through sacrifice and worship they can sometimes be placated.

5) violation of *taboos* associated with a wide range of sacrificial

objects and altars devoted to spirit worship (*yasungo*, "thing sacrificed to" or "on").[2] Such violation includes the failure to observe avoidance patterns and sacrificial and magical requirements associated with spirits worshipped by members of any particular organization, such as clan, a hunters' society, a healing society, or a men's society.

Thus, an uninitiated child or young person who unexpectedly dies brings to the family grief and the obligation to seek through divination the supernatural cause of such misfortune. After a series of consultations and sacrifices, there may be one or two nights set aside for publicly honoring the dead youth with feasting for guests and dancing in the village. But only those musical instruments of relatively low rank, such as the balafon, may be used, and very few, if any, masquerade types appear. A young Fono who dies before the *Kwörö* initiation phase, for example, would merit only the masquerade appearance of his age mates with the blacksmith Junior Grade *Kodöli-yëhë* masquerade from his and nearby Fono villages. One funeral I observed involved over fourteen blacksmith lineage segments and the same number of face masks.[3]

A different situation altogether is the problem of the *senoro kuu*, a person who suffers sudden death by violence or accident outside the microcosm of the village precincts.[4] Examples of the *senoro* category include death by drowning, serpent bite, arrows, wild beasts, and falling from a tree; in brief, this category applies to "anyone who dies before he can get to the village." Because the welfare of the entire village is endangered by such a death, the village chief, traditional trustee of the land, becomes responsible for setting into motion an elaborate series of precautions, sacrifices, and medicines that will purify the land and protect the villagers from further calamity. Every man, woman, and child in the "infected" village must taste the medicine and pay a token fee of about three cowries. Only men or women of great age and authority have sufficient supernatural protection to risk exposure to the body and supervision of the burial. When purification rites have been completed, a postburial funeral may then take place with ritual appropriate to the age and status of the dead person.

In some cases the withholding of funeral rites relates directly to the status of the dead one rather than to the manner of death. For example, the degrading end of a *möhö*, or uninitiated adult, stands at the opposite end of the "ideal" passing of an initiated elder. Rarely would even nonsacred music groups, let alone the ceremonies of the Poro society, honor his burial. Indeed, finding willing grave diggers might prove difficult. Such is the awful position of the uninitiated adult (one man described such a death as "of no more account than that of a chicken"!).

To summarize, death per se does not necessarily qualify one for a proper ritual funeral; that is, it does not qualify one for ancestral status. As suggested above, ideally death comes only to the fulfilled adult, the initiated elder who has made his or her contribution to village life and who has many children and grandchildren.

Restricting our attention now to the ritual funeral as opposed to the burial, what then is meant when a Senufo refers to a "real" (i.e., ritual) funeral? Stated most simply, the ritual funeral is defined by the ancestral rites performed by the Poro, Sandogo, or *Tyekpa* societies or a combination of them and incorporating a set configuration of instruments, masquerades, and figures appropriate to the memberships involved.

Although all initiated elders have earned the right to Poro society rituals, celebrations with a more elaborately conceived aesthetic content are accorded people of authority and status in the community. Given the premises of ancestor worship, it naturally follows that the more important the individual is in life, the greater will be his or her potential effectiveness as an intermediary between the world of the living and the universe of the supernatural. One memorable funeral I witnessed in the Kufulo region was for the senior wife of the village rain priest (*Ndaafölö*, "rain owner"), a powerful rainmaker who had died some months previously. In the traditional preburial songs (*nyamëënë*), friends and relatives called upon the dead woman to intercede for them with her husband in order that he, in turn, might ask the spirits of the sky for rain on their behalf. Because she was also a member of both the *Tyekpa* society and the powerful Sandogo society and was, above all, an important female elder of a matrilineage segment, many hundreds of people of all age levels and of both sexes and dozens of special instrumental and dance groups participated in her tumultuous and emotional burial-day celebration.[5] The venerable woman head (*nërëjaö*) of a "house" or lineage segment or both, a terrestrial "ancient mother" who is a reflection of maternal deity, is honored by a more embracing community effort than is a man.

Other persons of rank and status whose deaths would entail major funeral celebrations include: the village chief, head of the founding *sinzanga*, "owner of the land"; leaders of other *sinzangas* in the village; head of a matrilineage segment; head of the Sandogo society; heads of the *katiolo* residential units; and possibly other leaders and long-term members of any of the voluntary organizations, *Dözöbele*, the hunters' association, and *Nökariga*, the healers' secret society. In general, large and wealthy families (the two tending to go together in a subsistence economy), whatever their official position, produce impressive funeral celebrations for members of their families for rea-

sons of personal pride and prestige. Indeed, an element of ostentatious display of wealth appears to be a significant factor in addition to motives based on the ideology of ancestor worship.

Of paramount interest to the student of art and society is the fact that given the ideological premise of ancestor worship, the Senufo have chosen to employ aesthetic means as a primary way of dealing with the potential dangers of spirits of the dead. In the context of the funeral, sculpture, dance, music, and song text become instruments that provide closure for a person's life and activate the transition to a new status, that of ancestral spirit. Not only does the funeral include works of art, but the total event can be viewed as an orchestrated "work of art." The outside observer first experiencing a Senufo funeral is likely to be struck by the colorful but confusing crosscurrents of people, sounds, music, dances, maskers, costumes, displays of composite object assemblages, and a host of separate undertakings that together constitute the funeral. The apparent disorder is deceptive, however, for the Senufo discern an orderly progression of carefully defined and controlled events.

Every funeral for an elder has the same overall design—its formal structure, directional flow, and tempo are of similar pattern—yet each is individualized. Detailed elements of the design change according to individual identities and group membership: influencing factors include sex, age grade, ethnic group, membership in voluntary organizations, titles and status in the secret societies, family status, wealth, and social prominence in the community. In the most logical fashion, the Senufo funeral tends to reveal visibly and dramatically the nature and quality of a person's life. The measure of a man or woman's life is expressed both qualitatively and quantitatively in the design of the commemorative funeral. A long life characterized by numerous attainments and a proliferation of structured social relationships will be reflected directly in the commemorative funeral by length, elaboration and richness of texture and detail, and the number of participating individuals and groups.

In the Kufulo region and neighboring dialect areas three separate categories of funeral celebrations for elders may be distinguished:

1) *kuugo*, or *kuu wi yehen ngo* ("laid to rest in the house"). *Kuugo* is burial of the dead with minimal ceremony; however, the term is also used to refer to the first day or two of a funeral, which continues as the next category (*kuufuloro*) into the third and even fourth days. Whatever family and guest activities there may be, such as a display of a champion-cultivator staff, the Poro society is not yet officially "called out of the sacred forest." That is, burial may predate the required ancestral rites.

2) *kuufuloro* (Kufuru dialect, "sounds for the dead") or *kuulëëgi* (Tyebara dialect, literally, an "old" funeral, a term rarely used in the Kufulo region). *Kuufuloro* refers specifically to the sacred Poro drumming and generally to prescribed ancestral ritual performed by Poro members and featuring the most sacred art forms (certain categories of masquerades, musical instruments, and figure sculpture). A definitive mark of the *kuufuloro* is the official calling-out of the *tyolobele*, whose most important duties as Senior Poro initiates are concentrated in activities surrounding the funeral.

3) *Kuumo*, the "Great Funeral." *Kuumo* is a community funeral, a mass commemorative celebration for a village's dead. Traditionally *Kuumo* is a programmed festival of long planning and on a scale involving open invitations throughout several dialect areas. A *Kuumo* is held about once every five years.

The root word for all three is *kuu*, meaning "death" or "the dead one," according to tonal pattern.[6] In principle, all three categories are produced exclusively for initiated adult members of the men's and women's organizations, although exceptions occur. For example, most sacred forest groups will perform simple ritual funerals for young men who have advanced as far as the *Kwörö* phase. Also, under special circumstances, such as in the case of a daughter of a high Poro society official or the fiancée of a *Tyologo* initiate, young women will receive edited versions of ritual funerals. For example, the *tyolobele* perform a special dance for women employing sacred instruments, such as the *numaha* (wooden trumpet), normally reserved for men's initiations and funerals.

The first two categories most frequently are joined sequentially into what is effectively one funeral. The critical factor is the timing of the specific Poro society ritual that technically defines a *kuufuloro*, a funeral celebration that includes vital Poro ritual. In the case of the blacksmiths, for example, the essential ritual act is sometimes known as the "*pondoro*" rite (literally, "the Poro comes to fall"), a reference to a specific act of the blacksmith helmet masquerade *Kunugbaha* with its drum.[7] It is the various secret Poro society masquerade and drumming rituals that open the way to acceptance of a dead elder into the place of the dead, the ancestral world. Whatever else may happen at a funeral—display of champion-cultivator staffs, playing of balafon orchestras, dancing, and related activities—it is technically not the "real" funeral unless certain core Poro society masquerades and sacred drum songs are performed. A typical pattern would be, for instance, a death occurring on Sunday, *kuugo* on Monday, and the first day of the *kuufuloro* on Tuesday. Among the Senari groups, the *kuufuloro* is sometimes held several months later. If an elder of some

importance dies at a time when it is impossible for the family to organize and finance an appropriately elaborate funeral, the burial will be performed with minimal ceremony, and a proper funeral will be held later. The two most common reasons for postponement are the occurrence of death during a critical period in the agricultural cycle, such as during the rice harvest, when virtually 80 percent of the village has moved to the field houses, and the failure of the head responsible for the funeral to have adequate food or money on hand to support the heavy expenses entailed during a ritual funeral. A third, though less common, reason is the family's need first to determine the cause of death by consulting several *Sando* diviners.

Occasionally an "old" funeral may be held for someone who died as long ago as several generations back. One funeral ceremony I attended was for a kind of "unknown soldier," a Senufo elder who had been killed during an ancient war. The proper rituals had never been observed, and as a result he was causing some of the troubles currently plaguing the village. He was said to have spoken in a dream to one villager, who then sought counsel with the elders. The villager and elders consulted with many *Sando* diviners, who transmitted the message from the ancestors (*kuubele*) that the village must call out the Poro society for a ritual funeral.

The Fodonon group provides an important exception in the Kufulo region to the practice of *kuufuloro*, the delayed ritual funeral. Fodonon custom does not permit separation of burial and ancestral rites except in the terrible circumstances of a *senoro* death, in which case the ceremony will probably take place within a few weeks of burial. This is one of several instances of a correlation between dialect or ethnic group boundaries and significant variations of a given cultural form or institution. In this case, the Fodonon and Kufulo ethnic groups live intermingled but retain a sharply defined difference of belief concerning the propriety of a delayed ritual funeral. It is tempting to see the Fodonon as the upholders of an older, more strictly interpreted code of funeral ritual and the Kufuru, Tyebara, and other dialect groups of the closely related Central Senari cluster as having bent the traditions or compromised them to meet the practical demands of extenuating circumstances, such as bad weather, lack of rice, and travel distance for relatives.

The third category of funeral, the *Kuumo*, or "Great Funeral," seems to be fairly widespread in distribution, although the practice has fallen into disuse rapidly in recent years. In my village of residence, for example, there has been only one *Kuumo* in the last twenty-five years. Within virtually one generation, the Great Funeral has gone into such a decline in the Kufulo region that only a small percentage

of the villages continue to hold *Kuumo* celebrations. In the neighboring Kafige region the tradition has survived better, and I witnessed two quite spectacular Great Funerals in that area during the 1970 dry season.[8] During this period, I heard reports of Great Funerals given by villages in four different dialect areas. Since at least five different ethnic groups were named as sponsors (the Fodönrö, Kufuru, Kafiri, Gbatörö, and Kpeene dialect groups), it seems possible that the institution was once universal among Senufo cultural groups.

Broadly speaking, the *Kuumo* is a mass commemorative celebration for a village's dead, a final public tribute to the men and women who have died over a certain period of time (in the Kafiri dialect area around Sirasso, about every three years). A *Kuumo* never takes the place of a burial funeral or old funeral but rather may be given in addition to the regular ceremonies. It is associated in particular with the commemoration of a great chief or an important leader in the Poro society. Compared to the average ritual funeral (*kuufuloro*, "drum sounds for the dead"), normally involving three to ten villages, the Great Funeral is a vast production just in terms of the number of people involved. Word of a *Kuumo* may go out well over a year before the actual event, the news crossing several dialect areas and ultimately drawing thousands of people from different ethnic groups and villages. This "huge festival for the dead," as one elder phrased it, is held during the dry season—that is, during the period of lightest agricultural work and when climatic conditions for travel, masquerade performances, and dances are at their best.

Kuumo is also the traditional framework for the conclusion of certain key social contracts. First, *Kuumo* provides a last opportunity to meet such social obligations as the presentation of gifts of cloths and money due from those who were unable to give at the time of the funeral, thereby averting a potential breach in group relationships. More particularly, *Kuumo* publicly concludes the remarriage of widows, traditionally to younger brothers or nephews of their former husbands, who thus accept responsibility for their support. From the time of the ritual funeral of her husband, each widow has worn a mourning garment of leaves and ashes; at *Kuumo* it is replaced in the closing ceremony of the festival by a loincloth, cowries, and colorful woven textile (*mahana*) worn draped over the shoulder. The time of mourning is officially closed, and the disrupted family units are "repaired," to use the Senufo expression. Thus, *Kuumo*, at one level of meaning, is a restoration of balance in the social fabric in terms of marriage relationships in the community.

The dramatic ritual interaction of widows and Senior Poro initiates (who are wearing long, white cloths wrapped around the waist) con-

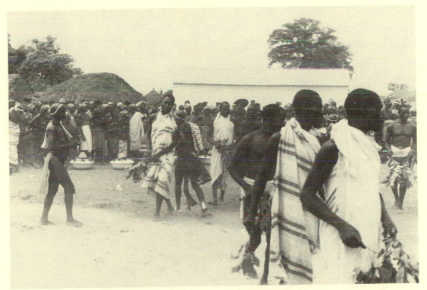

Plate 75 During the dance of Senior Poro initiates that climaxes the Great Funeral, widows in ritual dress rush into the circle to smear oil on the initiates' bodies (Sirasso area, April 1970).

stitutes the concluding ceremony of *Kuumo*. A vast circle of villagers is formed, highlighted at intervals by the widows (*lögutyaabele*), who, in the splendid dignity of their cloths, stand erect behind enormous carved wooden bowls often three feet in diameter. The bowls, heaped with rice, dried fish, spice baskets, and vegetable cakes, are an offering to their dead husbands. They will later be distributed throughout the village, one bowl for each *katiolo*. In the center of the circle, the *tyolobele* perform the *pintyeli*, or "drum and thigh dance," honoring elders "who have done much for the Poro." This dance is characterized by the group's circling in unison, executing steps with slow, measured precision, and carrying decorative clusters of green leaves from the sacred groves "to make the arm movements beautiful." When the dance is finished, the widows rush out to rub oil on the bodies of the now fleeing *tyolobele* (pl. 75). This vigorous skirmish with the young men is a fascinating instance of sex-group interaction in Senufo ritual themes. The purpose of this particular gesture was said to be a dramatized reminder of the countless times the women had ministered to their husbands, heating their bath water and rubbing oil on bodies tired from hours of hard labor in the fields. Significantly, it was said to be "bad luck" if a *Tyolo* was not touched by the women.

A FUNERAL NARRATIVE

At one level, the following narrative of a funeral concerns categories
of Senufo art described more fully in previous chapters or in the
Appendix and is intended to demonstrate how these individual cate-
gories form part of a larger aesthetic pattern, the funeral.[9] The second
concern is not so much the description of a particular ceremonial con-
text per se but rather the human context as a whole, in which "art"
is fully engaged with life and death. In this larger dimension, sweat
and laughter, the taste of yams in a succulent meat sauce, the fierce
pride of status, the fear of evil spirits, the tears of personal loss, and the
reuniting of friends are as much a part of the Senufo funeral as is the
joy of aesthetic experience.

WI KPOO ("HE IS DEAD")

On an ordinary morning the smoothed earthen courtyards of a
Fodonon village compound, the *katiolo*, would be virtually deserted
because all but a few women and children, busy with household proj-
ects, would have departed long since for the fields, workshops, or
markets. However, on the day of a death a disruption of the daily
work rhythm is evident in the small clusters of people sitting about
the courtyard talking softly and waiting. The expectant atmosphere
focuses on a large, bichamber house, where an elder of the *katiolo*
lies on a woven mat. In the outer room of the house a few close rela-
tives and friends sit quietly by the aged man, whose breath comes
harshly and with great effort. Outside, messages concerning food
reserves and cooking assistants are already being sent through the
women to various parts of the village.

When death comes, the man's wife and children weep, and those
who have waited take up the death wail, a stylized expression of loss
and grief: "We won't see him anymore. . . . He is tired and he has
suffered much . . . that is why the ancestors have come to take him
to *kuubelekaha* [village of the dead] . . . his work is finished, so you
cannot grieve . . . he is resting. . . ."[10]

Thus is set into motion the stylized and formal chain of events that
honor and commemorate the life and accomplishments of a village
elder. The funeral is to be a ritual act of both closure and transforma-
tion. The life "of one among us," as the Fodonon say, is finished.
Now the dead one must be given the final rite of passage, the trans-
formation into ancestral being that ensures his departure for the village
of the dead.

Siellepondo Soro was an important elder of the village, head of his *katiolo* and for many decades a leader in his Poro (Pondo) age grade. Having earned in his youth the title of "champion cultivator" and having won respect in later years as a "strong hunter," Siellepondo had achieved an enviable status in the area. Now his family and peers begin preparation for the visual displays and dramatic performances that will publicly proclaim and honor these achievements. Over and above these reasons, survivors dare not risk offending a dead one, an ancestor, who, in the spirit world, can be expected to have stature and power comparable to that in life. Thus, to please both the living and the dead, the funeral must be an event of beauty and pride for the family and village home of this elder. All details of the funeral are subject to outside evaluation and criticism, from the abundance of food and drink to questions of social protocol and correctness of ritual to the aesthetic quality of performers and equipment.[11]

KUUGOFÖLÖ KPAAGI MA
("AT THE KUUGOFÖLÖ'S HOUSE")

Leadership responsibilities for the funeral begin with the *kuugofölö*, or funeral chief—in this case, a younger brother of the deceased—who acts in consultation with the village chief and section chiefs, visiting maternal relatives, the leaders of the appropriate Poro society initiate classes, and other participating groups. As funeral chief, he coordinates the countless negotiations and decisions that control the nature and flow of people, art forms, and performance that "create" the individualized funeral production.

KATYOOLO MA ("IN THE KATIOLO")

The funeral chief's *katiolo* becomes one center of a network of directives and activities reaching throughout the village and beyond. The most important line of communication is with the *sinzanga*, which serves as the second organizational center of the funeral preparations. The *kuugofölö's* first responsibility is to send out the news of the death. After gathering together the boys and young men under his authority, he selects messengers to carry the news of death to both the village leadership and all those villages where there are branches of the maternal family, who must be informed. The burial and final Poro ceremony cannot take place until all major representatives of the lineage group are assembled. During this period of about three days, his brother's body lies at "rest" in the dead one's house (*kpokpaha*).

First to be informed in the village are the chief of the dead man's
sinzanga, the village chief, and the heads of the other *katiolo* and
sinzanga in the village, including the chiefs of the two Fono black-
smith groups, the Tyeli, and the Kufulo groups with their respective
leaders. Next, initiates (*pombibele*) are sent to inform the Poro leaders
in two neighboring villages (Kapile and Puloro) in accordance with
the reciprocal funeral relationship that binds these three villages to-
gether irrespective of the particular kinship ties for any given fu-
neral. On arrival, the messenger first visits the chief of the Poro society
or at least the chief of a section, who then delegates messengers to
spread the news of the death to all those concerned in the village. The
news is given within the Poro society in descending order of author-
ity, first the graduates and on down to the youngest section. Finally,
since it is a Fodonon elder who has died, the *kuugofölö* sends word
to all the nearby Fodonon settlements.

Elders, on receiving the news, meet to decide the nature and extent
of their group's participation. Where ties of origin, kinship, or other
reciprocal relationships are strong, the elders must choose the types of
delegations and performers to be sent to represent them at the funeral,
such as the *lango* dance team (in the case of women elders), balafon
orchestras (in the case of women and nongraduates), harp-lute (*bo-
longböhö*) orchestra (in the case of Fodonon), the initiate classes with
the core masquerades and drum ensemble of their respective *sinzangas*,
the hunters' bard ensemble (*kaariye*), and other entertainment genres.

While the *katiolo* functions as headquarters for the social affairs
and more public activities of the funeral, comparable flurries of activ-
ity concerning ritual and sacrifices are going on secretly in the *sin-
zanga*. As they have been trained to do immediately upon receiving
the news of a death, the initiates of all three Fodonon *sinzangas* change
to ritual dress and race to the sacred forest as fast as they can. Anyone
who tarries risks being fined heavily. As preparation for the important
ceremonies to come, it is the initiates' responsibility to make sure that
all ritual paraphernalia are in good performance condition. Instruments
are checked and tuned, raffia costumes fluffed and trimmed, carved
masks oiled and given fresh details of sacred paint that ritually renews
and prepares the masks for another funeral. Similar preparations take
place in the Fono and Kufulo *sinzangas* on the other side of the village,
where the Senior initiates, the *tyolobele*, are getting ready to assist
their Fodonon age mates in the funeral rites. As soon as they are ready,
the Fodonon initiates' first duty is to pay a ceremonial visit with
Nafiri masquerades (one of the easiest to assemble) and drum ensemble
to the *kpokpaha*, the dead one's house.

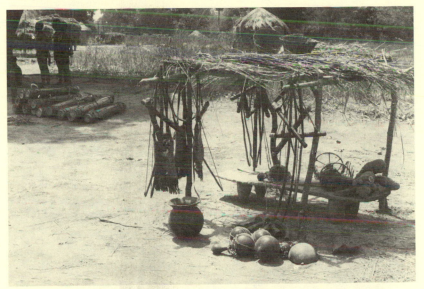

Plate 76 Ritual *kpaala* sheltering the funerary bed, near which
are placed objects relating to the achievements of an elder dur-
ing his lifetime (yams, musical instruments, and basketry car-
rier for produce of his fields). In the background, members of
the Senior Poro class (*tyolobele*) stand watch by the sacred
instruments of the Poro society (February 1979).

KPOKPAHA MA ("AT THE DEAD ONE'S HOUSE")

As soon as the body is washed and the laying-out, with temporary
burial cloths, is completed, the long "watch" begins in the *kpokpaha*.
Custom ordains that the widow not touch food until her husband is
given the proper rites and buried. A few women elders of the village
will take turns sitting by the body day and night until it is taken for
final burial ceremonies. Placed near the head of the cloth-covered
form are various objects that speak of the person's relationships and
accomplishments in life. Since Siellepondo was one of those in his
Poro class who had mastered the songs and calabash rattle of the
Koto masquerade, a rattle is placed by his side. A good farmer is
acknowledged by the presence of any of the crops he has worked
well, so for Siellepondo they have also placed a small pile of fine yams
and a basket overflowing with rice (pl. 76).[12] But Siellepondo was not
just a good farmer: he was *sambali*, a champion cultivator. Therefore,
the most important commemorative objects are the trophy staffs (pl.
77), *tefalipitya* and *kpono*, to be placed just outside the door of the
kpokpaha.

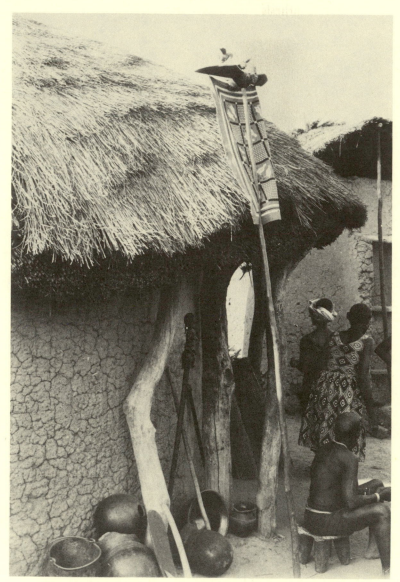

Plate 77 *Tefalipitya* staff and eagle staff on display by the dead one's house at a funeral for an elder *sambali* (champion cultivator) (Kufulo group) (January 1970).

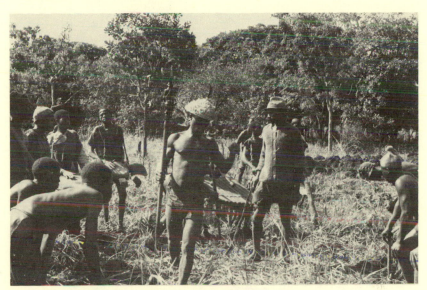

Plate 78 Cultivator contest (*kahama*) in yam field. A champion cultivator (*sambali*) is dancing with staff to greet musicians (October 1969).

The young man of Siellepondo's *katiolo* who is the incumbent holder of the *sambali* title carefully brings out the elegant carved wooden staff, which he is privileged to keep in his quarters as one of the rewards of his champion-cultivator status. This young man is in fact ninth in succession in the genealogy of title holders who have earned the right to hold this particular staff in trust during the period prior to their entry into the final initiation class of the Poro society. Many years past, this sculpture had been commissioned by a great-great-uncle and presented to his nephew, who became the first of the nine holders of the staff. So that all may know and remember that Siellepondo was *sambali*, the young man plants the iron tip of the staff in the smooth clay of the compound floor just beside the door of the house. Feeling a deep sense of continuity with the former generations of *sambali* of the *katiolo* (*tyakpari kuubolo*, the "ancestral champion cultivators"), the youth will henceforth include Siellepondo in his prayers. When it is time again for the hoeing contests, "he can't tire or be defeated by his rivals, for the *tyakpari kuubolo* of his *katiolo* will help him and give success to the field"[13] (pl. 78).

The next day a second champion-cultivator staff is brought to join the first, underlining the prestigious title of the dead *sambali* and boldly proclaiming the courage of the sons of the *nërëgë* segment. As commonly happens in villages of the Kufulo region, both types of

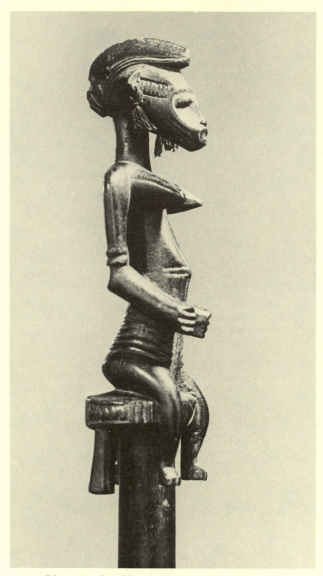

Plate 79 In this champion-cultivator staff, the seated female is presented in the traditional gesture of serene repose, designed as a dramatic contrast to the cultivator's striving in the fields (54″ long; length of seated figure, 9¼″; Afro-American Cultural Center Collection, Cleveland State University).

champion-cultivator staff are represented at the funeral: the seated female figure (*tefalipitya*, or *tyakparipitya* in Fodönrö) and the eagle with young birds borne on the wings (*Kpono*) (pls. 77, 79).[14] Both staff images are visual analogics rich in multiple meaning. To the Senufo viewer, the bird staff proclaims the universally understood analogy between the eagle with young (Bateleur eagle, "red" eagle, etc.) and the champion cultivator's strength, endurance, and courage—qualities that encourage his fellow cultivators to give their utmost to the work and thus make it possible for the vast yam fields to nourish the village as a mother bird feeds her young. The eagle's "children," borne on each wing, refer simultaneously to the younger age sets, who follow the champion cultivator as inspiration and model. The bird is mounted on a high pole, and attached to its wings is a bright red banner that waves festively above the thatched roof of the house (pl. 78). Seated on the stool that crowns the staff below, the beautiful young maiden, proud and upright in bearing, an honor guard in sculpture, looks out upon the visitors who come to greet the dead one (pl. 79). Her taut, young breasts and belly, promise of increase for the *katiolo*, and her perfectly controlled posture and features honor the champion in death as in life. Speaking in a different idiom than the song texts that express verbal praise in the course of the next few days, these sculptures sing out no less praise to the eyes of those who know the visual language of *sambali*: "A good cultivator has brought good fortune to his family; / The earth receives a good thing on Siellepondo's burial day."[15]

<div align="center">

WO DA KARI KPOKPAHA MA

("VISIT TO THE DEAD ONE'S HOUSE")

</div>

Upon arriving at the village, the funeral guest finds his host, who escorts him to the dead one's house. There he throws a few cowries into the room where Siellepondo, wrapped in a beautiful woven cloth of bold colors, lies amid the object display and the mourners holding the small group vigil by his side.

The first gesture of respect accomplished, the guest and his host proceed to the courtyard of the *kuugofölö*, where he is receiving visitors and their gifts. Elaborate greetings are exchanged, and the guest presents his gifts, with his host or some other village contact acting as spokesman. In addition to cowries, gifts of burial cloths and food are presented. By this means the guest both honors the dead and assists the funeral head with the expensive task of feeding large numbers of people and paying for the services of the various performers, including the village Poro organizations. However, these gifts,

especially the traditional cloth, are not merely financial assistance but expressions of social relationships. Certain of these relationships are to be spelled out explicitly in the context of the cloth-counting ritual on burial day.

This particular guest was a friend and age mate in a parallel initiate class in the next village; thus, he presents a cloth as a token of his friendship, also giving 100 cowries to the funeral chief, fifteen francs to the *katiolo* members, and vegetable leaves and peppers (for making sauce) to the widow. Relatives present more substantial gifts of food: large baskets of rice and yams. Multiplied a hundredfold, such cloths and baskets of food soon fill to overflowing the funeral chief's court-yard, creating a market-day atmosphere as guests continue to arrive at the village to make their presentations and renew old acquaintances. The more important of the elders will stay on with the funeral chief and the other elders of the host village. Gradually, in this way a small advisory group builds up of intervillage leaders, who serve as a kind of unofficial support group to the *kuugofölö*.

The relatively steady pace of new arrivals in the *kuugofölö's* court-yard is interrupted sporadically by bursts of heightened activity. Those making final presentations and lingering for relaxed conversa-tion or more serious discussions are joined now and then by more stylized visitors, whose appearance effectively transforms the slightly "market-day" quality of the scene into a more magical world of the arts, wherein oral literature, drama, music, and masquerades recall the underlying supernatural focus of the funeral.

Nyamëënë singers are among the first of the stylized visitors to both the funeral chief's house and that where Siellepondo's body lies in state; in this case, it is Siellepondo's sister and a supportive companion, each holding the hoe-handle dance ornament symbolizing the culti-vator ethic. The women begin "the cord of weeping," relating in song the good character and achievements of the deceased and creating in their audience a heightened sense of loss (pl. 80). When the song is finished, they move on to the next courtyard, beginning a tour of the village family units that will be repeated each day of the funeral cele-bration.

From beyond the courtyards that surround the *katiolo*, where the elders wait, come the reverberating tones of many drums and gongs. A group of initiates playing the sacred instruments of the Poro, pre-ceded by a pair of *Nafiri* maskers, has left one of the *sinzangas* on the fringe of the village and is coming to greet the dead one. The un-initiated, who are near the area where the procession passes, hasten to move behind walls and closed doors. No one but the initiated may risk exposure to the secret instruments of Poro.

Plate 80 Two Kufulo women singing the "cord of weeping" eulogy songs (July 1975).

Since this is a Fodonon funeral, the first of the Poro masquerades to make their appearance are the *Nafiri*, who are called out by the relatives of the dead man. The *Nafiri* usually appear in pairs, with twin designs and color schemes for their distinctive raffia topknots of bright reds, siennas, or dark browns and the tightly fitting knit suits. Each *sinzanga* has its unique geometric, banded patterns, which are readily distinguishable from other *Nafiri* pairs. Each pair is formed of a member of the youngest grade and a member of the Middle Grade of the Pondo initiate classes from one *sinzanga*.

Arriving at the dead one's house (*kpokpaha*), the drum and gong ensemble marches around it three times. Then, with a crack of their whips, the *Nafiri* pair order the drums to fall silent while they perform the greeting ritual honoring the dead one. As a ritual reversal of the movements of daily life and to emphasize the extraordinary character of man in mask, the *Nafiri* rules of comportment require backward motions in entering or leaving the house. Backing and stooping through the low doorway, the *Nafiri* circle and back over the body three times. Immediately after they back out of the house, the greeting ritual reaches its climax as the members of the pair begin to strike each other furiously with the long fiber whips carried as the principal insignia of the *Nafiri*. In the stylized thrashing motions of the whipping ritual, the swishes of bright raffia, the bold colors and stripes, the formal stance of torsioned bodies, the sweeping gestures of the arms extended through the twelve feet or more of rope whip, which traces a rapid, ever-changing calligraphy in the space around the confronting figures—all these belong more to the world of choreography and drama than to the uncontrolled violence of armed battle (cf. pl. 62 [color]). Yet the whips are nonetheless real and can cut and hurt. The secret Poro name for the whip attests to its scorpionlike sting; the self-flagellation signifies suffering and is enacted in recognition of Siellepondo's work and sacrifices for his Poro organization. In his younger years he suffered for others; now "it would be a sin if the young ones did not tire themselves and cut with whip" at his death.[16] The whipping performance, said to be "for the dead one," will be repeated later by the accumulated numbers of guest *Nafiri* pairs as part of the crescendo of ritual events shortly before burial.

Before retiring to the *sinzanga* for rest and, they hope, some cold rice provided by the *kuugofölö* and brought by one of the initiated women elders of the *katiolo*, the *Nafiri* will visit several compounds in the village, collecting cowries with the assistance of the accompanying initiates, the *pombibele*. These initiates are clothed austerely in the traditional funeral dress of Fodonon initiates: a small, ornamental apron of blue and white woven cloth, decorated with cowries, and,

slung over the shoulder, a cloth bag needed to hold the cowrie collection. The initiate support team gathers up the cowries solicited by the visiting *Nafiri*. The *Nafiri* and *pombibele* are in effect collection agents for the elders of their particular *sinzangas*; later the cowries will be redistributed among finished or graduated men of Poro, the *namboringwo*. Only these Poro graduates have the right to collect shares, for, as the saying goes, "the elders have sown in Poro; now they harvest what they have sown."

<div align="center">

YALIMIDYOBELE BA N A NYAARI

("THE YALIMIDYO MASKERS ARE WANDERING ABOUT THE VILLAGE")

</div>

As with other major funerals in this village, the initiates and the *Nafiri* maskers are not the only collection agents at work. Later in the afternoon the conversation groups scattered about the reception house and courtyard of the *katiolo* are interrupted by the approaching sounds of the familiar, buzzing voices of the *Yalimidyo* maskers. They wear a hidden membrane that distorts the voice, enhancing both the comic and extrahuman effects of their presentation. When the elders hear this particular Poro song, they know that the *Yalimidyo*, spokesmen for the elders and the dead, have left the sacred grove to circulate in the village.

Shortly after one of the waiting elders observes that "the *Yalimidyobele* are wandering about" (using the secret-language formula of speech), a group of three brightly costumed masqueraders bursts noisily into the courtyard. They have come to greet the funeral chief after having passed first by the house of their *sinzanga* chief, who, by Poro law, must receive the first greetings when *Yalimidyo* leaves its *sinzanga*. The three *Yalimidyo* are from the Kufulo farmer and blacksmith *sinzangas* of the village. Although this is a Fodonon funeral, the blacksmith (Fono) and Kufulo Poro memberships of Siellepondo's village have followed the customary practice of "calling out the *tyolobele*" of their respective *sinzangas* to assist the Fodonon groups in the funeral.

True to the Kufulo style of *Yalimidyo*, the appliqué face of each masquerader is the focal point of aesthetic energy and invention (pls. 11 [color], 61). Against a brown or indigo face is arrayed a fantasy of facial features and ornaments that glitter and dance across the face of each *Yalimidyo*. Lavish reds, yellows, and blues contrast with the shine of white felt and metal cutouts (pl. 11 [color]). Eyes, nose, mouth, and scarification marks are translated into basic geometric planes and kinetic shapes—zigzags, star bursts, crescents, dashes, and

dots. The brilliant colors are repeated in the yarn coiffures and poly-chrome raffia capes and are literally capped by the characteristic scarlet head crest of the Kufulo substyle. The color and shape of the maskers' head crests intentionally echo the red caps, emblematic of high office in Poro, worn by certain of the elders in the audience.

In vibrating, querulous tones, the three *Yalimidyo* thrust out their hands (fingers decorated with raffia strands of pendant cowries), de-manding cowrie money in the characteristic analogic and symbolic language of Poro: *"löhö syoo gbaa"* ("give this person some water to drink") (pl. 61). With laughing remarks, most of the elders deposit a few cowries in the gaping mouth of the large cowhide bag carried by each *Yalimidyo*; the gesture follows a set formula known to all Poro initiates. Elders who have nothing on them to give regretfully tell the maskers, *"punweegele yaha"* ("my waterholes," i.e., pockets, "are dry").

After the elders have given money or cowries, the *Yalimidyo* recite formal blessings, calling upon the ancestors to grant them health, long life, good fortune, many children, and other blessings. Not only clowns but intercessors, the *Yalimidyo* maskers walk the village as kinsmen and spokesmen of Ancient Mother and the ancestors. To show disrespect or flout their demands is certain to bring troubles upon oneself and one's family.

On this day a graduate "master of the art of speaking *Yalimidyo*" is accompanying two of the ablest of the current *Tyologo* class. The persons chosen to wear the *Yalimidyo* linguist masquerade must be innovative and adept in their use of Poro aphorisms and vocabulary. The group of *Yalimidyo* approaches a "stranger" in the gathering, one of the funeral guests from another village, and asks him for some corn beer in the secret language. Their purpose is not to obtain the beer but rather to test the man's knowledge of Poro. They sing a punning couplet: "One doesn't eat *red monkey* [using the vernacular word for red monkey, which, in Poro language, means the *Yalimidyo* bag]/One eats *water of red monkey*" [meaning corn beer in Poro vocabulary].[17] The man addressed gives the expected response—a jesting query about the maskers' thirst and a small donation of cowrie shells placed in the bag according to a formula of gestures known only to Poro initiates.

Another aspect of the *Yalimidyo*'s art lies in his ability to create humorous situations and lines. One of the *Yalimidyo* maskers ap-proaches a young man who has come to the funeral all spruced up in French shirt, slacks, and shoes. Traditional dress at a funeral com-municates various roles and identities, such as farmer, hunter, initiate, graduate, widow, and so forth. This dress on a male of that age on

such an occasion communicates at once that he has left the village nexus and is probably unschooled in Poro. His very dress proclaims loudly that he does not share either in the physical labors or the age-grade role expected in the traditional society. To the vast enjoyment of the onlookers, the *Yalamidyo* masker publicly ridicules the young man's status. Reaching into his shoulder bag, he pulls out a small, carved, female figure and places it at the feet of the young funeral guest. In a loud, high-pitched voice, distorted by rapid speech and the hidden mouthpiece, he shouts, "Here—this is your girlfriend [*pitya*]—take her to your place!" This leaves the victim little choice but to give money or cowries in order to save face. He dares not refuse to give something to the masked man lest it lead to an embarrassing scene or, worse, lest the *Yalimidyo* speak badly of the young man to the ancestors, ensuring future troubles for him.

The small group of *Yalimidyo* maskers now takes its leave of the *kuugofölö* and other elders, continuing to move from courtyard to courtyard, greeting elders, collecting funds for Poro, and conveying news of the progress of events in the sacred groves and elsewhere.

KI N NYOO TORO! ("IT IS VERY BEAUTIFUL!")

Although such fiber masquerades as *Yalimidyo* are the most highly developed and specialized of the ephemeral works of art contributing to the composite aesthetic of the funeral, the people themselves add their own quality of color and glitter to the event. Funerals are the occasion for a general flowering of personal adornment, perhaps the oldest form of expression in the visual arts, throughout the village. Coiffures, textiles, and ornaments of brass, cowries, and leather are all intended to show the participants at their most attractive as well as to provide information about the wearers. Special garments exhibiting the finest craftsmanship of regional weavers and textile-painting specialists replace the subdued buff and sienna tones of the everyday work clothes. Brass ornaments, such as chameleon rings (pl. 25), worn by both men and women as *yawiige*, have been polished with sand and lemon juice to a gold shine. Especially striking are the women's large, boat-shaped ankle bracelets, which catch the light as they dance, flashing in and out of the circling patterns of the women's dance steps. The smallest toddlers express their families' pride as they run about the courtyard, brass anklet bells and rows of shiny yellow brass bracelets jingling and flashing. Little clusters of white cowrie shells (*työgö*, signs of beauty and good fortune also used to ornament the *tefalipitya* staffs) are worn by small children and women "to be beautiful."[18]

Certain modes of dress and coiffure serve to distinguish status and identity. Young, unmarried girls wear short, wraparound skirts, which, along with the scarification designs on back and abdomen, exalt the body's perfection, destined to be altered in a few years by the rigors of field, household, and child-rearing responsibilities. The Senufo use a special word for "beautiful" in the context of young people's ornament: *nayiliwe*, which can also mean "youthfulness." The traditional indigo weave with white and red supplementary weft patterns has been supplied since at least the nineteenth century by the Dyula and later by Senufo artisan groups, such as the Kpeene and Tyeduno ethnic groups. Many of the hairstyles worn by both sexes conform to set conventions that indicate marriage status or membership in a particular ethnic or age group.

Members of the hunters' association (*Dözöbele*) of adequate means and prestige stand out from ordinary men by their special dress: tunics and drawstring trousers of strip-woven white cloth, tailored and hand painted by a sequence of specialists (weaver, tailor, and painter). Each costume is a unique work of graphic art, the geometric patterns and figurative designs (*yawiige* motifs) revealing the direct brush strokes of a master of the *fila* painting and dyeing technique (pls. 32, 81).

Membership and age-grade status in the Poro society in particular is expressed by certain types of dress and ornament. The elite of village leadership, more likely to be in modest robes of subdued tones, are frequently identifiable by their coveted red (or blue) caps, a sign of leadership in the Poro society. Also scattered among the visitors to the *kuugofölö*'s courtyard are a few men in their thirties and forties who are readily identifiable as recent Poro graduates, resplendent in the vivid colors and bold geometric designs of the *Kafwö* graduate tunics and robes (pl. 74). The greatest triumph of personal decorative art seen at the funeral is the ritual dress worn by the *tyolobele*. As cowrie shells, beads, textiles, skins, and the like enhance the visual beauty of wooden sculpture, such as the carved Poro masks, so the accumulation of body ornament enhances the splendor of the initiate himself (pl. 19 [color]). His ritually nude body, shining with oil, itself becomes the backdrop for a display that achieves its aesthetic effect primarily by the accumulation of elements and by a pendant motif, clusters of hanging objects of various colors and textures. The blacksmith *tyolo* wears a leather and cowrie headband; a beaded necklace; a leather-covered bark quiver with a basketry cap; a fringed leather shoulder bag colored with the "secret" red dye of the leatherworkers; a purely ornamental bandolier of bright red leather triangles alternating with clusters of minutely braided tassles of leather and

Plate 81 Fodonon elder, a chief of the Pondo society, attending funeral garbed in a *fila* shirt and a red cap with black tassel (May 1979).

cowries (*työgö*) (pl. 19 [color]); a long, tubelike cloth sack slung over the shoulder with a carved wood or cast metal slip ring in the form of a miniature circular stool with four bent-knee legs (*tyotana*); a knife in dyed leather sheathing (*ng'önö*); a belt of leather and cowries (*tyosakelige*) (pl. 19 [color]); and a carved wooden cosmetic box containing oil (pl. 14) used by the *tyolo* on himself and for cleaning the masks (*sungbolo*).[19]

MARIFABELE ("THE GUN PLAYERS")

Shortly before dusk, the hunters' association arrives in a body before the *kpokpaha*, the dead one's house. Accompanied by the costumed *kaariye* bard, they come to render homage to one of their members in a ceremonial manner appropriate to Siellepondo's prestigious status as a great hunter. The hunters carry as many of the old flintlock guns (*marifa*) as they can muster for the event. Some of the guns date back to the days of Samory, when skillful Senufo blacksmiths forged an armory that held back the French for a while. The members range in age from old men to young *Tyologo* initiates, identifiable by their funeral ritual dress (*kaadya*, tailored loincloths with ornamental aprons), contrasting with the painted geometric and figural hunters' shirts and trousers worn by the older men. Calling out greetings and laments to their "brother" who has left them, the hunters sing as they circle around the *kpokpaha*, letting off several volleys as a near-instrumental element of the song. The bard sings a hunter's praise song: "If he kills a very dangerous animal in the bush, one like *senoho* [wild bush cow] and sleeps on its fresh skin . . . this is a great thing . . . this is a brave man."[20]

MII NI FO ("I AM PYTHON")

By the time the long afternoon's glare has softened to pinks mixed with the blue-grey haze of hundreds of cooking fires, the funeral guests have all returned to their hosts' houses to wait for the evening meal. Many will not have eaten since the rice gruel taken in the early morning. After the guests have been settled and fed, the village enters a period of relative quiet, a restful interim before the all-night watch, with music and dance groups, begins, two or three hours before midnight. As young and old gather near the courtyard fires, one or two of the older males, seated on the log benches of the domestic *kpaala* that forms part of the traditional architecture of the *katiolo*, help pass the time by recounting fictional tales with song refrains and a

moral lesson to entertain the group. One group of youngsters and assorted visitors listens with fascination as Zana, a gifted raconteur, relates again the ancient tale of how *Fo* the python tricked a beautiful young maiden; this tale alludes indirectly to the powerful Sandogo institution. A nightly tradition in earlier times, tale telling more recently has become an art rarely practiced except during the comparatively leisurely periods of funeral celebrations.

The night vigils, filled with talk and music, are intended to comfort grieving relatives, to drown out the sound of their tears, to honor and please the dead one, and, above all, to uphold the prestige of the *katiolo* and *nërëgë*. In common with the *pombibele* initiates' and the *kuugofölö*'s, the women's responsibilities are extremely demanding. The women of the dead one's *katiolo*, along with other hostesses throughout the crowded village, work to the point of exhaustion preparing food for hundreds of visitors. For the young, the privileged elders, and most of the visitors, the occasion is more relaxed and enjoyable. Throughout the nights the elders sit by courtyard fires, finding time to gossip, discuss the crops, and renew acquaintance with old age mates, drinking friends, and relatives from other villages. Convivial groups pass around calabash bowls of peppered corn beer.

By eleven o'clock the night is filled with music, voices, and streams of people throughout the animated Fodonon sections of the village. Strolling from one *katiolo* to another, a group of funeral guests enters a crowded compound, where a *körikaariye* ensemble of musicians, led by a hunters' bard, is captivating its audience with jokes, songs, wise sayings, and narratives. The vocalists' words are interspersed with the stirring, clanging rhythms of the long, spoon-shaped iron rasps. Sponsored and sent as part of the contribution of a maternal kin group in a nearby village, the hunters' bard is a master of the *kaariye* genre. Considered a much "stronger" performing artist than the local specialist, he and his backup chorus are received warmly.

The spectacular costume worn by the bard is charged with the accumulated weight and impact of many images that convey power and magic (pl. 20). Both the elaborate appliqué tunic and the headdress incorporate a wide range of objects and materials that speak of the bush, danger, and the intermediary role of bush spirits in the struggles of hunter or warrior with his adversaries. The composition of the tunic is rich in texture and color: pieces of genet or leopard skin alternate in geometric patterns with panels of dark cloth; bold red cloth circles form the center of ornamental rosettes and quatrefoils outlined with white cowrie shells; and the sleeves are edged with fur, fish eagle, or hawk feathers and bundles of slender, long porcupine quills. The headdress is also trimmed with exploding bunches of quills,

the strong contrasts of red felt, dark dyes, and white cowries, and the flashing of small reflector mirrors. Attached to the bonnet are several small antelope horns, traditional containers of magical substances and iconic reference to the magical intervention of bush spirits and diviners in the successful hunt. A beaded veil, formed of many short strands of costly trade beads, partly obscures the bard's face, enhancing the cumulative effect of mysterious powers.

With a horse-tail dance whisk and a bag of wildcat skin draped over one arm, the bard plays the six-stringed harp-lute (*köri*), which is slung by a cord around his neck and shoulders. The strings are grounded on the sounding board by a graceful female head and torso, whose abstract planes and remote, calm expression seem to counteract and balance the clamor of the iron rasps and the dramatized flourishes and extravagant trills of the musicians. As with the antelope-horn motif, the figure carving is an iconographic element that speaks of divination and bush spirits.

The central theme of the tale just getting under way is, "man alone cannot live." Following the usual structure of a *kaariye* number, the bard does not begin abruptly with the narrative and choral refrain but warms up to it gradually with many greetings, the introduction of his chorus, and a string of jokes and proverbs punctuated with instrumental flourishes by the rasp players. As is often the case, this group is accompanied by an accomplished hunter, who encourages the performers with the high, clear tones of a cast-brass hunter's whistle (*satoro*). The bard and chorus sing the refrain: "One finger alone cannot take of the sauce," a vernacular rephrasing of a well-known proverb: "*Kabeele nidya da gba loomo gbaa?*" (Can one finger take of the sauce?) The narrative itself purports to relate a "factual" account of a man who tried to live alone and had nothing but troubles, and after an energetic instrumental passage, the bard concludes the number with the advice, "The ancestors say 'go work.'" Encouraged by the gifts of money and complimentary salutations from the warmly receptive audience, the group soon launches into a second selection, which picks up and further develops the theme of work with the favorite tale of "Tortoise, Bat, and the Young Maiden." Shouts of laughter interrupt the narrative as the versatile artist renders superbly comic sound effects and gestures to dramatize the main action of the story, in which Tortoise, the good cultivator, gets the girl (Glaze 1976: 288–90).

While the performers rest and accept offerings from an ever-increasing number of listeners, one small group of funeral guests moves on to the large courtyard of the neighboring *katiolo*, where the men's *bolongböhö* harp ensemble is in progress (pls. 82, 83). Seated in a

Plate 82 A master musician (left) of the one-stringed
harp-lute, *bolongböhö*, in a performance combining the
famous musician societies of Lataha and Wahatyene at a
Kuumo in the Kafiri dialect area (May 1970).

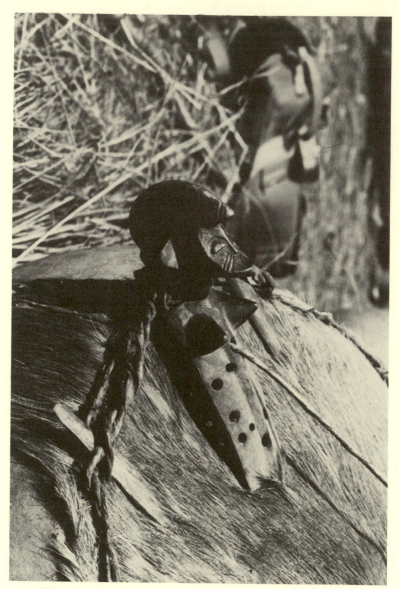

Plate 83 Detail of the sounding board of the *bolongböhö* (harp-lute), the bridge carved in the form of a female bush spirit (*madeö*) (May 1970).

large half-circle, a group of ten men is playing and singing in a theater space created entirely by the smoothed earthen yard and the warm lights of a bonfire and kerosene lanterns. The open-air theater pulsates with the perfectly timed chords of the strings, which are decorated with the more rapid, percussive beats of the "drum" bases of the harp. Intertwining with them is yet a third line, the vocal melody with its lilting rhythms. The harp provides the major accompaniment to the song, which the musicians themselves sing; a minor accompaniment is provided by two younger men with *tyeli*, the cowrie net–calabash rattles. The lengthy song sequence (twenty to thirty minutes long) is nearly finished, its main theme discernible in the refrain, "If you don't have a spoon for your manioc sauce, / You have to be content with a leaf" (i.e., Be content with what you have).[21]

Each musician's instrument is a large calabash harp similar to the *kora* of the Mandingo area. *Bolongböhö* is a one-string harp-lute with a long, curved stem terminating in a vibrator attachment of iron and brass jangles (bells, chains, rings). The resonating bowl is a large, rounded calabash covered with stretched cowhide. The string stretches diagonally from the stem and is fastened across the hide surface with a bridge in the form of a female figurative sculpture identical in type to that of the *körikaariye* harp-lute (pl. 83). The figure's heart-shaped face, with its scooped-out planes, is primarily a reference to the idealized form of youthful female beauty based on observation of the natural model. A more concrete illustration, close at hand, of the sculptor's accentuation of the convex curve can be seen in profile in the head of the lead musician as he bends to his harp string (cf. pls. 82 and 83, and the face mask in pl. 69). Thus, the figure communicates one purely aesthetic meaning, a beautiful ornament in the form of the female head and torso, virtually a synonym of beauty to the Senufo sculptor. However, this *madeö* figure, as with the parallel motif on the *kaariye* bard's harp, also conjures up for its viewers the general world of the bush spirits.

While the musicians rest and more people join the audience, a calabash is passed around to collect gifts of appreciation for their music and skills with poetry and aphorisms in the ancient Fodonon vocabulary. Now they are slowly working into a new sequence, whose theme is, "Each one must die." This song leads into a series of reflections upon the central theme: "Before dying, one must take food for oneself . . ." [i.e., you must live, must lead a normal life]. "A *madeö* of death who comes to kill . . . the family is obligated to close the door . . ." [i.e., because no one remains]. "The bad *madeö* who wants to finish their family. . . ." This time, however, the song begins with brief passages that announce, direct, and encourage the small dancer

newly arrived on the scene. A boy of age seven or so in the full cos-
tume of the children's Poro *Kanbiri* masquerade (pl. 58) has been led
late at night by his age mates and "older brothers" through narrow
paths between compounds to this fire-lit area where the elders are
playing. Here, in view of villagers and funeral guests, he dances with
stylized movements to the calabash rattles, played by his Intermediate
Grade instructors, and to the harp rhythms and still largely incom-
prehensible language of the elders' songs.[22]

The children's masquerade costume is quite similar to the *Koto*
masquerade worn by the Senior initiates, with its black, knit suit
worn beneath a full-bodied construction of plant-fiber cape, wristlets,
and anklets. The black, knit stocking mask, with its red crest deco-
rated with cowries, has a long "tail" that terminates in a round mirror
two or three inches in diameter. As the child turns and stamps in
quick dance movements, the swinging mirror catches the gleam of
firelight with much the same aesthetic effect as do the round, cast-
brass disks of the whirling *Koto* as they flash and gleam in the sun-
light.

Selected as a good dancer from among his peers, the child is learn-
ing *sur place* to cope with the problem of how to move without trip-
ping on his long anklets, how to move his long, grass wrist fall (pl.
58) to artistic effect without letting his hands show, and, more diffi-
cult still, how to follow directional signals from his guide since he
cannot really see where he is going through the small eyeholes. Ex-
posed to possible public ridicule and shame, the boy and his age mates
are tested in their progress. The elements of expectancy and pride in
a successful performance notwithstanding, this is an awesome hurdle
for a very small boy. Relatives are present to criticize if faults are
seen; only nonrelatives may praise his success. When the novice per-
former loses a part of his anklets, which have been secured insuffi-
ciently to withstand the stamping feet, immediately six or seven elders
rise to shout "angry" directives at the dancer's age mates, whose task
it was to dress their representative properly. After a hasty retirement
for repairs, the small masker is able to resume his dance, and cowries
are awarded his group.

And so the night vigil continues until dawn.

IN THE SINZANGA OF THE LARGE ANTELOPES ON BURIAL DAY

Throughout every night of the funeral period and for one night a
week during the three weeks following the elder's burial, the initiate
classes of Pondo sit watch by the *kpaala*, the monumental log shelter
that dominates the ceremonial clearing in the Fodonon part of the

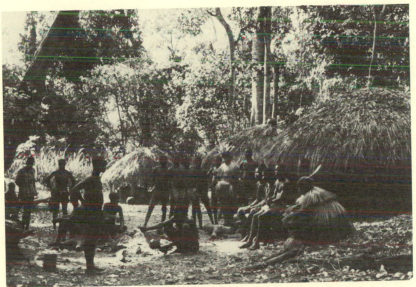

Plate 84 Interior of a typical Fodonon *sinzanga*, of a simpler plan than those of the Senambele, features distinctly styled storage houses. A group of Pondo society initiates is waiting to begin a *Koto* performance. Left to right: a *tyeli* instrumentalist-vocalist, a *Kurutaha* masker, and the *Koto* masker (January 1970).

village (pl. 12). On the morning of burial, while most of the villagers are still sleeping after the night-long activities, the *tyolobele* snatch a quick breakfast sent to them by women from the dead one's *katiolo* and retire to the *sinzangas*, where they are soon hard at work making ready the major masquerades for the day's liturgical performances.

In the center of the sacred forest a lofty kapok tree towers above the clearing. The tree's huge, buttresslike roots dwarf the domed, thatch, pole house where Pondo society equipment is stored. It has stood witness to scores of Pondo generations. In the *sinzanga* is an atmosphere somewhat reminiscent of the backstage of a theater in the last hours before an important performance (pl. 84). Maskers in various stages of dress, with bits and pieces of costume littering the floor of the *sinzanga*, "the Ancient Mother's *katiolo*," create a lively scene. One initiate, partly dressed in the leopard-spotted drawstring suit of the *Tyo* masquerade, stands talking with a couple of his age mates from one of the visiting Pondo society groups. Over to one side of the *sinzanga*, one of the more artistically skilled of the older initiate classes very carefully touches up the bright red and white, painted decoration of the carved head of the *Gbön* mask. With a small, rounded stick

dipped in white chalk paint he traces a series of dotted lines running across the sharp planes of the nose and muzzle (cf. pl. 9 [color]). One member of the Senior class helps a younger brother tighten the cords on the large cylindrical *syo* drum, giving it a final tuning for the coming performance.

Another group of initiates hauls out masquerade components from the dark recesses of the storage house, where they have been protected from dust and insects in baskets suspended from the thatched roof. The *pombibele* begin unwinding and fluffing out the dozens of rolls of raffia strips. Strip by strip, layer by layer, two or three age mates will construct the full-bodied forms of *Gbön* and *Koto*; this is a long and tedious process requiring many hours.

Relaxing in groups here and there on the log furniture of the *sinzanga* are a few elders and some advanced initiates, who supervise and assist if necessary. Some of the elders have come simply to greet the children of Pondo (*pombibele*) "at their Mother's work."[23] Finally, the guest initiate classes from both major Fodonon *sinzangas* of a neighboring village are ready to visit the house of the dead one with their instrumental ensembles and *Gbön* masquerades. Just before they leave the *sinzanga*, the drums and gongs strike up the "song" that warns the village that Pondo is coming out of the *sinzanga* to "walk through the village." The uninitiated must take care. The entire Lower Grade class marches along, carrying gongs, iron scrapers, the large, double-membrane drum (*syo*), the three bowl-shaped pottery drums (*gunugo*), and the speaking tubes (*yeele*), which form the core instrumental ensemble of their Pondo society. They are accompanied by a few initiates from the Middle and Upper grades. The older initiates, chosen for their superior ability, have the dual responsibility of playing and teaching their successors. Two "intelligent ones," one from each of the upper grades, walk behind the *plaö* class with the kazoolike *yeele*, singing into the buzzing membrane; that imbues their songs with an extrahuman quality appropriate to the secret language of the Pondo society, *Tiga*, said to be the "language of the dead ones."

Accompanied by the joint drum ensembles of both Pondo societies, the two *Gbön* maskers, with rapid, measured strides, their raffia pantaloons kicking up the dust, arrive at the edge of the large courtyard in front of the dead one's house. Here they change to a tighter, tenser style of motion. As they move into the center of the courtyard, the *Gbön* make abrupt swishing movements from side to side, on the alert and on guard. They stop, facing the door of the *kpokpaha*. Each *Gbön* personage firmly grasps a long walking staff (*kagaana*), associated especially with women elders and possibly even Ancient Mother

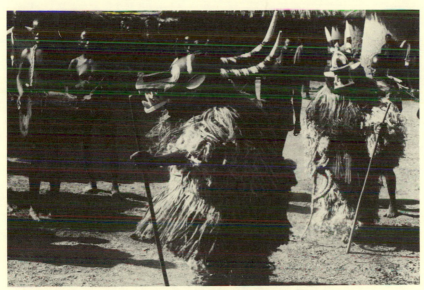

Plate 85 Gbön masquerades of two different guest Pondo so-
cieties come to greet the spirit of the dead elder at his house
(March 1970).

(*Katyelëëö*) herself. The crimson and cream-colored raffia of the
massive body looks almost translucent in the near-midday sun.[24] The
zoomorphic helmet masks, with sweeping antelope horns painted in
the bold black and white bands of the distinctive style of this particu-
lar village, emerge from the high raffia collars (pl. 85).

As the drums move into a new sequence, the two *Gbön* maskers
drop to their knees in an ancient gesture of respect and submission
and thus, on their knees, approach the house where Siellepondo lies
"resting." Rising, they lean on their walking sticks, shaking and trem-
bling like very old people, referring, with this imitation, to the many
generations of ancestors of which the *Gbön* masquerade is a visual
remembrance. Their voices transformed by the membrane-covered
speaking tubes, two of the *pombibele* sing greetings to the dead one
and voice the group's sorrow at no longer having Siellepondo with
them. One of the *Gbön* maskers, shaking a long raffia sleeve, pretends
to remove some of the thatch from the roof; this is a reference to the
Gbön action attribute of mounting the roof of the *kpokpaha*, an old
tradition still followed by several Fodonon and Tyeli groups in the
area.[25] As a house without a roof is no longer lived in, so Siellepondo's
life among them is finished, and his spirit should not linger in resi-
dence. The drum signals a change to walking rhythms again, and the
group returns to the *sinzanga*.

FANGA (THE GRAVE)

By late morning the essential relatives have all arrived at the village, and the many preparations for burial are nearly completed. The grave diggers, appointed by the funeral chief (*kuugofölö*) early on the first day of the funeral, have finished the complex underground burial chamber that the *kuugofölö* and younger relatives of Siellepondo now go to inspect.[26] A cow is sacrificed at the grave, its meat to be distributed according to social relationships in a religious act that involves all concerned parties in a communal offering to the ancestral spirit of Siellepondo. Friends, age mates, and every member of the maternal family, down to the youngest child, will taste this meat. All afternoon youngsters can be seen hurrying along village paths carrying broad plaintain leaves with little piles of meat, which represent specified portions according to rank in kin group and Poro.

KUTONFANI (THE BURIAL CLOTHS)

Immediately after the grave is pronounced well made, the *kuugofölö* returns to the *katiolo*, where the dead man's own inheritance of burial cloths, along with the gift presentations of the past three days, are to be counted. With the counting of the cloths is set into motion a crescendo of events that reaches its denouement in the ceremony featuring the Poro masquerades. Whereas the appearance of special performers and art forms during the days of preparation was relatively sporadic in tempo and sequence, now there is a manipulation of objects and events leading to the instrumental and masquerade liturgies that reveals a conscious sense of drama and climax.

The counting of cloths begins, presided over by the official announcer (*faniteö*), who acts as a kind of master of ceremonies (pl. 86). The *faniteö* has been chosen by the funeral chief and other village elders for his intelligence, his ability to speak fluently with wit and humor, and his good carrying voice. As each cloth is presented one by one to the brothers and nephews of the dead one and the general assembly, the *faniteö* calls out clearly the giver's name two or three times. Each cloth is subjected to comments and judged for its size and beauty. Small cloths are laughed at, whereas others that reach extravagant lengths of fifteen feet or more occasion laughter of quite a different nature in response to the speaker's exclamations on the good fortune and importance of the dead one.

As with so many of the separate events that together constitute a Senufo funeral, the cloth-giving ceremony functions as a device to define and consolidate relationships among groups and individuals.

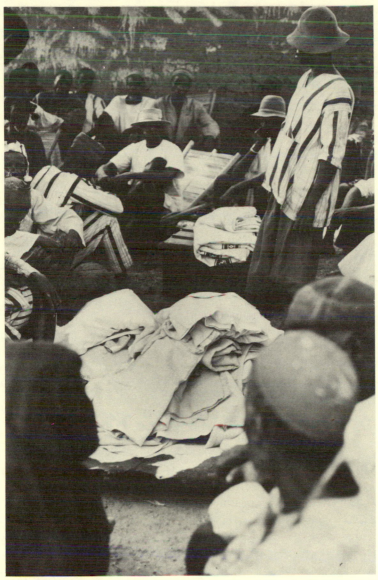

Plate 86 The counting and presentation of funerary cloths before burial (January 1970).

This is a time for making social contracts. For example, one particular family wishes to negotiate a marriage agreement between their daughter and one of the sons in the dead one's family, so they offer cloths for the burial. The cloths are accepted; this act obligates Siellepondo's family and concludes the agreement for marriage between the two families. Had they not been in agreement, the elders would have refused the cloth.

The cloth-giving ceremony is also an occasion for an individual to indicate public expressions of approbation of a particular person. A husband praises the qualities of his wife, on whose behalf he presents a generous gift cloth to the funeral chief when there is a death in her maternal family. Age mates (*kandang'o*) from other villages present cloths on behalf of close friends at funerals for elders of that friend's family. In brief, each funeral cloth presented is a visual, material expression of social ties and obligations. A small number of cloths of poor quality reflects a troubled and unsuccessful family. Also, the ceremony is an opportunity for increasing personal and family prestige with the display of wealth.

When all the cloths have been counted and their donors named, Siellepondo's heirs decide after lengthy discussion how many of the total number will be returned to the family "bank" and how many will actually be used as burial cloths. Once this decision is made, people quickly begin to congregate near the *kpokpaha* for the sewing of the cloths.

KE WARI FANI WI NA ("HURRY TO SEW THE CLOTHS," A DRUM SONG OF EXHORTATION)

A few initiates and relatives carry the body outside the *kpokpaha*, placing it on the stack of thirty-five cloths chosen for burial. Each cloth is carefully wrapped around and sewn in place, creating a smoothly molded form made aesthetically pleasing by the vivid colors and patterns of the outer cloth (pl. 87). A bright red Poro elder's cap is fastened at the head of the form, partially hidden by the layers of cloth (cf. pl. 62 [color]). The group of elders who kneel beside the body as they work is an extremely select one. Their status is partially expressed by neat, gray beards and the red, dyed caps of Poro leadership; these men are no less than the chiefs of every significant *katiolo* in the village. A group of *Nafiri* maskers, with their whips, stands by quietly supervising the procedure. This is a moment of both tremendous dignity and anticipation of more dramatic events to follow. The Pondo society drum ensemble encourages those who are wrapping and

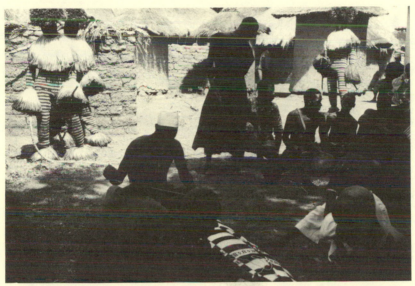

Plate 87 *Nafiri* maskers stand guard, and Pondo society initi-
ates drum as elder representatives of the village *katiolos* sew the
outer decorative cover on the multicloth burial casing of a
Fodonon male (March 1970).

sewing in the same spirit as do the balafon orchestras for the Senam-
bele groups. The drum tempo continues the crescendo toward the final
realization of the burial liturgy.

KPA O WAA ("PORO IS THERE," I.E., DRUMMING AT THE CEREMONIAL GROUNDS)

As soon as the sewing of cloths is completed, some of the initiates
place the now splendidly adorned body on a woven blacksmith mat
and, escorted by *Nafiri* maskers, carry it to the center of the open
courtyard near the *kpokpaha*. Following the tradition in this village,
the *kuugofölö* and other elders have assembled here for the first part
of the Fodonon's share of the final ceremony.

The final ceremony, described below, follows the schedule of mas-
querades given here in outline form. This framework is fairly constant
for the funeral of a male Fodonon elder, changing only with the addi-
tion of a *Nökariga* initiate drum ensemble in the case of funerals for
members of that society. This overview gives an idea of the sequence

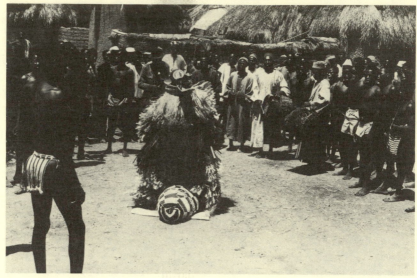

Plate 88 Gbön masquerade, in final ceremony for Fodonon male, dances over the body in "the initiation of the cadaver" (March 1970).

of movements from one ethnic group to another and from one part of the village to another.

1. At the *kpokpaha*:
 Fodonon rainmaker-farmers (pls. 9, 44 [color], 88)
 Gbön and *Poyoro* masquerade performances as presented by the initiates and *tiga* songs by elders from:
 Pleuro, two *sinzangas* (i.e., one *Gbön* and one *Poyoro* from each *sinzanga*)
 Tapéré village, one *sinzanga*
 Kapile village, three *sinzangas*
 Pundya village, three *sinzangas*

2. At the great *kpaala*:
 Kufulo farmers (pls. 11 [color], 63)
 Kponyungo and *Yalimidyo* masquerade performances from:
 Pundya village, one *sinzanga*
 Fono blacksmiths (pls. 8, 11 [color])
 Yalimidyo and *Kunugbaha* masquerade performances from:
 Pundya village, two *sinzangas*

3. In the *sinzanga* of the large antelopes:
 Fodonon rainmaker-farmers (pl. 62 [color])
 Nafiri masquerade performances from:
 All participating *sinzangas*

> *Tyo* masquerade performances from:
> Pundya only

4. At the grave:
> Burial (all Poro society orchestras playing)

First on the ritual agenda is the Fodonon liturgy, featuring the *Gbön* and *Poyoro* masquerades with sacred Pondo society drums and songs. The visiting Fodonon groups from other villages begin the performance, according to the custom that dictates that the host village and host *sinzanga* always have the privileged concluding position in the ceremony. The next most important position, in order of appearance, is taken by the group from Kapile, the village with a reciprocal funeral relationship with the host. "The most important last" is in accordance with the canons of group discussion: the youngest are heard first, and elders with greatest authority speak last.

Women and children are conspicuously absent from the audience except for six or seven elder women of initiate status (*tyotya*), who remain off to one side of the area. Most of the men present are graduate members of the participating Poro organizations as well as friends and relatives from more distant villages. *Nafiri* maskers, their flamboyant red topknots rising a foot or more above the general height of the human wall (pl. 44 [color]), hold back the encircling crowd of onlookers, thus keeping the performance space clear.

GBÖN WA KPAALA TAANA NA YOO
("GBÖN IS DANCING IN BEAUTY AT THE KPAALA")

As the *Gbön* masker from the first *sinzanga* makes his appearance in the performance area, he walks rapidly up to the *kuugofölö*, who removes his hat in a gesture of respect. As the deep booms of the "person" (*syo*) drums set the beat, the high-pitched rapid "songs" of the pottery "tortoise" drums (*gunugo*) and iron rasps (*kaariga*) shift into a more urgent, expectant tempo. In a whirling dance the *Gbön* executes dizzying turns that whip its raffia skirt and capes parallel to the ground. The tensely watchful support group of initiates exhorts the *Gbön* masker to his optimum performance of the dance with calls and singing: "Yo-o-o-o-o . . . yo!—yo!—yo!" (Da-a-a-ance . . . dance!—dance!—dance!) By alternating sustained chords with sharp staccato notes, the group of twenty or so *pombibele* thus encourages the *Gbön* masker throughout the dance with these and similarly abbreviated phrases. Showers of cowrie shells praise the *Gbön*'s dance, keeping many of the *pombibele* scrambling to fill their cloth bags.

Taking a much-needed break after dancing under the weight of

many pounds of raffia in the heat of a tropical sun, the *Gbön* masker comes to kneel before the *kuugofölö*. The elders welcome him and praise his skill while the resting dancer is screened by the bodies of the surrounding group of *pombibele* (pl. 9 [color]). Although both elders and some of the initiates lift strands of raffia cape to fan the masker, their gesture has more symbolic than practical value in physical terms; moreover, on a philosophical plane, their cooling-down gesture seems to be a symbolic response to the supernatural heat engendered by this powerful masquerade.[27]

After this brief respite, the *Gbön* masker and accompanying musicians return to center stage to perform the final ritual act, a direct interaction with the body of Siellepondo. Three or four age mates and younger relatives of the dead elder come up to the *pombibele* musicians, relieving them of the pottery and wood drums. This gesture honors Siellepondo and expresses their sense of loss. The full raffia skirts swish as the masker twists from side to side, straddling the body and walking from its foot to its head. Three times he assumes this parturitionlike posture over the elder's body in remembrance of his service in the three grades of Pondo and symbolically marking his birth as ancestral spirit (pl. 88).

The *Gbön* masker and *pombibele* of Siellepondo's *sinzanga* have already visited the *kpokpaha* twice, calling his secret Poro name at the door of his house. Now, for the third time, they address the dead man, calling him by the name given during his graduation from Pondo: "Kolonyungo,* you will be followed" (i.e., we know we cannot remain here—one must die). "Oh, rise up to speak with us." When he doesn't get up, they sing, "We will follow you. He has returned to the country of the ancestors. . . . We must strike up the Pondo drums."

POYORO (PORO DANCE)

A musical change signals the entrance of the second masquerade type from the first *sinzanga*, *Poyoro*, featuring the beautiful "Poro dance" mask (pl. 44 [color]). In contrast to the animal forms of the massive *Gbön* antelope mask, the *Poyoro* face mask presents the delicate lines of a stylized human face. The well-oiled, glossy, black face is set off against the colorful, hooded cloth cape and the diagnostic cream and crimson hues of the Fodonon raffia skirt. Unlike the blacksmith *Kodöli-yëhë* masquerade, the *Poyoro* masquerade is sacred

*Literally, "chief of the country"—in Poro language usage, a name reserved for the age-grade leader of a graduating Senior initiate class.

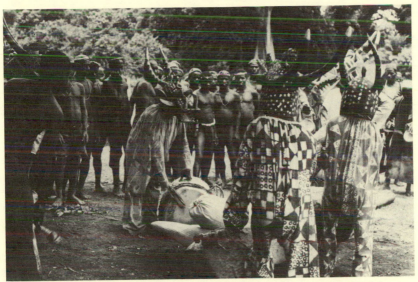

Plate 89 *Kponyungo* masquerades and *tyolobele* Senior initiates from five separate Kufulo *sinzangas* appear together at a funeral for a Kufulo elder (May 1970).

to the Pondo society and cannot be viewed by uninitiated women and children, although both the Fodonon and blacksmith face masquerades incorporate the so-called Kpelié face mask type.

The motion style of the *Poyoro* masker is entirely different from that of the *Gbön*. The *Poyoro* masquerade demands extreme skill and is characterized by tremendous contrapposto positions, the bending torso and head, side-twisting hips, bent knee, and wide-spread legs, creating pyramidal forms in space. In combination with the bent-knee, spread-leg postures, the fluid, loose-jointed series of movements is deeply sexual. The *Poyoro* masker carries a short, iron staff topped with three ornamental iron rattles; this forms an upright axis, placed firmly on the ground, which acts as a counterpoise device in diametric opposition to the dance movements.

PONDORO (PORO DRUMMING)

After the *Gbön* and *Poyoro* masquerade performances by the initiate classes of eight separate Fodonon sacred groves, the body is carried to the large arena surrounding the great *Kpaala*, the Fodonon ritual center itself. An imposing architectural structure, the *Kpaala* rises many feet above the thatched roofs of nearby houses and grana-

ries, at the meeting point of the major Fodonon *katiolo* boundaries (pl. 12). A massive log shelter, it also serves as an elder's council house, its six and one-half layers of stacked logs symbolic of stages and years of Poro. Once the scene of Siellepondo's graduation ceremony (*Kafwö*), it is now the place where the assisting Kufulo and blacksmith Poro groups perform their parts of the funeral ritual. Later, the *Kpaala* will also provide the setting for the *Koto* team performance, a commemorative postlude celebration that may take place anywhere from two hours to two weeks after the burial (pl. 70).

First, *Kponyungo* (pls. 63, 89), the long-horned antelope mask of the Kufulo *sinzanga*, plays its drum song to Siellepondo. Its deep-toned, cylindrical drum is accompanied by a Poro graduate on the long, slender drum, sacred to Ancient Mother. The *Yalimidyo* masqueraders join the circle, adding their song to the sequence. Finally, the blacksmith masquerade performs its critical role, a rite protective of the village that is held for every initiated adult irrespective of sex or ethnic membership (see table 6). The *Kunugbaha* enters the *Kpaala* area accompanied by a *tyolo* guide, who slowly rings out the iron bell that calls to spirits (cf. pl. 8). Its large, brassy eyes gleaming in the sun, the *Kunugbaha* swiftly approaches the body with a furtive crouching gait; it is a spirit stalker that creates a stylized effect of running in slow motion. The *Kunugbaha* mask and costume bristle with antiwitchcraft visual signals: the aggressive forms of piercing tusks, devouring mouth, pointed teeth, magic bundles, and wild-beast skins. With an animalistic cry that rises on a sliding scale to a thin, high note, the kneeling *Kunugbaha* strikes its drum phrases by the side of the body while an elder sings of Siellepondo's honorable life in the Poro society.

When the blacksmith ritual is finished, the Fodonon initiates again lift to their shoulders the mat supporting the cloth-encased body and depart at a near run for the dead man's own *sinzanga*. Here, in the last act of the final ceremony, the *Nafiri* maskers and the *Tyo* masker encircle the body; then, in turn, the *Nafiri* pairs from all the participating Fodonon groups reenact the flashing arabesques of the whipping ritual (pls. 62 [color], 90).

And so, in the *sinzanga* of the large antelopes, where Siellepondo has "suffered" and "tired himself" for the work of the Poro society, his peers and heirs in Poro fulfill their commitment to an elder who now "has returned to the country of the old ones." Burial follows immediately. A few initiates and *Nafiri* maskers carry the corpse at a near run to the area where the grave is ready. To the accompaniment of the various Pondo society drum ensembles, the body is carefully placed in the horizontal underground chamber, the entrance is sealed,

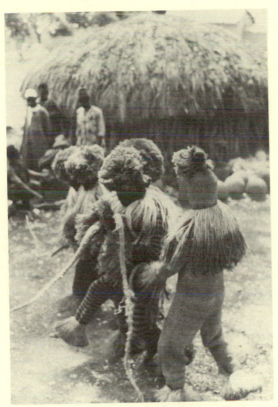

Plate 90 Nafiri masquerades in a Fodo-
non sacred grove. A third *Nafiri* rushes
in to halt the "hot," flailing whip of
a matching *Nafiri* pair; this gesture
symbolizes the intercessory role of older
age grades in Pondo (May 1979).

and the vertical shaft is filled. As a final salute, which signals the end
of the programmed events, a few members of the hunters' association
fire volleys with flintlock rifles. The funeral is over, and people dis-
perse to the *katiolos* to rest and eat.

CHAPTER 5

Conclusion

If my data from the Fodonon and the Kufulo region can be taken as representative of the Senufo area as a whole, then certain broad conclusions may be drawn regarding the ethnic context of Senufo art. First, there is a demonstrable correlation between Senufo language and dialect groupings and certain kinds of differentiation in artistic traditions. For example, I showed in the discussion of the Poro society in Chapter 3 that stylistic and typological differences, particularly in reference to masquerade constructions, are essentially a function of ethnicity and, within each ethnic group or dialect, of age-grade stratification. The relationship between language and other cultural boundaries is especially striking in respect to the larger language groupings, such as Central Senari and Southern Senufo. For example, the Kufulo Poro system is essentially the same as the Poro system found among other Central Senari groups, such as the Tyebara. The ground plan and architectural structures of the sacred forest sanctuary follow the same general pattern in all Senambele groups and contrast dramatically with the Fodonon version (pls. 39, 84, 90). Or again, unlike the elaborately constructed raffia costume of the Fodonon *Gbön* masquerade (pls. 85, 88), the helmet masquerades (pls. 8, 63) of the Fono and Kufulo (both Central Senari cultures) feature painted and tailored cloth suits. This differentiation of masquerade costume corresponds to the basic language division, noted above, between the Fodonon and Central Senari groups. In comparison with other Senambele groups, Kufulo Poro does exhibit some regional variations, including its own distinctive version of the *Yalimidyo* fiber masquerade type, the variants of which coincide with dialect boundaries within Central Senari. At the same time, the presence of two separate professional woodcarving

groups, the Fono blacksmiths and the far more transient Kule, ensures the continuing distribution of related sculpture styles over a wide geographic range irrespective of ethnic group boundaries.

In Senufo culture, the wearing of masks is in itself one of the strongest and most visible expressions of male and female role differentiation. Apart from their numerous individual religious, social, and aesthetic functions, masquerades are a display of male pride and political power, with the women in many contexts providing the admiring audience. Conversely, figure sculpture may be said to be especially an expression of the women's role as authoritative intermediaries with the spiritual world. Most figure sculpture dedicated to use in Poro society contexts is ultimately traceable to communications with the *Sando* diviners.

A central thesis of this book has been the importance of the funeral as an integrative system in which art plays a vital part. A popular tale that explains the origin of death in the Senufo world raises a theme of art and death comparable to that found by Griaule among the Dogon (Griaule 1938:55–58). A brief synopsis of the traditional Senufo tale is as follows:

> Death entered the world at the hands of a genie or bush spirit because of a Senufo woman. Her error was to steal meat that belonged to the bush spirit and eventually deliver her own daughter to the cannibalistic bush spirit. In the end, the woman was killed by the *madeö* and returned by her people to the village. When the *madeö* saw their grief-stricken weeping, he realized that he had done a bad thing. But then he saw the woman's people begin to bring out balafons and drums. And soon they were "laughing, eating, singing and dancing." The *madeö* decided that he had done them a good turn after all. The tale concludes: "And from that time on the *madeö* has remained here in the village, killing people. If he weren't staying here, there would be no death in the village. It is because of this bush spirit that death came to the village."[1]

The subtle irony of the tale is that through their exploitation of the social and aesthetic potential of the situation, i.e., the woman's death, the Senufo became needlessly involved with elaborate funerary art and ritual, resulting in still more death in the village. Thus, a fatal cycle was set in motion: the village's pleasure in funeral-related art forms and activities (e.g., balafons, drums, songs, masked dances, feasting, etc.) ensured the *madeö*'s continued presence in the village, bringing death, which, in turn, engendered beauty and enjoyment of the funeral ceremonies. The tale is revealing in its treatment of the intertwined relationships of the negative factor, death, and the positive factors, art and aesthetic enjoyment.

The Senufo physical environment is harsh in many ways. Dependent on perfectly timed rainfalls for their subsistence and subject to a wide range of tropical diseases, the villagers have struggled for centuries against the odds of high infant mortality rates, malnutrition, and chronic and debilitating diseases. It is not surprising that the great wealth of Senufo art forms is related either indirectly or directly to the Senufo's constant and personal confrontation with death. Whether through the enclosed aesthetic setting of the *Sando* diviner, who probes the mystery of death's cause, or the more public aesthetic displays of the funerals, which deal with death's effect, the Senufo community brings the vitality of aesthetic expression to counterbalance the psychological weight of death and loss. Similarly in the context of initiation, the arts celebrate the "death" and spiritual "rebirth" of the initiate.

In Senufo culture the important events that bracket a person's life are not the occasions of physical birth and burial but rather one's ritual "birth" through initiation and the ritual closure of life in one's village through Poro ancestral rites in the commemorative funeral. In the life of a person, age, time, and history tend to be reckoned by the regular ebb and flow of the six-and-one-half-year cycle. As indicated in the previous chapters, the uninitiated are not considered whole persons. Uninitiated adults (*möhö*) are virtually without social or political rights in the village and may be subjected to force and harassment without legal recourse. The outcast status of *möhö* in former times is said to have befallen unfortunate initiates who were too poor to pay the heavy annual fees required to finish Poro. At funeral times, stick-carrying fiber masqueraders in some villages steal the *möhö*'s food and threaten him. The *Yalimidyo* and *Tyelige* masks also search out the *möhö* for a beating and force him to flee to the bush. When meat is divided among members and initiates during Poro events, the *möhö* receives nothing. Worst of all, the *möhö* is unable to find a wife, for all women will refuse to marry him. Indeed, one of the principal rewards of achievement in hoeing contests and Poro training is the granting of a wife. Poro elders explained that to be a *möhö* is a sin and that "a *möhö* can't stay in the village or he thinks himself to death" (i.e., the psychological torment is too great to stay under such circumstances).

In traditional Senufo perspective the "path of Poro," an expression in common usage, offers the desirable alternative to this status of nonpersonhood. Training in the stages of Poro is viewed as the beginning of courage, strength, truth, knowledge, obedience, endurance in hard work, and, above all, discipline of mind and body. Poro song texts

are particularly important vehicles for the expression of these positive values held forth as ideals to the initiates.

In the visual arts, self-control, as an ideal of behavior, is reflected in Poro sculpture. The large-scale figure sculpture representing ancestral man and woman, one pair the sacred possession of each *sinzanga* (pls. 3, 5, 6), communicates in visual terms the very opposite of both *möhö* status and the bush: an expression of the purity of the path of Poro. The ideal expressed is not so much one of physical beauty, although that is an element of the visual communication, but of striving for perfection in the moral, intellectual, and spiritual formation of the individual in Poro. Senufo figures of this category, by their economy of form, gesture, and facial expression, express an inward-directed energy, containment, and control. In diametric opposition to the idealized image of the ancestral couple are the aggressive, outward-thrusting forms of the Poro helmet masquerades. The menace of open jaws and jagged teeth and the explosive force of bundles of feathers, quills, bristling layers of skins, and other materials are icons appropriated from the bush world as symbols of power. Held in the reins of temporal authority, images of outward aggression appropriated from nature express the invisible powers of the supernatural. The masquerades incorporating these symbols are intended to act as deterrent forces against law breakers, witches, and malevolent spirits of harm to the village.

The two major art traditions of the Poro society, the ancestral couple and the Poro helmet masquerades, reiterate for the initiate and the Poro membership the contrasting philosophies and images of the civilized and the noncivilized, which find greatest public expression in the context of the commemorative funeral for elders. Thus, for example, Kufulo and Fono Poro societies place the ancestral couple in a position of honor near the small *Kpaala* display of accumulative objects summarizing the dead elder's achievements. Standing in a posture of perfectly controlled strength and containment of gesture and expression, the guardian couple watches over the site where the body will be brought for final ancestral rites and where the maskers perform. In contrast to the idealized humanity of the couple, the aggressive, animalistic forms of the helmet masquerades project a world of dangerous and evil forces brought under the control of sanctioned authority.

Both the advancement ceremonies of the Poro initiation cycle and the funeral rituals for graduated members provide the central contexts for Senufo villagers' experiences of the arts, either as audience or participants. The enormous importance of advancement to the

individual member of each age grade and kin group is expressed primarily by aesthetic means. An event like *Kwörö* requires the assemblage of numerous art forms, many newly created for the occasion, of various constructions set up as complex displays, and of an accumulative buildup of art forms, performances, and events that climax in the final rite of passage. The same tempo of preparation, crescendo, and climax characterizes the funeral.

In Western society people are exposed daily to forms that are consciously aesthetic and hence often ignored through familiarity. The contrast with Senufo culture is striking. In a Senufo village or region, the rhythm of exposure to aesthetic forms is in itself a consciously aesthetic device. At periodic intervals the austerity and monochromatic tones of every day are blown wide open to a feast for eyes and ears that creates an orchestrated heightening of human experience in the context of the initiation or funeral event. For a few days or weeks the exposure is maintained and then completely submerged again behind the veil of Poro secrecy.

One of the definitive characteristics of Senufo art could be said to lie precisely in this quality of art in time, art as an appearance and a display that is temporal and ephemeral. To be sure, certain of the material components, such as masquerade and figure sculptures, may be preserved carefully and guarded jealously for several generations. Along with more ephemeral creations, they can be, and indeed are, subjected individually to artistic criticism. To the Senufo, however, their full intellectual and aesthetic value is realized only in their dramatic appearance in the context of the funeral or initiation. The rhythm of exposure provides a rich and deeply satisfying sense of historic continuity to the old and one of wonder and dazzlement to the young.

Appendix

INTRODUCTION

In order to respect informants' requests for secrecy as much as possible, I have observed the following considerations when giving the names of certain objects, rituals, or titles. When a Senufo secret word is withheld, a close translation in English and the public name are given. Here it is the underlying meaning that is more important, not the listing of Senufo secret terms. I regret that sometimes the use of secret names has been unavoidable. Secret names for some masquerade types vary not only according to dialect groups (e.g., Kufulo versus Tyebara) but also from village to village within the same ethnic group, and, in some cases (e.g., the Fodonon category of *Nafëërë*), the name is idiosyncratic to the sacred grove of a single Pondo or Poro society organization. Some masquerade types have but one name, known also to noninitiates, but possess features whose full significance is known only to initiated members. In this sense, no masquerade is entirely public.

The masquerades below represent all the basic types present in the research area during the years 1969–70 with the exception of the masquerades of the Tyeli Poro societies. Also, I have not included those masking traditions which seemed idiosyncratic to one Poro organization or village, such as a Kufulo fiber masquerade seen only once and a strange (imported?) face masquerade that served as escort to one of the Fono *Kunugbaha* masquerades. Those indicated by an asterisk were not seen as a complete unit in a performance context but were reported by local informants. The women's *Nafiri*, not included in the Appendix, is described briefly in Chapter 2 (pp. 79–81).

I. Fodonon
 A. *Kanbiri*
 B. *Tyo*
 C. *Kurutaha*
 D. *Koto*
 E. *Nafiri*
 F. *Poyoro*
 G. *Gbön*

II. Fono
 A. *Kamuru*
 B. *Kodöli-yëhë*
 C. *Kwöbele-kodöli*
 D. *Kunugbaha*

III. Kufulo
 A. *Gbongara*
 B. *Kponyungo*
 C. *Zwatyori*

IV. Kufulo and Fono
 A. *Kmötöhö*
 B. *Tyelige*
 C. *Yalimidyo*

V. Sandogo Related
 A. *Fila*
 B. *Kotopitya* (Fodonon)
 C. Women's *Nafiri**
 (Fodonon,* not included in
 Appendix)

I-A. FODONON: KANBIRI

Ethnic group: Fodonon
Age grade: Primary or children's Poro
Vernacular name and meaning: *Kanbiri* is the short form of *Piilekanbiri*, "little children's" dance mask (*piile*, "little children"; *kanbiri* may possibly refer to the *kabile*, a small hoe used by little boys at the hoeing contests). *Kanbiri* is also the masquerade association of the youngest boys; the mask construction, along with accompanying songs and dance steps, provides the first test of a boy's capabilities. By definition, the group is highly imitative of the older Poro grade activities and forms. Fodonon equivalent of *Kamuru* (see II-A for comparison).
Description of masquerade (pl. 58):
 I. Material components
 A. Mask—A black cloth hood in intentional imitation of *Koto*'s knit hood (I-D) with a similar red cloth crest decorated with white cowrie shells: the shells may extend in a long tail that terminates in a small, round reflector mirror.
 B. Costume
 1. Sometimes a tight-fitting knit suit similar to *Koto*.
 2. Wide cape, full skirt, full wrist and ankle ornaments of dried, prepared grasses. The children are expected to make the costume without supervision on the basis of their own ingenuity and observation of the adult masquerades. They even have a small adobe house for storing their costumes in the village.
 II. Sound components
 A. Vocal-nonvocal—The *Kanbiri* masker is normally accompanied by age mates who sing and clap.
 B. Instrument(s)—When the *Kanbiri* association appears with the men's harpist associations, the *Kanbiri* dance to the accompaniment of two calabash-and-cowrie-net rattles (*tyeli*) played by boys in older grades and a full *bolongböhö* ensemble (pl. 82).
 III. Performance context(s)
 The only performance context is the commemorative funeral involving Fodonon participation (no restrictions on age, group, or sex). During the day of burial, the young members of the *Kanbiri* association tour the village, hoping to win the elders' approval and to earn cowrie shells with their performances. In the Dikodougou area, the *Kanbiri* masquerade also performs in conjunction with the harp-lute (*bolongböhö*)

musicians' association as one of the musical events of the night watch prior to burial or as part of postburial commemorative celebrations.

I-B. FODONON: TYO

Ethnic group: Fodonon
Age grade: Any of three initiate grades of Pondo
Vernacular name and meaning: *Tyo* (or *Tyōo*) is said to be the name of a kind of wildcat.[1] *"Auxiliary" mask* is a summary term more descriptive of its characteristic roles in the performance context, where its multiple duties include being both "constable" and "clown." A secondary mask to *Koto* (see I-D).
Description of masquerade (pl. 70):
I. Material components[2]
 A. Mask—Sack mask with upper corners modified to suggest catlike ears. Often an appliqué strip of nose creates a comical face. Simple eye holes cut.
 B. Costume
 1. Sack body with the legs made considerably shorter than the wearer's, creating the gathered, baggy effect of pantaloons (a pattern comparable to the men's drawstring breeches found throughout the Western Sudan). Sack-shaped mittens are sewn onto end of sleeves, completely hiding the hands.
 2. Both pieces (i.e., the mask and body) of woven cotton fabric, painted or dyed dark brown on cream ground with an overall pattern of small rings or "spots."
 3. Raffia anklets, brown, buff, or cream colored, with red trim.
 C. Other attributes—Carries whipping stick in one hand and a forked stick in the other; these double as "props" in pantomimes.
II. Sound components
 A. Vocal-nonvocal—Masker is nonvocal.
 B. Instrument(s)—No associated musical instruments.
III. Performance context(s)
 As part of the *Koto* masquerade team (composed of *Koto*, *Kurutaha*, and *Tyo*), *Tyo* is essentially an auxiliary mask that assists, supports, and supplements the performance of *Koto*. Appears in three contexts:
 A. Initiation—Appears with *Koto* team at Senior graduation (*Kafwö*), where seen only by initiates and members of Poro. Accompanying *Kurutaha*, it circulates among elders, collecting money and keeping order.
 B. Funeral (secret and sacred ritual)—Joins *Nafiri* masks in commemorative ceremonies immediately prior to burial, held in the deceased's *katiolo* and the sacred grove. These rites, the "initiation of the cadaver," are for a restricted Pondo society audience.
 C. Funeral (comic pantomime)—As part of *Koto* team, it may appear during postburial celebrations for a Fodonon elder. As an "inter-

mission" filler that allows *Koto* to rest, *Tyoφ* provides comic and dramatic entertainment along with the other secondary mask, *Kuru-taha*. May be seen by women and children in this context. Keeps crowd in order for *Koto*.[3]

I-C. FODONON: KURUTAHA

Ethnic group: Fodonon
Age grade: Any of three initiate grades of Pondo
Vernacular name and meaning: Quasi-public names—*Kurutaha*, "the One That Comes Back Again," mask, and *Wawoolii*, "the Eater." Both names are quasi-public; that is, the name itself, but not all its implications and inner meaning, is known to noninitiates. Both names allude to the insatiable appetite of this mask for cowries and money—an income that will be shared out to Pondo members according to formulas of rank and status in the organization. Fodonon equivalent of *Yalimidyo* (see IV-C for comparison).
Description of masquerade (pls. 60, 70):
I. Material components[4]
 A. Mask—Cloth sack mask with earlike or pointed corners and small holes cut for eyes. Square-jawed appearance (see II below).
 B. Costume
 1. Monotone (beige or brown), one-piece "sack" suit of woven and tailored cloth.
 2. Raffia anklets, wristlets, and cape of characteristic Fodonon bright creams and reds.
 3. Two long, knit sashes ending in raffia tassles. Worn as a "loin-cloth," these are tucked through a leather cord around the waist that holds in place the secret stuffing that forms the distended belly.[5] One iron bell (half-circle, fold-over type) tied to waist cord (same as *Yalimidyo*).
 4. Ornamental crown with style varying according to local traditions. Two examples illustrated: wreath of green leaves and basketry band ringed with bird feathers.
 5. Hidden mouthpiece (see below).
 C. Other attributes—Carries a short-handled whip.
II. Sound components
 A. Vocal-nonvocal—This mask type "speaks" (an attribute perhaps more important than any single visual factor).
 B. Instrument(s)—A hidden device of wood or brass that distorts human speech tones. A hollow, kazoolike instrument of crescentic shape attached transversely across the mouth.
III. Performance context(s)
 A. Initiation (see *Tyo*)—Part of *Koto* team. Greets elders in audience, jokes, and is known for "intelligent" speech (i.e., witty, creative, adept in secret *Tiga* language, etc.).
 B. Funeral—Part of *Koto* team, talks to crowd, embarrasses and intim-

idates noninitiates; "polices" crowd during *Koto* performance, acts as a distraction during rest periods; joins *Tyo* in comedy skits that ridicule social groups and customs, human weaknesses, disease, etc. In both contexts the masquerade collects cowries and money for Pondo.

I-D. FODONON: KOTO

Ethnic group: Fodonon[6]
Age grade: Initiates and graduates of Pondo society
Vernacular name and meaning: Koto—no literal translation known. In essence, *Koto* is preeminently a masquerade that is intended to be beautiful and whose central purpose is aesthetic enhancement of an event. *Koto* is the Fodonon's mask of initiation, or "Mask of Changed Life." *Koto* is seen as a personification of the supernatural or spiritual power that changes the status of initiates and the dead or, rather, the visible symbol and guardian of those powers that sanction each transformation. The full, rounded forms and such attributes as the stirring-spoon insignia (*gbënëge*) are female and suggest a reference to Ancient Mother.
Description of masquerade (pls. 59, 74, 84):
I. Material components
 A. Mask—The basic pattern is a black, knit hood (or "head") with a coiffurelike, longitudinal, red cloth crest decorated with white cowrie shells and one or two white feathers.[7] Within this pattern are countless small variations of the crest ornamentation, which are never the same from one *sinzinga* to another, such as intertwined strings, rosettes, little cloth balls or buttons, and dangles of cowries.
 B. Costume
 1. A tight-fitting knit suit of heavy cotton cord yarn dyed black.
 2. Long, full-bodied wrist and ankle attachments. The wraps of red and cream-colored raffia are neatly braided along the two-inch edging. The bouffant wrist wraps, whose pom-pom qualities are used extremely effectively in the dance, are always larger than those for the ankles.
 3. All but the lower arms and legs of the suit are then covered with a dome- or bell-shaped mass formed of many layers of red and cream-colored raffia wraps wound around an "armature" of raffia padding worn harness fashion over the upper torso. A two-tiered effect is produced by a breast-length raffia cape.
 4. Cast-brass ornaments: three (sometimes fewer) round, flat disks, the smaller attached at each side of mask crest and the larger at the back of the costume. Often with finely cast designs on one side, these disks can be quite beautiful examples of craftsmanship (the larger average four to five inches in diameter). I have also seen some that appeared to be modified tin-can lids.
 C. Other attributes

1. The *Koto* masker always carries a scepter that takes the form of a round, flat disk on the end of a handle. It is of one piece (disk ca. five to six inches in diameter, handle ten to twelve inches long) with or without surface decoration, in cast brass, forged iron, or carved wood. These scepters can be impressive works of art in themselves. The scepter is called *gbënëge*, a reference to a large wooden stirring paddle, a woman's implement of like shape.

II. Sound components

Both vocal and instrumental accompaniment figure in the total *Koto* masquerade identity.

A. Vocal-nonvocal—The *Koto* mask is in fact a speaking mask, although its speech is limited to certain purposes and is usually in subdued tones to initiates and elders, quite unlike the loquacious speech of the *Kurutaha* mask. *Koto*'s most important speaking role is on the occasion of *Kafwö*, when he confirms the new secret name of the graduate.

B. Instrument(s)—A pair of musical instruments: *pondotyeli*, a calabash-and-cowrie-net rattle. Two associate vocalists (who are playing rattles at the same time) sing texts appropriate to *Koto*. Musicians range from postgraduate "masters," including recent *Kafwö* graduates, to initiates who have been found to excel. (All three age grades may perform.)

III. Performance context(s)

The *Koto* masquerade may be considered the most important of all Fodonon masquerades in terms of its intersection with three of the most critical points in a man's life: (1) entry into the sacred forest and conferment of the status of newly born initiate; (2) the completion of initiation and graduation as a completed man; and (3) the ritual funeral, which commemorates a man's life and ensures passage to the spirit world of the dead.

A. Initiation (audience restricted)

1. At the conclusion of the entrance ordeals, the *Koto* ceremonially takes its scepter to sanction its newly acquired character as initiates.[8]

2. At the opposite end of the twenty-year initiation cycle, the *Koto* performance is the climax of a three-day graduation ritual (*Kafwö*) in which each initiate is blessed individually by *Koto*.

B. Funeral—Commemorative funeral for elders who are past members of *Pondo*.

1. Before burial, those who have achieved mastery of the *Koto* dance will be among the select who dance by the body during the drumming ceremony (restricted audience).

2. The final ritual of the Pondo society after burial is a postlude performance by the *Koto* team, a public event enjoyed by women and children.

I-E. FODONON: NAFIRI

Ethnic group: Fodonon
Age grade: Lower Grade (*Pilao*) and Middle Grade (*Pilaëësalang'o*) of Pondo
Vernacular name and meaning: Public name is "*Nafiri*" or "*Nafëërë*," with the root meaning "man dressed up." The word *Nafëërë* is not only a general public name for this specific fiber masquerade type of the Dikodougou area Fodonon but, with local variations, is also used widely throughout the Central Senufo region as a generic term for several categories of fiber masquerades. The production of a renewed *Nafiri* fiber assemblage constitutes the first major step of a beginning initiate class in the three-grade Pondo cycle, and it is the *Nafiri* which first signals the funeral of a Pondo society member. Secret name(s): The *Nafiri* type is given a different secret name by each Pondo organization (i.e., "Rascal," "Driver Ant," "Red One"), although many refer to the heat or cutting power of the long whip—the mask's central attribute.
Description of masquerade (62 [color], 87, 90):
 I. Masquerade components
 A. Mask—A close-fitting mask of finely knit cotton yarn that pulls down stocking-mask fashion over the head. The mask is crowned with a pom-pom of raffia; color depends ultimately on the local *sinzanga*, but the most common hue is the bright or dark red characteristic of the Fodonon style. (Bright ocher yellow and near-black sienna examples observed were considered the exceptional idiosyncrasies of particular *sinzangas*).
 B. Costume—A close-fitting, knit, one-piece suit of subdued monochromatic beige tone sometimes with decorative, knit, horizontal bands in one or two additional colors.
 C. Other attributes—Whip (*pëëö*), a long, powerful one of thickly roped fiber that tapers to a length of six or more feet. The Pondo word for this type of whip is the same as the vernacular word for the scorpion and alludes to the whip's capacity to inflict a painful sting.
 II. Sound components
 A. Vocal-nonvocal—Masker is nonvocal but known by the crack of its whip.
 B. Instrument(s)—No direct association with any one musical instrument. Indirectly its appearance may be (though not necessarily) combined with the "marching ensemble" or standard Pondo orchestra (two drum types, iron gongs, small iron scraper, kazoo).
III. Performance context(s)
 A. *Nafiri* are essentially funeral masks whose central purpose is to honor and pay homage to male elders at their funerals. (Pairs of *Nafiri* demonstrate respect and gratitude for the elder's contribution to the Pondo organization by the device of whipping each other.

Their "suffering," in commemoration of the elder's own past suffer-
ing for Pondo, is a symbolic payment of debt.) Ritual whipping
occurs in two contexts: at the house of the dead one, when each
Pondo group comes to greet the dead one, and as part of the *sin-
zanga* ritual just prior to burial.

B. First masquerade to be called out upon the death of a Fodonon
elder. An "escort" masquerade to the Pondo musical ensembles
(which visit the dead one's house immediately on arrival at the
host village), *Nafiri* have a set ritual for the visit, including the
whipping performance and a certain formula of entering the house
and encircling the body.

C. Collect cowries for their Pondo organization from women in host
villages.

I-F. FODONON: POYORO

Ethnic group: Fodonon
Age grade: Theoretically, all three Pondo grades and graduates. Is not
associated with any one grade in particular; in fact, is usually danced by
older initiates to show the lower grades "how to" and frequently danced
even by elders who wish to honor friends in this way.
Vernacular name and meaning: Poyoro, Poyöölö ("dance of Pondo"). A
masquerade of intentional beauty and feminine qualities, Poyoro is designed
"to be beautiful [*nyo*] for the funeral." *Poyoro* is said to be the "wife" of
the *yasungo*, in this case the sacrificial altar of the *sinzanga* that is associated
with the *Gbön* masker. The *Poyoro* masker, wholly female in his dance
movement, follows the *Gbön* masker in the final rites honoring deceased
(male) members of the Pondo society.
Description of masquerade (pl. 44 [color]):
 I. Material components
 A. Mask—Carved wooden face mask of acceptable format.[9]
 B. Costume
 1. Black, knit, one-piece suit covering all of body but head, hands,
 and feet. Same basic suit as used for *Koto* mask (cf. I-D).
 2. Full raffia skirt with the cream base and rich, bright red border
 trim that characterizes Fodonon raffia techniques.
 3. Raffia wristlets and anklets of same color scheme. The stylized
 Poyoro wrist falls tend to be three or four times the length and
 body of the *Kodöli-yëhë* equivalents.
 4. One-piece cloth cape attached to rim holes of mask and draping
 arms and back.
 C. Other attributes—Carries a forged-iron staff with ornamental finial
 of iron bells.
 II. Sound components
 A. Vocal-nonvocal—Masker does not speak. Support group shouts
 stylized cries of encouragement.

B. Instrument(s)—The core ensemble of secret-sacred Fodonon Pondo instruments (not to be seen by noninitiates) includes a two-headed, large, barrel drum of wood and skin; three small pottery drums (see I-G); speaking tubes; and miniature iron scraper and gongs.

III. Performance context(s)—Funeral commemorative, sacred ritual

A. Leaves the *sinzanga* only to perform the commemorative funeral ritual at side of body of a deceased member, including greeting family and elders, and to address the dead one at his house prior to burial.

B. A sacred-secret category masquerade that may be seen *only* by members and senior initiates of Poro and Pondo, never by uninitiated women and children.

C. Traditionally follows the appearance of the *sinzanga*'s helmet mask (*Gbön*).

A NOTE ON HELMET MASQUERADES:
GBÖN, KUNUGBAHA, AND KPONYUNGO

This brief note on the meaning and context of the helmet masquerades is intended as but an introduction to what is both a complex and sensitive institution in Senufo culture—masks as visual signs of protective and aggressive magic. As the most powerful masquerade of each Poro or Pondo society, the helmet masquerade is the one most hedged about by protective sanctions and secret knowledge guarded by an elite. Evidence I collected in 1975 and 1978–79 indicates that some masking traditions have no direct connection with the Poro society originally but stem from individual encounters and conflicts with *madebele* (bush spirits) and that the masking society itself may actually be initiated by a woman *Sando* diviner. In other words, certain helmet masquerades come into being for the purpose of coping with particular situations involving the *madebele*. A second dimension of helmet masquerades, which can be mentioned only briefly in this context, is that masquerades should be viewed as but one element of an object-knowledge complex. The Senufo design the helmet masquerade to be the most dramatic public manifestation, supported by ancillary masquerades and less visible altar sculpture, of the power source itself—which might be an aesthetically uninteresting pot filled with a secret formula of "medicine" used to combat sorcerers and protect the group membership. Therefore, the basic meaning given below provides at best a preliminary understanding of the major purposes of the helmet masquerade used in 1969 and 1970 by the Poro organizations of the three principal ethnic groups of the Kufulo region: the Fodonon, the Fono, and the Kufulo. Although ethnicity is expressed by the configuration of the particular masquerade complex, including style, typology, and musical instruments of each, no major difference of meaning, only one of degree, was discernible between the three major helmet masquerade types. For that reason I am providing a basic statement of purpose and meaning pertinent to all three

before defining the material and stylistic features that distinguish one masquerade type from another. The blacksmith masquerade was unquestionably the most important of the antiwitchcraft masks; this importance was reflected visually in the accumulative power of media and symbol.

The helmet mask constructions are the senior and most "dangerous" of Poro society masquerades. They are the embodiment of supernatural powers and knowledge of magical formulae, expressed through aggressive forms and symbols, including the adjunctive accumulation of signifying natural material to the carved zoomorphic head. These powers are augmented by age and validated by the accretion of magical substances and blood sacrifices to *Kolotyolo* and *Katyelëëo*, the ancestors, and the bush spirits. The masquerade incarnates powers that may be directed against lawbreakers (felons) and sorcerers and against negative spirit forces, such as witches, wandering dead, and malevolent bush spirits.

Another real level of meaning of this masquerade is that it provides the men with a psychological leverage to ensure that women and other uninitiates keep their places in the social order. The primary purpose remains a protective one: the substances and signs of danger incorporated in the masquerade are assembled in order to protect their group from social and supernatural evils. The masquerade is both "secular" and "sacred," embodying both the supernatural powers of the bush spirits and of the ancestors and the temporal authority of the elders and of leadership of the organization.

I-G. FODONON: GBÖN

Ethnic group: Fodonon (and related *Gbönzoro* group)
Age grade: All three Pondo grades.
Vernacular name and meaning: *Gbön*.[10] The semipublic name, *Gbön*, may be a play on words between *gböö* (high tone), meaning "big" or "great," and *gbön* (low tone) referring to the baboon. True, this is both the largest and the most senior of the masks, but the first-level translation of *Gbön* refers to the powerful animal of the bush. However, the basic meaning goes far beyond this simple reference (see above note on helmet masquerades, a general discussion of meaning applicable to *Gbon*, *Kunugbaha*, and *Kponyungo*.)
Description of masquerade (pls. 9 [color], 85, 88):
 I. Material components
 A. Mask—Carved wooden zoomorphic helmet mask: a box-shaped muzzle projects from the dome-shaped helmet, crowned usually with the chameleon figure, and is balanced by antelope horns. The horns may be handled as a flat, wide, curved plane or as rounded, curved horns and spiral grooves. In general, the horns of *Gbön* are said to be shorter than the long antelope horns of *Kponyungo* (pl. 89; III-B). Rarely do *Gbön* masks have wild boar tusks emerging from the corners of the mouth. The muzzle usually has a row of

small, conical teeth. Masks can be highly polychrome, with painted sienna red and white geometric patterns.

B. Costume
1. High raffia polychrome collars that hide the base of the helmet.
2. Layer upon layer of raffia wraps is attached to form a full-bodied, dome-shaped mass of cream and crimson raffia. Similar layers of raffia give a ruffled or pantaloon effect to the leggings and sleeves.

C. Other attributes—Carries a tall, straight walking stick (*kagaana*) used by women and old people.

II. Sound components
A. Vocal-nonvocal—Nonvocal
B. Instrument(s)—The *Gbön* masker himself does not carry an instrument but is accompanied by fellow initiates (*pombibele*) carrying two drum types:
1. Public name—*Numbinge*; secret name—"person." A large, two-membrane, cylindrical drum.
2. Public name—*Pehele*; secret name—"tortoise." A set of three pottery drums of modulated sizes.

III. Performance context(s)
A. Funeral—The funeral is the primary context for the *Gbön*, which is the principal in the ancestor rites of the commemorative funeral for elders who were graduates of the Pondo society.
B. Initiation—The helmet mask component of the *Gbön* masquerade is involved in the rites inducting new Lower Grade initiates into the Pondo society.

II-A. FONO: KAMURU

Ethnic group: Fono[11]
Age grade: Primary or children's Poro
Vernacular name and meaning: "Beginner's Dance Mask"—The masquerade(s) and the association both bear the name *Kamuru*, provisionally labeled "Discovery Group" on the basis of suggested etymology of the word.[12] In the *Kamuru* group begins the teaching of the fundamentals of the socioreligious ideology and concomitant codes of behavior in a structured process of successive revelations that reach their climax in the final initiation cycle (*Tyologo*).

Kamuru is appropriately seen as a category composed of two types or subtypes of masquerades, with one type having several closely related variations of costume and context.

Description of masquerade (pls. 65, 67):
I. Material components
Two subtypes that probably represent two different stages of progress.
A. Subtype 1 (knit suit)

1. Mask—Knit hood with a longitudinal, red cloth crest with a tail and cowrie decoration.
2. Costume
 a. One-piece, knit suit with horizontal band designs, the white suit contrasting with the brown or indigo patterns.
 b. A short, neatly trimmed waist skirt of multicolored raffia and raffia trim on ankles.
 c. Belt of iron bells pulled tight over the buttocks.
B. Subtype 2 (cloth suit)
 1. Mask—Knit hood with longitudinal, red cloth crest with cowrie decoration.
 2. Costume
 a. A plain cloth suit of monochrome buff browns.
 b. Ragged-looking raffia cape, wristlets, and anklets.
II. Sound components
 A. Vocal-nonvocal—Nonvocal
 B. Instrument(s)—Instrumental accompaniment depends on the subtype and context
 1. Knit style—The support team and chorus provide the rhythm by singing, the rhythm syncopated, with the bells sounded by the dancer's hip movements.
 2. Cloth-style, preburial event—Blacksmith (played by Poro Junior Grade initiates and older). Instrumental ensemble (*Fonobinge*) of flute, gong, and drum.
 3. Cloth-style, postburial event—Intermediate iron scrapers and flute ensemble (same accompaniment as for *Kodöli-yëhë* mask).
III. Performance context(s)
 Basic context is funeral, but in a peculiar sense it is simultaneously an initiation experience for the young performers in that it is their first age-grade experience, time of testing, and exposure to public criticism.

II-B. FONO: KODÖLI-YËHË

Ethnic group: Fono
Age grade: Junior Grade (*Plawo*)
Vernacular name and meaning: *Kodöli-yëhë*; short form—*Kòdöli* (other variations: *Kpeli-yëhë*, i.e., *Kpelié*, Kafiri dialect area). *Yëhë* means simply "face" in Central Senari language. Thus, "face masquerade" is a fairly literal translation. As with other masquerade types in the *Kodöli* category, *Kodöli-yëhë* dances and entertains as part of the funeral social festivities. More specifically, *Kodöli-yëhë* is at the same time an age-grade mask that is part of the initiation process. Finally, there is a significant aspect of female symbolism in the masquerade.
Description of masquerade (pls. 42, 43, 66, 69):
 I. Material components

 A. Mask—Carved wooden face mask of acceptable format, including proportion, surface coloring, and iconographic details.

 B. Costume
 1. Overskirts: short, closely knotted raffia skirt; multicolor (hip-length) and long, loosely spaced raffia strands (below knees).
 2. Raffia wristlets and anklets, long enough to cover hands and feet.
 3. One-piece cape or two-piece shoulder cape and head scarf.
 4. Cloth leggings and shirt (tailored, hand-sewn, woven cloth in Kufuru (may be knit in other areas).

 C. Other attributes—Carries one or two horsetail dance whisks.

II. Sound components
 A. Vocal-nonvocal—Support team or chorus encourages dancer with songs and chants.
 B. Instrument(s)—Blacksmith ensemble including one bamboo or wood flute and three forged-iron rasps.

III. Performance context(s)—Essentially a funeral mask
 A. Appears only in context of funerals involving the blacksmiths. As with the smaller-children's masquerades, such as *Kamuru*, *Kodöli-yëbë* is implicitly an initiation mask in the sense that it is a key area of learning and testing. Although the dancer may be sixteen or seventeen years old, he is still a "child" in the eyes of Poro elders. For the commissioning, manufacture, and organization of masquerade components and in the planning and execution of performance, the youngsters prove their abilities to cope with responsibilities in an extended "practice session" that lasts several years.
 B. A public mask that may be seen by the uninitiated, including women and children.
 C. Traditionally preceded in appearance by the younger-age-set mask, *Kamuru*.

II-C. FONO: KWÖBELE-KODÖLI

Ethnic group: Fono
Age grade: Intermediate, *Kwörö* graduation phase
Vernacular name and meaning: *Kwöbele-kodöli*, literally, "*Kwörö* graduate's masquerade." A dance mask worn by initiates celebrating the completion of the last important phase of initiation prior to entering the Senior Grade (*Tyologo*).[13]
Description of masquerade (pl. 21):

I. Material components
 A. Mask—A black, knit hood that covers the head, with a longitudinal red crest of padded cloth (cf. the Fodonon *Koto* and the child masquerade *Kamuru*). Ornamented with cowries, painted curvilinear designs, cloth buttons, leather and cowrie dangles, etc.
 B. A close-fitting, one-piece, knit suit of white cotton yarn, decorated

with painting on dark, geometric band designs, using a dye technique said to be similar to *Fila*.

Breast-length cape and ankle-wrist trim of dyed raffia arranged in alternating panels of bright, variegated colors.

Round disks of metal (brass, tin) attached at side of head crest and at buttocks (cf. *Koto*).

Most important unit of costume in terms of its great expense and high aesthetic valuation is the decorative waist belt, called *"Kwöbele Kpaakörögi."*[14] Its purpose is strictly to be "beautiful" (*nayili gii*, "youthlike beauty"). Other than the factors of size, general refinement of detail, and the metal disks, this belt provides the only significant distinction between the blacksmith child as *Kamuru* (knit type) and the blacksmith *Kwöbele-kodöli*.

Description: A wide leather belt worn just below the waist, ornamented with cowrie-shell designs. The lower border is given a thick fringe of short leather braids that are tied off with a shell. Several small cast-brass bells (*tana*) are attached to the fringe. The bells are of two styles (spherical and bell shaped) and are often exquisite examples of finely detailed casting.

C. Other attributes:

A horizontal dance whisk, a smaller-scale version of the long, flowing dance whisk used by the blacksmith senior graduates at the time of *Kafwö*.

II. Sound components

A. Vocal-nonvocal—Masker is nonvocal.

B. Instruments: (1) the masker wears small bells with clear, "sweet" tones that ring as the dancer shakes his hips; (2) accompanying support team and chorus (who chant encouraging remarks) include three long forged-iron rhythm rasps and a flute (same ensemble as that used for the *Kodöli-yëhë* performance).

III. Performance context(s) (as compared with *Gbongara*):

In general, same as for the farmer counterpart, *Gbongara*, that is, primarily Kwörö initiation and, coincidentally, funerals involving their ethnic and age group.

Also as with *Gbongara*, the *Kwöbele-Kodöli* is supported by a team of his age mates, dressed in the ritual *Kwörö* feather head piece ornaments and *sakelige* belts and carrying the long, braided fiber whips.

A significant difference is the presence or absence of sound components. Unlike *Gbongara*, *Kwöbele-Kodöli* is a true dance mask and is accompanied by age mates playing two of the traditional blacksmith instruments, the forged-iron rhythm rasps and a flute. In this respect, the blacksmith *Kwörö* masquerade is more specifically for entertainment in its conception than is the *Gbongara*, which seems to be more of an authority symbol.

II-D. FONO: KUNUGBAHA

Ethnic group: Fono
Age grade: Senior (*Tyologo*). Specific responsibility for the performance
secrets of the mask restricted to a select guardianship.
Vernacular name and meaning: Kunugbaha (in some areas, *Kanamitoho*).
The secret names of this antiwitchcraft mask are composite ones, abbre-
viated phrases referring to the speed and efficacy of the lethal powers of
the mask. The thrusting, aggressive forms of the daggerlike boar tusks are
one of the essential motifs of this mask type and express in plastic terms
the underlying meanings of danger, power, and strength associated with
the masquerade.(See above note on helmet masquerades, a general discus-
sion of meaning applicable to *Kunugbaha*, *Kponyungo*, and *Gbön*.)
Description of masquerade (pls. 8, 64):
I. Material components
 A. Mask—A zoomorphic, carved wooden helmet mask, usually with
 a rounded, flaring mouth. Style and form of blacksmith masks vary
 considerably from one group to another; the two constant features
 are an absence of the antelope-horn motif and an emphasis on boar
 tusks (sometimes bristling with six or eight) and teeth (both sepa-
 rately defined and as an accordionlike screen of teeth across the
 back of the mouth). The chameleon motif is optional. The mask
 frequently has bulging, shiny eyes of brass. In contrast to the *Gbön*
 and *Kponyungo* masquerades, the *Kunugbaha* is characterized by an
 abundance of additive materials on the helmet mask itself. At times
 the carving is largely hidden by great bunches of green leaves,
 black feathers, and power-magic bundles (quills, feathers, and in-
 ternal organs of certain animals).
 B. Costume
 1. Composite collar and cape of skins and furs of wild bush animals
 (e.g., wildcats, hyena).
 2. Jump suit with drawstring neck and straight-cut legs and sleeves
 painted in deep red or sienna brown dyes, with geometric and
 figurative patterns. Although the suit type is the same as for
 Kponyungo (III-B), Fono costumes of the Kufulo region were
 generally more varied and ambitious in design than those of the
 farmer groups.
 C. Other attributes:
 The Fono masker always carries a double-membrane drum (ca. ten
 inches in diameter). The drumhead is often painted with a bush
 spirit figure.
II. Sound components
 A. Vocal-nonvocal—The masker emits a high, eerie, animalistic wail
 during the drumming ritual at the site of the body and deathbed.
 B. Instrument(s)

1. The masker himself plays the double-membrane drum.
2. The masker is always accompanied by an age mate (*tyolo*) sounding an iron bell mounted on a handle.

III. Performance context(s)[15]

Commemorative funeral rites for all village elders, male or female, who are graduates of their respective Poro organizations. The *Kunugbaha* has a distinct motion style, approaching the *kpaala* and deathbed with a crouching, animallike movement.

III-A. KUFULO: GBONGARA

Ethnic group: Kufulo

Age grade: Junior Grade, fifth-year graduation phase (*Kwörö*)

Vernacular name and meaning: *Gbongara*[16]-*Kwörö* initiation mask. Exact translation uncertain but in part refers to the large size of the mask and could be rendered, for example, as "Big Raffia Mask." This is the important initiation masquerade responsibility of the *Kwöbele*, who now openly assume the role of "understudy" to the *tyolobele*, or senior initiates. The masquerade is meant to instill admiration, awe, and respectful fear in those below this level of initiation.

Description of masquerade (pl. 55):

I. Material components

A. Mask or "head"—Composite fiber helmet mask of essentially the same construction and design as for *Tyelige*.[17] The one distinctive element of the *Gbongara* mask is a long queue of variegated color rather like a long stack of nested "cups" (about three inches in diameter) of raffia. To this hip-length queue is attached a large brass bell. Also, it wears the white, black-tipped kite or vulture feather of *Kwörö*.

B. Costume—The body is layer upon layer of raffia, which covers it entirely, somewhat resembling a haystack in motion.[18] A diagnostic feature of *Gbongara* is one of proportion; as the Senufo say, *Gbongara* is "wide like a house," or "it can barely get through the passageways in the village." (N.B.: the motion style is intended to accentuate this feature by the way the arms are held and moved at the side of the body where the raffia buildup is greatest.)

C. Other attributes

1. A short, hooked club or cudgel carried by mask (wood).
2. Associated, although not carried by the masquerade itself, are long, braided fiber whips carried by the support group of *Kwöbele* (i.e., *Kwörö* initiates) wearing the feather headdress and ornamental belts (*sakelige*).

II. Sound components

A. Vocal-nonvocal—Masker is silent (needs verification).

B. Instrument(s)—None.

III. Performance context(s)

A. An important part of the climactic celebrations of *Kwörö*, **Junior**

Grade graduation, or advancement, two years prior to entering the final initiation phase (*Tyologo*). Its appearance follows a training period of preparation, learning, and various ordeals and thus announces the successful completion of this time of severe trials.

Gbongara has its own special "dressing room" and storage house on the outskirts of the village, near the *lodala* area.[19] A characteristic motion pattern is a slow, majestic "stalking" through the village, which is intended to instill fear in noninitiates. It never appears alone but is accompanied by guides or support team (fellow *Kwöbele*).

B. While essentially an initiation masquerade, *Gbongara* will also appear as part of the festivities at Great Funerals (*Kuumo*) if any of the main participating villages have held *Kwörö* in the past year or so (i.e., the appearance of both *Gbongara* and *Kmötöhö* at a funeral is largely circumstantial, depending on the physical state of preservation of costumes whose primary purpose is a particular initiation ceremony that occurs but once every six and one-half years).

III-B. KUFULO: KPONYUNGO

Ethnic group: Kufulo

Age grade: Senior (*Tyologo*). Specific responsibility for the performance secrets of the mask restricted to a select guardianship.

Vernacular name and meaning: *Kponyungo* is the semipublic name (*nyungo* means "head"; *kpoo wii*, high-mid tone, means "the dead one" or "corpse," and *kpoo*, high tone, means "to kill"). Thus, a broad translation of *Kponyungo* is "funeral head mask." It may be noted that in the Kufulo region one often hears "*kpofölö*" rather than "*kuugofölö*" for a funeral chief. Nickname: *yakaha* (lit., "mouth open"). One secret name employed in the research area referred to the warthog, a dangerous animal of the bush represented by one of the principal iconographic features of the mask (see above note on helmet masquerades, a general discussion of meaning applicable to *Kunugbaha*, *Kponyungo*, and *Gbön*).

Description of masquerade (pls. 17, 63, 89):

I. Material components

A. Mask—Carved, wooden, zoomorphic helmet mask; same dome-shaped helmet and antelope horns as on the *Gbön* mask (I-G). The *Senambele* see the mask as basically an antelope head that is given additional select features for both symbolic and decorative purposes. The antelopes represent specific species, a fact that accounts for some important "style" differences to be observed in collections. *Kponyungo* masks tend to be more elaborate than the austere forms of the *Gbön* and in 1969–70 were painted with lavish polychrome decorations. Whereas the *Gbön* usually has only the chameleon figure on the crest, the *Kponyungo* frequently has a group of figures, which may vary slightly from one mask to another. A common

grouping is a bird (fish eagle, long-crested helmet shrike, or horn-bill) biting a chameleon attached to a cup form, the latter a reference to a container for magical herbs and leaves. Another element (pl. 63) is a female figure added to the muzzle of the mask. Occasionally a magic bundle of porcupine quills and feathers is inserted into holes on the head or muzzle, but this is not a consistent feature, as it is with the artisan helmet masks. The most critical features are the warthog tusks and antelope horns.
 B. Costume—Jump suit with drawstring neck and straight-cut legs and sleeves (hands and feet allowed to show in contrast to the conservative *Gbön* raffia costume) painted in deep red dyes or sienna browns with geometric and figurative patterns. Each suit has a unique design.
 C. Other attributes—The masker carries a large, double-membrane, cylindrical drum beaten with a flexible, bludgeonlike stick.
II. Sound components
 A. Vocal-nonvocal—Nonvocal
 B. Instrument(s)
 1. The masker himself plays the double-membrane barrel drum (average, sixteen inches in diameter).
 2. *Kponyungo* is accompanied by an age mate playing the most sacred of the Kufulo Poro society drums, a long narrow cylindrical one (ca. four feet long) played with a bent stick.
III. Performance context(s)
 Ancestor rites in the commemorative funeral for graduates of the Poro society. As with the Fono *Kunugbaha*, the *Kponyungo* masks, one for each participating Poro organization, drum by the side of the carved wooden bed used in Central Senufo funeral ritual. This ritual always takes place by the small *kpaala* of the lineage group to which the dead man belonged.

III-C. KUFULO: ZWATYORI

Ethnic group: Kufulo
Age grade: Senior (*Tyologo*)
Vernacular name and meaning: Three known name variants, depending on village: *Liityele, Jofani, Zwatyori*. Literal meanings are secret but refer in some cases to *formal* aspects and in some cases to the *action* of the mask (e.g., "donkey," "ears," or "not letting anyone by without taking a whack at him").
Description of masquerade:
 I. Material components
 A. Mask—Cloth sack mask with earlike corners emphasized.
 B. Costume
 1. Body suit, gathered at neck, has legs with a close-cut, more tailored appearance than *Tyo* and *Fila* sack costumes.

2. Painted design, dark brown or neutral, is based on a linear pattern of rectangles, variously filled with checkerboards, circles, triangles, etc., similar to suit worn by the Kufulo *Kponyungo* masker.

C. Other attributes—Carries two long whipping sticks that emerge from hole in closed, extended sleeve that hides the hands.

II. Sound components

A. Vocal-nonvocal—A nonvocal masker.

B. Instrument(s)—None

III. Performance context(s)

A. A secondary mask that keeps order and chases away noninitiates during either initiation or funeral ceremonial activities.

B. Licensed to beat and steal from strangers and from *möhö*, village males who, for some reason, have failed to continue in and complete Poro initiation and responsibilities.

IV-A. FONO AND KUFULO: KMÖTÖHÖ

Ethnic Group: Junior Grade, advanced phase just prior to graduation (*Kwörö*)

Vernacular name and meaning: (Kufuru and Kafiri dialects)—*Kmötöhö*; public name (there would seem to be no other name for this mask type): "the catch-and-hit mask." The main stem of the word means "to hit" (*kmö*). *Töhö* suggests a "catching game"; that is, the whipping is not a serious threat but mainly for amusement.

Description of masquerade (*pl. 54*):

I. Material components

A. Two-cornered sack mask of plaited palm leaf (similar to the plaited mats and baskets made by blacksmith women), with rounded bottom.[20]

B. A rudimentary raffia or grass cape of intentional crudity, meant to contrast with beauty of climactic masks of the Fono and Kufulo graduating *Kwörö* classes, the *Kwöbele-Kodöli* and *Gbongara* masquerades.

C. Other attributes: A short-handled fiber whip.

II. Sound components

A. Vocal-nonvocal: Masker does not speak.

B. Instruments: None

III. Performance context(s)

A. Principal association is *Kwörö*, Intermediate graduation: a warm-up, preliminary mask that, in effect, announces a pending *Kwörö* celebration. Runs through village, chasing children, for weeks before the final event. (They are of such low rank that in theory it is not a "sin" for a female to wear them.)

B. Funeral: In general, the appearance of this mask type at a funeral is strictly dependent upon whether a participating *sinzanga* happens

to have held *Kwörö* recently enough for the masks to be still intact (usually within a year or two).[21]

IV-B. KUFULO AND FONO: TYELIGE

Ethnic group: Kufulo and Fono
Age grade: First phase of Senior Grade (i.e., never worn after first three years of *Tyologo*)
Vernacular name and meaning: *Yalimidyo-tyelige* or *Tyelige* (short form); "Follower of *Yalimidyo*" was given as the meaning of *Tyelige*. Etymology of word is not certain; "Learner" mask would be an equally appropriate designation for this mask.[22]
Description of masquerade (pl. 10 [color]):
 I. Material components
 A. Mask—a composite fiber "helmet" mask:[23]
 1. A large, squared-off, knitted face of dyed black yarn, decorated with abstract pattern of lines, circles, or braided bands worked into the knit with thin, palm fiber strips.
 2. A short-trimmed, multicolored raffia fringe (doubled in front to hide the neck) frames the face.
 3. A thick and evenly trimmed coiffure of multicolored raffia, attached at back and sides, falling just below the shoulders.
 4. Optional: some local *sinzangas* may give extra flourishes and embellishments (such as a crest) to the basic "helmet" mask to enhance the aesthetic qualities and add to the mask's prestige.
 B. Costume
 1. A close-fitting, knit, one-piece suit completely covers the body. Frequently, an extended, peglike "navel" is knit and surrounded by interwoven palm strips representing the navel scarification pattern associated with Senufo girls who have reached marriageable age. (Color and pattern of the suit vary locally.)
 2. Trimmed with multicolor raffia fringes at wrist and ankles.
 3. An iron bell attached to waist (same as for *Yalimidyo*, IV-C).
 4. A thick cloth or leather belt (*sakelige*) that can be more ornamental in style than the plain leather cords characteristic of the Kufulo area *Yalimidyo*. Palm strips are interwoven into a decorative band of lozenges.
 5. A knit sash (*Yalimidyo mahana*) worn as described for *Yalimidyo* mask (IV-C).
 C. Other attributes:
 1. Carries a cowhide bucket bag (same as *Yalimidyo*).
 2. Carries an imitation, wooden gun (same as *Yalimidyo*).
 II. Sound components
 Same as *Yalimidyo*.

III. Performance context(s)
 A. As with *Yalimidyo*, principal context is the funeral. The mask is literally a "follower" of *Yalimidyo*, a learner or apprentice who accompanies an experienced *Yalimidyo* (ideally a "master" of the art of mask speech) on his rounds.[24]
 B. Initiation: Assistance at *Kwörö* Intermediate graduation.
 C. Policing or disciplinary agent: in former times, if a boy was giving his elders trouble, such as refusing to work in the fields, the *Tyelige* masquerade would be sent to chase and hit him, instilling fear of authority.

IV-C. KUFULO AND FONO: YALIMIDYO

Ethnic groups: Kufulo and Fono
Age grade: Advanced phase of Senior Grade (*Tyologo*) and graduate members of Poro
Vernacular name and meaning: Kufuru-dialect public name—*Yalimidyo* or *yalidyo* (short form). Both the public and secret names vary from one dialect area to another. There are additional secret names or ritualized forms of polite address exchanged between a new *tyolo*, or Senior initiate, and an experienced Poro member who is wearing the masquerade. The fundamental sense of this multipurpose masquerade is conveyed partially by the epithet "Circulating Linguist Mask." It is also termed an "ancestor mask" (lit., "maternal uncle") and is considered a "younger brother" of the deified Ancient Mother. The exact etymology of the public name is uncertain, although it definitely includes the idea of "speech."[25] The *sinzanga*, or "secret," name (literally, "passing around the village") used in the Kufulo region refers, on the other hand, to the characteristic motion patterns of the mask type. The various public and secret names of the mask type in different areas never contradict, but rather complement, each other, each group choosing to express different characteristics of a complex masquerade character.
Description of masquerade (pls. 11 [color], 61):
 I. A. Mask: a complex headpiece composed of:
 1. A two-part coiffure.
 a. A decorative, stylized reference to the red cap of Poro leadership (wood base, covered with red cloth, ornamented with white cowries and topknots or "whisks" of ram's hair).[26]
 b. A shoulder-length hair fall of multicolor strands of yarn.
 2. A sack-type face mask. The decorative face design, always in a highly individualized style, is created with a combination of paints, appliqué, and embroidery stitching using bits of cloth, yarns, cowries, pieces of tin, etc.
 B. Costume:

1. A suit of locally woven cloth, usually dyed a solid brown hue, though occasionally will be seen other dyes, such as indigo or yellow. Rarely, the suit is left white and painted with linear graphic designs, as for some Kufulo and blacksmith helmet masquerades.
2. A raffia cape attached at neck (length just covers the breast and shoulders), of loose strands of multicolor raffia, sometimes arranged in broad sections of color.
3. A long, knit sash of geometric, banded design with raffia fringes, looped in back around a leather cord belt and brought forward like a loincloth, with both fringes in front.
4. An iron bell of characteristic semicircular, fold-over style is worn at waist.
5. Hidden mouthpiece (see II below).

C. Other attributes:
1. Carries a large, cowhide, bucket-shaped bag with shoulder strap.
2. An imitation weapon. In the Kufulo region, a carved wood gun, often a flintlock type.[27]
3. Small whip (optional).

II. Sound components
A. A verbal masker: to be a "master of language" is the primary task of the masker, especially of the poetic-secret Poro language, which is in part idiosyncratic to each local *sinzanga*.
B. Instrument: technically part of the costume, a hidden kazoolike speaking tube distorts the voice.

III. Performance context(s)
A. Primary context for *Yalimidyo* is the funeral. Within the funeral context, major roles and responsibilities include:
1. Circulating throughout village compounds, greeting and blessing elders, collecting money for Poro, keeping elders (especially chief and leadership) informed as to progress of events in the *sinzanga*.
2. Assisting with formal ritual of commemorative funeral.
3. Learning, recreating, and performing the song texts that constitute a major portion of the literature of Poro.
4. Harassing or punishing anyone who ignores or disobeys Poro demands, rules, and law.
5. Mock harassment of children and noninitiates.
 Yalimidyo is personified ancestor, intercessor-cantor, poet, oral historian, comedian, courier, tax collector, and, occasionally, policeman. He is all these things and more.
B. A secondary context is assisting at the final secret initiation rites of *Kwörö*. A major contribution is also providing pageantry for the occasion during the semipublic ceremony by the *Kpaala*.

V-A. FONO AND OTHERS: FILA

Ethnic group: There is no reason to believe the mask is restricted to any one group, although I observed it only among blacksmiths; it was reported also for the Fodonon.

Age grade: "Children who have not yet done Poro" (mask is outside Poro system although wearer is of Primary Grade age level)

Vernacular name and meaning: Fila (short form of *Filafāni*, literally, "dye-painted cloth") is a cloth "painted" with dark stripes on light ground by means of a positive dyeing technique; cloth of this particular technique and style is associated exclusively with the bush spirits (*madebele*) and *Sando* divination.[28] The basic sense of the mask name is "amulet masquerade" or "divination cloth masquerade," that is, a visual symbol of protection and atonement.[29]

Description of masquerade (pl. 40):

I. Material components
 A. Costume and mask
 1. Sack mask with pointed corners above and drawstring effect with bottom edge tucked under collar or suit.
 2. Sack-style "body" modified with arms and legs, the right arm sewn shut and extended into a long bag for receiving cowries.
 3. Both pieces of locally woven cotton fabric (strip weave) dyed with dark brown stripes of *Fila* style and technique.
 B. Other attributes: Carries two or more long whipping sticks.

II. Sound components
 A. Vocal-nonvocal: Masker is silent.
 B. Instrument(s): None.

III. Performance context(s)
 A. Owned by a woman and worn by male child of Primary Grade (her child or child of descendant if deceased) at times of commemorative funerals for elders (men or women) in which the woman and her maternal family participate.
 B. The masquerade is worn as part of a diviner's prescription to a client, intended to neutralize or placate offended bush spirits. The particular offense is generally related to the woman's having accidentally broken a taboo by having seen a Poro textile masquerade when out in the fields (the domain of the bush spirits). If sickness comes later, she will consult a *Sando* diviner, who will say she has seen the "bush spirit's Poro" and must have a *Fila* mask made as a kind of remedy for her illness.
 C. The masquerade will appear during funerals for the rest of the woman's life, the responsibility often transmitted to succeeding generations. The money it collects belongs to the bush spirits. The masquerade becomes a perpetual offering of reparation, embodied visually by a masked personage wearing the textile style that communicates "diviner" and "bush spirits."

V-B. FODONON: KOTOPITYA

Ethnic group: Fodonon

Age grade: Worn by *pombibele*, any of the Pondo initiates

Vernacular name and meaning: Kotopitya, literally, "Koto's girlfriend." ("*Kotopitya-yëhë*" [face] may be used to underline the fact that it is the face mask component being discussed.) Commissioned, purchased, and "owned" by a woman, the mask is part of a *Sando* diviner's "prescription," intended to neutralize the potential dangers of a woman's past encounter with bush spirits. Since performance is the responsibility of Pondo initiates, the mask is therefore a kind of bridge between the two institutions Poro and Sandogo.

Description of masquerade (pl. 41):

I. Material components[30]

 A. Mask—Face mask of acceptable format (according to informants, this part could be the same as *Poyoro*)

 B. Costume—Said to be essentially the same as *Nafiri* from neck down (see Appendix, I-E)

II. Sound components

 A. Vocal-nonvocal—Same as for *Koto* team (vocal)

 B. Instrument(s)—Same as for *Koto* team (two calabash rattles)

III. Performance context(s)

 A. Given to male Pondo. Initiates (*pombibele*) dance with it as part of *Koto* dance only for funeral of initiated male. However, the mask is stored by women when not in use.

 B. Once a year the woman "donor" sends it into the bush to "worship" the *madebele*, or bush spirits.

 C. Involved in girls' excision rites if donor's daughter is in group.

Notes

1. SENUFO FARMER AND ARTISAN GROUPS OF THE KUFULO REGION

1. Apart from information on the Upper Volta Senufo groups adapted from Prost's figures (*Contribution à l'étude des langues Voltaïques*, 1964), the linguistic data used in this study are based primarily on the research of W. E. Welmers ("Report on Senufo Dialect Studies," a survey made for the Korhogo Baptist Mission in 1957) and on revisions by Welmers's co-workers in the survey, missionary linguists Betty Mills and Richard Mills. These reports have considerably updated the provisional linguistic classification of subgroups listed by de Tressan (*Inventaire linguistique de l'Afrique Occidentale Française et du Togo*, 1953), which was used in the 1957 Holas monograph *Les Sénoufos y compris les Minianka*).

2. Population figures for Senufo dialect groups are drawn from the following sources: (1) Welmers ("Senufo Dialect Studies," 1957), whose figures are based on the population statistics for the administrative subdivisions (*sous-préfectures* and cantons), with adjustments of estimated additions or subtractions when dialect boundaries did not parallel subdivision boundaries; (2) Prost's work (*Contribution*, 1964) on the Upper Volta groups; and (3) the SEDES report on the Korhogo region undertaken for the Ivorien Ministry of Finance and Planning ("Rapport demographique," *Région de Korhogo*, vol. 1, part 1, Sept. 1965, table D4, p. 13).

3. Village and canton statistics are available in all *sous-préfecture* archives. Village population figures have been taken from "Inventaire des villages de la sous-préfecture de Dikodougou" (5 June 1968), a manuscript in the Dikodougou archives, and table D5 of the SEDES report ("Rapport," p. 14).

4. The names used throughout the text for specific ethnic groups are in each case a Westernization of the actual Senufo word, which varies in form according to the designated suffix: plural (*bele*), masculine singular (*naö*), feminine singular (*tyoo, dya*). This simplification not only is for the general reader's convenience but also is in keeping with a practice acceptable to urbanized Senufo in modern Ivory Coast. The now common term *Fodonon*, for example, is a French-language modification of the masculine singular form (*Fodonaö*). Some names are virtually impossible to represent within the limitations of Western orthography. For example, the masculine

singular form of the *Kpeene*, or brasscasters, should read as follows: *kp*; nasal open *e* low tone; nasal open *e* high tone; *n*, nasal *a* low tone; open *o*!

5. The Fodonon group was not yet identified and thus not included in the 1957 linguistic survey (Welmers, "Report on Senufo Dialect Studies"). I was able to collect some data of a linguistic nature in 1969–70 from Fodonon informants; these data included general information on the comparative relationships of Fodönrö to other dialects (as reported by the Fodonon, not tested with linguistic analysis) and a modest vocabulary list. This information on language relationships was my first clue in the field to the Fodonon historical and cultural ties with the Gbonzoro and other groups to the south, discussed below in this chapter. A few years later (personal communication, Ruth Casey, 1973) I learned that the southern connection had been confirmed by Tagbana informants, who were able to understand a significant portion of some recorded Fodonon speech; that suggests a relatively high degree of mutual intelligibility between Tagbana and Fodönrö as compared with Central Senari dialects.

6. The expression *despised caste*, as used by early French military personnel and administrators, such as Berenger-Feraud (1882), Dr. Tautain (1884), Monteil (1915), and Zeltner (1908), in reference to other Western Sudanic cultures, simply does not fit the Senufo situation. Even the caste trait of endogamy turns out to be rather flexible in practice in the Senufo context. I learned of several instances of marriages between blacksmiths and farmers, woodcarvers and farmers, and Fodonon and Kufulo farmers. Indeed, as is discussed below in this chapter, some of the artisan groups, such as the Tyeli, may be a dialect group that has undergone social change in respect to occupation. I have also documented examples of blacksmith settlements changing to farming and in time changing their identity from "Fono" to "Kufulo." Such dialect groups as the Fodonon or the Nafanra are scarcely less endogamous in social attitudes and marriage patterns than the so-called castes or artisan groups. Some anthropologists (e.g., W. A. Shack, "Notes on Occupational Castes among the Gurage of South-West Ethiopia," *Man* 54 [1964]:50–52) contend that one cannot have a caste group in a larger society and not consider the whole society a caste society.

7. Interview with Songileena Sillue, chief of Kwokaha *katiolo*, whose ancestors came from the important Fono village of Kwokaha, mentioned above in this chapter (Puloro, July 1970).

8. This information from the Kufulo village chief of Karafiné has been given in the text as the most likely explanation of the etymology of the word *Kufulo* received from informants. To further explain the sense of the word *furu* as used in *Kufuru* he gave another example, *kobilefuru*, meaning "to cut or strike a path in the bush." Although informants were in basic agreement that *Kufuru* is the name of the *syeere* ("words," i.e., language) of the Senambele in the Kufulo region, opinions differed as to the origin of the term *Kufulo*. One Kufulo elder thought that *Folo* was the name given to them by the Fodonon, whereas others were certain that *Kufulo* was the name given to the whole area by the Tyebara people. The Tyebara refer to the people themselves as *Kufurubele*.

9. Interview with Chief Sona and Kufulo elders, Guiembe, 4 May 1970.

10. I was told that there is a certain powerful figure sculpture that is brought out only for the funeral of an *Ndaafölö*, but I was unable to view the figure because of its highly restricted purpose. Each Fodonon village

seems to have its own "rain owner," or rain priest (*Ndaafölö*); this term is an inherited title through the maternal lines. There was one rain priest, chief Foholo of Kapile, whose powers had earned him a reputation that reached into the Kafiri dialect area. The *Nökariga*, or healers' society, and material culture were rather more visible than the rainmaker cult in village affairs, oral traditions, and funeral rituals. I have described the art and mythology of *Nökariga* briefly elsewhere (*African Arts*, 10 [1978]: 68–70). It is this Fodonon society that is the context for the so-called ring of silence, illustrated in Goldwater (1964: pl. 139).

11. My principal informant on the Guro connection was a leader in the *Nöökariga* society who noted that the Guro, or "Lobele," had a healers' society that was "even stronger" than the Fodonon in its secret knowledge of healing (conversations with Wayirime Soro, June 1970).

12. An important unpublished manuscript in the archives of the former Ecole des Hautes Etudes (originally for French colonial administrators, now ENFOM) includes a discussion of the "Sonon branch of the Senufo" living in three cantons of the Mankono region (d'Agostini 1951–52).

13. Oral histories collected at Tufundé, Puloro, and Pundya from Fodonon and Fono elders (November 1969 through August 1970) all indicate that the Fodonon predated the Fono arrival in the area, before which time a group of blacksmiths to the south (e.g., the village of Kulopakaha, twenty-five kilometers south of Puloro), called the "Sungboro," supplied the Fodonon of these villages with iron tools and musical instruments. This sequence is also reported in a manuscript (n.d., script) in the files of the Catholic Mission at Dikoudougou recording oral histories collected locally. The document notes that the Fodonon called the Fono to come work in the area as blacksmiths.

14. I have not yet been able to ascertain the ethnic identity of the Sungboro, particularly the classification of their language. Sungboro villages include Kporopakaha and Tenetyele. The Sungboro in Kporopakaha have spoken only Dyula for years, and only a few elders remembered words in their original language. Significantly, Sungboro blacksmiths, in common with the Tyeduno smiths living in the Kafiri dialect area, have never made the large *daba* hoe, which is the principal product of Fono forges. Both Tyeduno and Sungboro blacksmiths made a small hoe, called "*kope*" or "*kwope*." According to Sungboro oral tradition collected at Kporopakaha, the first Sungboro families there came from Tenetyele, but originally their people came from Kpon (Kong).

15. Senufo oral histories tend to be extremely vague about times of war and "force" (*fanga*). Wars mentioned in regional traditions include references to the "time of slavery" (which seems to be synonymous with the Samory era in the 1880s and '90s) and the "war of Kenedougou." At this time, there is no way of knowing what period of the Kenedougou Kingdom history is meant, its Senufo control in the mid-nineteenth century or the time of the Manding conqueror Touré Tieba in the 1870s and '80s. The three villages of Kiemou, Diegon, and Nerkene are said to have been burned by warriors during the "war of Kenedougou," although the Nerkene men were able to repel the strangers with bows and arrows (council of Kufulo and Fono elders, Nerkene, 12 December 1969).

16. Although the Fono group in the research area claims to have "its own language" or dialect, the vernacular used from infancy seems to be

that of their Kufulo farmer neighbors, the Kufuru dialect. Their "language," at least today, is certainly more a matter of both technical and secret-sacred ritual vocabularies (Poro language) peculiar to the blacksmith artisan group. In the case of the other artisan groups, less populous and more scattered in distribution than the ubiquitous Fono group, the process of farmer dialect adoption is essentially the same.

17. This pattern was consistent in the accounts of village founding and settlement I was able to collect, which included the following villages: Pundya, Puloro, Tufundé, Nerkene, Guiembe, Nöokataha, Diegon, Karakpo, Pindokaha, Zangbokpo, and, in the Kafiri area, Nafoun, Solokaha, Mbala, Dagba, and Ojaha.

18. To take the village of Pundya as an example, all four principal Fono *katiolos* had northern origins: one from Guiembe, one from Nöokataha, and two from villages near Korhogo (Kpatarakaha and Kapele, the group from the latter village traveling to its present location via the Nafanra area near Napié). Blacksmiths from Pundya and other Kufulo region Fono settlements regularly made trips to the villages of Kasambarga, Koni, and Kwokaha in the Tyebara area; in these blacksmith settlements, smelting and extraction of iron ore were done.

19. Maurice Delafosse was one of the first to note that *numu* wives are pottery specialists, listing the *noumou*, blacksmiths and potters, as the first of six "castes" among the Manding-speaking peoples (1912:118).

20. Blacksmith women do not have a monopoly on basketmaking; several kinds of basketry and mat making are practiced by individuals in the farmer groups. For example, one type of basket traditionally made by farmer-group craftsmen is a sturdy weave (of palm fiber?) cemented with a cow dung mixture; made in all sizes, the larger ones were used to store Poro masquerades. The basketry hats worn by balafon musicians and by competitors in the hoeing contests are also made by farmers. The blacksmith basketry style is a more delicate weave, and the most important type is the *danga*, the flared basket with a four-cornered base.

21. The Kule are sometimes called "Daleebele" by the Tyebara people, but this latter term is apparently peculiar to that one dialect group. The Kulebele had a very minor part in my research on the Kufulo-Fodonon region since the ethnic makeup of the focal villages led to a concentration on the Fodonon and Fono groups. For a richly documented study of the Kulebele, the reader is referred to Delores Richter's Ph.D. dissertation ("Art, Economics, and Change: The Kulebele of Northern Ivory Coast," Southern Illinois University, 1977). Quite apart from the author's central research concerns, her data on Kule styles are useful in sorting out Senufo substyle classification.

22. Richter's extensive work (Ph.D. dissertation) on Kule genealogies and oral history has been an especially important contribution to the field. She has succeeded in documenting the village origins and kinship ties of a large number of Kule in the Korhogo and Boundiali areas. Both the "western" (e.g., Nafoun and Boundiali) and "eastern" (e.g., Sumo and Korhogo) Kule ultimately trace their origins to Mali.

23. From an account related by a blacksmith carver (Senyenen'tene Yeo, Pundya, April 1970).

24. Interview with Yatehe Yeo, Kufulo chief of Pindokaha, one of the three principal Kpeene settlements in the Kufulo region.

25. As an example of one such tradition, Morisige Danyogo, the founder of the Kpeene *katiolo* at Katriorokpo, came from Kpon (Kong). According to oral tradition, at that time they were not Muslim but followed the old practices of Poro. Legend has it that many generations ago the founder planted the seed for a giant old baobab tree now standing in the *katiolo* of the Kpeene (chief elder Musa Danyogo, d. 1970, 10 December 1969). In common with other Kpeene elders, no one at Katiorokpo knows where his or her ancestors were before the settlement at Kong, the city that marks the ultimate in time depth for so many Senufo oral traditions.

26. The date is that suggested by Ivor Wilks in "The Northern Factor in Ashanti History" (1961:5–6) and "A Medieval Trade Route from the Niger to the Guinea Coast" (1962:337–41) in the *Journal of African History*. The development of the Kong State is discussed most fully in Edmond Bernus's excellent historical analysis "Kong et sa région (1960). M. Victor Diabaté, Ivoirien archaeologist with the Institut d'Histoire, d'Art, et d'Archéologie (IHAA) at the Université d'Abidjan, is currently directing an excavation at Kong that should provide key data on this pivotal area.

27. This version of why the Kpeene left Kong was related by Nangbo Tuo, a brasscaster living at Tapéré (28 December 1969).

28. The Lorho seem to stand in the same relationship to Kulango farmers as the Kpeene do to the Senufo. Delafosse (1912:156) called the Lorho a "sub-family" of the Koulango and noted that a large proportion of the Lorho were brasscasters. Since the word *loro*, referring to the brasscasters, is also found among the Manding peoples, Delafosse concluded that it was the Manding who gave the Koulango-Lorho group their name. The difficulty here is to determine whether the connection between the Manding area Lorho and the Gur area Lorho is simply a matter of a Manding loan word (i.e., *lorho* coming to mean a generic term for any brasscaster group) or whether indeed it is a case of one occupation-linked caste dispersed over a large area. If the latter case is true, the Kpeene (i.e., Lorho) must be viewed as one artisan caste with a common lineage and widespread branches throughout the Sudanic culture zone.

29. The Lorho figure in several of the accounts of the founding of Bondoukou recorded by early French administrators (e.g., Tauxier 1921: 49, and Benquey, in Clozel 1906:172). Along with the G'bins and the Nafanra subgroup of the Senufo, the Lorho were involved in the history of Begho, the medieval commercial city in the Banda Hills area of Ghana. Begho, collapsed under Ashanti pressure by 1725, was the southern terminus of the long Manding trade route reaching down from Djenne into the goldfields of Akan territory, exchanging salt, metals, and other products for gold and kola nuts (Wilks 1962). I suspect that the Kpeene language is indeed of non-Senufo origin and is traceable by linguistic research. The village of Djorogokaha, which the Dyula call "Logoso," near Ferkésédougou, is settled by people who call themselves "Wadanwa." My one interview with village elders (Logoso, 5 May 1970) was inconclusive on the point of a linkage with the Kpeene. However, the founder was said to be from a village near Kong, and at that time the emigrants were divided into "those who prayed" (i.e., Moslems) and "those who did Poro."

30. One middle-aged brasscaster, an accomplished master of the art, interviewed in the Kafiri dialect area, explained with great sadness that his

young son refused to learn the techniques because he could make more money in the textile profession. The brasscaster added that it was difficult to find enough people who want to buy the ornaments and noted, for example, that the local *sous-préfet* had ordered the village women to stop wearing the traditional ankle bracelets. Thus, governmental efforts at cultural modernization have been a factor in the decline of brasscasting, as has the influence of Christian and Moslem teaching.

31. Senufo sources acknowledged that it was the Dyula who introduced weaving in the Korhogo region; the date I suggest is based entirely on our knowledge of the fourteenth- and fifteenth-century commercial expansion of the Manding, which had its focus on Kong.

32. I was able to spend several days observing these men at work, discussing the history of their group and their technology (interview with Nangbo Tuo, Tapéré, 28–29 December 1969, and Songi Soro, Kapile, 27 April–3 May 1970).

33. There is no evidence that the Senufo *Tyelibele* have any relationship with the caste-linked groups called the "Dieli" and reported widely in Manding cultures throughout the Western Sudan (see Glaze 1976:50–51). Among Manding peoples, such as the Bamana and Sarakole, *Dieli* is a synonym for *griot*, a generic term for caste-linked praise singers, musicians, and oral historians. In all the Manding cultures where the Dieli are reported, the occupation of leatherworking is specific to quite a different group, the "Garanke." The only case where the Dieli are griots *and* leatherworkers is that of the Malinke-speaking Dieli living among the forest-region Dan of the western Ivory Coast (Zemp 1964, 1966). Thus far the record is silent as to where, when, and from whom the Senufo Tyeli learned the art of leatherworking and whether the etymology of the Senufo word *tyeliwe wii* (leatherworker, or member of the Tyeli ethnic group or both) has any historical connection with the Dieli groups found among Manding peoples.

34. Fodonon oral history connects the Dyula of Kadioha with Dyula military expeditions originating from Kong (Glaze 1976: Appendix I, 1). However, the process of Manding expansion south was considerably more complex than is suggested in this one narrative, and one may presume that the Manding presence in Central Senufo country goes back at the very least to the period (the late fourteenth or early fifteenth century) when the trade route from Mali to Kong and Begho was established (Wilks 1961: 5). Some Dyula settlements in Central Senufo are more ancient than many of the neighboring Senufo settlements; for example, Dyula elders of Mbala in the Kafiri area noted that their ancestors, weavers and farmers, founded the village that was joined much later by Kafibele and Tyeduno settlers (Ali Koné, Mbala, 25 April 1970). The Malinke of northwestern Ivory Coast are essentially one and the same people as the "Dyula" as the word is used in this text. This excludes the mixed lot speaking "trade Dyula," including immigrant labor and urbanized Malinke who have left their traditional roots and villages permanently. The Dyula dialect of the Kong area is clearly distinguishable from the Malinke Dyula dialects of the Odienne and Man areas. The Ouattara Dyula Islamized empire at Kong was established at the beginning of the eighteenth century (Bernus 1960: 247–50), before the beginning of Islamized Malinke-Dyula political kingdoms in the Odienne area. The Vakaba reign, "King of Kabadougou," has

been dated to about 1750 (Campion, "Odienne Cercle," 1917). The time depth of the settlement of animist Malinke-Dyula, such as the Nafana branch of Malinke located south of Odienne, and other Manding groups in the area around the Kufulo is not known. Fodonon elders of Pundya, however, were insistent on the point that the Fodonon were the earlier inhabitants of the Malinke-Dyula wedge to the southwest.

2. ART AND THE WOMEN'S SPHERE

1. Parts of this chapter have been published under the title "Woman Power and Art in a Senufo Village" in *African Arts*.

2. For example, see "The Mother and Child Motif," in Trowell and Nevermann (1968:119–26) or O. Nuoffer, *Afrikanische Plastik in der Gestaltung von Mutter und Kind*.

3. In recent years there have been some notable exceptions to this general tendency. To mention but a few examples: Warren d'Azevedo's pioneer studies of the women's *Sande* groups and the institutionalization of male-female members of Gola society; Robert F. Thompson's many contributions to our understanding of Yoruba women in contexts of art and authority (artists, priestesses, "mothers and witches"); and Henry Drewal's research on the Yoruba mask Iyanla, "mask for the mothers of western Yorubaland."

4. Holas, for example, in his 1957 monograph on the Senufo (*Les Sénoufo [y compris les minianka]*), does not mention the Sandogo society at all in his section "Vie spirituelle," part VI (pp. 137–66), although in part IV, "Vie de la société," he does mention Sandogo in one brief paragraph, saying that "the women have a remarkable spiritual influence in every area of society" (p. 87). See also Goldwater (pp. 23–24).

5. My description of the diviner's dance with sculpture is based on observation of a series of consultations with a visiting *Sando* from the Tagwana dialect area (Waseula from Kanawolo village), held at Kafiné village in the Gbonzoro dialect area (8 February 1970). The dramatic outdoor performance I witnessed by a Tagwana diviner is not typical of *Sando* practice in the Kufulo region, where consultation is always a private affair held in a small, interior setting. The diameter of a *Sando's* consulting chamber is generally less than the length of a woman.

6. George Murdock's tables (1967:49, 70) indicate an "absence of any matrilineal kin groups and also of matrilineal exogamy." Holas (*Les Sénoufo*, 1957) certainly mentions matrilinearity as a possible option but fails to offer a systematic analysis of kinship structures and terminology for any one group. However, Père Knops reported the importance of matrilineage in the Nafara areas as early as 1956, and the French demographer Louis Roussel has made an important contribution to Senufo kinship studies, published in 1965 for the Ivory Coast Ministère du Plan (*Région de Korhogo*, "Sociologie," no. 2). The most thorough study of Senufo kinship undertaken to date is the current research of Albert Kientz, who, since 1971, has been engaged in dissertation research and sociological surveys for the Ivory Coast administration in the Korhogo *Sous-Préfecture*.

7. Informants said that *Lango* is a very ancient Fodonon dance and that its purpose is to honor elder women. In addition to the membrane drum

with "two faces," the hand gong and thumb ring, the stacks of iron ankle bells, and the whips (with metal bands running the length), another instrument that always accompanies a *Lango* dance is a whistle (*fefele* type associated with Poro graduates) that "calls the names of the good dancers." The bellows-shaped hand gongs (four to six inches high) and thumb rings were traditionally made by the Sungboro blacksmith group of Kulopakaha village for *Lango* groups in the Pundya area. According to informants, today this dance is associated in particular with the Fodonon groups of Lataha and other Fodonon villages in that area near Korhogo.

8. The reader is reminded that information of this nature is considered highly privileged and secret. The core source groups on Poro are listed in the Preface.

9. In every instance of a male and female pair observed in the field, the female, without exception, was created larger than the male, although the degree of difference in height and size varied. This proportional difference seems to be one of the basic style conventions of Senufo paired-figure sculpture, at least in the area of research.

10. This greeting is used only by Poro society members of the Central Senari dialect groups, such as the Kufulo and the Fono (blacksmiths). The Fodonon Pondo societies have a different set of greetings in their secret language, *Tiga*. However, both groups worship the same maternal deity but under different names. *Katyelëëö* in the Central Senari dialects and *Malëëö* in the Fodonon dialect.

11. Since the word has appeared in previous publications, I have retained the Tyebara dialect term, *Katyelëëö*; the word consistently used in the Kufuru dialect is *Malëëö*. Although the vernacular word for *mother* (*noo*, high tone) is not in the word *Katyelëëö* (*tyelëëö* means "ancient woman"), the secret vocabulary and expressions used by Poro society members are explicit in their references to this deity as "mother." A related word of interest in the vernacular Central Senari dialects is *nolëëö*, a term of respect meaning "grandmother" or "old mother" ("Dictionary: Tyebara-English; English-Tyebara"). Earlier, Bohumil Holas (1966:145) described the essentially feminine nature of the deity *Katyelëëö* in contrast to the "masculine" deity of the equally important *Koulo Tyolo* (*Kolotyolo*). My own inclination, based on informants' comments, is to consider *Kolotyolo* neuter rather than specifically masculine. According to Holas, *Katyelëëö* literally means "Mother of the Village," although my field data suggest that the *ka* could refer to *katiolo* as appropriately as to *kaha* (village) (1955: 145). Unfortunately, I have not yet been able to compare notes on Senufo religion with Père Convers, who, according to sources at the Catholic Mission of Korhogo, supplied Holas with numerous data used in the 1955 monograph.

12. One French Catholic source has suggested that the etymology of *Kolotyolo* is "woman [*tyolo*] from a far place [*kolo*]." However, Richard Mills, who is fluent in Tyebara, has not been able to get this suggestion confirmed from Senufo in the Korhogo area. It is abundantly clear that very little progress has been made to date in the area of research on Senufo religious concepts and structures. The interpretations presented in this chapter are provisional conclusions at best and not without contradictions concerning the nature of various deities and spirits. At the same time it must be noted that the Senufo themselves, in common with most societies, are by no means always in agreement about spiritual matters.

13. For example, the most sacred drum of one ethnic group's Poro society is secretly called "*Malëëö*." This drum is believed to detect such felons as murderers and thieves. The drum is valued more highly than the helmet masquerades that it sometimes accompanies and is the one absolutely essential object in the rituals of ancestor worship at funerals for elders.

14. I am especially grateful to the learned elder Dyambeleyiri Soro (d. 1975), former village chief of Pundya, who took time to carefully explain the subtle differences in meaning of *Kolotyolo*, *Nyëhënë* and *Yirigefölö* in religious practice and terminology (interview with Dyambeleyiri, Pundya, 1 August 1970).

15. That *Fo* is "first" of *Sando* insignia was the consensus of *Sando* diviner informants.

16. Since the *Yirigefölö* shrines were ubiquitous in the research area, my observation of shrines was frequent and the sources too numerous to mention individually here. For information on the *Nyëhënë* altars, I am especially indebted to former chief Sana Soro (d. 1975) of Guiembe as well as to the Sekongo elders of Pundya.

17. Nande Soro, the one male *Sando* among my major informants, spent about ten years with his maternal grandmother as a *Sando* apprentice, literally "child of *Sando*" (*sandopia*).

18. My informant in this case was a woman *Sando* from a mixed Tyebara-Nafara border area (Nabunyakaha, 11 April 1970).

19. This general distinction made by my informants is also reported in some unpublished notes by Lu Johnson in the Baptist Mission of Korhogo archives. This extremely interesting document records an interview with five former *Sando* diviners from the Tyebara and Nafara dialect areas and includes valuable details concerning the technique and symbolic sets employed by *Sando* diviners.

20. In addition to my five major *Sando* informants, at least six other diviners, including one young man who, because of leprosy, was unable to work in the fields, gave this explanation.

21. All diviner sources emphasized that a *Sando* who dies must always be replaced by someone within the matrilineage (*nërëgë*).

22. In the case of the male *Sando* Nande, the succession would follow this order: (1) (*wi koro pia*) the daughter of an older sister; (2) the older sister herself if she has no daughter; (3) the *Sando*'s son if the older sister dies (interview with Nande, Puloro, 8 January 1970). A woman *Sando* in the Kafiri dialect area also indicated that succession preferably skips one generation to designate a young girl in the female line who can then be trained over a long period of time (interview with Senyeneni Sillué, Solokaha, 24 April 1970).

23. Informants were Fodonon men who were age mates of the man concerned in the affair (Pundya, July 1970).

24. My source in this instance was the Fodonon man concerned in the dispute (Pundya, July 1970). Apparently the nature of the fine is fairly consistent among the kin-group-linked Fodonon settlements of Pundya, Puloro, Kapile, Tapere, and Tufunde.

25. In a group interview, the consensus of Fodonon male informants (Pundya, July 1970).

26. Since the *madebele*, or bush spirits, are virtually a constant factor in Senufo thought and conversation, I was able to discuss them with indi-

viduals who represent a cross section of ethnic groups, sex, age, and status. I have attempted to present a composite picture that is reasonably accurate. On record there have been vivid descriptions by Senufo "eyewitnesses" of *madebele* seen in fields or dreams ranging from hairy-headed dwarfs with backward feet (a phenomenon reported elsewhere in West African lore) to mysterious animals with rhinolike horns to bush spirits who take on specific guises, such as a *Yalimidyo* masker talking to a woman in a field! Such visions may occasion some very specific sculpture commissions for images representing those particular *madebele* apparitions. In general, however, *madebele* are conceived as being rather like invisible, small people, with their own institutions and villages paralleling the visible Senufo ones.

27. Interview with Dyambeleyiri, Pundya, 1 August 1970.

28. Conversations with the elder Kanigui Soro, Pundya, February 1970.

29. Based on conversations with numerous Kufulo region villagers who were willing to discuss why they consulted a *Sando* or wore a particular *yawiige* charm.

30. For the two examples of the hoe sign and the cowrie-within-a-cowrie sign, I am indebted to the Baptist Mission Anthropology Files (Lu Johnson).

31. Perhaps one of the most significant aspects of the *madebele* complex is the Senufo tendency to connect the imagination and creative, innovative forms to visions given them by the *madebele*. This phenomenon begs further investigation and bears some striking similarities to d'Azevedo's findings among the Gola in respect to the *neme* and *jina* spirits (d'Azevedo 1966:16–26).

32. Interview with a Fodonon male diviner (Puloro, 26 March 1970).

33. Recounted by a Fodonon woman who is both a twin and a mother of twins (Pundya, May 1970).

34. Conversations with numerous twin-associated women in Pundya and at local markets, including Nöokataha, Tyembe, and Kapile.

35. The following interpretation of the navel design motif is based on analysis of my data after leaving the field and incorporates information given by Pundya informants in several different contexts.

36. The creation myths mentioned briefly by Holas (1962:15–16) have yet to be published as complete texts. Albert Kientz, a French ethnographer working in the Senufo area since 1970, is currently preparing for publication a major compilation of Senufo oral tales and myths in French translation with Senari transcription by Pastor Dosogimo Yeo, a Fodonon trained in phonetics by the Baptist Mission of Korhogo. Most of the tales recorded by Kientz's assistants were narrated by Abraham Kundirigina Soro of Dikodougou, a blind Kufulo elder and leader of the local Protestant church. Abraham is a master of the tale-telling art; his superb abilities as a raconteur, mimic, and dramatist are much appreciated in the area. In July 1975 I was able to record some of Abraham's favorite tales. One of them was a creation myth about the first two living creatures in the world, *Gbori* (the chameleon) and *Kangbari* (the long-crested helmet shrike). This tale was the most striking piece of an increasing amount of evidence that the so-called hornbill motif cited so frequently in the literature on Senufo art (e.g., Goldwater 1964:17–18; Holas 1969:138) needs to be reexamined. My research in June and July 1975 indicates that a more careful study of the Senufo names for local birds and their incidence in graphics and sculpture

will reveal a more complex iconography than previously suspected.

37. The distinction between *nikanhaö* spirits specifically and *madebele* in general needs further investigation. Some *Sando* diviners are believed to work for and be under the control of a *nikahaö* spirit. This type of *Sando* diviner is considered to be apart from those members of the Sandogo society who have inherited the position within a particular matrilineage segment.

38. Interviews with Fodonon Pondo initiates and elders, including Zana Soro, *sinzangafölö* of Pundya (Pundya, August 1969–August 1970). I have not yet seen a women's *Nafiri* to verify the description given by informants nor the costume and performance of the *Kotopitya* masquerade. One face mask component of the *Kotopitya* was photographed and its history obtained. There is much yet to be understood about the dynamics of the relationship between the *Sando* diviners, who recommend the masquerades as protective devices, and the subsequent development of the owner's commission and performances of the masquerades in question.

39. Data on *nyamëënë* funeral songs were collected in reference to funerals featuring this genre documented among Fodonon, Fono, and Kufulo groups in Pundya, Puloro, and Zangbokpo villages.

40. Excerpts from the biographical song text composed and sung by Yede Yeo (recorded at Pundya, 27–28 July 1969) for the funeral of Yefingyenge Yeo.

3. ART AND THE MEN'S SPHERE

1. The first important discussion of the term *Poro* was in the now-classic studies by George Harley, "Notes on the Poro in Liberia," published in 1941 (*Papers of the Peabody Museum*, vol. XIX, no. 2), and "Masks as Agents of Social Control in Northeast Liberia" (vol. XXXII, no. 2). To Harley, Poro seemed a widespread and possibly intertribal society with trade, governance, and initiatory responsibilities. The Senufo examples studied were different in that there was a marked emphasis on the autonomous character of the separate Poro societies, including secret vocabularies idiosyncratic to each group and unintelligible to neighboring Poro memberships. Although some intervillage and even interdialect ties existed, Poro functions centered on intravillage government and socialization. What historical relationship, if any, the Senufo Poro institution or its name has with the "Poro" groups reported elsewhere in Ivory Coast, Liberia, and Sierra Leone is a question that remains unanswerable so far on the basis of published data. However, in view of certain confusions current in the literature, it should be noted that I use *Poro society* to refer to the Senufo men's secret societies in lieu of *Lo*, a Manding-language word for a parallel organization found among the neighboring Dyula. Inexplicably, the Dyula term is used in Goldwater's *Senufo Sculpture from West Africa* (1964). Briefly, the word *Poro* is a convenient French and English simplification of related words used by the various dialect groups in the Central Senufo area: for example, *Pörö* by Kufuru and Tyebara speakers and *Pondo* by Fodönrö speakers. The Fodonon term for the Pondo society in their secret language, *Tiga*, is *kpakpapeeli*.

2. Related by a Fodonon elder during my 1978–79 sojourn in the

Kufulo region. The complete text of this core Poro narrative will appear
in a later publication.

3. Related by a Fodonon elder who was village chief and leader of the
principal Poro society. This particular narrative was followed immediately
by an account of how the women were given *Tyekpa* that concluded with
the summary statement, "When *Kolotyolo* took Pondo and gave it to the
men, the women went to the stream and were given *Tyekpa* (by the
madebele)" (Dyambeleyiri Soro and group of Fodonon elders, 1 February
1970).

4. *Fubehefölö* is the word used in the Kufuru text. The interpreter ex-
plained the meaning as "wicked." The implication seems to be wickedness
in the added sense of a guilty state, of having broken taboos. Compare with
Tyebara dialect: *"fuu,* to be blind, to be taboo, as a sacred restriction";
"fuvolo" (*folo* is *volo* after nasal), a "lacking one" (in a moral and spiritual
sense), a "guilt-owner" ("Dictionary: Tyebara-English; English-Tyebara,"
p. 36).

5. Excerpt from the contribution of the elder Gona Soro to the re-
corded "History of the Blacksmith *Katiolos* of Pundya" (tape 29B.4 in the
Glaze collection, Indiana University Archives of Traditional Music, Bloom-
ington). Gona, of mixed Fono and Kufulo descent, was one of the "village
intellectuals" (interview with Gona Soro, Pundya, 25 May 1970).

6. A rather intriguing explanation was offered for the admittance of
women: "Before, the women didn't participate in *Tiga,* but during the war
an event occurred that led to the inclusion of women. During the war,
women were imprisoned together with the men. The plan for escape was
discussed in *Tiga* in order to exclude the other non-Fodonon prisoners. So
the men escaped, but since the women didn't understand the plan, they had
to remain." Just which "war" and how "historical" it may be is left un-
answered in this somewhat romantic tale.

7. My sources on *Tiga* were the Fodonon chiefs and elders of Pundya
who agreed to accept me as a *Tiga* candidate extraordinary. My elementary
"schooling" in the *Tiga* language and in the concepts of the bush school
was an essential prerequisite of more intimate contact with the affairs, in-
cluding the art forms, of the Pondo society.

8. A precise definition of *Tiga* is impossible until this "language" has
been subjected to linguistic analysis. At this point, *Tiga* is one of several
factors that seem to be evidence of a historical and linguistic connection
between the Fodonon and the southern Senufo groups. *Tiga* was first men-
tioned in print by Père G. Clamens, who found it in use in the Tagwana
dialect area to the south of the Fodonon. He found "Tika, the secret lan-
guage of the Poro," to be totally unlike the vernacular Tagwana or any
neighboring non-Senufo languages ("Poignard et hache de parade en cuivre
sénufo ancien," *Notes Africaines,* 51 [1951]:93–94). According to Kufulo-
Fodonon informants, *Tiga* is a "little like *Fodörö*" although clearly "apart."
The Kufulo and Fono are said to find it extremely difficult to learn *Tiga*
because they cannot speak *Fodörö,* and very few of those (non-Fodonon)
who participate in the Fodonon *Tiga* school are actually able to speak it.

9. *Pübele pöri* was the common designation employed by older initiates
and elders of all groups having active "children's Poro" masquerade asso-
ciations in the Dikodougou area. My principal informants concerning the

children's Poro were Fodonon and Fono elders, who discussed children's Poro from the adult perspective and also drew upon their childhood memories.

10. Baba Coulibaly, in Béart, p. 80.

11. Based on an interview with blacksmith elders, who explained that "the very first Poro" referred to the sequence in a man's life and that a historical sequence of origin was not intended (Nerkéné, 24 March 1970). It is interesting to note, however, that in one oral tradition relating the origin of Poro in the Korhogo area, the organization of the secret society began with the youngest children's groups, and it was not until they were ready to advance and their younger brothers ready to enter that the next grade was created, and so on (B. Coulibaly, in Béart, p. 800).

12. Interview with Sona Yeo (d. 1975), former chief of Guiembe (Tyembe, 22 October 1969).

13. As stated above, my sources of information for these details were not the children themselves but the elders, using their observations and recollections of their own childhood activities.

14. Marcel Griaule, *Jeux dogons*, pp. 265, 269 ff. Cited also in Charles Béart (1955: II, 574–76). From the Senufo adult's point of view, the meaning and intent of the children's Poro or any one of their activities could conceivably have a profoundly religious content of which the children themselves are totally unaware. Such was apparently the situation that Zahan found among the Bamana in reference to the organization of small children known as *tyekorobani*, preliminary to the *N'Domo* society. According to Zahan's interpretation, this lowest of Bamana age grades has a highly symbolic place in a remarkably elaborate ideology supporting the initiation system. Here again the exact significance of Senufo children's Poro in the total conceptual framework of the adult Poro has not yet been investigated fully.

15. Baba Coulibaly, "Sociétés secrètes sénoufo," Doc. IFAN, W. Ponty, I, XV, CI2, n.d. This material was published by Charles Béart in *Jeux et jouets de l'Ouest Africain* (1955:799–808). The source is also cited by Bohumil Holas in *Les Sénoufo* (1957). Coulibaly's description of the "poro society" in Korhogo is valuable for comparative purposes despite its air of being either heavily autocensored or gleaned by a noninitiate. Also, problems of Senufo-French orthography abound.

16. *Jeux et jouets*, pp. 800–801.

17. Goldwater provides an excellent stylistic analysis of the face mask, but his attempt to summarize the context and meaning of face masks simply reflects the prevailing confusion in the literature, not to mention the nearly total lack of concrete data on associated age groups and ethnic groups.

18. Ironically, this component is never used traditionally in Senambele (i.e., Kufulo of the Central Senari farmers, the "true" Senufo) mask types. Outside the Kufuru area, there are numerous additional mask types. Three examples from the published literature are indicated below, the first two involving several problems of interpretation.

Senufo: (1) *Korrigo* (Bochet, 1965). It is impossible to learn from Bochet's data whether, for example, his *Kiembara* are in fact Tyebara-speaking (Central Senari) farmers or blacksmiths. Age grade is equally unclear. (2) *Kodoli* is said by Kufulo informants to be used in recent times

by young boys of some Central Senari farmer groups (especially the Tye-bara area) as an entertainment dance with balafon orchestra. It is considered a "sin" for blacksmiths to use it in this context.

Non-Senufo, or *Dyula*: (3) *Lo* (i.e., Dyula, equivalent of Poro). First reported by Prouteaux (1925). The historical relationship to Senufo mask traditions, particularly that of the brasscaster group, remains unknown. Field experience proves that it is not impossible that the group photo-graphed by Prouteaux was actually a group of Kpeene in the process of conversion to Islam who called themselves "Dyula" (as so many converts do in the area) and who had retained the more secular of their Poro masquerades.

19. In fact, this third feature seems to be a constant primarily of the area inhabited by speakers of the Central Senari dialects. It is absent in most known examples from the southern-border-zone substyles.

20. My assertion that a primary function of *Koto* is providing aesthetic enjoyment and entertainment is based on observation and on explicit state-ments by Fodonon graduates of Pondo. Informants stressed that *Koto* is there *because* it is *nyöö*, good and beautiful, and pointed out that *Koto* is not characterized by the animal sacrifices connected, for example, with *Gbön*, the ancestor and antiwitchcraft masquerade.

21. The *Korubilaö*, or *Korubla*, helmet mask is hornless, has a simple, domed head and boxlike mouth, and in performances is always crowned with a huge, plumed bouquet or bouquets of black feathers. A sketch by Bochet is illustrated in Goldwater (fig. 12), and an example of the carved head component type can be seen in Goldwater's plate 62. The fact that the local Tyeli *Korublaö* was renowned for its fire-spitting performances has no bearing on the classification since the magical emission of fire or water is a secret that travels independently of mask morphology. Accord-ing to informants, the possession of a certain "secret" associated with one Poro group's helmet mask can be taught, for a fee, to an apprentice from another village ("If someone in a village knows many secrets, another vil-lage will go to him for help"). Conversely, some secrets, especially the more spectacular, are guarded jealously. The Tyeduno Poro society *Gbön* mask at Diegon is said to do an extraordinary dance with a small pot of water that "keeps floating."

22. This performance of the Tyeli *Koto* was one of dozens of mas-querade performances representing many different ethnic groups (including the now rare maskers of the Dyula *Lo* society) at a huge *Kuumo*, or Great Funeral, at Ojaha in the Kafiri dialect area. My informants on the *Koto* and "ugly child" mask were Tyeli elders from the village of Tyelikaha (inter-view with Tyeli elders, Ojaha, 28 May 1970).

23. Jean Laude has cogently described the special role of the blacksmith as both artist and mediator in the context of Dogon culture and Sudanic cultures in general (*African Art of the Dogon*, 1973:42). Another case in point and one that underscores the geographic breadth of this Sudanic zone trait is James Vaughan's analysis of the ritual relationships between the Marghi (farmers) and the Ing'Kyagu (smiths and potters) of the Mandara Mountains in Northeast Nigeria. Vaughan also found that the stereotype "despised caste" was inappropriate to the symbiotic relationship of farmer and blacksmith in Marghi society (Warren d'Azevedo, ed., *The Traditional Artist in African Societies* [Bloomington: Indiana University Press, 1973],

pp. 162–71). Patrick McNaughton's data on the blacksmith masks of the Bamana suggest that there is a close historical relationship between Komo masks and the Senufo blacksmiths' helmet masks (personal communication, April 1978). Though this is not the place for comparative analysis, there is good reason to believe that the connectives can be reconstructed on the basis of form and content.

4. THE FUNERAL AS SYNTHESIS

1. Concepts similar to those expressed by Kufulo region informants have been reported in other Senufo subgroups. According to a Nafanra informant from Lagbokaha, a dead one who is not given proper funeral rites will "throw sickness or dreams on the living." Without satisfactory funeral rites, "the dead are with the dead but still living," and "the other dead will chase him out of the place of the dead." Such a person is "isolated, belonging neither to the living nor the dead"—*taga kubele ni woweebele nige ni* ("Questionnaire on Death and Funerals," 1969–70, collated by Helen Skinner).

2. *Yasungo* seems to be the generic name for any object involved in blood sacrifice, regardless of which spirits are being worshipped. (*Ya* is a common prefix meaning "thing," and *sun* is the verb "to sacrifice.") The word is quite distinct in meaning from *yafuungo*, meaning a "taboo" (e.g., *Sando* and other-type diviners are especially bound by food and clothing restrictions). The reason for a certain taboo usually is either *madebele* or the *katyëënë*. Other than the ubiquitous *yirigefölö* altars present in nearly every domicile, the most common type of sacrificial altar found in Kufulo region villages is *katyëënë*. The precise nature of *katyëënë* shrines and altars needs clarifying in future research. The term, as used in the Kufulo region, always implied an object conglomerate receiving blood sacrifice and a specific formula of magical-medicinal substances. Small houses devoted to *katyëënë* shrines are frequently covered with bas-relief figurative moldings covering a wide subject range.

3. February 1970. This funeral was for a young blacksmith who died one year before he would have begun *Tyologo*. Although he had lived with his father at Kapile, the *kuufuloro* postburial rites were held in the village of his mother and maternal uncle. The villages represented were about half the number of *Kodöli-yëhë* masks, which represented the number of Fono *sinzangas* coming from each village.

4. During the year 1970, there were two deaths in the *senoro kuu* category in the village where I was living. Both were drownings of adolescents. This type of death necessitated elaborate protective measures, including "medicine" taken by the family as well as by the rest of the village. It is virtually impossible to describe the aura of fear that touches a village during such a time or the tension at the risk of further spreading an evil that could cause such a disaster. The financial burden on the family is enormous, including exorbitant payments to bush taxis to transport the highly "contaminated" body to the outskirts of the village.

5. July 1969. The night-watch activities and the final ceremony included *kaariye*, *nyamëënë*, Sandogo society drummers (women), *Tyekpa* society drummers (women), *fönöpinge* (blacksmith drum, gong, and flute

ensemble), five balafon orchestras, and the men's *bolongböhö* ensemble. Sculpture involved in this funeral included the *tefalipitya* staff for champion cultivators, three-legged drums with bas-relief figurative designs, large-scale figurative sculpture used by the *Tyekpa* society, and the blacksmith *Kunugbaha* helmet mask.

6. *Kuu*, "death," is low-mid in tone; *kuu*, "the dead one," is high-low in tone.

7. The word actually refers to the kneeling position of the *Kunugbaha* masker while beating the drum he carries. It is considered "poor speech" in Poro usage to refer to a mask's "hitting" or "beating" a drum.

8. Details on *Kuumo* are based largely on two great funerals I attended in the Kafiri dialect area in April and May 1970 at Solokaha and Ojaha villages.

9. The funeral narrative is a reconstruction of a typical Kufulo region funeral in general and, specifically, an example of one particular framework, the funeral of a male Fodonon elder. The descriptions of events are based on Kufulo region funerals observed fully or in part over a sixteen-month period (May 1969–August 1970). Of the more than thirty funerals documented during this period, twelve were Fodonon, of which four were for male leaders in the Pondo society. Particulars concerning Poro society activities and materials were obtained during interviews and discussions of song texts with Poro members and village leaders from the focal area. All details are correct for the Fodonon ethnic group and funeral type with the exception of one instance in which I took liberties with strict ethnological accuracy (for the Fodonon group) for the sake of conveying an image of Ancient Mother by employing a phrase that is universal among Central Senari groups, that is, most Senufo groups. The secret phrase "greetings at your Mother's work" is theoretically not known to Fodonon who have not also been initiated into a *senambele* Poro society.

10. Loud and protracted death wails are not for elders but rather for the anguish of unexpected deaths, especially of young people. The Baptist Mission report on customs concerning death and funerals has been an exceptionally helpful reference for comparison with my own data drawn from the Kufulo region. According to reports in the Tyebara and Nafana dialect areas, in the death wail the relatives may name what they consider to be the cause of death, such as *kuubele* or *madebele* ("Questionnaire on Deaths and Funerals").

11. I have documented instances in all these areas of criticism. For example, although the aesthetic merit of a masquerade component, such as a helmet mask sculpture or costume, is not the *purpose* of most masquerade performances, aesthetic quality is nonetheless essential to this purpose. In one dramatic instance at a funeral for a Kufulo elder, in the midst of the climactic drumming rites by the *kpaala*, I witnessed a highly vocal rejection of a mask and costume that was judged so visually deficient that it was not allowed to enter the ceremonial area around the deathbed. As the *Kunugbaha* masker from a visiting Poro group appeared at the edge of the clearing and started to enter the "stage," six or seven men suddenly started gesturing and shouting violent objections, insults, and instructions that the mask and tattered skin cape were to be left at the edge of the clearing. The mask was carved indifferently, and, worse, its symmetry and completeness were marred by missing and damaged parts. In such a condition it would not honor, and perhaps would even anger, the powerful Sandogo society

head who had died. Although I never learned the outcome, I imagine that the shamed and disgraced Poro leadership soon commissioned a new mask and costume. Along similar lines, individual Poro memberships tend to seek out and jealously guard painted costumes, masks, decorative or magical additives, and performance gimmicks that will set their masquerades apart and engender the admiration of other groups. As an example, Nambopi, a talented blacksmith initiate, did stunning work on the geometric and figurative designs of painted cloth suits worn by the *Yalimidyo* and *Kunugbaha* masquerades. Although many other Poro groups would like to have commissioned his work, he was forbidden by his elders to do work that would appear locally in competition with theirs.

12. An ancient tradition among blacksmith groups is to place a symbolic arrangement of objects associated with the forge beside an elder's body. The most important of these is the *kafolo*, a pair of iron tongs soldered permanently (if a man) or joined temporarily (if a woman) to the broken fragment of the *daba* (hoe) blade at the point where it loops to become a hoe handle.

13. These were the exact words of Pehe Soro of Pundya, a *sambali* of such widely reputed abilities that other *katiolo* champions in the area would no longer agree to be matched against him in field contests. The powers of the ancestors are also thought to be enlisted through the magical properties of a stuffed belt of genet skins, iron gongs, and herbal materials worn by *sambali* during contests. These belts, *yapwöhö*, are made by Poro society elders.

14. The theme of the champion cultivator as culture hero, and its usefulness in understanding Senufo ideas about beauty of character and form, is appearing in a separate publication. In reference to distribution pattern, the seated female figure appears to be the more widespread sculpture type; however, I saw the bird variant used by at least four different ethnic groups (Kafiri, Kufulo, Tangara, Fodonon). Among the Fodonon, the bird icon is associated with the powerful Bateleur eagle (*Terathopius ecaudatus*), greatly respected for its hunting prowess, speed, and fierce protection of its nest. The Fodonon name for the sculpture is *Kpono*; the Central Senari dialects use the term *Katyörinyëhë* (*nyëhë*, "red") for what is either the same eagle or a large species of hawk-eagle. The style conventions have developed independently of naturalistic detail.

15. Adapted from the song text of a praise singer performing at the funeral of a *sambali*'s mother (November 1969). The tape is now in the collection of the Indiana University Archives of Traditional Music.

16. The key theme here of suffering in recognition of others' suffering, given several times by Pondo society initiates and elders, is a leitmotiv in Senufo thought and ritual. Sandogo society women express the same idea when they roll, kneel, and crawl around and under the deathbed during the final ceremony for women leaders.

17. A mark of the master in the verbal art of Poro language is not only his command of a large body of memorized proverbs and aphorisms (*kaseele*) but also his dexterity in singing one thing in the vernacular while communicating something clever, funny, wise, or ancient in the secret language. The artist with the best reputation in the Kufulo region was Mëëpariga, a blacksmith elder and high-ranking leader in Poro (Guiembe, d. 1977).

18. Senufo language suggests a significant interrelationship between

moral and aesthetic values in Senufo thought and culture. The two most important verbal expressions used to describe something well made, good to look at, beautiful, or pretty are *nyo*, "good" (not the same as *tene*, meaning "good" or "sweet to the taste or the ear") and *nayiliwo*, meaning "beautiful" within the framework of "youthfulness." In this, the Kufulo data have striking similarities to Robert Farris Thompson's analysis of Yoruba aesthetics (*African Art in Motion*). Two other Senufo terms of aesthetic valuation are *tana* (or *tahana*) and *sityilimë*. The first may be translated as "beautiful," "ornamental," or "decorative" and, as far as I can judge, is used invariably in a context that implies personal show, pride, prestige, and even ostentatious display. Both children's brass ankle bells and equestrian figures used by *Sando* diviners, for example, can be termed *tahama*. *Sityilimë* can be used to mean ornament or decoration but may also have a more profound meaning of creativity or creative intelligence. Further research is needed to clarify the subtle distinctions of context and shades of meaning of the four words.

19. Of the ornaments, the *tyotana* has particular significance to initiated Poro members. The secret name for the *tyotana*, along with its meaning, is known only to initiates, and in this case I was unable to obtain this information. The *tyotana* figures in a Poro narrative song text for which I have full translation but in which the object itself is not explained. The *tyotana* itself bears a striking formal relationship to Sudanic, especially Dogon, stool forms.

20. Excerpt from a *kaariye* song text recorded at a funeral for a Fodonon woman (July 1969)—in other words, the musical genre is played to honor any worthy individual, not just hunters.

21. Excerpt from a *bolongböhö* song text (same funeral as above). *Bolongböhö* is not an obligatory instrument to learn during any of the Poro society grades; this fact argues for its being a relatively recent introduction in Central Senufo culture in contrast to the wholly sacred Poro instruments. The musicians belong to a voluntary association involving fees and "rules" extraneous to Poro. The *bolongböhö* musicians of the Kufulo region were taught by instructors from the famous harp-lute associations at Lataha and Waratyene, major Fodonon villages in the Korhogo area. *Bolongböhö* might be termed a quasi-sacred instrument in the Fodonon subgroup in the sense that Poro language is used in the songs and the music genre is considered appropriate to funerals for male elders. Indeed, unlike such Central Senari groups as the Kufulo, Tyebara, and Fono, the Fodonon permit playing of the highly popular "balafon," or xylophone, only at funerals for women and children. The significance of this fact in terms of historical sequence and cultural borrowing or innovation is not clear.

22. A completely different masquerade type, called "*Nifërilo*" or "*Nunfori*," dances to harp-lute orchestras among Fodonon groups in the Nafana and Tyebara dialect areas. The *Nifërilo* is virtually indistinguishable in style from the *Tyo* masquerade of the Kufulo region Fodonon groups.

23. This phrase is in fact part of a greeting in Poro language used only by Senambele (Central Senari farmers) Poro members.

24. The *Gbön* masquerade bears some striking resemblances in style to certain masquerades of the Nuna in Upper Volta. Formal parallels include the multilayered raffia leggings and capes of the *Gbön* masquerade, a "tail" of several colored raffia tassels, kneeling with tall walking canes, and

the stylized walk (film by F. Wolf, *Nuna Dances*, University of Pennsylvania, Visual Aids, 1966).

25. The mounting of roofs (homes of deceased) by masked dancers appears to be a widespread ceremonial pattern in Voltaique cultures. Griaule was the first to document the tradition (with regard to the *Kanaga* mask of the Dogon), and R. Bravmann has reported a similar tradition in the Bobo-Dioulasso area. The full significance of the act in Senufo culture and the historical significance of its apparent restriction to the Fodonon and Tyeli groups are questions requiring further research. This might be considered evidence of the "archaic" nature of these two Senufo subcultures.

26. The graves in the Kufulo region are as follows: a vertical shaft eight or more feet deep, at which level a horizontal, underground burial chamber is neatly carved out of the hard, laterite soil. When the body, wrapped in cloths, has been placed inside on a woven mat along with any objects belonging to the dead person that are to be buried with him or her, the entrance to the chamber is sealed with wood and then leaves and the vertical shaft filled in with dirt and then topped with a broken pot. Some Kufulo informants say this is a reference to an earlier mode of burial: a round, vertical shaft covered with a turned-over pot. Informants also said that many fine burial cloths used to be put in the chamber until theft became a problem in recent years.

27. This provisional interpretation has not yet been confirmed directly by Senufo informants. Thompson has described similar gestures of "cooling down" the "heat" of powerful masks; this pattern he has documented among the Yoruba, Banyang, and Dan (see, for example, 1974:214).

5. CONCLUSION

1. The summary and lines quoted in the conclusion were taken from three versions of the classic Senufo tale "The Origin of Death." The first two were collected by Albert Kientz, the first related by a blacksmith, Sasungo Silue of Dikodougou, and the second by a Fodonon woman, Kala Woro of Tufundé (Kientz, personal communication, 27 March 1974). In July 1975 I collected a third version of this tale, related by the master tale teller Abraham Soro Kundirigina of Dikodougou.

APPENDIX

1. In this context it may be pertinent to note an extremely close style and type parallel found among the Bamana in one of the *N'Domo* society masquerades. A "feline mask," including feline ears and spots, was reported and illustrated by Zeltner in 1910 (fig. 2). In some of the Bamana groups, this type of cloth-fiber mask is worn by the first level of the *N'Domo* society, called "lion" (*dyaraw*), which, according to Zahan, is considered the symbol of "teaching," "light," and the "clarification of an object given by thought." Unknown to the small initiates, the *dyaraw* level is a prefiguration of the *Komo* society's *dyolokow* (Zahan, pp. 54–58).

2. Fodonon groups living in the Tyebara dialect area (e.g., Lataha and Waratyene villages) have a masquerade type called "*Nũfori*" that also features wildcat-spot patterns and is nearly identical in form and design to the *Tyo* type of the Dikodougou-area Fodonon. The *Nũfori* (called a "pantherman" by the tourist bureau!) dances to music of the Fodonon one-stringed-harp orchestra (*Bolongböhö*) and may be seen by women and children. *Nũfori* is not to be confused with the Fodonon fiber masquerade type called "*Nafiri*," a funerary mask of restricted audience.

3. According to one Senufo elder, *Tyo* is "less important" than the other two masks of the *Koto* team and is "mainly to frighten children."

4. A comparison of *Kurutaha* with the Kufulo and blacksmith *Yalimidyo* mask reveals several parallels of mask form and behavior. Some major differences notwithstanding, especially in regard to performance context, the two masquerades appear to be parallel in type, although which ethnic group used this type first is not known.

5. The uninitiated see an intentionally comic figure that is forever pregnant or, as one young Fodonon phrased it, "an eternal pregnancy." Only the initiated know the secret of what is actually carried inside to make the swollen belly of the masker. Suffice it to say here that the stuffing safeguarded in the mask's "womb" is a marvelously concrete statement of the continuity that links this masker to those who have gone before. The particular performer and costume are necessarily transitory, but the dramatic character and its office continue from generation to generation.

6. As discussed in Chapter 3 (pp. 132–35), the Tyeli group also has a *Koto* masking tradition, although stylistic features differ. In an article on Senufo funeral ritual, Père Knops reported a "diéli society" masquerade in the Nafara area called "*Kutô*," although his brief description includes several puzzling features that do not really mesh with the *Koto* described above. Knops wrote:

> The *tuleman*, also called *Katô* or Kutô, which is peculiar to the *dieli* society, that is, a Senufo group which contemporary ethnographers are inclined to consider as the first occupants of the country, but who have, however, the scarification common to all Senufo. The *tuleman* is a cloth [or net?] of woven raffia provided with holes for the eyes and mouth; it is topped with a row of warthog [*sic*; porcupine?] quills or feathers and it carries a cane in its right hand. Its dancer is accompanied by one or two small drums or by bells in wood or iron, and the mask itself sometimes uses a wood or ceramic whistle (1961: 135).

7. The knit hood may be of a more decorative pattern than the straight knitting of the suit (such as a chevron design between parallel double ribs). The red crest is suggestive of a cockscomb to the Western eye, but to the Senufo the intended reference is to the ancient hairstyles associated with men's and women's age-grade status. Also, red is the color of beauty and authority in Pondo.

8. Gilbert Bochet has provided some brief supplementary notes on this mask in an unpublished letter to Robert Goldwater (Korhogo, 10 December 1964). Through the kindness of Tamara Northern I was shown a copy of this letter, written in response to the just-published *Senufo Sculpture*. According to Bochet, the scepter is the "active part of *Koto*," the true "effective force."

9. See Chapter 3, pp. 127–32.

10. The etymology of *Gbön* is uncertain. Bochet's study of Senufo masks (1965) is not helpful in respect to this mask; the Fodonon's *Gbön* is not mentioned in the text, although his drawing of a mask called *"gplige"* (fig. 2) is identical in form and style to some Fodonon *Gbön* masquerades used by the Kaplé (Dikodougou) Pondo groups. The earliest reference to a *Gbön* masking tradition is Prouteaux's important description of "Les Gbons" (1918), in which he describes a performance observed among the Ligbi at Bouna (it is not clear from Prouteaux's article whether the Ligbi were Muslim at that time). Prouteaux noted that he had observed essentially the same masking tradition among diverse peoples, including the Senufo of the Central Senufo area (i.e., the Boundiali and Korhogo districts) (pp. 37–38). The antiwitchcraft *"Gbain"* masking tradition, which Bravmann found in use in the Bondoukou *Préfecture* among a mixture of Manding and Voltaique communities, many of them Muslim (*Islam and Tribal Art in West Africa*, 1974: 128), has a number of striking parallels with the Fodonon *Gbön* masking tradition. Since Bravmann's field research on *Gbain* was in the southeastern fringes of the Southern Senufo language region, I believe that his conclusion that "the Gbain was originally a Muslim Mande tradition" (p. 128) requires reexamination in light of my data on the *Gbön* masking tradition of two southern Senufo groups, the Fodonon and the *Gbonzoro*. Since the Fodonon claim to have lived once as far north as the Boundiali area and still have numerous communities in the Korhogo district, it is not impossible that the masks observed by Prouteaux in these areas were Fodonon.

11. Although I have never encountered a Kufulo children's Poro, the Kufulo and other Central Senari farmer groups do have associations comparable to *Kamuru* and *Kanbiri*.

12. No literal translation known. For a discussion of the possible etymology and meaning of *Kamuru*, see Chapter 3, p. 101.

13. This textile masquerade is considered much more important than the lower-ranked *Kodöli-yëhë*, or "face masquerade." The latter is worn by the blacksmith Junior Grade initiates during the first phase (four years). The whole village knows that the boy wearing the textile *Kòdöli* has attained a more advanced status in the initiation system than the boy who wears the "juvenile" carved mask. As one blacksmith elder put it, "If you are a child, you wear the *Kodöli* in wood. If you are older and ready to be a *tyolo*, you are given cloth masks by the elders. Everyone in the village knows—cloth is first in importance, and wood follows cloth [in importance]." Clearly, a Senufo is applying somewhat different standards in judging the "worth" of a masquerade than those applied by a Western collector of "African art," who would probably pass over the masquerade objects (knit suit and hood, leather belt, etc.) as ethnographic curiosities!

14. The belt is made by a leatherworker specialist of the Tyeli group and the bells purchased from a brasscaster of the Kpeene group.

15. This masquerade may be involved in an aspect of Senior initiation rites, but I have seen no indication of this.

16. The etymology is uncertain, but field data strongly suggest that the key word may be *gböö*: "big, immense, great, mighty." The Kufulo masquerade *"Gbogara"* is yet another example of puzzling conflicts of mask terminology that arise occasionally when one compares data from two dif-

ferent dialect areas. Baba Coulibaly's outline of Korhogo area Poro masks lists *gbogoro* or *gbogora* (worn by boys seven to ten years of age) as the first of two children's masquerades. According to his drawing (from memory?), the costume has no exact parallel with Kufulo types; however, the black knit hood and red crest and bleached fibers are the same as for the Fodonon children's type. The only difference is that the loose, fiber cape of "*gbogora*" seems to be of one piece from collar to knees whereas the Kufuru-Fodonon is a two-piece cape and skirt (Béart: fig. 559).

17. Exactly the same type as the composite fiber helmet used for *Tyelige*. It may even be the very same object, but this needs verification.

18. Some *Gbongara* bodies are stringy and untreated in appearance, whereas others have been painstakingly cut and tufted, giving a richly textured effect. The work of tying on the raffia is an extremely long and tiring process, especially for the wearer, who may not even have time to eat that day. Senufo consider the *Gbongara* masks to be aesthetically pleasing (unlike the *Kmötöhö* masks) when well done. The *Gbongara* masks of the Kafiri dialect area in particular are reputed to be very beautiful.

19. The *lodala* is a special enclosure of saplings for the *Kwöbele* near the adult *sinzanga*, which they may not yet enter.

20. The substyle variant of this mask type in the neighboring Kafiri dialect area is a mask of similar shape and proportion but made of shaped bark and decorated with painted spots. Also, the raffia costume is conceived more elaborately.

21. One group in the Kafiri dialect area stated that their *sinzanga* traditionally preserves the best *Kmötöhö* "for the village" (to use at the big commemorative funeral [*Kuumo*], but this is not universal practice).

22. A linguistic inquiry should consider words ending in *selige* ("beginning time" or "thing") and the prefix *tye* when it refers to matters concerning a "wife" or "woman." The navel design is female, and the concept of a "wife mask" would fit in easily with Senufo habits of thought.

23. A new mask is made by each new *Tyologo* class in the six-and-one-half-year cycle. The artist and assistant(s) are chosen from within their class for their skills, and advice from older specialists may be sought.

24. The appearance of a *Tyelige* at any village funeral tells the Poro-educated Senufo immediately that the wearer is a "new" *tyolo* and that his *sinzanga* has had *Kafwö* less than three years before.

25. In the case of this masquerade, providing a literal translation for both the public and secret names offers no difficulty. When asked, "What does *Yalimidyo* mean?" Kufulo and Fono elders answered that *Yalimidyo* is "a way of speaking through masks" and would point to this or that man as a "master" of mask talking. The clear emphasis was on the art and technique of mask speech. In view of the secret name, the probable etymology of *Yalimidyo* stems from two Senari words: *yala yala* (or *yaari yaari*), which means "to wander about," and *dyoo*, meaning "to speak, to talk." Public names in other dialect areas: Tyebara—*yaridyögö* (i.e., the public name is nearly identical with the Kufuru, although, the *sinzanga* names of each area have a quite different translation; the literal translation of the Tyebara-area *sinzanga* or secret name for the mask type refers to the ancestral nature of the mask, "Maternal Uncle"); Nafara—*Nogökpelege*; Kafiri—*Komaani*.

26. The color red is symbolic of leadership and seen in red cloth caps worn by governing elders in the Poro society.

27. The kind of weapon carried apparently is a subgroup variable. In the Nafara area a carving representing a sword with ornamental hilt in a scabbard is common. In the Tyebara area some *Yalidyögö* carry short, thick-forked sticks (ca. one and one-half to two feet long).

28. See Anita Glaze, "Senufo Graphic Arts," *Ba Shiru*, 1972, no. 4, pp. 37–46.

29. There was some indication that the *Fila* masquerade could also be called a *Nafiri*, but this requires checking in the field.

30. This masquerade was described by Fodonon informants, but I never saw it performed. The tradition is still alive, however, and one Fodonon woman in the focal village, on the advice of a *Sando*, had just commissioned a *Kotopitya* at the time of my departure from the field, in August 1970.

Bibliography

The central emphasis of this bibliography is primary source material, with an emphasis on historical and cultural documentation, consulted between 1966 and 1968 as preparation for fieldwork. A few major publications of later date have been added.

The bibliography is arranged in five parts. In respect to published materials, I have divided the references into two sections: before 1940 and after 1940. A separation of the pre-World War II period and the postwar period is useful in that. first, it sets forth as a group the earliest published references to the Senufo and, second, it tends to reflect significant differences of training and points of view on the part of observers during these two periods. A section of selected unpublished materials includes archival documents and manuscripts consulted in Europe and Africa between 1968 and 1970. Finally, there is a brief section of references cited in the text and concerning materials outside the Senufo area. Catalogs containing illustrated examples of Senufo art have not been included in the bibliography unless cited in the text.

The following abbreviations are used in the bibliography:

Bul. Ag. Gen. Col.	*Bulletin de l'Agence Générale des Colonies*
Bul. Com. Et.	*Comité d'études historiques et scientifiques de l'Afrique occidentale française: Bulletin*
Bul. IFAN	*Institut fondamental d'Afrique noire, Dakar: Bulletin.* Formerly, *Institut français d'....*
Bul. Soc. Anth. Préhist.	*Bulletin de la société royale belge d'anthropologie et de préhistoire*
N.A.	*Notes africaines*
Rens. Colon. et Docum.	*Renseignements coloniaux et documents*
Rev. Et. Ethn. Soc.	*Révue des études ethnographiques et sociologiques*

I. BIBLIOGRAPHIES

Brasseur, Paul. *Bibliographie générale du Mali (Anciens Soudan Français et Haut-Sénégal-Niger)*. Dakar: IFAN, 1964.

Gay, Jean. *Bibliographie des ouvrages rélatifs à l'Afrique et à l'Arabie*. Amsterdam: Meridian Publishing Co., 1961.

Holas, Bohumil. *Les Sénoufo (y compris les Minianka)*. Paris: Presses Universitaires de France, 1957.

Joucla, Edmond A., and Grandidier, G. *Bibliographie générale des colonies françaises*. Paris: Société d'Editions Géographiques, Maritimes et Coloniales, 1937.

II. PRIMARY SOURCES BEFORE 1940

Benquey, (Capitaine). "Notice sur la ville de Bondoukou." In *Dix ans à la Côte d'Ivoire*. Edited by Marie François-Joseph Clozel. Paris: A. Challamel, 1906.

Binger, Louis-Gustave. *Voyage du Niger au golfe de Guinée par le pays de Kong et le Mossi (1887–1889)*. Paris: Librairie Hachette, 1892.

Boissier, J. "Le chef de la terre en pays sénufo." *Outre-mer* 7 (1935): 251–56.

Bonneau, (Lieutenant). *La Côte d'Ivoire: Notices historiques et géographiques*. Paris: Henri Charles-Lavauzelle, n.d.

Bourgoin, (Lieutenant). "Cercle de Séguéla." In *La Côte d'Ivoire: Notice publiée à l'occasion de l'Exposition Coloniale de Marseille*. Paris: Emile la Rose, 1906.

Brun, Joseph (Père). "Le totémisme chez quelques peuplades du Soudan Occidental." *Anthropos* 5 (1910): 844–69.

Caillié, René. *Journal d'un voyage à Tomboctou et à Jenné, dans l'Afrique Centrale (1824–1828)*. Paris: l'Imprimerie Royale, 1830.

Chartier, J. "Le Cercle de Kong." *Rens. Colon. et Docum.*, supp. to *L'Afrique Française* 25 (1915): 19–26.

———. "Le Cercle de Tagouana." *Bul. Com. Et.*, no. 11 (1921), pp. 229–74.

Chéron, Georges. "Les Minianka: Leur civilisation matérielle." *Rev. Et. Ethn. Soc.* 4 (1913): 165–86.

———. "Essai sur la langue minianka." *Bul. Com. Et.*, no. 4 (1921), pp. 560–616.

———. "Usages minianka." *Révue d'ethnographie et des traditions populaires* 4 (1923): 139–48.

———. *Le dialecte sénoufo du minianka (grammaire, textes et lexiques)*. Paris: Paul Geuthner, 1925.

Clozel, Marie François-Joseph. *Dix ans à la Côte d'Ivoire*. Paris: A. Challamel, 1906.

Clozel, Marie François-Joseph, and Villamur, Roger. *Les coutumes indigènes de la Côte d'Ivoire*. Paris: A. Challamel, 1902.

Collieaux, M. "Contribution à l'étude de l'histoire de l'ancien royaume de Kénédougou." *Bul. Com. Et.* 8 (1924): 128–81.

Delafosse, Maurice. *Vocabulaires comparatifs de plus de 60 langues ou dialectes parlés en Côte d'Ivoire et dans les régions limitrophes*. Paris: E. Leroux, 1904.

———. "Le Cercle de Korhogo." In *La Côte d'Ivoire: Notice publiée à l'occasion de l'Exposition Coloniale de Marseille*. Paris: Crette, 1906.

———. *Les frontières de la Côte d'Ivoire, de la Côte d'Or et du Soudan*. Paris: Masson, 1908.

————. "Le Peuple Siéna ou Sénoufo." *Rev. Et. Ethn. Soc.* 1 (1908):16–32, 79–92, 151–59, 242–75, 448–57; 2 (1909):1–21.

————. *Haut-Sénégal-Niger.* Paris: Emile LaRose, 1912.

————. "L'animisme nègre et sa résistance à l'Islamisation en Afrique Occidentale." *Revue du Monde Musulman* 49 (1922):121–63.

Ferreol. "Moeurs et coutumes des Sénoufo." *Rens. Colon. et Docum.*, supp. to *L'Afrique Française* (1904):104.

————. "Essais d'histoire et d'ethnographie sur quelques peuplades de la subdivision de Banfora." *Bul. Com. Et.* 7 (1924):100–127.

Freeman, Richard Austin. *Travels and Life in Ashanti and Jaman.* London: A. Constable, 1898.

Gallieni, (Commandant). *Voyage au Soudan Français (Haut Niger et pays de Ségou) 1879–1881.* Paris: Hachette, 1885.

Knops, (Père). "L'enfant chez les noirs du Cercle de Kong (Côte d'Ivoire): réponses brèves à un questionnaire." *Anthropos* 26 (1931):141–50.

————. "L'enfant chez les Sénoufos de la Côte d'Ivoire." *Africa* 11 (1938): 482–92.

Labouret, Henri. "La parenté à plaisanteries en Afrique Occidentale." *Africa* 2 (1929):244–54.

Maclaud, (Dr.). "Notes sur les Pakhalla." *L'Anthropologie* 7 (1896):18–34.

Meniaud, Jacques. *Sikasso ou l'histoire dramatique d'un royaume noir aux XIXᵉ siècle.* Paris: Bouchy, 1935.

Monnier, Marcel. *Mission Binger, France Noire.* Paris: Librairie Plon, 1894.

Monteil, Charles Victor. *Soudan français: Contes soudanais.* Collections de Contes et Chansons Populaires, vol. 28. Paris: Editions Léroux, 1905.

————. "Le coton chez les noirs: État actuel de nos connaissances sur l'Afrique Occidentale Française." *Bul. Com. Et.* 9 (1926):585–684.

Monteil, Parfait Louis. *De Saint-Louis à Tripoli par le Lac Tchad (1890–1892).* Paris: F. Alcan, 1894.

————. *La Colonne de Kong: Une page d'histoire militaire coloniale.* Paris: Henri Charles-Lavauzelle, 1902.

Nebout, M. "Monographie du Cercle de Bondoukou." In *Dix ans à la Côte d'Ivoire*, edited by Marie François-Joseph Clozel. Paris: A. Challamel, 1906.

Neveux, Maurice (Dr.). "Fétiches de la Côte d'Ivoire." *Société d'Ethnographie de Paris*, N.S., no. 7 (1923), pp. 134–65.

Perron, Michel. "Contes et traditions populaires dans les races de la Sénégambie et du Niger." *Bul. Ag. Gen. Col.*, no. 58 (1930), pp. 576–90.

————. "Agriculture et industries indigènes chez les Sénoufos du Cercle de Kong." *Bul. Ag. Gen. Col.*, no. 282 (1932), pp. 1361–71.

————. "Un pays moyen, le Soudan de la Côte d'Ivoire." *Bul. Ag. Gen. Col.*, no. 281 (1932).

————. "Recherches sur toute survivance d'esclave domestique ou de servage en pays Sénoufo." *Bul. Ag. Gen. Col.*, no. 287 (1933).

————. "Situation économique et agricole du pays sénoufo: notre rôle." *Bul. Ag. Gen. Col.*, no. 286 (1933).

Prouteaux, Maurice. "Notes sur certains rites magico-religieux de la Haute Côte d'Ivoire." *L'Anthropologie* 29 (1918–19):37–52.

————. "Premier coup d'oeil sur la religion séné." *Bul. Com. Et.* 2 (1921): 225–51.

————. "Divertissements de Kong." *Bul. Com. Et.* 8 (1925):606–50.

————. "Premiers essais de théâtre chez les indigènes de la Haute Côte d'Ivoire." *Bul. Com. Et.* 12 (1929):448–75.

Quiquandon, F. "Histoire de la puissance mandingue d'après la légende et la tradition: Les Traouré dans le Kénédougou jusqu'au moment de l'arrivée de la mission Quiquandon." *Société de Gèographie Commerciale de Bordeaux: Bulletin*, ser. 2, 15 (1892):305–18, 369–87, 400–429.

Rapp, E. L. "Die Nafana-Sprache auf der Elfenbein-und Goldküste." *Mitteilungen des Seminars für Orientalische Sprachen zu Berlin* 36 (1933): 66–8.

Ruelle, E. (Dr.). "Notes anthropologiques, ethnographiques et sociologiques sur quelques populations noirs du Occidentale Française." *L'Anthropologie* 15 (1904):516–19, 657–703.

Salvan, (Administrateur). "Le cercle de Dabahala." In *La Côte d'Ivoire.* (Notice publiée à l'occasion de l'Exposition Coloniale de Marseille.) Paris: Crette, 1906.

Sidibé. Mamby. "Monographie de la région de Banfora (Cercle de Bobo)." *Bulletin de l'enseignement A.O.F.*, Oct.–Dec. 1921, p. 52; Jan.–Mar. 1922, p. 65; July 1922, p. 62; Oct.–Dec. 1922, p. 59; Jan.–Mar. 1923, p. 39; Apr.–June 1923, p. 40.

Tautain, L. (Dr.). "Notes sur les croyances et pratiques réligieuses des Banmanas." *Revue d'Ethnographie* 3 (1884):399.

————. "Le Dioula-dougou et le Sénefo." *Revue d'Ethnographie* 6 (1887): 395.

Tauxier, Louis. *Le Noir de Bondoukou: Koulangos, Dyoulas, Abrons, etc.* Paris: Léroux, 1921.

Traoré, Dominique. "Notes sur le royaume mandingue de Bobo." *Bulletin de l'enseignement A.O.F.* 26 (1937):58–77.

Vendeix, Marie-Joseph. "Etudes sur les fiancailles chez différentes peuplades de l'Afrique Occidentale." *Bul. Com. Et.*, ser. 1, 16 (1933):155–62.

————. "Fêtes des semailles des moissons chez les paysans Sénoufo." *Bul. Com. Et.* 16 (1933):163–67.

————. "Notes sur la principale divinité chez les Sénoufo et les Bambara." *Bul. Com. Et.* 16 (1933):128–33.

————. "Nouvel essai de monographie du pays sénoufo. *Bul. Com. Et.* 17 (1934):578–652.

III. PRIMARY AND SECONDARY SOURCES AFTER 1940
(Secondary Sources Marked with an Asterisk)

Atger, Paul. *La France en Côte d'Ivoire de 1843 à 1893: Cinquante ans d'hésitations politiques et commerciales.* Dakar: Université, Section d'Histoire, 1962.*

Avice, Emmanuel. *La Côte d'Ivoire: Pays Africains, 1.* Paris: Société d'Editions Géographiques, Maritimes et Coloniales, 1951.*

Béart, Charles. "*Les associations,*" *d'après Baba Coulibaly: Doc. IFAN, W. Ponty, I, XV, C12. Jeux et jouets de l'Ouest africain.* Vol. 2:799–807. Mémoires de l'Institut Français d'Afrique Noir, no. 42. Dakar: IFAN, 1955.

Bernus, Edmond. "Kong et sa région." *Etudes Eburnéenes* 8 (1960):239–324.*

Bochet, Gilbert. "Le 'poro' des Diéli." *Bul.* IFAN 21 (1959):61–101.

———. "A propos des fondements spirituels de la vie sociale des Sénoufo."
 Bulletin de la Société Royale Belge d'Anthropologie et de Préhistoire
 74 (1964):5–31.

———. "Les Masques sénoufo, de la forme à la signification." *Bul.* IFAN 27
 (1965):636–77.

Bouys. "Samory et les forgerons de Dabakala." *N.A.* 18 (1943):12.

Clamens, G. (Père). "Conte Tagana Pyo (Côte d'Ivoire)." *N.A.* 47 (1950):
 99.

———. "Des noms de personnes en dialecte tagwana." *N.A.* 46 (1950):
 50–51.

———. "Anthroponymie nyarafolo." *N.A.* 52 (1951):120–22.

———. "Langues sécrètes du poro." *N.A.* 51 (1951):93–94.

———. "Essai de grammaire sénoufo-tagouana." *Bul.* IFAN 14 (1952):1403–
 65.

———. "Le serpent en pays sénoufo." *N.A.* 56 (1952):119–20.

———. "Curieuse statue de cuivre sénoufo." *N.A.* 57 (1953):14–15.

———. "Des noms vernaculaires du Typhlops dans quelques dialectes
 sénoufo." *N.A.* 58 (1953):49–52.

———. "Dieu d'eau en pays sénoufo." *N.A.* 60 (1953):106–8.

———. "Les Nyi-Kar-Yi de Watyene." *N.A.* 60 (1953):108–10.

———. "Notes d'ethnologie sénoufo." *N.A.* 59 (1953):76–80.

———. "Rapprochements sénoufo-dogon." *N.A.* 57 (1953):15–16.

Clamens, G. (Père), and Adandé, A. "Poignard et hache de parade en
 cuivre sénoufo ancien." *N.A.* 58 (1953):49–62.

Clement, Pierre. "Le forgeron en Afrique Noire: Quelques attitudes du
 groupe à son égard." *Revue de géographie humaine et d'ethnologie*
 2 (1948):35–58.

Delafosse, Maurice. *La langue Mandingue et ses dialectes (Malinké, Bam-
 bara, Dioula). Dictionnaire Mandingue-Français*, vol. 2 (Bibliothèque de
 l'école nationale des langues orientales vivantes, T. X, XV). Paris: Paul
 Geuthner, 1955.

Delmont, P. "Quelques observations sur l'état civil indigene au Soudan
 occidentale." *Bul.* IFAN 7 (1945):54–79.

Deloncle, Pierre. *L'Afrique Occidentale Française: Decouverte, pacification,
 mise en valeur.* Montligeon: Editions Leroux, 1934.*

Duprey, Pierre. *Histoire des Ivoiriens: Naissance d'une nation.* Abidjan:
 Imprimerie de la Côte d'Ivoire, 1967.*

Glaze, Anita J. "Woman Power and Art in a Senufo Village." *African Arts*
 8 (1975):24–29, 64–90.

———. "Art and Death in a Senufo Village." Ph.D. dissertation, Indiana
 University, 1976.

———. "Themes in the Language of Senufo Ornament and Decorative
 Arts." *African Arts* 12 (1978):63–71, 107–8.

Goldwater, Robert. *Senoufo Sculpture from West Africa.* New York: Mu-
 seum of Primitive Art, 1964.*

Henry, R. "A propos d'une exposition sénoufo." *N.A.* 79 (1958):83–5.*

Himmelheber, Hans. "Massa-Fetisch der Rechtschaffenheit." *Tribus*, N.F.,
 4–5 (1954–55):56–62.

———. "Deutung Bestimmter Eigenarten der Senufo-Masken (Nördliche
 Elfenbeinküste)." *Baessler-Archiv*, N.F., 13 (1965):73–82.

————. "Ringe und Anhänger der Senufo (Nördliche Elfenbeinküste)." *Baessler Archiv*, N.F., 15 (1967):247–70.

Holas, Bohumil. "Fondements spirituels de la société sénoufo." *Journal de la Société des Africanistes* (Paris) 26 (1956):9–31.

————. *Les Sénoufo (y compris les Minianka).* Paris: Presses Universitaires de France, 1957.

————. "Note sur la fonction rituelle de deux categories de statues sénoufo." *Artibus Asiae* 20 (1957):29–35.

————. "Réponse à M. Knops au sujet des Sénoufo." *Bul. So. Anth. Préhist.* (1960):71.

————. "La conception du monde et de l'individu chez les Sénoufo." *Connaissance du monde*, N.S., 48 (1962):10–20.

————. *Sculpture Sénoufo.* Abidjan: Centre des Sciences Humaines de la Côte d'Ivoire, 1964.

————. *Animaux dans l'art ivoirien.* Paris: P. Geuthner, 1969.

Houis, M. "Trois essais de classification des langues de l'Afrique noire occidentale." *N.A.* 60 (1953): 118–19.

Huet, Michel. *Les hommes de la danse.* Lausanne: Guide du Livre, 1954.*

Knops, (Père). "Notes sur une lampe Sénoufo et ses artisans." *Bulletin des Musées Royaux d'Art et d'Histoire* (Brussels) (1953):66–71.

————. "Contribution a l'étude des Sénoufo de la Côte d'Ivoire et du Soudan." *Bul. Soc. Anth. Préhist.* 67 (1956):141–68.

————. "Critique de 'Fondements spirituels de la vie sociale Sénoufo' de M. Bohumil Holas." *Bul. Soc. Anth. Préhist.* 69 (1958):130–38.

————. "Aspects de la vie agricole des Sénufo de l'Afrique occidentale." *Bul. Soc. Anth. Préhist.* 69 (1958):105–29.

————. "L'artisan sénufo dans son cadre ouest-africain." *Bul. Soc. Anth. Préhist.* 70 (1959):83–111.

————. "Fables sénufo." *Bul. Soc. Anth. Préhist.* 71 (1960):55–69.

————. "Rituel funéraire Sénufo." *Bul. Soc. Anth. Préhist.* 72 (1961): 129–48.

Kulaseli. "Une phase de l'initiation à un poro forgeron sénoufo." *N.A.* 65 (1955):9–14.

————. "La levée du deuil chez les femmes du clan forgeron (Dikodougo, Côte d'Ivoire)." *N.A.* 103 (1964).

Labouret, Henri. "A propos des labrets en verre de quelques peuplades voltaïques." *Bul.* IFAN 14 (1952):1385–1401.

Lavergne de Tressan. *See* Tressan.

Lem, F.-H. "Au sujet d'une statuette sénoufo." *Bul.* IFAN 4 (1942): 175–81.

————. "La rupture d'union conjugale chez les animistes et les musulmans du Moyen-Soudan." *En Terre d'Islam*, N.S., 17 (1942):8–22.

Maesen, Albert. "Le sculpteur dans la vie sociale des Sénoufo de la Côte d'Ivoire." Presented at the Congrès International des Sciences Anthropologiques et Ethnologiques, 3e session, Brussels, 1948. Comptes rendus, Tervuren, 1960.

Person, Yves. *Samori: une revolution dyula.* Mémoires IFAN, no. 80. Dakar: IFAN, 1968–70.

Prost, R. P. André. *Contribution à l'étude des langues Voltaïques.* (Mémoires IFAN, no. 70) Dakar: IFAN, 1964.

Richard-Molard, Jacques. "Les groupes ethniques." In *L'encyclopedie coloniale et maritime.* L'Afrique Occidentale Française, vol. 1, 1949.

Richter, Delores. *Art, Economics and Change: A Study of the Kulebele of Northern Ivory Coast.* Ann Arbor: University Microfilms, 1977.
———. Personal communication, 21 May 1972.
———. Personal communication, Korhogo, Ivory Coast, July 1975.
———. "Further Considerations of Caste in West Africa: The Senufo." Unpublished MS, 1978.
Roussel, Louis. *Rapport démographique* and *Rapport sociologique.* Région de Korhogo: Étude de développement socio-économique, vol. 1–20. Paris: Société d'Études pour le Développement Socio-Économique, 1965.
Sanogho, S. "Les ornementations tégumentaires des Sénoufo de Kenedougou, Soudan Français." *N.A.* 58 (1953):22–23.
Thiam, Bodiel. "Le dieungue ou anneau de cheville d'esclave." *N.A.* 53 (1952):13–14.
———. "Canne coutumière Sénoufo." *N.A.* 88 (1960):122–3.
———. " 'Kouroubla,' masque des cérémonies du poro Sénoufo." *N.A.* 109 (1966):25–27.
Traoré, Dominique. "Fondation et vicissitudes de la province Ganan, cercle Sikasso." *N.A.* 35 (1947):26.
———. "Les relations de Samory et de l'état de Kong." *N.A.* 47 (1950): 96–97.
Tressan, Michel de Lavergne de. *Inventaire linguistique de l'Afrique Occidentale Française et du Togo.* Mémoires IFAN, no. 30. Dakar: IFAN, 1953.
Welmers, William E. "Notes on two languages in the Senufo group, I: Senadi, II: Supidi." *Language* (Baltimore) 26 (1950):126–46, 494–531.*

IV. UNPUBLISHED MATERIALS

ABIDJAN. NATIONAL ARCHIVES. MONOGRAPH SECTION.

"Coutumes des populations sienamana du Cercle de Kong." Coutumier. Cercle de Kong. Dossier Korhogo [by M. F. Delmotte], 1919.
"Coutumier de la Côte d'Ivoire: Groupe Senoufo-Lobi." Dossier Korhogo, n.d.
"Enregistrements des coutumes indigènes du Cercle des Tagouanas, Octobre 1916, Cercle de Katiola." Dossier Bouaké [by J. Chartier], 1916.
"Monographie du Cercle de Kong." Dossier Korhogo, 1911.
"Monographie du Cercle de Touba (Odienné). Dossier Seguela-Odienné, n.d.
"Monographie du pays de Sinématiali." Dossier Korhogo [by Knops (Père)], 1925.
"Odienné Cercle: Dossier Seguela-Odienné" [by Campion], 1917.
"Les paysans Senufo de Korhogo (Côte d'Ivoire)." Faculté des Lettres et Sciences humaines de Dakar, Travaux du Departement de Géographie, no. 8 [by Sinali Coulibaly], 1960.
"Usages coutumiers en matière de mines, Nov. 10, 1914–April 6, 1915." In Subdivision de Ferkessedougou. Dossier Korhogo, 1914–15.

DAKAR. NATIONAL ARCHIVES.

"Historique de la province du Gouato: Cercle de Touba." Cote 5G-41,

chemise no. 2 (4) [by (Lt.) Curault], 1900.
"Historique du village indépendant de Lodjouko: Cercle de Touba." Cote 5G-41, chemise no. 2 (3) [by (Lt.) Curault], 1900.
"Dictionary: Tyebara-English; English-Tyebara." Mimeographed. Korhogo, Côte d'Ivoire: Mission Baptiste, 1967.

DIKODOUGOU. SOUS-PRÉFECTURE ARCHIVES.

"Inventaire des villages de la Sous-Préfecture de Dikodougou, 5 June 1968."
Kientz, Albert. Personal communication. Dikodougou, Côte d'Ivoire, 15 June 1973.
————. Personal communication. Mimeographed field notes. Bischwiller, France, 27 March 1974.
Maesen, Albert. "De plastiek in de kultuur van de Senufo van de Ivoor-kunst (Fransch West Afrika)." Doctoral dissertation, University of Ghent, 1940.
Mills, Richard, and Mills, Betty. Letter to Dr. John T. Bendor-Samuel. Notes on the classification of Senufo language groups. From the Baptist Mission, Korhogo, 2 May 1968.

KORHOGO. MISSION BAPTISTE. ARCHIVES. ANTHROPOLOGY FILE.

Interview with former *Sandobele*. Mission Baptiste, Korhogo [by Lu Johnson].
Responses to "Questionnaire on Death and Funerals." Mission Baptiste, Korhogo [ed. Helen Skinner], 1969–70.
Welch, Robert. Personal communication. Ferkessedougou, Baptist Mission, 5 May 1970.
Welmers, William E. "Report on Senufo Dialect Studies." Mimeographed. For the Baptist Mission, Korhogo, 1957.

PARIS. ENFOM.

Paris. Archives. École Nationale de la France d'Outre Mer (ENFOM). Rapports de Stage et Mémoires.
"L'architecture en pays Sénoufo." ENFOM, 38 [by Pierre Roman], 1954–55.
"Coutumier civil Senoufo de Canton de Kiembara." ENFOM, 5 [by François Foatelli], 1948–49.
"Essai de monographie sur les Karaboros du Cercle de Banfora (Haute-Volta)." ENFOM, 43 [by René Ouin], 1952–53.
"Essai d'une monographie des groupes Ouan et Mona de la Subdivision de Mankono en Côte d'Ivoire." ENFOM, 1 [by Jacques d'Agostini], 1951–52.
"Le fétichisme des Senoufos de la région de Korhogo." ENFOM, 15 [by Dubois de Prisque], 1952–53.
"Les Gouins du Cercle de Banfora." ENFOM, 5 [by G. Besnard], 1952–53.
"Komo." ENFOM, 46.S.A.C. [by R. d'Hautfoeuille], 1947–48.
"Vie rurale et vie urbaine dans le pays Senoufo de Côte d'Ivoire." ENFOM, 19, 1951–52.

V. REFERENCES OUTSIDE THE SENUFO AREA

Bérenger-Féraud, Dr. "Etude sur les griots: Des peuplades de la Séné-gambie." *Revue d'Anthropologie*, 2d ser., 5 (1882):266–79.

Bravmann, René A. *Islam and Tribal Art in West Africa*. Cambridge: Cambridge University Press, 1974.

Camara, Seydou. *The Songs of Seydou Camara*. Translated by Charles Bird with Mamadou Koita and Bourama Soumaouro. Kambili: Occasional Paper in Mande Studies, vol. 1. Bloomington, Ind.: African Studies Center, Indiana University, 1974.

d'Azevedo, Warren. *The Artist Archetype in Gola Culture*. Reprint no. 14. Reno, Nev.: University of Nevada, Desert Research Institute, 1966.

Goldwater, Robert. *Bambara Sculpture from the Western Sudan*. New York: Museum of Primitive Art, 1960.

Griaule, Marcel. *Masques dogons*. Travaux et mémoires de l'Institut d'Ethnologie, Université de Paris, no. 33. Paris: Institut d'Ethnologie, 1938.

Laude, Jean. *African Art of the Dogon: The Myths of the Cliff Dwellers*. New York: Viking Press, 1973.

Mauny, Raymond. "Baobabs: Cimetières à griots." *N.A.* 67 (1955):72–76.

Monteil, Charles. *Les Khassonké: Monographie d'une peuplade du Soudan Français*. Paris: Ernest Leroux, 1915.

Murdock, George P. *Ethnographic Atlas*. Pittsburgh, Pa.: University of Pittsburgh Press, 1967.

Nuoffer, O. *Afrikanische Plastik in der Gestaltung von Mutter und Kind*. Dresden, n.d.

Sidibé, Mamby. "Les gens de caste ou *nyama-kala* au Soudan Français." *N.A.* 81 (1959):13–17.

Tautain, L. (Dr.). "Notes sur les castes chez les Mandingues et en particulier chez les Banmanas." *Révue d'Ethnographie* 3 (1884):343–52.

———. "Etudes critiques sur l'ethnologie et l'ethnographie des peuples du bassin du Sénégal." *Révue d'Ethnographie* 4 (1885):61–80, 137–47, 254–68.

Thompson, Robert Farris. *African Art in Motion: Icon and Act in the Collection of Katherine Coryton White*. Los Angeles, Calif.: University of California Press, 1974.

Trowell, Kathleen Margaret, and Nevermann, Hans. *African and Oceanic Art*. New York: H. N. Abrams, 1968.

Wilks, Ivor. *The Northern Factor in Ashanti History*. Achimota: Institute of African Studies, University College of Ghana, 1961.

———. "A Medieval Trade Route from the Niger to the Guinea Coast." *Journal of African History* 3 (1962):337–41.

Zahan, Dominique. *Sociétés d'initiation Bambara: Le N'domo, le Korè*. Paris: Mouton & Co., 1960.

Zeltner, Fr. de. "Notes sur la sociologie soudanaise." *L'Anthropologie* 19 (1908):217–33.

Zemp, Hugo. "Musiciens autochtones et griots Malinké chez les Dan de Côte d'Ivoire." *Cahiers d'études Africaines* 4 (1964):370–82.

———. "La légende des griots Malinké." *Cahiers d'études Africaines* 6 (1966):611–42.

Glossary

This glossary consists largely of vocabulary items from two Central Senari dialects, Kufuru and Tyebara, with a few vocabulary items from Fodönrö added when necessary. Words of non-Senufo derivation are so indicated. A selection of important Senufo terms employed in this text, the glossary is designed for the general reader and therefore does not include all the linguistic data necessary for Senufo language analysis. Accordingly, I have omitted the noun class markers and the tonal pattern even though these two aspects are essential to learning Senari or Fodönrö.

Senufo orthography differs from English at several points. For example, the glottal stop, an important consonant in the Senufo language, is represented by the letter *h* in Senufo orthography. Below is a list of unfamiliar symbols along with an approximate equivalent. The symbols in parentheses are those used in standard Senufo orthography. Our alternative symbol conforms to standard type.

Vowels	English	Senufo	Consonants	English	Senufo
a	dr*a*ma	d*a*ba	ng'	si*ng*er	dang'a
o	b*oa*t	K*o*to	h	Oh! Oh!	yë*h*ë
ö (ɔ)	b*ou*ght	G*ö*rö	ty	*ch*eat	*ty*eli
e	b*ai*t	Kule	sy	*sh*eet	*sy*oo
ë (ɛ)	b*e*t	ty*ë*lë	dy	*j*ot	sind*y*obele
i	b*ea*t	f*i*la	kp	bac*kp*ack	*kp*ok*p*aha
u	b*oo*t	gun*u*go	gb	big *b*ox	*Gb*on

Senufo has nasal vowels, ã, ẽ, õ, ũ, and ĩ, which are roughly equivalent to an, en, on, un, and in, respectively. For purposes of standard type the glossary uses these equivalence symbols.

daba—(a Dyula loan word; see *tiya*) a type of hoe made by blacksmiths, characterized by its short, wooden handle and wide, scooped iron blade (maximum width, twelve inches).

danga—a small basket with a four-cornered base made by blacksmith women; also refers to the cowrie hat formed with the basket as base and used by women funeral singers.

dëëbele—evil spirits and witches whose identity and malevolent activities can be identified through *Sando* divination.

Dözöbele—hunters of the hunters' association.

fila—a category of textiles defined by its style (parallel stripes), its technique (a positive dye and direct painting method), and its purpose (protective device prescribed by a *Sando* diviner).

Fo—python; primary emblem of the *Sando* diviner, *Fo* is a messenger between the spirit world and human beings.

Fodonon—a farmer ethnic group in the Kufulo region; a branch of the Southern Senufo peoples, the Fodonon are found in various parts of the Central Senufo region around Korhogo.

Fodönrö—the Senufo dialect spoken by the Fodonon; Fodönrö is closely related to Tagbana, which is part of the Southern Senufo language division.

Fono—the blacksmith artisan group that has lived in a symbiotic relationship with farmers of the Central Senufo region; the women are specialists in basketry crafts.

Gbön—most senior masquerade of the Fodonon men's society, incorporating carved zoomorphic helmet mask with short antelope horns and full raffia costume.

Gbongara—a Junior Grade fiber masquerade of the Kufulo group that appears at *Kwörö* graduation ceremony.

Görö—a public celebration held during the dry season after *Kafwö* graduation and featuring dancing by the graduates' female counterparts and an abundance of food and drink. *Görö* exchange relationships between villages may cross dialect boundaries.

kaariye—genre of hunters' praise music popular throughout Central Senufo, using a small lute-harp (*kori*) and iron rasps (*kaariga*).

Kafwö—three-day ceremony of final graduation from the last, seven-year phase of the men's initiation societies (both Poro and Pondo systems).

kahafolo—(lit., "village owner") village chief.

kahama—a hoeing contest between two cultivating teams composed of members of different *katiolos* in which as many as three different age sets participate.

Kamuru—masquerade association of the children's Poro; a common generic name for children's masks encompassing several styles.

Kanbiri—masquerade association of the children's Pondo; Fodonon equivalent of *Kamuru*.

kandang'o—a friend and member of the same age grade (not necessarily of the same Poro organization or village).

katiolo—a residential ward and cooperative work unit with a predominant tie to one matrilineage segment; also, the space defined by the houses, granaries, and courtyards of the residents.

Katyelëëö—"Ancient Mother," an aspect of deity conceived as maternal and protective; her basic channel of contact with humanity is through where she has her terrestrial home (*katiolo*) (Fodonon variant, *Malëëö*).

Kmötöhö—low-ranking masquerade worn by Junior Grade initiates of the Kufulo and Fono Poro during *Kwörö* period.

Kodöli-yëhë—masquerade with carved face mask component worn by Junior Grade initiates of the blacksmith Poro society.

Kolotyolo—one of two principal Senufo deities, the Creator God; non-visible and wholly good in nature.

Koto—fiber masquerade of the Pondo society that appears at initiations and funerals and whose central purposes are aesthetic display and entertainment.

Kotopitya—(lit., "*Koto*'s girlfriend") a Fodonon masquerade incorporating a face mask of the *Kodöli-yëhë* type owned by a woman; *Kotopitya* accompanies the *Koto* masquerade only in those instances when a *Sando* diviner has ordered it for a female client.

Kpaala—an open log shelter with stacked layers of wood poles placed at alternating angles. Serving both as domestic courtyard furniture and as a visual reference to the ancestral lineage of the *katiolo* chief, the *Kpaala* is a focal point during the funeral ritual. Among the Fodonon, a monumental version is central to Pondo society initiation activities.

Kpeene—the brasscasters' artisan group; the men are brasscasters or weavers and the women, potters.

kpokpaha—(lit., "dead one's house") where death watch is held for funerals of elders.

Kponyungo—a generic word for helmet mask, in Kufulo region usage it refers specifically to the most senior of the Poro society masquerades used by the Kufulo farmer group; a zoomorphic helmet mask with long antelope horns incorporating antelope and warthog motifs and usually with a chameleon, a bird (various species), and a hollow cup on the crest.

Kufulo—(*Kufurubele*, pl.) a farmer ethnic group in the Kufulo region that is a branch of the Central-Senari-speaking farmers (Senambele); *Kufulo* also commonly refers to the region south of the Solomougou River, i.e., the Dikodougou area as a whole.

Kufuru—a dialect of the nine-member Central Senari dialect cluster, Kufuru is spoken by the Kufulo people, the branch of the Senambele living in the Dikodougou *sous-préfecture*.

Kule—(*Kulebele*, pl.) a woodcarving artisan group found throughout the Central Senufo area; the men are sculptors and the women, specialists in calabash craft.

Kunugbaha—a zoomorphic helmet mask with warthog tusks as a dominant iconographic element; most senior of the blacksmith masquerades, incorporating the primary symbol of the power and authority of Poro leadership; having punitive powers, it seeks out evildoers and lawbreakers, including witches.

Kurutaha—a secondary fiber masquerade of the Fodonon Pondo society.

kuubele—(*kuu*, sing.) the dead or spirits of the dead; the term may also refer generally to the ancestors.

kuufuloro—ancestral funeral ritual performed for Poro members either at the time of actual burial or at a delayed funeral celebration; by definition must include certain sacred masquerades and musical instruments.

kuugo—burial and commemorative funeral; may include various nonsacred musical genres.

kuugofolo—(lit., "owner of the funeral") elder responsible for all matters concerning the funeral of a member of his *katiolo* or matrilineage segment.

Kuumo—a Great Funeral; a commemorative celebration for a village's dead; a community funeral on a massive scale involving guests from many villages; intended to honor Poro leaders and assign responsibility for the widows.

kwöbele—fifth-year Junior Grade initiates participating in the three-month *Kwörö.*

Kwöbele-kodöli—fiber masquerade worn by graduates of the blacksmith Junior Grade as part of the dance celebrating the completion of *Kwörö.*

Kwörö—a three-month training period in the fifth year of the Junior Grade (*Plawo*) of the Fono and Kufulo Poro cycle, climaxed by the ritual death and rebirth of the initiate, who is then fit for entry into the third and final grade of Poro instruction and service.

madebele—bush spirits; quasi-human spirits believed to inhabit the forest, fields, and waterways surrounding the Senufo village; maleficent and unpredictable beings who demand constant propitiation; they work harm but are not considered wholly evil, as are the *dëëbele*; also used as a generic term for any representation of the human figure in sculpture or graphics.

möhö—a derogatory term for an adult male who either refuses or is unable to complete the Poro initiation cycle; an outcast; a nonperson.

Nafiri—fiber masquerade of the Pondo society, the fabrication of which signals the beginning of a three-grade initiation for a particular set of boys.

Namboringwö—graduate of the *Kafwö* ceremony; title of a man who has successfully completed all phases of Poro initiation and has graduated from the final grade (alternate term, *kafwökön*).

Ndaafölö—(lit., "rain owner") rain priest or rainmaker; an inherited title and office found only in the Fodonon dialect group.

nërëgë—matrilineal clan or matrilineage segment (*narigba* is Tyebara dialect; *Konyoho* is Fodonon dialect).

ng'aambele—twins, twin spirits (intercessory spirits) worshipped by mothers of twins or women whose near maternal relatives and ancestors gave birth to twins.

Nökariga—healers' society; an institution that seems to be limited mainly to the Fodonon group; the principal insignia of a *nokariga* healer is a brass ring featuring a stylized bush-cow head.

Nosolo—a tent-shaped masquerade, incorporating a small version of the *Kponyungo* antelope mask, that appears during the Poro feast of the third year of Tyologo in the Central Senari groups' Poro cycle. The name refers not to the antelope horn motif but to the large size of the construction; hence the name "elephant" (*so*).

nyamëënë—(lit., "cord of weeping") a genre of biographical narrative and praise singing performed by women at funerals for members of their kin group.

nyëhënë—(lit., "sky" or "light") an aspect of deity and the name for the earthen altar in the family compound for the worship of the creator god *Kolotyolo.*

nyo—to be good, beautiful.

Pilalëëö—(lit., "the elder or mature child") third, or Upper, grade in the Pondo (Fodonon) initiation cycle; six and one-half years long.

Pilalëësalang'o—(lit., "those who rely on or support the *pilalëëö*") Middle Grade of the Pondo (Fodonon) initiation cycle; six and one-half years long.

Plaö—(*Pilaao*) (lit., "the little one") the Lower Grade or entrance grade of the Pondo initiation cycle, six and one-half years long.

Plawo—(*pilaabele*, pl.) Junior Grade of the Kufulo and Fono Poro initiation cycle.

Pombia—(*pombibele*, pl.) (lit., "child of Pondo") generic, general term for Pondo society initiates although most frequently applied to the youngest grade.

Pondo—the Fodonon group's equivalent of the men's Poro society of the Central Senari dialect groups. The women's counterpart is called "*Tyekpa.*"

Poro—an initiation society that is universal for Senufo males. The authority structure of a village is composed of the leadership of its several Poro societies, each having its own sacred grove and age sets of initiates. Poro societies function as systems of government, education, and economic controls and as channels for the worship of bush spirits, lineal ancestors, and Ancient Mother.

Poyoro—masquerade of the Pondo society incorporating a carved wooden face mask.

sambali—champion cultivator; also the name of an important category of funeral music for male elders.

Sando—(*Sandobele*, pl.) any member of the Sandogo society but especially those who function as diviners.

Sandogo—women's divination society constituting the core female leadership in the village; Sandogo elders work closely with male authorities in the Poro society.

Senambele—(*Senaö*, masc. sing.) generic term in the Senufo language for farmers of the several Central Senari dialect groups.

Senari—the dominant language of the Senufo peoples.

senoro—a much-feared category of death—death by violence or accident—requiring special ritual and purification measures; includes death from childbirth.

sinzanga—sacred grove, the sacred precincts of the Poro society to which noninitiates are forbidden entry (Fodonon variant, *Kölöhö gii*).

Sungboro—a minority artisan group of the southern Fodonon area; blacksmiths specializing in gongs and small iron hoes (*kope*).

syeelëëö—the maternal uncle (mother's brother) and male authority within a matrilineage segment; figuratively, *uncles* refers to one's maternal ancestors.

tefalipitya—a carved staff, held in trust by successive generations of champion cultivators, that is a prominent feature of funerary visual displays (Fodonon variant, *Tyakparipitya*).

Tiga—the secret language of the Pondo society in the Fodonon initiation

cycle; also, the name of a three-month bush school with intensive instruction in this language.

tiya—wide-blade iron hoe; Dyula loan word *daba* now used more commonly.

Tyeduno—an artisan group of blacksmiths traditionally specializing in small hoes (*kope*), knives, and guns. Distinct from the large Fono blacksmith group, the Tyeduno have *katiolo* in several Kufulo region villages, where they now are weavers and farmers.

Tyekpa—women's secret society in the Fodonon dialect group and the female counterpart of Pondo; commemorative funeral ritual for members involves the use of large-scale figurative sculpture.

tyële—(verb) "to divine," a technique or system of divination employed by *Sando* diviners.

Tyeli—a Senufo dialect group not yet classified linguistically; today a quasi-artisan group specializing in leatherworking as well as farming.

Tyo—a secondary fiber masquerade of the Pondo society.

tyolo—(*tyolobele*, pl.) initiate(s) of *Tyologo* (see below); the initiates' greatest responsibility during this period is the production of correct masquerade performances and other duties at funerals.

Tyologo—the Senior Grade, the last and most important period in the Central Senari Poro initiation cycle, lasting six and one-half years. Traditionally, this is a period of instruction, of mandatory service to the elders and the community, and of severest testing and preparation for adult leadership. Heavy fees and fines imposed during this period are distributed among Poro members.

tyotya—elder woman initiate and auxiliary member of the Poro society past childbearing age.

Yalimidyo—a colorful fiber mask of great importance in Fono and Kufulo Poro societies, the *Yalimidyo* has complex functions ranging from clown to poet to intermediary with the spirits.

yasungo—(lit., "thing to sacrifice on") any number of sacrificial objects and altars devoted to spirit worship and involving blood sacrifice.

yawiige—(lit., "thing worn as medicine or charm") a *Sando*-associated concept: an object worn as a protective charm to appease or neutralize the malevolent actions of a spirit that attaches itself to a person; the *yawiige* category includes a wide range of miniature brass animals and symbols worn in accordance with the advice of a *Sando* diviner.

Index

ancestors: human intermediaries with, 12, 48, 89, 92; relative importance of male and female, 51; choose *Sando* diviners, 59; corrective power of, 60–61; *nyameëne* prayers to, 83; as mediators between humans and supernatural, 92, 149, 152; laws of, 92; funerals render dead into, 149, 153; qualifications for status as, 150–52; relative importance of individuals as, 152–53; masquerade embodies powers of, 208

ancestor worship: blood sacrifice in, 93; funeral as manifestation of, 149–50, 152–53, 158–92; drum essential in, 231n13

Ancient Mother (*Katyelëëö*): *katiolo* of, 11, 53, 92, 181; drum sacred to, 53, 192; female aspect of Deity, 53; maintains law and order, 53, 91–93; supervisor of Poro initiates, 103; *Yalimidyo* spokesman for, 136, 170, 219; female head of matrilineage segment reflection of, 152; walking stick associated with, 182; attributes of Koto suggest, 203; blood sacrifices to, 208; nomenclature for, 230n11

antelope: horns, on helmet masks, 30, 134, 137, 192, 208, 215–16; horns, divination objects, 64; symbol of power and magic, 137; uses of various parts of, 137

anti-aestheticism, in masquerade tradition, 131, 133, 134–35, 217

architecture: of *katiolo*, 8; of *Kpaala*, 23, 191–92; of basketmakers' workshops, 31; of *Sando* round houses, 78; of *sinzanga*, 97, 194; of Poro training house, 103–104; of *kakpara*, 112

artisans: groups of, 2, 5 (table); language of, 2, 4–5, 21, 225–26n16; relationship between farmers and, 2, 4–6, 8, 21, 140–42; caste in regard to, 5–6, 31, 224n6; marriage customs of, 5, 6, 224n6; flux in occupation of, 6, 38, 40, 224n6; settlements in Pundya area, 7; disturb bush spirits' domain, 12; style of, 13–18, 136; inspiration of, 69; relation between quality and function in work of, 76; joint productions between, 84. *See also* basketmakers; blacksmiths; brasscasters; leatherworkers; potters; weavers; woodcarvers

balafon: low religious ranking of, 95, 151, 160, 187, 236n18, 240n21; at funeral, 187, 195, 238n5

Bamana (people), 3, 30, 31, 43, 103, 137, 228n33, 235n14, 241n1

Banfora dialect group (Tenyer, Kler, Syer, Senar), 2 (table)

basketmakers: Fono women, 2, 5 (table), 30–31, 84; farmers, 226n20

Baule (people), 3, 4

blacksmiths: ethnic identity of, 2, 5 (table); economic interdependence of farmers and, 4, 26, 27, 140, Fono sup-